SCULPTURE AND CERAMICS OF PAUL GAUGUIN

SCULPTURE and CERAMICS of PAUL GAUGUIN

BY CHRISTOPHER GRAY

THE JOHNS HOPKINS PRESS
Baltimore, 1963

Acknowledgments

IN A WORK OF THIS NATURE one must depend on
the good will and aid of many people. Foremost
among those to whom I am indebted are, of course,
the many collectors of Gauguin sculpture and
ceramics who have allowed me to study their
collections and include them in this catalogue.
My indebtedness to them is attested by
the very existence of this work.

Among the many scholars who have given me
invaluable aid I would like particularly to thank
Merete Bodelsen and Pola Gauguin of Copenhagen,
Ebbe Arneberg of Oslo, Roseline Bacou and
Maurice Malingue of Paris, John Rewald,
Robert Goldwater, Samuel Wagstaff, and
Richard Field. Without their help I would not
have been able to achieve whatever measure of
success I may have had in my undertaking.

CONTENTS

PART I: *GAUGUIN THE SCULPTOR*

PART II: *THE CATALOGUE*

COLOR PLATES

Part I Gauguin the Sculptor

CHAPTER 1

THE EARLY YEARS,
1873-1887

GAUGUIN STARTED HIS CAREER AS an artist late in life, but his interest in sculpture commenced not long after his interest in painting. Shortly after his marriage to Mette Gad in 1873, he and his wife were living in the house of the sculptor Aubé. Four years later they moved to an apartment in the house of the sculptor Bouillot. Gauguin, a man with a great facility with his hands, inevitably became interested in the work of his new landlord. Soon Bouillot was helping his tenant in a project to carve a marble bust of his wife Mette (Cat. No. 1). This work, executed in 1877, seems to be Gauguin's first sculpture. It, and a bust of his son Émil, executed in the same year are, as far as we know, his only works in marble (Cat. No. 2).[1] The choice of material, as well as the manner of execution, were undoubtedly influ-

[1] In a letter in 1925 Émil Gauguin wrote: "If I am not mistaken, my father only made two sculptures in marble; one of my mother, and this one." (Letter courtesy of Knoedler and Co.)

enced by Bouillot. Both pieces are conventional and close to the academic realism of Bouillot which followed the popular style of sculpture in the second half of the nineteenth century. Such professional stonecutter's tricks as the treatment of the hair to give the effect of blondness, the use of the drill to create the effect of lace at the neck, and the carving of the eye to give the effect of a reflection of light on the dark pupil, appear in the two busts, but these illusionistic devices disappear as Gauguin matures as an artist.

A carved wood statuette, which apparently represents the *Birth of Venus*, may belong to this earliest period of Gauguin's career as a sculptor (Cat. No. A–1). Unfortunately the history of this piece is not known, and its attribution to Gauguin is by no means certain. If it is by the artist, the traditional manner of working strongly suggests the influence of Bouillot, as well as its subject, drawn from the Greek art for

1

which Gauguin later expressed a distaste.[2] If this piece was actually executed under Bouillot, it may have been he who taught Gauguin the art of carving wood as well as stonecutting.

After 1876 and 1877 Gauguin's art began to mature rapidly, and he became more closely associated with the new group of the Impressionists, joining them in their discussions on art at the *Nouvelle Athènes Café*. In 1879 he had progressed so far that he was invited by Pissarro to exhibit with the new group. By now Gauguin's painting begins to show more clearly the influence of his mentor Pissarro, and he soon began to be attracted more and more to Degas. In 1880 Gauguin exhibited seven paintings with the Impressionists, together with his marble busts of Mette and Émil, but attracted no particular critical attention. In 1881, on the other hand, Gauguin scored a very considerable success at the Impressionist Exhibition when the critic J. K. Huysmans singled out his study of a nude for high praise.[3] In addition to his paintings that year the artist also exhibited two sculptures in wood, *La Petite Parisienne* and *La Chanteuse* (Cat. Nos. 4, 3). Not only do these pieces mark Gauguin's debut before the public as a wood carver, but they also mark a break with the conventionality of his earlier work. Since 1880 Gauguin had been living in a house rented from the painter Jobbé-Duval at 8, Rue Carcel, and the studio of his former landlord, Bouillot, was no longer easily available for work in stone. Wood was a natural choice under the circumstances, and it remained Gauguin's preferred material for sculpture for the rest of his career. Gauguin himself in *Avant et Après* re-

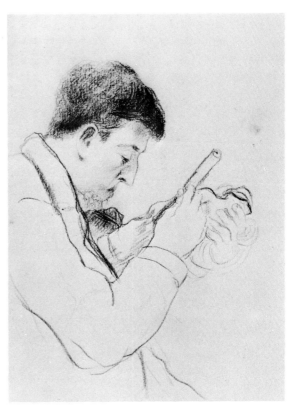

Fig. 1. Sketch of Gauguin carving by Camille Pissarro (*circa* 1880–1883). The National Gallery, Stockholm.

marked that he had shown a precocious ability in wood carving:

I was whittling one day with a knife, carving dagger handles without the dagger, all sorts of little fancies incomprehensible to grown people. A good woman who was a friend of ours exclaimed in admiration, "He's going to be a great sculptor!" Unfortunately the woman was no prophet.[4]

The medallion, *La Chanteuse*, is particularly interesting in that it shows the introduction of a number of new elements into the art of Gauguin. The subject is closely akin to the interpretations of the contemporary scene that are found in the painting of such Impressionists as Degas, with his paintings of entertainers and café so-

[2] "La grosse erreur, c'est le Grec, si beau qu'il soit." (Paul Gauguin, *Lettres à Daniel de Monfreid*, edited by Mme Joly Segalen (Paris, 1950), letter XXXVII. (Hereafter referred to as: Segalen, *Lettres*.) Richard Field has shown that in spite of his fear of the Greeks Gauguin used many Greek works of art as prototypes in his own works. (Richard Field, "Gauguin plagiaire ou créateur," in René Huyghe *et al.*, *Gauguin* (Paris, 1960), pp. 139–69.

[3] J. K. Huysmans, "L'Exposition des indépendentes en 1881," reprinted in *L'Art moderne* (new edition; Paris, 1908), pp. 262–66.

[4] Paul Gauguin, *Avant et Après* (facsimile edition; Copenhagen, 1948), p. 193.

ciety. The execution of the piece is not yet sure, for there is a combination of the conventional technique of the marble busts, which appears in the execution of the head, even to the details of the carving of the eye, with a more impressionistic handling of the flowers and the forms in the background. Gauguin never bothered with conventional rules in the execution of his work, but here he has found no proper synthesis of his own ideas, and the work lacks unity of conception. Two other aspects of this work are also of interest. It is apparently Gaugin's first attempt to use the form of relief in his sculpture, and it is also polychromed. The revival of polychrome sculpture at the end of the nineteenth century was a widespread phenomenon. Gauguin, with his growing awareness of the importance of color, and his essentially free approach to his work, was among the first to realize the potentialities of polychromy. As a possible source of this development, it is interesting to note that Gauguin's former landlord, the sculptor Aubé, worked for Haviland of Limoges, making porcelain figurines. In this form of sculpture the tradition of polychrome had never died out.

In *La Petite Parisienne*, the subject again suggests an outlook similar to that of the Impressionists, and in this case the wood is carved freely, and with a certain verve. However, Gauguin's lack of mastery over the material is shown in certain defects of the carving of the hands, and the somewhat excessive use of the file and sandpaper on the bust. Perhaps because the piece is small, and the material slight, Gauguin felt freer in expressing his own artistic perception. Though the statuette has all the elegance of a *Parisienne*, which the artist intended to express, there is also another quality appearing that was to play an important part in Gauguin's later sculpture and ceramics. As a painter, Gauguin was developing a profound feeling for what he regarded as the essential materials of the painter's craft, color and line, which he tended to liberate from the too severe strictures of naturalistic representation in order to allow them

to have an esthetic expressiveness of their own. In the same manner, when Gauguin worked in wood and potter's clay, he expressed the craftsman's innate love and respect for the qualities of his material. In his two earlier works in marble, under the influence of Bouillot, he had followed the eighteenth-century tendency toward a virtuosity that denied the quality of the stone. In his work in wood he began to react esthetically to both the quality of the chisel cut and the fiberous grain of the wood, allowing both to play their part in the expression of the figure.

In 1881 Gauguin also executed his first known piece in the field of the decorative arts. That year he made a cupboard which is still in the possession of the Gauguin family in Copenhagen (Cat. No. 5). This work marks the appearance of certain new influences on the work of the artist. The basic form of the cupboard is oriental in its derivation, it apparently draws its basic elements from the type of furniture then being made in England, and to a lesser extent in France, under the influence of a revived interest in the furniture of the Far East.[5] As such, the cupboard belongs to the early phase of a development that was to create the style of *Art Nouveau*, which flourished at the very end of the century when Gauguin had retired to the South Pacific. The cupboard, consisting of two separable rectangular cabinets, is decorated in part by wood carvings by Gauguin and in part by a bit of rococo carving that Gauguin had found. The sheaf of wheat at the top is of the eighteenth century, and the garland of carved flowers and foliage decorating the middle upright of the upper cabinet were designed by Gauguin to be more or less consistent with the spirit of the eighteenth-century carving. On either side of the foliage, the artist has placed small carved wood medallions of his two sons, Jean on the right and Clovis on the left. In the execution of these parts Gauguin has not intro-

[5] S. T. Madsen, *Sources of Art Nouveau* (New York, 1955), pp. 189–91 (Cat. No. 5a).

duced any great innovations in the older French tradition, but in the panels of the lower section of the cabinet, the influence of the decorative carving on oriental furniture appears.[6]

In 1882 Gauguin exhibited with the Impressionists again, but he did not receive the critical acclaim of the year before. In addition to the twelve paintings and pastels that appeared, there was again a piece of sculpture, a polychrome wax bust of his son Clovis (Cat. No. 6). The year before Degas had shown at the Impressionist exhibition his *Petite Danseuse de Quatorze Ans*, which was also executed in painted wax.[7] Though Gauguin's piece has none of Degas' preoccupation with the quality of characteristic movement, he was certainly turning more and more from the academic realism of Bouillot toward Impressionism, and the influence of Degas soon becomes apparent in other ways.

In 1882 Gauguin undertook what appears to be his first thoroughly worked out carving-in-relief, the piece that has come to be known as *La Toilette* (Cat. No. 7). Unlike *La Chanteuse*, this piece is not polychromed. It is done in pearwood, with a carefully graded relief. The figure of the nude girl brushing her hair in the foreground is in quite high relief, which grades down to the barely indicated elements of the landscape in the distance.

It is dangerous to speak of "Impressionist" sculpture, but this piece, with immediacy of the presentation of the awkward figure of the young adolescent, suggests the reinterpretation in sculpture of the *Nude Sewing*, which had achieved a critical success in the Impressionist Exhibition of 1881, and reminds one of the influence of both Pissarro and Degas, which is strongly marked in Gauguin's work at this time. By now the academic influence of Bouillot has completely disappeared, and Gauguin has achieved a redinte-

gration of his style along the new lines that were beginning to interest him, producing, still as an amateur, a work of which no professional need apologize. (One thinks of Manet's remark to Gauguin: "There are no amateurs but those who make bad pictures.")[8]

In 1883 Gauguin gave up his position as a banker to devote himself entirely to art. In 1884 he and his family left Paris for Rouen, where he hoped to make his diminishing funds last longer. It was at this time that he executed a wooden box which was his next production in the field of wood carving (Cat. No. 8). The box shows the influence of Degas in the scenes of ballet dancers on its top and front panels. The scene on the front is based on Degas' *Rehearsal of a Ballet on the Stage*, which was executed about 1874.[9] The ends of the box are decorated with ornamental cut leather handles. On the back, in addition to the ornamental hinges and a plaque bearing Gauguin's signature and the date, two *netsuke* are inlaid in the wood. These latter have the form of *okame* masks used in the *kyogen* for comical female parts.[10] By the 1880's oriental art, particularly that of Japan, had become popular. Many of the Impressionist painters came under its influence, and later in his career Gauguin noted that Japanese art was one of the most important influences in the formation of his own style. Here, as in the cupboard of 1881, the oriental influence appears in his decorative arts.

Though the main themes of the panels on the front and top are drawn from the ballet, that on the top is of peculiar significance, for it is apparently the first example of the introduction of symbolic intent into the works of Gauguin. At the far left of the panel are a series of incompletely differentiated spherical forms, the uppermost of which may represent the moon. Next there is a seated figure of a woman in which the maternal aspects are emphasized. Just to the right of this figure, near the bottom frame of the

[6] M. Maurice Malingue pointed out to me that the theme of these panels is based on the Chinese good luck symbol of the bat. Though a symbol is used here, it is not clear whether it is used with symbolic intent, or simply as a decorative element.

[7] John Rewald, *Degas Sculpture* (New York, 1956), plates 24–31.

[8] Paul Gauguin, *Avant et Après*, p. 73.

[9] Collection of the Metropolitan Museum of Art, New York.

[10] M. R. Tollner, *Netsuke* (San Francisco, 1954), Nos. 228, 241.

panel there is a bodiless head with features suggestively reminiscent of those of Degas. The part of the scene just described is isolated from the rest of the panel by an irregular form suggestive of stage scenery. The next figure to the right, perhaps that of a wardrobe mistress, faces leftward and makes a gesture of negation toward the scene on the left side of the panel. Further to the right are two ballet dancers. At best the interpretation of this scene is ambiguous, but separation of the ballet dancer from her natural role in life as a woman is suggested by the nature of the composition.

The introduction of symbolism into Gauguin's painting is generally thought to date from his stay in Brittany in 1888 and 1889 when he painted such pictures as the *Vision after the Sermon* and the *Yellow Christ* along with others.[11] However, a letter that Gauguin wrote his friend Émile Schuffenecker in January of 1885 shows clearly that he was concerned at that time with the symbolic role of painting, and it seems plausible that this box, executed the year before, is the first surviving attempt of the artist to express himself symbolically.

On the interior of the box appears an even more startling image, for on opening the box one finds a nude figure apparently laid out as if it were a dead man in his coffin. The symbolism of this figure is peculiar, especially as the inside of the cover is adorned with cut leather pieces on the ends, which, from their disposition, suggest that they were intended to hold padding in place. On the whole, the conception of the box seems to be that of a box for ladies' vanities, but beneath them must have lain the figure of death.

Gauguin's failure to make a living as an artist, his return with his wife to Copenhagen, and his unsuccessful attempt to earn his livelihood as a tarpaulin salesman in Denmark, are all too well known to bear repeating here. Our concern with Gauguin as a sculptor brings us to his return to Paris in June 1885. The following year was one

of the darkest in his career, and he sought any means of earning money, even bill-posting. When he had arrived in Paris he had hoped that he could get work in Bouillot's studio, but Bouillot was either unable or unwilling to give him employment. Seeking some means of adding to his income, Gauguin seems to have thought of turning to the applied arts. As early as 1881 he had worked on decorative wood carving, and in 1883 his interest in the crafts had led him to suggest a revival of tapestry weaving.[12] Now his mind turned toward ceramics.

Gauguin remembered that his old landlord Aubé had supplemented his income from sculpture by doing ceramics. The etcher Bracquemond, a friend of both Degas and Pissarro, and one of the original exhibitors with the *Société des Independents*, had also worked for Haviland for nearly twenty years.[13]

The beginning of Gauguin's career as a ceramicist is recorded in a letter that he wrote to his wife toward the end of May, 1886:

> M. Bracquemond the engraver has put me in touch with a ceramicist who plans to make some artistic vases. Charmed with my sculpture he begged me to make him some works according to my taste this winter which, when sold would be *divided half and half*. Perhaps this will be something important to fall back on in the future. Aubé has worked for him in the past. These pots made him a living and this is important too.[14]

The ceramicist to whom Gauguin was referring was Ernest Chaplet. On reaching the age of fifty the year before, Haviland had set him up with his own small pottery on the Rue Blomet in Paris. He had already worked thirty years in the leading factories of France and had earned

[11] *Vision After the Sermon*, National Gallery of Scotland, Edinburg; *The Yellow Christ*, Albright Art Gallery, Buffalo.

[12] Camille Pissarro, *Lettres à son fils Lucien*, edited by John Rewald (Paris, 1950), letters of June 16 and July 21, 1883, pp. 50, 57.

[13] Alfred de Lostalot, "Les Artistes contemporians,— M. Félix Bracquemond," *Gazette des Beaux-Arts*, XXX (1884), pp. 155–61.

[14] Paul Gauguin, *Lettres à sa femme et ses amis*, edited by Maurice Malingue (Paris, 1946), letter XXXVIII. (Hereafter this collection will be referred to as: Malingue, *Lettres*, followed by the number of the letter.)

a reputation as one of France's best ceramicists.[15] He was not only a thorough-going craftsman but also he had the artistic perception to grasp the promise of the works of sculpture of Gauguin. As Gauguin wrote nine years later:

> Chaplet "who is one of the select few among artists, the equal of the Chinese," as Bracquemond has so rightly said, understood me, and my attempts seemed interesting despite the inevitable experimentation.[16]

When Gauguin decided to take up the making of pottery as a means of supplementing his income, he was entering a field in an extraordinary state of fermentation. Largely as a result of the Industrial Revolution, applied arts had suffered a serious setback. The demands for large quantities of inexpensive goods had led to the application of methods of mass production to the crafts. These goods were no longer the products of skilled artist-craftsmen, but the mechanical reproduction of designs that unskilled creators found easier to combine from a miscellany of borrowings from past art than to invent themselves.

As the Industrial Revolution took place earlier in England than on the Continent, a reaction set in there sooner. Among the first to take up the crusade against the barbarous productions of the Machine Age were the architect A. W. Pugin and the critic John Ruskin.[17] In the arts, their ideas were carried on by the Pre-Raphaelite Brotherhood, in which the painter and poet Dante Gabriel Rosetti was a moving spirit. Though Rosetti and the Pre-Raphaelite Brotherhood went far in the development of the concept of the artist-decorator, it was Rosetti's follower, William Morris and his associate Walter Crane who effected the revolution in English arts and crafts. From the time of Pugin the revival of the arts had been more or less associated with the idea of forming free associations of artists who worked together in the manner of the medieval guilds, with all the processes of production in the hands of the skilled designer. In 1860 William Morris set up such a co-operative venture, centering around his famous Red House in London. Within ten years Morris was applying his ideas of close collaboration between artist and craftsman to almost every branch of the decorative arts. In England he was becoming recognized as the leader of a renaissance in the arts and crafts, and his reputation was spreading on the continent through international exhibitions and critical essays on his ideas and work in various journals.[18]

France, like England, had also fallen behind in the applied arts with the development of industrialization. Since the revolution, France had suffered a number of styles in the applied arts based on the production of past periods. The Neo-Classic style was followed by Neo-Baroque, which, in turn, had been followed by a revival of the Rococo style under Louis Philippe. The Great Exhibition of 1851 opened the eyes of the French to the fact that they were losing their leadership in the decorative arts, and remedial action was demanded.[19] Soon the applied arts began to receive official encouragement. By 1863 the *Union Centrale des Beaux-Arts Appliqués à l'Industrie* was formed, and in 1865 it opened a museum devoted to applied art. In the same year, as well as in 1869, 1874 and 1876 the Union sponsored exhibitions of the decorative arts. By 1877 another agency, the *Société du Musée des Arts Décoratifs* was founded, and three years later, in 1878, the *Union Centrale des Beaux-Arts Appliqués à l'Industrie* and the *Société du Musée des Arts Décoratifs* were amalgamated into the *Union Centrale des Arts Décoratifs*.[20]

The revival of interest in the decorative arts had been in part stimulated by a reaction against

[15] Roger Marx, "Souvenirs sur Ernest Chaplet," *Art et Décoration*, March, 1910, pp. 89–98.

[16] Paul Gauguin, Letter to the editor of *Le Soir*, April 25, 1895, quoted from Charles Morice, *Gauguin* (Paris, 1919), p. 155.

[17] Georges Vidalenc, *William Morris, son oeuvre et son influence* (Caen, 1914), chaps. I, II.

[18] Temple Scott, *A Bibliography of the Works of William Morris* (London, 1897). See also: Jacques Lethève, "La Connaissance des peintres preraphaelites anglais en France," *Gazette des Beaux-Art*, May–June, 1959, pp. 315 ff.

[19] Madsen, *Sources of Art Nouveau*, p. 139.

[20] *Ibid.*, p. 140.

the eclectic borrowings of the traditional designers, and a basic problem of the new movements was to develop a style that was both honest and suitable as well as esthetically pleasing. As almost all the styles of the past had been revived at one time or another, the general attitude in both England and France was that the craftsman must return to natural forms for the esthetic material of a new style. As early as the Exhibition of 1851, the potter Grainger had attracted attention by utilizing the forms of plants for the decoration of his works. The naturalistic form of decoration had been further developed by the theoretician Dresser.[21] In France, with the de-

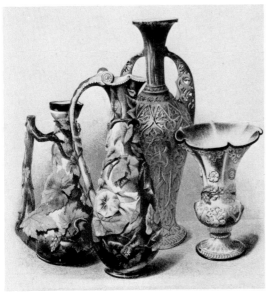

FIG. 2. Vases of Beauvais ware designed by Zeigler and made by Mansard. Exhibited in the Great Exhibition of 1851. From M. Digby Wyatt, *Industrial Arts of the Nineteenth Century of the Great Exhibition of MDCCCLI.*

[21] *Ibid.,* pp. 164–65. The decoration of pottery with plant motifs in relief, in a somewhat more traditional manner, had been used by the potter Mansard at Voisinlieu (Beauvais ware) since 1838. Examples of his work are shown in Auguste Demmin, *Histoire de la céramique* (2 vols.: Paris, 1875), Vol. II, plate cxlv. I am indebted to Mr. Richard Field for pointing out the importance of Demmin's work, for which the plates were made by Gauguin's protector, Gustave Arosa. Through Arosa's plates Gauguin may well have been familiar with the works of Mansard, whose pottery had attracted attention at the Exhibition of 1851. See M. Digby Wyatt, *Industrial Arts of the Nineteenth Century at the Great Exhibition MDCCCLI* (London, 1853), plate vi. (See Fig. 2)

velopment of Naturalism in painting toward the middle of the century, it was natural that those who sought a revival of the decorative arts with a new style should also turn to nature for their inspiration. There was in addition another stimulus toward the use of natural forms in decoration, and that was the growing popularity of Japanese crafts in the second half of the century. The fact that Japanese objects of applied art were often executed by the most competent of oriental fine artists also contributed to the appreciation of their quality in a period when more and more French artists were beginning to take a sincere interest in the applied arts. Probably in all periods craftsmen have realized that plant forms have a naturally decorative quality; but in a period which was dominated by Naturalism and science, it was inevitable that these forms should be exploited. Indeed, it is interesting to note that a number of the men who worked in the crafts at this time were trained as botanists.[22]

In the special field of ceramics the trend was the same as in the field of applied arts in general. After a period of revival styles, the potter toward the middle of the century began to feel the need for a fresh approach. One direction of development was to reconsider the essential nature of the ceramic material itself and develop both form and decoration from the nature of the clay and its manipulation. In this direction potters were led back to the study of the popular common wares of earlier periods in which the potter had followed his own esthetic instincts in ornamentation through his handling of the clay itself. Another direction that was followed, largely under the influence of the growing number of artist-potters, was to return to nature for design material, combining plant forms and imagination to produce a new naturalistic decoration which did not depend on existent styles for their inspiration.

In England, though the old-established manufacturers continued working largely in the traditional manner, a number of smaller potteries began experimenting with the development of a

[22] Madsen, *Sources of Art Nouveau,* p. 168.

new style. Grainger's use of plant forms has al-
ready been mentioned. Newer small potteries,
producing such wares as Elton, Barum, and
Martin, were beginning to attract attention in
the early eighties. Elton ware was produced by
the son of Lord Elton, who worked at Cleve-
don.[23] He had started as a complete amateur in
1879, and through his own efforts developed an
earthenware decorated with barbotine and sgraf-
fito in the patterns of plants and animals in a
highly original fashion. The ware produced by
the Martin brothers at Southall is another ex-
ample of an art pottery started by an amateur.[24]
Robert Wallace Martin had been trained as a
sculptor, but finding the profession unprofitable,
he and his three brothers had set up as potters in
1872. They produced a highly imaginative
stoneware that was decorated with incisions
filled with color. In addition they produced
stoneware statuettes and grotesques of a strik-
ingly original nature. C. H. Brannum, who pro-
duced Barum ware, was a potter by inheritance,
but he turned his father's pottery at Barnstable
in North Devon from the manufacture of drain
and roofing tile to the making of art pottery, in
which the decoration was worked out in terms
of incisions through a white slip to the red clay
of the body of the pot.[25]

Since the 1860's Henry Doulton had been
encouraging the Doulton works in Lambeth to
develop artistic pottery in salt-glazed stoneware
in addition to the firm's production of utilitarian
wares. By the seventies a number of artists work-
ing for Doulton were creating a new type of pot-
tery which was decorated with incised patterns
filled with color before the salt-glaze firing.[26]
These works drew largely on forms from the
plant and animal world, and were highly praised

[23] Cosmo Monkhouse, "Elton Ware," *Magazine of Art*,
VI (1882), pp. 228–33.
[24] Cosmo Monkhouse, "Some Original Ceramicists,"
Magazine of Art, V (1882), pp. 443–50.
[25] *Ibid.*, p. 449.
[26] The chief artists working for Doulton in this early
period were Miss H. B. Barlow, Arthur Barlow, and Miss
E. J. Edwards, whose works appear from 1872. Miss E.
Simmance appears in 1873, and F. A. Butler in 1874.
(J. F. Blacker, *The A. B. C. of English Salt-Glaze Stone-
ware* [London, 1922], p. 173.)

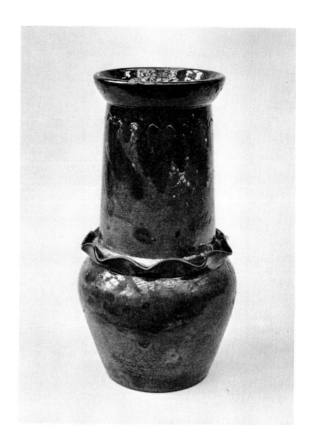

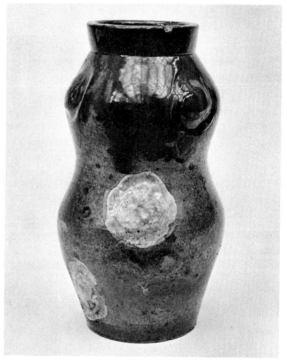

FIG. 3. Two pots by Th. Bindesbøll. The Ordrups-
gaard Museum, Copenhagen.

by contemporary critics for having "no affected imitation of antique wares." These works of the Doulton firm, which were already setting out on the path of *Art Nouveau*, won the *Grand Prix* at the Paris Exposition of 1878.[27]

In Denmark the same developments were taking place, for about 1880, Theodor Philipsen, who was to become the leading Danish exponent of Impressionism and a lasting friend of Gauguin—apparently a rare exception to Gauguin's statement that he hated all Danes—started an art pottery. He worked with Bindesbøll, son of the architect of the Thorwaldsen Museum, at the Frauens Pottery Factory in Copenhagen (Fig. 3). Another group of art potters was started by the Skovgaard family about 1880. The Skovgaards were artists by training, for their father, P. C. Skovgaard, who was the undisputed master of Danish landscape painting, also worked at Utterslev outside Copenhagen with the potter Johan Wallmann. The oldest of the Skovgaards, Joachim (1856–1938), made a reputation in all the handicrafts, including ceramics, while his brother Niels (1858–1938) revived the tradition of polychrome sculpture in terracotta.[28]

France also saw a great development in the art of ceramics in the second half of the nineteenth century. Deck and Rousseau experimented with decorations in bold and simple floral patterns.[29] Laurin introduced a popular ware decorated with barbotine, but it was perhaps Charles Haviland of Limoges who was most active in developing the new style.[30] It was for Haviland that Gauguin's old landlord Aubé had worked making figurines. The etcher Bracquemond, a friend of both Degas and Gauguin, after working for a while at Sèvres, had designed decorations for Haviland ware.[31] But above all,

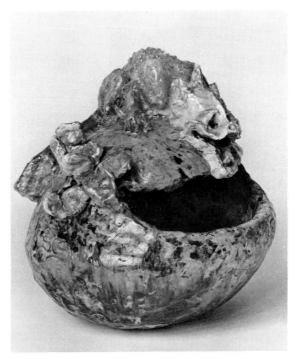

FIG. 4. Pot by Suzette Skovgaard (1888). The Museum of Decorative Arts, Copenhagen.

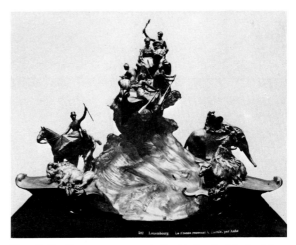

FIG. 5. *La France recevant la Russie* by Aubé. Archives Photographiques.

[27] *Ibid.*, p. 153.
[28] Erik Lassen, "Nyere Dansk Keramisk Kunst, "*Keramik* (Copenhagen, 1956), p. 356. (Courtesy of Merete Bodelsen.) See Fig. 4.
[29] Eduard Garnier, "La Céramique et la verrierie moderne," *Gazette des Beaux-Arts*, XXXI (1885), pp. 26–38.
[30] *Ibid.*
[31] Madsen, *Sources of Art Nouveau*, pp. 174–76. Alfred de Lostalot, "Les Artistes contemporians," pp. 420–26.

the master ceramicist Ernest Chaplet had gone to Haviland in 1882 after leaving Laurin where he had been instrumental in developing barbotine ware.[32]

At Haviland, where Chaplet was given the post of technical director, he devoted his energies to the creation of a renaissance in stoneware. Though the manufacture of stoneware had long been established in France, the use of this material in modern times had been restricted to the making of utilitarian objects such as cider jugs and butter jars. One of the reasons for Haviland's interest in the revival of stoneware was the success that Doulton had achieved with that material at the International Exposition of 1878, but another factor was the growing interest in oriental wares. At the Exposition of 1878 Japan had displayed, among other things, modern oriental ceramics in stoneware. In the same year the Japanese Imperial Commission had published the book *Le Japon à l'Exposition Universelle de 1878* (Paris, 1878) in which the formulas for Japanese porcelain and stoneware were given together with the formulas for their glazes.[33]

Though the oriental influence was probably the strongest single factor in the development of Chaplet's style in stoneware, he also drew upon the earlier tradition of the use of the material in Europe.[34]

Chaplet's work in stoneware, and that done under his supervision at Haviland, is marked by certain general characteristics (Fig. 6). One is

[32] Herman Seger describes barbotine ware in his report of the Exposition of 1878 as follows:

Barbotine means engobe or paste, and barbotine painting stands for a method of decoration which is essentially plastic in character, bringing out the colors by means of paste. . . . The decoration consists usually of flowers and animal pieces, preferably birds, which are in a manner painted plastically, so to speak.

Herman August Seger, *Collected Writings*, edited by Albert V. Bleininger, B. Sc., translated by members of the American Ceramic Society (Easton, Pennsylvania, 1902), p. 904.

[33] See part II, pp. 25–64.

[34] Warren E. Cox suggests the influence of German stoneware on Chaplet. (Warren E. Cox, *The Book of Pottery and Porcelain* [New York, 1944] II, 1012, Fig. 1362.)

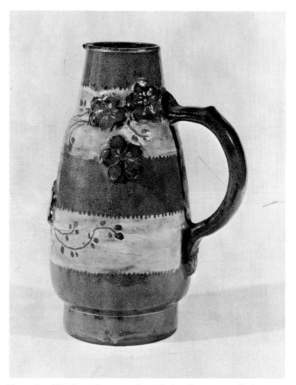

FIG. 6a. Pitcher decorated with barbotine and slip under a transparent glaze. Executed by Ernest Chaplet. Musée des Arts Décoratifs, Paris.

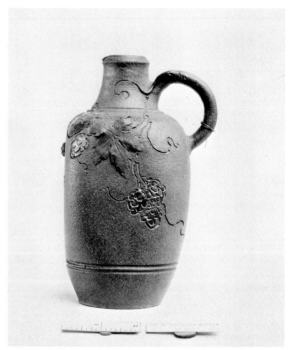

FIG. 6b. Jug made at Haviland under the technical direction of Ernest Chaplet (1882–1886). Courtesy of the Metropolitan Museum of Art, New York. Gift of George Haviland, 1923.

FIG. 6c. Vase made at Haviland under the technical direction of Ernest Chaplet (1882–1886). Courtesy of the Metropolitan Museum of Art, New York. Gift of George Haviland, 1923.

FIG. 6d. Pitcher made at Haviland by Ernest Chaplet. Musée des Arts Décoratifs, Paris.

the frank acceptance of the texture of the stoneware itself as a decorative element. His forms are generally derived from the older tradition of utilitarian stoneware, such as bottles and pitchers, with an admixture of forms derived from oriental wares. They all have in common the fact that they are wheel-made and recall the original functional nature of pottery as containers. The ornament is applied as a surface decoration to the body of the pot shaped on the wheel. Generally Chaplet used one basic type of decoration on his stoneware. First, the major structural elements of the pot, such as the lip, the base, and the handle, are decorated with zones of either abstract or other ornamental forms that emphasize the structure of the pot. It is generally in the middle zone, which presents itself as a structurally neutral area, that Chaplet elaborated the decoration in terms of naturalistic decorative forms usually drawn from the plant world, but sometimes from the animal. In executing these decorations Chaplet used essentially three techniques: forms modeled in high or low relief, incised lines, and color in the form of either slip or glaze that was restricted to the plant forms or the creation of a neutral background for them. Generally he combined all three techniques in the same piece, and often added additional lines in gold as an accent. In the middle zone Chaplet typically arranged a group of plant forms, some of which might be modeled in relief, while others were executed with an incised outline. When these forms had been established, such elements as leaves and flowers would be colored with either slip or glaze. After the pot had been fired, certain elements would be accented in gold, and the pot would be refired to fix the metal.

Though Chaplet was experimenting with the potentiality of new materials, and though he was seeking to develop a decoration whose character would not conflict with the esthetic nature of the pot, he remained essentially conventional in his approach.

During the period in which he was working for Haviland, Chaplet did not restrict himself

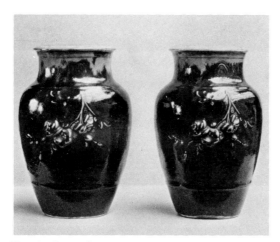

FIG. 7. Pair of porcelain vases glazed red with a copper transition glaze. Executed at Haviland by Ernest Chaplet. Courtesy of the Metropolitan Museum of Art, New York. Gift of George Haviland, 1923.

entirely to work in stoneware. He also took part in the attempt to rediscover the secrets of oriental glazes (Fig. 7). One of the most important, which had intrigued French potters for a number of years, was the famous copper red called *sang de boeuf*. Experiments had been carried out by Salvetat at Sèvres as early as 1848 to produce this glaze, but without any consistent success. In 1880, the potter Deck in Paris succeeded in producing a good copper red, and by 1883, Seger in Berlin had established the firing of this glaze on a commercial basis. By 1884 Haviland had progressed sufficiently in this field to be able to exhibit a number of pots glazed in copper red in the international exhibition of that year.[35]

The success of the *sang de boeuf* glaze depends on the careful maturing of the glaze in a reducing atmosphere in the glost kiln, as opposed to the more usual oxidizing atmosphere. Improper control results in either wares in which the green of the copper salts is not reduced to the red produced by colloidal metallic copper, or the glaze is only partly reduced, and a mottled effect results.[36] The French potter of the second half of the nineteenth century became enamored of these mottled, and often very colorful, effects of transition glazes, and he often set out deliberately to achieve them. For example, Seger records that in 1884 the potter O. Millet of the Sèvres manufactury exhibited "pottery decorated with various beautiful colored glazes, placed along side of each other and over each other, thus giving a flame effect."[37]

Though Gauguin met Chaplet in May, he had little time to work with him in the spring of 1886, for by the middle of June the artist was ready to leave Paris for Brittany, and he did not return until the middle of November. On the twenty-sixth of December Gauguin wrote his wife again:

> I am making ceramic sculpture. Schuffenecker says that they are masterpieces, as does the fabricator also, but it is probably too artistic to sell. Never-the-less he says that given the right occasion at an exposition of industrial art this idea might catch on like wildfire.[38]

In the absence of specific dating, it is necessary to find other evidence indicating what pots Gauguin executed in 1886. A clue to his earliest works is found in two paintings that were executed in 1886. One, the *Still Life with a Portrait of Charles Laval*, shows a vase that can be identified as the work of Gauguin. The other, *Fleurs sur une commode*, shows another of the artist's pots (Cat. Nos. 9, 10).[39] These two pictures indicate that these ceramics were completed in the spring of 1886. Another bit of evidence that helps in establishing the dates of Gauguin's ceramics is the fact that he sometimes inscribed a number on the soft clay of the pot before firing. The lowest numbers that have been found are 19 and 20 (Cat. Nos. 12, 13). After 20 the series is interrupted, and resumes, possibly, with

[35] Seger, *Collected Writings*, pp. 967, 1042.
[36] J. W. Mellor, "The Chemistry of Chinese Copper-Red Glazes," *Transactions of the Ceramic Society*, XXXV (1935–1936), pp. 364–78, 487–91.

[37] Seger, *Collected Writings*, p. 963.
[38] Malingue, *Lettres*, XLV.
[39] Gauguin's letter to his wife in the end of May, 1886 (Malingue, *Lettres*, XXXVIII), spoke of his intention to work in ceramics that winter, but the evidence of these pictures shows that he executed at least two pots in the spring before he left, and possibly more.

the number 47, which is inscribed on the bottom of the pot instead of the usual place on the side near the signature of the artist (Cat. No. 25). After 47 follow numbers 49, 50, 54, 55, and 56, giving a fairly complete series (Cat. Nos. 36, 38–40, 46, 49). After 56 the next number is 64, and finally a pot numbered 80 (Cat. Nos. 52, 55). Unfortunately, less than one-quarter of the pots by Gauguin that have been found bear numbers, and it is difficult to be sure exactly what numbering system he adopted. There are three possibilities. One, that there is a complete series of numbered pots in addition to the un-numbered. The second is that Gauguin counted all his pots, placing the appropriate number in the total series on some pots. The third possibility is the same as the second with the added assumption that some pots were not counted, either because they differed from the others, or for some other reason. The first possibility would imply, assuming the same ratio between numbered and unnumbered pots in Gauguin's work as is found in the series of known pots, that Gauguin executed upwards of 350 pots. But, for a number of reasons this figure seems far too high. In the first place, all the numbered pots are in a style consistent with the first pots that Gauguin executed in 1886, while none of them can be shown to have the style that develops in his works after his return from Martinique, though the pot numbered 64 apparently represents a Martiniquan theme. It is probable that Gauguin may have continued this style to some extent after his return from Martinique, but in general, the works of that period seem to be pots of a more elaborate nature, of which the number would necessarily be smaller. An idea of Gauguin's rate of production is given in a letter from Gauguin to Bracquemond, saying: "If you are curious to see all the little products of my folly come out of the kiln, it is ready—55 pieces in good shape—You are going to scream at them but I am convinced that it will interest you."[40]

That this letter must have been written not later than the middle of January, 1887, is shown by a letter that Pissarro wrote to his Lucien on January 23, 1887, in which Pissarro records the opinion of Bracquemond concerning Gauguin's new pots: "He told me that there were some examples which he had executed that were good, but others which had nothing. All in all, he appeared to be saying to me that it was the art of a sailor, picked here and there."[41] On the basis of this correspondence, we can say that at one firing, early in January, 1887, Gauguin had completed fifty-five pots. But we know, from the representations in pictures that there were at least two, and probably more, pots that had been fired before the middle of June in 1886. Gauguin had produced fifty-five pots between his return to Paris in the middle of November and the end of December, a period of six weeks. He met Chaplet late in May and went to Brittany in the middle of June. He could have made a number of pots in the two or three weeks before he left. Actually, the pots numbered 19 and 20 show no Breton motifs. Further evidence concerning Gauguin's early ceramics centers around the pots numbered 56 and 64. As number 64 shows a Martiniquan theme, we may assume that it was done after Gauguin's trip to the Caribbean in 1887.[42] Curiously, there are two pots numbered 56 (Cat. Nos. 46, 49). One of the numbers is incised on the bottom, the other is on the side near the signature. There is only one other known example of a number incised on the bottom of Gauguin's pots, the number 47 on the bottom of Catalogue number 25. In both cases the pots are glazed. As the glaze would cover both the signature and a number, Gauguin has signed the pots in gold after firing. But

[40] The letter is in a private collection in Basel. It is reproduced by Lee van Dovski in his book *Paul Gauguin oder die Flucht von der Zivilisation* (Bern, 1948), plate 3.

[41] Camille Pissarro, *Lettres à son fils Lucien*, edited by John Rewald (Paris, 1950), pp. 131–32. The significance of these two letters was first pointed out by Merete Bodelsen in her book *Gauguin Ceramics in Danish Collections* (Copenhagen, 1960), p. 6, note 9.

[42] It is not impossible that Gauguin saw a woman in a Martiniquan costume in Brittany, even before his trip to Martinique. A *Still Life with Flowers*, dated 1886 (Wildenstein & Co.), shows a Negress in a red bandanna.

as the firing was probably done some time after the pots were made, he may have incised the number on the bottom at the time it was made to insure accuracy.[43]

The other pot numbered 56 appears in a drawing in the *Album Gauguin* in the Cabinet des Dessins of the Louvre together with drawings of a large number of pots (Figs. 8, 9). These drawings are divided into two groups. On the first page of the notebook are sketches of seven or eight pots. On the same page is a drawing of a faun which recalls the faunlike head of Mallarmé and the head of a faun that Gauguin sketched in the margin of his study for his etching of Mallarmé.[44] This suggests that the head of the faun in the notebook may be associated with the faun in Mallarmé's *L'Après-midi d'un faune*, and a date toward 1890 to 1891, when Gauguin had met the poet. None of the pots shown on this page has ever been found, suggesting that they were never made.

Toward the end of the notebook, after a gap of several blank pages, there is another group of sixteen pots, of which nine can be identified. All of them are of more or less the same type, and among them appear the numbered pots 56, 64, and 80, which are all of the numbered pots including and above number 56 that have ever been found. Furthermore, no pot from any known Scandinavian collection is shown, though pot numbers 49, 54, and 55 are in Copenhagen and Oslo. Finally, the pots in the second group are associated with motifs from Martinique. A sketch for pot number 64, a head of a Martiniquan woman is on page 20. On page 22 are a number of drawings of Martiniquan women, and on page 27 there are drawings of a hummingbird, a stalk of bananas, and a cashew nut, all Martiniquan themes.

These facts suggest that the drawings were made after Mette Gauguin had taken a number of Gauguin's pots to Copenhagen in the spring

FIG. 8. Drawings by Paul Gauguin. *Album Gauguin,* page 1 (recto). Cabinet des Dessin, Louvre.

of 1887 after her husband's departure for Panama, and that they were made at a time when Gauguin had already been in the Caribbean. This leads us to 1888 or 1889 and suggests a possible reason for there being two pots numbered 56. One may have been done before Gaugin left for his trip, and the other numbered 56 after his return, because he forgot the first number 56. However, the evidence is not as clear as it might be. In the first place, the drawing of number 56 was surely done after the pot had been made. This slight, quick, yet extremely accurate sketch could hardly be a sketch for a pot whose form must have grown in part from the actual manipulation of the clay in the hand of the artist. In the case of another pot (Cat.

[43] No glazed pots other than these two bear incised numbers of this type.

[44] Marcel Guérin, *L'Oeuvre gravé de Gauguin* (Paris, 1927), No. 12.

9*a*) Page 20 (verso).

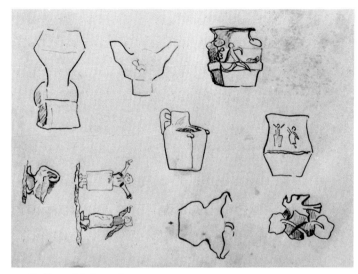

9*c* Page 25 (recto).

9*b*) Page 21 (recto).

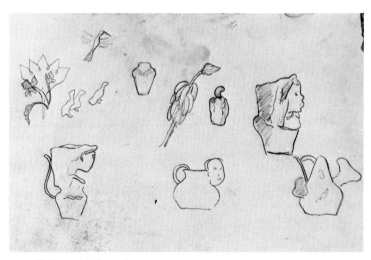

9*d*) Page 27 (recto).

FIG. 9. Drawings by Paul Gauguin. From the *Album Gauguin*. Cabinet des Dessin, Louvre.

No. 26) we find a drawing of extraordinary ex-
actitude as to form, except for the little decora-
tive figure. But this pot was started on a dis-
tinctly cardiod base, whose shape has been lost
in the final execution, indicating the change in
the idea of the artist as the pot took shape in his
hands. The almost exact representation of the
form of the final pot indicates again that the
drawing must have been made after the pot.
Furthermore, this pot is very closely akin to the
pot numbered 47. It has the same little figure
of the *Bretonne*, and it has the same triple han-
dles with the inner crosspiece. In another *carnet*,
recently published by the Hammer Galleries in
New York, there are a number of sketches of
pots which seem far more tentative in nature
than those in the *Album Gauguin*.[45] Among
them is a drawing that has the appearance of
being an early study for the pot catalogued un-
der number 37 (Fig. 10c). This pot also ap-
pears in the *Album Gauguin* in its final state.
As the material in the Hammer album is asso-
ciated with sketches that apparently date from
Gauguin's first visit to Brittany in 1886, the evi-
dence again points to the possibility that the
representation of the pot in the *Album Gauguin*
was drawn after the pot had been made. From
this we are forced to the conclusion that the in-
clusion of a drawing of a pot in this group is not
certain evidence that it was executed after Gau-
guin's return from Martinique.[46] However, on
the weight of all the evidence, we must give the
execution of pot number 56 to the period after
Gauguin's return, but this raises another serious
problem. We know that Gauguin executed at
least two pots in the spring of 1886. He speaks
of fifty-five newly fired pots in January of 1887.
At least two more pots are given to the spring of

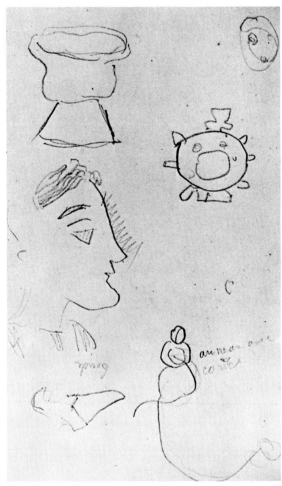

10a) Page 71.

Fig. 10. Sketches from Gauguin's *Carnet*, edited by
Raymond Cogniat. Courtesy of the Hammer Galleries,
New York.

[45] Paul Gauguin, *Carnet de croquis,* text by Raymond
Cogniat, foreword by John Rewald (New York, 1962),
pp. 71–73. (See Fig. 11)

[46] As it seems probable that a number of the pots were
made before the drawings, one wonders what purpose the
drawings served. In considering this question it is worth
noting that in the case of only five pots (Cat. Nos. 37,
38, 57, 62, 63) can we show that they were either given
away or sold in this period. Drawings of four of these five
appear in the *Album Gauguin* (Cat. Nos. 37, 57, 62, 63).

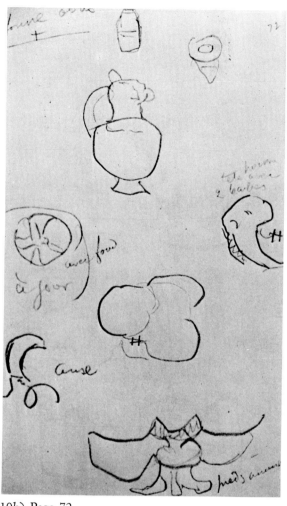

10b) Page 72.

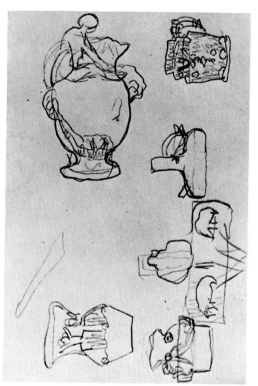

10c) Page 73.
10d) Page 98.

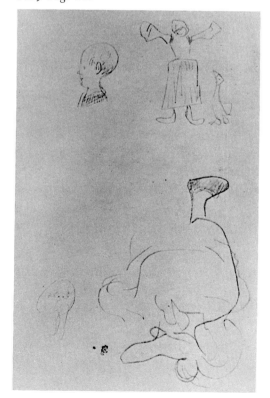

1887 (Cat. Nos. 45, 35). This makes a total of not *less* than fifty-nine pots executed before his departure for Martinique. The most obvious and probably the most satisfactory explanation is that Gauguin did not count all the pots on which he worked in his numbered series. For one thing, the pots of which the body was made by Chaplet, and only the decoration done by Gauguin, may not have been counted.[47] We know of at least three of these which were done in the fall of 1886, and at least two were done in the spring of 1887. Still, considering that he had executed at least fifty-seven pots by the end of 1886, it seems strange that he did so few pots in the spring of 1887. The period from January until his departure for Panama on the tenth of April was one of the longest periods that he had had in which he might have worked on his ceramics. To be sure, he seems to have been discouraged by the poor reception of his vases with even his friends, but Gauguin's almost complete inactivity in the spring of 1887 does not seem in character.[48]

Turning now to the pots that Gauguin executed in the spring of 1886, one is known only from its representation in the painting, *Still Life with a Portrait of Charles Laval*, and a sketch Gauguin made of it in a letter to his wife Mette (Cat. No. 9). From the painting it appears to be a rather large pot, unglazed, and handmade with a very free form. The other pot, which is in a private collection in Paris, is interesting in that it is the earliest known pot executed by Gauguin (Cat. No. 10). It is made by a process of hand-coiling in free form based on the shape of a hollow tree stump. On the front of the stump appears the mask of a woman, and on the surface of the stump are a number of appendages, some of which take on the forms of animal heads. The whole of the pot, except the mask, is covered with a glaze which occurs frequently on Gauguin's early pots. This glaze is quite unique. Its mottled colors, ranging from red and yellow through dark brown, black and olive green, suggest the *flammé* effects of the transition glazes with which Chaplet was experimenting.[49] At this time Chaplet was working with copper-red reduction glazes which often produce a mottled *flammé* that was much sought after at the end of the last century. However, that on Gauguin's pot is not basically a copper glaze, but one in which the colors are due to iron. Iron, like copper, can produce a number of colors, depending upon its state in the glaze. In its oxidized state iron can produce colors ranging through red, yellow, brown, and black, depending on the degree of oxidation and the concentration of the metallic salts in the glaze. When fired under reducing conditions, the colors produced by iron are those typical of the Chinese green celadon glaze, varying from a grass green through olive green to a pale grey-green.[50]

Though the range of color on the exterior of Gauguin's pot is extreme for an iron transition ware, those on the interior, a sage green turning brown in spots, are absolutely typical. From the nature of the exterior we may surmise that the piece was fired in a reducing flame to produce the celadon greens, and then briefly in an oxidizing flame to produce the mottling of reds, brown, and black. As the interior of the pot was more protected than the exterior from this final oxidizing flame, more of the reduced iron green remains, and only in spots does the oxidized brown appear. It should be noted that this double firing, first in a reducing flame, and then briefly in an oxidizing flame, is the process recommended by Seger for the production of the best *sang de boeuf* glaze, which we know Chaplet was experimenting with in 1886.[51] Curiously, though this is clearly an iron transition glaze, the author

[47] None of the pots in which Gauguin collaborated with Chaplet bear an incised number similar to those on the numbered series. Some bear stamped numbers (Cat. No. 42).

[48] In a letter to Mette written just before his departure, Gauguin said that all his ceramics remained to be sold. (Malingue, *Lettres*, XLIX, p. 104)

[49] Robert de la Sizeranne, "Chaplet et la Renaissance de la céramique," *Revue de Deux Mondes*, Vol. 57 (1910), p. 166.

[50] Cf. A. L. Hetherington, *Chinese Ceramic Glazes* (South Pasadena, 1948).

[51] Seger, *Collected Writings*, pp. 733 ff.

knows of no examples of such a glaze in Chaplet's own wares. It appears only on pots that Gauguin made at this time.

Though the effect of the glaze on Gauguin's rustic pot is quite striking, it has a number of defects that would probably have been considered highly undesirable by Chaplet. In addition to the extreme irregularity of the color pattern, the glaze has not adhered well to the pot and is full of patches of bubbles. The lack of adherence of the glaze has caused it to draw back from some areas, in the same manner a thick oil draws back from a wet surface. Though these effects would generally be regarded as faults by a potter, they do not detract from the appearance of Gauguin's pots. The artist, making the best of the accident, has even stressed the irregularity of the glaze by outlining the edges of the bare areas in gold that was applied in a later firing.

The next group of pots that we can assume to be early are those that can be gathered around the pots numbered 19 and 20, the lowest known numbers in the numbered series. As stated previously, the two numbered pots have no specifically Breton motifs, and may predate Gauguin's trip to Brittany. Though both pots are made by hand, they are not particularly alike in their conception. Number 19 is formed by coiling, working up from a square base to a three-lipped rim. It is decorated with the upper part of the figure of a ballet dancer and other ornaments applied to the surface of the pot in a more or less abstract and possibly symbolic manner. Pot number 20, on the other hand, has a more regular shape produced by a method of joining shaped slabs of clay and working them together. In this case the ornament on one side is pictorial, showing a landscape with a fisherwoman.

Both pots are basically unglazed, but decorated with colored clay.[52] On number 19 the color is applied in the form of slip, while on number 20 the artist used both slip and a thicker, barbotine-like clay modeled to form such colored elements as the tree.

To this pair can be added another pot of a similar conception and technique (Cat. No. 15). All three of them are relatively simple in form, retaining, though handmade, the quality of a traditional pot with applied decoration. All of these have motifs that are not directly associated with Brittany, and are executed in the technique of relief sculpture with little use of incised line. Beyond these two early groups of pots, there are a larger number of pots that are closely related in style and execution. All are of a relatively coarse stoneware body fired to various shades of brown. They are handmade, and either unglazed or glazed with the typical iron transition glaze. The decorative forms of the unglazed pots are usually colored with slip, or formed of colored clay. Gold accents are used at times on both the glazed and unglazed pots.

In general, the pots are of moderate size, ranging from 27 cms. high to as small as 13 cms. They are all technically pots, in that they are designed as containers, but the shapes vary greatly. Some are more or less conventional, while others are completely fantastic in form.

A number of themes run through the decoration of the pots Gauguin executed in 1886. Besides the usual little *Bretonne* and geese or sheep, there is a series of pots on which sunbursts appear. Sometimes these seem to be no more than sunset or sunrise effects on a general landscape background (Cat. Nos. 15, 28), but at other times the sunburst is used in a way that suggests some sort of symbolic significance (Cat. Nos. 16, 36). Another theme that is used very frequently is that of the *Bretonne* with upstretched arms (Cat. Nos. 31–36). The first appearance of this theme is in one of Gauguin's *carnets*,[53] where it is associated with the drawing of an unidentified pot and other sketches that apparently date from the fall of 1886 (Fig. 10d).

[52] On some of Gauguin's pots of this period there occurs material that is in fact a glaze, but it should be remembered that colored slips in which a large amount of metallic oxide coloring matter is included tend to melt at the high temperature at which stoneware is fired. What appears as glaze may be colored slip which has melted to become glaze.

[53] Paul Gauguin, *Carnet de croquis,* p. 98.

The same little *Bretonne* with the upstretched arms appears on two pots illustrated on page 73 of the same *carnet* (Fig. 10c). These pots are almost certainly to be identified with Catalogue numbers 34, 35. This theme also appears in the *Album Gauguin* in the Cabinet des Dessins of the Louvre, both as a separate sketch and in a sketch with two figures (pages 4, 25). The same theme of two figures was used by Gauguin on one of the pots on page 25 and also in the decoration of one of his pairs of wooden shoes (Cat. No. 81).

After his return from Martinique Gauguin began to repeat certain figures in his painting, and there are some, such as the "woman in the waves" that he used so consistently that it seems probable that they had a symbolic significance.[54] It is not clear whether the repeated figures in his ceramics of 1886 may also have some symbolic meaning, but in any case, it is another example of the anticipation in Gauguin's ceramics of tendencies which appear later in his painting.

The sources of inspiration of these new wares come from the background of the revival in ceramics in the second half of the nineteenth century, but Gauguin has interpreted them in a very personal way. The first thing to remember is that Gauguin referred to his works as ceramic sculpture. Usually the sculptor, designing works to be executed in ceramics, makes a model in wax or clay from which a master potter draws a mold in which the ceramic material is formed either by slip casting or pressing. In any case, the actual manipulation of the ceramic body is left in the hands of the craftsman. Gauguin, on the other hand, worked with the ceramic clay itself, and with his innate sensitivity to the quality of materials, he achieved an understanding of the nature of the clay and the esthetic potentialities of its manipulation that was far beyond the usual run of ceramic sculpture.

This characteristic of working with the material itself and of freely developing his forms from it separates the work of Gauguin from the vast majority of artists who were collaborating in the decoration of ceramics. Such men as Bracquemond, and the potters Deck and Rousseau, and even Chaplet, tended to restrict their contribution to the decoration of ceramic wares to essentially "painting" a design on the form of a pot that had already been produced by one of the usual techniques of ceramic manufacture: turning on the wheel, pressing in a mold, slabbing, or slip-casting.

Gauguin objected not only to the conventional decoration of contemporary pottery, but also to the mechanical forms of pottery thrown on the wheel. In this he took exception even to the works of Chaplet, whom he admired, and whose technical means he used in the actual decoration of his pottery.[55]

In his first letter to Mette about his intention to work in ceramics, Gauguin mentions his old landlord, the sculptor Aubé, whose works had been in ceramic sculpture of the type of little figurines for which Sèvres is famous. Though the works of Aubé may have given Gauguin the idea for his ceramics, the execution is different and owes its form to other sources. Like Chaplet, Gauguin was probably influenced to some extent by oriental wares, but he looked at them with far different eyes. The basic conception of the combination of natural forms and pots may be the same, but there is no trace of the orientalizing aspect of Chaplet's work. Though one finds similarities to the works of Gauguin in the works of the Chinese and Japanese artists that Gauguin undoubtedly saw not only at the exhibitions at the Galerie S. Bing, but also in Bing's periodical *Art japonaise*, there is no trace of *chinoiserie* about his works.[56]

Another important source of Gauguin's ideas about ceramics was his knowledge of pre-Columbian American pottery, particularly that of Peru. As a child Gauguin had spent several years in Peru with his mother, not leaving until he was seven years old. When he returned with his mother to France, she had brought with her a collection of Peruvian antiquities, with which

[54] See notes under Cat. No. 74.

[55] See *infra*, pp. 22–23, 25–26.

[56] S. Bing's periodical, *Japon artistique*, did not begin to appear until May, 1888, but see Figs. 11, 12, 13.

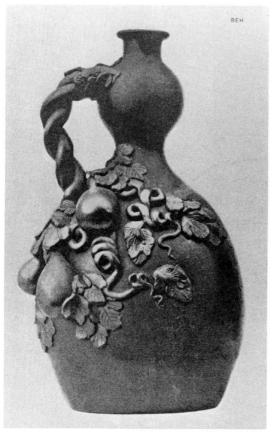

FIG. 11. Flask in Bizen stoneware. *Artistic Japan,*
XXIV (1890).

FIG. 12. Ota terra-cotta vase. *Artistic Japan,*
III (1888).

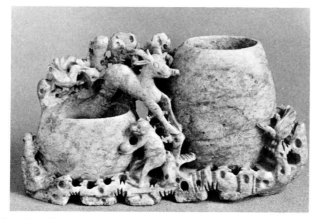

FIG. 13. Chinese carved steatite vase. Collection of the author.

Gauguin grew up. Though this collection had been destroyed in the burning of his mother's house at St. Cloud in 1870, Gauguin's guardian Arosa also had a number of pieces from pre-Columbian America, including several from Peru, in his extensive and important collection of ceramics of all sorts.[57]

The influence of Peruvian pottery can be confirmed in a number of pots of this period in which the basic ideas of the Peruvian potters are translated more or less directly in the pots of Gauguin. One pot, which appears constantly in his paintings, may have been a pre-Columbian pot in his own collection.[58]

Though the forms of Gauguin's pots differ markedly from those of Chaplet, the technical means that Gauguin used were strongly influenced by the older ceramicist. Chaplet was thinking of the plastic ornaments of his pots as decoration for their basic form, and their style is decorative. Gauguin had a horror of the "pretty." Though his pots must be considered as decorative objects, he did not conceive of them as objects to be decorated. While Chaplet worked almost exclusively on classic wheel-made forms, Gauguin, forming the clay by hand, used many of the ornamental devices of the older tradition of the wares of stoneware workers that flourished in France, England, and Germany from the sixteenth century.[59] He certainly saw a number of these pieces in the collection of Arosa, but the decoration of his wares with loops, rings, and

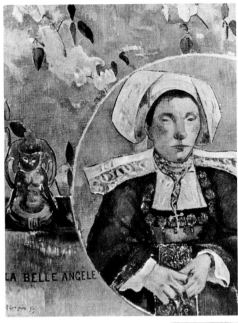

FIG. 14. Representations of a figure pot in paintings by Paul Gauguin. Above: Detail from *Interior* (1881). Oslo Museum. Below: *La Belle Angèle* (1889). Louvre. Photograph by Agraci.

[57] I am indebted to Mr. Richard Field for pointing out the importance of the Arosa collections. Information on these large and important collections can be found in: Auguste Demmin, *Histoire de la céramique*, (2 vols.; Paris, 1875). This work, of which the plates were reproduced in phototype by Gustave Arosa, also contains reproductions of a number of pieces in Arosa's collection (see particularly Vol. I, plates viii, xiii, and xxxv). Other information about Arosa's collections can be gleaned from the catalogues of the following sales:

Arosa (G.) 21 février, 1878.
Faiences, porcelaines.
Arosa (A.) 4 mars, 1895.
Faiences anciennes.
A(rosa), Mme. 30 mars, 1896.
Objets d'art, ancienne porcelaines de Chine, Tapisseries du XVIII Sᵉ

[58] The first person to my knowledge to point out the similarity of this pot to pre-Columbian pottery was René

Huyghe in his commentary on Paul Gauguin's *Ancien Culte mahorie* (Paris, 1951), p. 20. I have been able to trace this pot in Gauguin's possession back to 1881, where it appears in his painting *Interior with a Bouquet of Flowers* (Fig. 14) (Collection of the National Museum Oslo). Huyghe (p. 21) also notes that Gauguin himself refers to the collection of Peruvian pottery of his acquaintance Maury (*Avant et Après*, p. 110).

[59] On a page of one of Gauguin's sketchbooks that he used in 1886 there is a rough drawing of a vase in the form of a ring (Fig. 10a). The prototype for this drawing was undoubtedly a German sixteenth-century stoneware pitcher. These German pitchers were often made in the form of a ring, and sometimes in the form of crossed rings. Gauguin may also have known of the new development in stoneware in England. In 1882 Cosmo Monkhouse published two articles on the new developments in

complicated handles formed of rolls of clay, naturally grew out of his method of constructing his pots by coiling, where the potter is constantly thinking in terms of the very rolls of clay of which the pot itself is made.

In addition to these works in which the body of the pot and the decoration are both made by the artist, there are a small number of pots in which the body was made by Chaplet, and the decoration was made by Gauguin. Three of these, at least, can be dated in 1886, for they bear Chaplet's mark (a chaplet) surrounding the monogram H & Co (Haviland and Company). As Chaplet left Haviland in 1887 to work on his own, these works must fall in 1886.[60] Two of these pieces are identical in size, shape, and decorative technique which, though clearly by Gauguin, is essentially that used by Chaplet in decorating his stoneware (Cat. Nos. 42, 43).

The third piece that bears Chaplet's seal combined with the initials H & Co is a rectangular jardiniere (Cat. No. 41), which differs from anything else that Gauguin executed in the fall of 1886. The rectangular panels on the four sides are filled with pictorial low reliefs related in style to Gauguin's carved wood relief *La Toilette* (Cat. No. 7) of 1882. Gauguin ap-

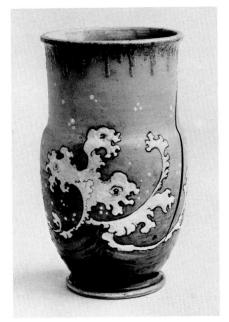

Fig. 15. Vase executed by Chaplet in 1887. The Museum of Decorative Art, Copenhagen.

England: "Some Original Ceramicists," *Magazine of Art,* V (1882), 443–50; "Elton Ware," *Magazine of Art,* VII (1882), 228–33. It should also not be forgotten that Gauguin spent three weeks in England in the spring of 1885.

Gauguin's awareness of the older tradition of ceramics did not depend solely on the extensive collections of Arosa. They were also being exhibited in the new Musée des Arts Décoratifs in Paris since 1877, and his old landlord Aubé had been appointed director of the École Bernard Pallisy.

[60] Contrary to the statement of Roger Marx ("Souvenirs sur Ernest Chaplet," p. 94), Chaplet worked for Haviland through 1886. The evidence is clear in his continued use of the H & Co mark, and in the statement of Georges Haviland at the time of his gift of a number of Chaplet pots to the Metropolitan Museum of Art in New York in 1923. Apparently Chaplet left Haviland in 1887, for there is an interesting pot in the collection of the Kunstindustrimuseet in Copenhagen (inventory number A 10/1906) which bears Chaplet's mark with a smoothed over place in his mark where the H & Co usually appears. This piece can be fairly accurately dated because it was purchased in 1887 by William Salomonsen (see Fig. 15).

parently attempted to use glaze on these reliefs in a manner similar to painting in oil colors on a wooden relief, but the soft lead glazes have run to such an extent that in many places the colors have become obscured.

Though we can be fairly sure of a number of works that must have been executed in the fall of 1886, it is more difficult to date the works that he did in the spring of 1887. Actually, we have reason to believe that he did relatively little, for there is evidence suggesting that the numbered series was resumed in 1888, after his trip to Martinique, with the number 56 (Cat. No. 49). One reason for his inactivity was probably

his discouragement, for just before his departure for the Caribbean in April, he wrote his wife that "all my ceramics remain to be sold."[61]

Nevertheless, there are certain works that can be dated with some assurance in the spring of 1887. A second jardiniere is a twin of the rectangular jardiniere of the previous fall except that the painting in glaze was replaced by barbotine; it also lacks the Chaplet seal and the H & Co (Cat. No. 44) of the earlier work. Bodelsen also places the execution of a cylindrical jardiniere now in Brussels (Cat. No. 45) in this period.[62] Curiously, other information is given by a report of an exhibition held by Theo van Gogh in December of 1887, where Félix Fénéon describes five pieces:

> Stoneware, spurned by all, funeral and hard, he loves it: haggard faces, with broad brows, with smallest eyes half closed with flattened nose—two vases; a third: head of a royal ancient, some Atahuallpa who one robs of his possessions, his mouth torn into an abyss; two others of an abnormal and cloddish geometry.[63]

The works that Fénéon described must have been executed before Gauguin's departure for Martinique, for he did not resume his work in ceramics after his return until the end of January in 1888. Yet there is nothing known in Gauguin's work which would fit the description of the first three pieces except two pieces that have always been thought to have been executed after his return from Martinique (see Cat. Nos. 65, 66). Whether these two pieces were actually executed at this time, or later, it is evident that, in addition to his continuation of the style of

pots that he executed in 1886, Gauguin was beginning to experiment with new forms.

If we may rely on Fénéon's description of the works that he saw in December 1887, there is an important fact that emerges. Three of the five pieces are in the form of heads. Though they may have been technically containers, the form was no longer that of a pot, no matter how fantastic, which has been decorated. Form and decoration have been fused into what we are led to consider as ceramic sculpture. A tendency in this new direction is already indicated by a pot of the numbered series that Gauguin almost surely executed late in the fall of 1886—number 54 (Cat. No. 39). In this pot, the head of a *Bretonne* is conceived and executed in a different manner than in the earlier works. The head is formed in the round as if it were a piece of clay sculpture, and the hollow in the back of the head has been excavated after the head was made. This is the approach of the sculptor in clay, who thins the body of his work so that it will not be broken because of excessive stress in a too thick mass of clay. It is not the approach of a potter forming the body of a vase. To be sure, the position of the hole, in the back of the head, shows that Gauguin was still thinking in terms of a pot, but the first conception is that of sculpture. Number 56, beginning as a pot, is more traditional in its conception, but, nevertheless, the idea that the artist has realized is that of a pot in the shape of a head and torso, not that of a pot decorated with a figure.

With the continued lack of success in his projects, Gauguin gradually became more and more taken with the desire to leave France and to escape to the tropics. As early as the spring of 1885 he had been thinking of going to one of the overseas colonies where life was reputed to be cheap. Instead he had gone to Brittany, but now he suddenly wrote his wife: "Next month, on the packet boat of April 10, I shall embark for America. . . . I am going to Panama to live as a savage."[64]

[61] Malingue, *Lettres*, XLIX
[62] Merete Bodelsen "The Missing Link in Gauguin's Cloisonism," *Gazette des Beaux-Arts,* LIII (May–June, 1959), pp. 329 ff.
[63] Félix Fénéon, "Calendrier décembre," *La Revue indépendente,* VI:15 (January, 1888), p. 170. Fénéon was describing the exhibition put on by Theo van Gogh at Boussod et Valadon. It is important to remember that in December, 1887, Gauguin had written his wife that he had done no work in ceramics since his return from Martinique (Malingue, *Lettres,* LIX). These pieces, exhibited in December, must have been done before he left.
[64] Malingue, *Lettres,* XLVII, XLVIII.

The timing of Gauguin's trip to Panama was nothing less than disastrous, for by 1886 the Panama Canal Company was on the verge of collapse, and the country was suffering from uncontrolled inflation. He and his friend Charles Laval, who had accompanied him, were forced to work in the canal excavations in order to get the money to leave. By June, 1887, Gauguin and Laval, both ill from Panama, managed to reach Saint-Pierre in Martinique.

While there are a number of paintings that were executed in Martinique, there is almost no sculpture from that trip. The two things that Gauguin executed in the line of the decorative arts are a dagger and sheath and a bamboo brush holder decorated with designs burnt into its surface with a hot iron (Cat. Nos. 47, 48).

Though Gauguin's activity in sculpture during his trip to the Caribbean was minimal, his stay in the tropics had an important effect on his art. The island of Martinique is colorful and bold in design, and the love of the tropics that he found there influenced the whole of the rest of his life.

On his return to Paris, Gauguin still had a great interest in his ceramics, believing that they would furnish him an important source of income. In August he had written Mette from Martinique:

> I have, in this post, good news of my *ceramics*. It seems that they have had some success and (one doesn't know) perhaps on my return I will find a break in the clouds. When things get going a little it is a *very good trade* in which to earn 15 to 20 frs. a day along with my painting.

Gauguin wrote more explicitly to Schuffenecker:

> Laval has received some fairly good news from Paris about me. You know that a certain man came to buy some pots at Chaplet's place. He was very enthusiastic about them and has made plenty of propaganda in his circle which ought to buy some others of them. Moreover, it seems that I pleased him immensely; he will be inclined, it seems, to advance me 20 or 25,000

francs so I can form a partnership with Chaplet. Under these conditions one could set up an excellent business firm and I would have my daily bread assured, modestly, but assured.

In November he wrote Mette:

> On returning here I found a small silent partnership offered by one of those who admire me and who has bought some pots from me. It was arranged for me to join with Chaplet, which would have allowed me to gain my living and create, I think, a place in the future for all of us in a field (the artistic field) that I understand very well.
>
> Bang! Chaplet has retired to live on the income of his little savings. Still another thing that slips through my hands.[65]

Actually, Chaplet had moved from his factory on the Rue Blomet to set up shop permanently at Choisy-le-Roi, leaving his old place to Auguste Delaherche.

In December Gauguin again wrote his wife that "since my arrival there has been no great change if it is not that I hope to have some work in ceramics, but not before a month."[66] In the same letter he said he had sold a pot for 150 frs. to a sculptor, and illustrated another pot for which he expected to get at least 150 frs. (Cat. No. 9).

By 1888 the artistic interests of Gauguin and Chaplet were drawing apart, though they continued to respect and admire each other's work. After moving to Choisy-le-Roi, Chaplet devoted his energies to work in porcelain on which he was trying to re-create the *flammé* glazes of the Chinese potters (Figs. 16, 17). He had given up working in stoneware, and with it his interest in its modeled ornamentation based on naturalistic forms. Now his pots took on the refinement and purity of the abstract form of oriental porcelain, with the glaze itself as its sole ornament. On the other hand, Gauguin was turning more and more toward the creation of ceramic sculpture

[65] Malingue, *Lettres,* LV, LVI, LVIII.
[66] *Ibid.,* LIX.

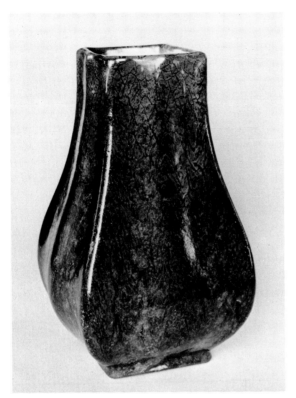

FIG. 16. Vase in porcelain covered with a red copper transition glaze. Executed by Ernest Chaplet. Musée des Arts Décoratifs, Paris.

FIG. 17. Rooster by Ernest Chaplet. Porcelain with a red copper transition glaze. Musée des Arts Décoratifs, Paris.

on which the glaze was used in a free but still naturalistic manner.

In the winter of 1888–1889 Gauguin was again working in ceramics, and had re-established some arrangement with Chaplet.[67] But an article by Gauguin in the *Moderniste* of June 1889 shows that his hope for a close collaboration between the two did not materialize.[68] In this article Gauguin reviewed the ceramics in the *Exposition Universelle* of 1889, praising the work of both Chaplet and Auguste Delaherche, but he also criticized the mechanical nature of their forms, saying that they ought to associate themselves with an artist-sculptor. Delaherche was the only ceramicist, other than Chaplet, that Gauguin ever mentions in his writings, and the appearance of his name coupled with that of Chaplet suggests that the artist may have been interested in finding another potter with whom he could establish a working arrangement.[69] As has already been said, Delaherche had taken over Chaplet's old studio on the Rue Blomet. He had continued to work in stoneware, while Chaplet had gone on to work in porcelain. Both the convenience of his studio, which was only a twenty-five-minute walk away, rather than the far longer trip to Choisy-le-Roi, and Delaherche's continued interest in stoneware, may have led Gauguin to use Delaherche's facilities for some of his work. In support of this suggestion, it should be noted that in his sketchbook Gauguin wrote down Delaherche's name in the spring of 1889, together with the fact that he was a ceramicist. About the same time, Gauguin also recorded that he had given Delaherche an

[67] In May Theo van Gogh wrote to Vincent: "J'ai vu dernièrement Gauguin qui travaille actuellement à de la sculpture" (Vincent van Gogh, *Verzamelde Brieven van Vincent van Gogh*, [Amsterdam, Antwerp, 1955], IV, 267).

[68] Paul Gauguin, "Notes sur l'art à l'Exposition Universelle," *Le Moderniste,* June 4 and 14, 1889, pp. 84–86, 90–91.

[69] In a letter to Daniel de Monfreid in January 1901, Gauguin referred to the ceramicist as "cet atroce Delaherche qui est fourré partout et qui a tué l'art dans la céramique" (Segalen, *Lettres,* LXXI).

album of his works.[70] Actually, in the *Mercure de France* for December, 1893, Charles Morice referred to Delaherche as having been the one who formerly fired the pots of Gauguin.[71] As Morice had known Gauguin since the winter of 1890, his statement must be given a considerable amount of weight.

It may also have been at this time that Gauguin made a number of notes on ceramic formulas. He copied down a number of recipes that he had found in Brongniart's *Traité des arts céramiques*.[72] First, in the upper right recipe, Gauguin gives a formula for a black-bodied *grès* (Fig. 18):

Pâte de grès noire
Kaolin	0.02
Argile plastique	0.48
Ocre calcinée	0.43
Manganèse	0.07
	1.00

On page 210 of volume two, Brongniart, under the heading of *Grès-Cérames Fins*, gives the following formula:

Pour pâte noire
Kaolin	2
Argile plastique bleuatre	48
Ocre calcinée	43
Manganèse	7
	100

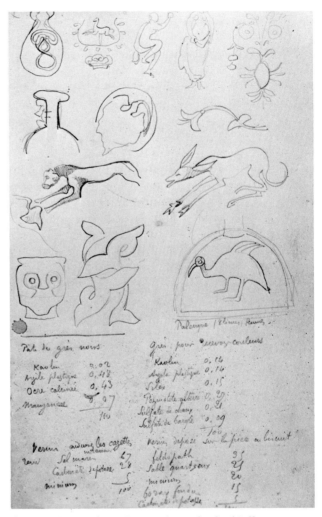

Fig. 18. A page from Gauguin's notebook. (Collection of Mme Joly-Segalen.) Top: Thirteen designs, of which (reading left to right, top to bottom) numbers 7, 9, 10, 11, and 13 are taken from the following plates in Brongniart's *Atlas*: (7) XXX:13, (9) XXIX:1, (10) XXIX:1, (11) XXVIII:2, and (13) XXVIII:3. Bottom: Various formulas from Bronhniart's *Traité des Arts céramiques*. Photograph by Hervochon.

[70] Paul Gauguin, *Carnet,* edited by René Huyghe (Paris, 1952), pp. 214, 223.

[71] Charles Morice, "Paul Gauguin," *Mercure de France,* December 1893, p. 292.

[72] Alexandre Brongniart, *Traité des arts céramiques, ou des poteries,* 3rd edition, with notes and additions by Alphonse Salvetat (Paris, 1877). The pages of formulas are in the collection of Mme Joly-Segalen. One page is shown in Fig. 18. Another set has been published in Merete Bodelsen, *Gauguin Ceramics in Danish Collections,* p. 35. This latter set came from Brongniart, Vol. II, *Section I: Poteries communes modèrnes,* p. 3 ff. The formulas are for such wares as *terrines, poêlons and marmites,* and the glazes are the common lead glazes used at that time.

GAUGUIN

Grès pour recevoir couleurs

Kaolin	0.14
Argile plastique	0.14
Silex	0.15
Pegmatite altéré	0.27
Sulfate de chaux	0.21
Sulfate de baryte	0.09
	1.00

Vernis enduire les cazettes intérieur

Sel marin	.67
Carbonate de potasse	.28
Minium	. 5
	1.00

Vernis deposé sur la pièce en biscuit

Feldspath	.35
Sable quartseux (sic)	.25
Minium	.20
Borax fondu	.15
Carbonate de potasse	. 5
	1.00

BRONGNIART

Pâtes destinées à recevoir diverses couleurs (p. 207)

Kaolin de Cornouailles	14
Argile plastique de Devonshire	14
Silex	15
Sulfate de baryte	9
Pegmatite altéré de Cornouailles	27
Sulfate de chaux	21
	100

Vernis avec lequel on enduit l'intérieur des cazettes (p. 211)

Selmarin	67
Potasse	28
Oxyde de plomb	5
	100

Glaçure . . . par immersion (p. 211, No. II)

Feldspath	35
Sable quarzeux	25
Minium	20
Potasse du commerce	5
Borax calciné	15
	100

In order to compare the other formulas on the page, see table at left. In every case, though the terminology varies slightly, the proportions of ingredients are identical in each of the sets of formulas. In addition, Rotonchamp, in describing another entry in Gauguin's notebook, says that he recorded that *grès* should be fired between 100 and 120 degrees on the scale of the Wedgwood pyrometer, a bit of information that Brongniart gives on page 193.[73]

Several significant conclusions can be drawn from this information. Perhaps the most important is that at this time Gauguin probably had no satisfactory arrangement with any potter, for if he had, his formulas would be based on those in use by the shop. Certainly Gauguin, with his dislike of *la partie cuisine* of the arts, would have used the materials such as clay and glaze of the shop.[74] Further, if he were working with a potter this last point would have been insisted upon so that his works could be fired compatibly with the other products of the shop. As each practical potter finds it necessary to adjust formulas of glaze and clay to suit the particular quality of materials available and the general mode of working, it is not probable that he was working with someone who followed Brongniart's formulas, which were based on English practice and called for English materials.

In turning to the discussion of the ceramics that Gauguin made after his return from Martinique we must remember that as he left Paris in February for Brittany to stay for the rest of the year, he probably did little pottery in 1888. The one piece that can be surely dated in that year is a magnificent cup recently published by Bodelson.[75] Another vase in the collection of Léon

[73] Jean de Rotonchamp, *Paul Gauguin* (Paris, 1925), p. 43.

[74] Gauguin's aversion to *la partie cuisine* in art has been overemphasized. The aversion to technical matters in art was part of the Idealist conception of "genius." According to A. G. Lehmann (*The Symbolist Aesthetic in France* [Oxford, 1950], p. 58) Schopenhauer felt that artistic genius was independent of technical skill. A great artist does not need to be able to paint.

[75] Merete Bodelsen, "Gauguin's Bathing Girl," *Burlington Magazine* CI (1959), pp. 186–88.

Fayet may belong to the same year because the identical figure of a bathing girl is used on both (Cat. Nos. 50, 51). Though the conception of the form of this cup is bolder than anything that Gauguin had undertaken before his trip to Martinique, it still preserves the characteristics of his earlier works in which a pot is decorated with figures. But if the form continues the older type, the glaze is characteristic of a number of his later works. As early as the fall of 1886 Gauguin had tried to use colored glazes in a painterly manner, but without complete success. Then, in the spring of 1887, he used the method developed by the potter Deck to control the running of colored glaze by outlining the areas of color with a "cloison" of resist (see Cat. No. 45). In this cup of 1888, the artist shows the ability to control the glaze effects without the use of "cloisons," partly through the use of a leadless glaze that matures at a higher temperature, partly through the use of a more restricted number of colors, and partly through the combination of glaze with underglaze colors.

The sheer pressure of numbers suggests that the pots numbered 56 and 64 must have been done soon after Gauguin's return from Martinique. That numbered 64 represents the head of a Martiniquan woman. A third pot (Cat. No. 63), which represents the theme of Leda and the Swan, is linked to the pot numbered 56 by their representation in a wash and charcoal drawing probably done in the winter of 1888–1889. All three pieces are shown in the *Album Gauguin*. Though the three pieces show a more sculpturally integrated form, they continue the style of pot that Gauguin was executing before his departure for Martinique both in general conception and in manner of decoration.

In 1889 Gauguin used the theme of Leda and the Swan in various media with a clear symbolic intent.[76] The juxtaposition of the pot with this theme with the pot numbered 56 in the charcoal and wash drawing raises the question

as to whether he saw some relationship between the two. Number 56 is formed of the upper part of the torso of a woman, and the handle of the pot is formed by a tail of a cat. The exotic nature of this combination is further emphasized by the barbaric necklace and the green disks over the breast. The association of the tail of a cat with the figure of a woman produces the suggestion of a cat-woman, perhaps a sister of the Egyptian goddess of joy, Bastet, whose symbol was the cat. The motif of Leda needs no explication, but the juxtaposition of these two themes in the drawing suggests that Gauguin was anticipating in his ceramics the theme of the eternal mystery of woman which was to figure so largely in his later works in painting and sculpture.

In addition to the continuation of the early style of pottery with developments more or less in line with his last works of 1886–1887, there is a new type which appears after Gauguin's return from Martinique. These works are larger and more compact in form. The modeling of a coarser bodied clay takes on a more sculptural quality. Though these vases are often technically containers, in many cases this aspect is very much subsidiary to the sculptural form. There is less use of applied ornament and a richer use of glazes to produce colored effects.

In his review in the *Moderniste* of the ceramics in the Exhibition of 1889, Gauguin went to some length to express his ideas:

The ceramic art is not an idle pastime. In the most distant epochs of the past, among the Indians of America one finds that art constantly in favor. God made man with a little mud. With a little mud one can make metals, precious stones, with a little mud and also a little genius! Now isn't the material most interesting? Which doesn't stop nine out of ten educated people passing in front of that section with extreme indifference. What would you have? There is nothing to say: they don't understand.

Let us examine the question and take a small piece of clay. Such as it is there, it is not very interesting; you put it in a kiln, it cooks like a

[76] Gauguin used the motif of Leda and the Swan a number of times. See notes under Cat. No. 63.

lobster and changes color. A little firing changes it, but not much. It is necessary that it reach a very high temperature for the metal which it contains to become fused. I am far from giving in the above a scientific lecture, but by a little insight we seek to make it understood that the quality of a ceramic lies in its firing. A man who has taste will say that this is badly or well fired.

The material that comes out of the fire now shows the character of the furnace and now becomes more grave, more serious according to the degree to which it passes through the inferno. Consequently all these botches that are shown, because a light firing is daintier and easier to do. It follows from this that all decoration of ceramics ought to be carried out in a character analogous to its firing. Because the great basis of beauty is harmony. . . . As a result the insipid coquetteries of line of subjects are not in harmony with a severe material. Hollow colors next to full colors are not in harmony. And see how nature is an artist. Colors obtained in the same fire are always in harmony. Also a ceramic artist will not apply enamel colors one over another with a different firing. At the *Exposition Universelle*, that is the case with the majority of the ceramicists. There is even one who has passed the bounds by applying painting in distemper or in benzine on a fired material. Pushing impudence even further, he called his turnip "High Fired Fresco." And the state orders these enormities at the factory of Longwy. A fresco is not a fresco unless the color enters the plaster while it it fresh. Fresco is not applicable at all to ceramics.

High fire is a lie as not a color has passed through the fire. And the state authorizes these lies.

Let us get back to our knitting. Sculpture, like drawing, in ceramics, ought to be modeled "harmoniously with the material."

I will beg sculptors to study carefully that question of adaptation. Plaster, marble, bronze and fired clay ought not to be modeled in the same fashion, considering that each material has a different character of solidity, of hardness, of appearance.[77]

[77] Paul Gauguin, *Le Moderniste*, June 4 and 14, 1889, pp. 84–86, 90–91.

Very few of the ceramics that Gauguin made after his return from Martinique seem to have been sold during his lifetime. Many were left in the hands of Schuffenecker when Gauguin left for Tahiti. Some were given to friends, and others remained in the hands of his family in Copenhagen.

The ceramics which Gauguin made after his return from Martinique differ from those that he had executed before his departure, but it is difficult to be precise about their dating within the period set by his return in 1888 and his departure for the South seas in the spring of 1891. Apparently sketches for these pieces do not appear in the notebooks, and their motifs are not borrowed from paintings, though in at least two cases the objects themselves appear in paintings (Cat. Nos. 65, 66).

Probably one of the earliest of these pieces was the tobacco jar formerly in the collection of Émile Schuffenecker, but now in the Louvre (Cat. No. 66). This stoneware pot, with an over-all greyish-brown glaze, is in the shape of the grotesque head and shoulders of a man. It is probably the piece referred to by Gauguin in a letter to Madeleine Bernard in November, 1889: "Ask Émile to get at Schuff's a large pot which he saw me make, it represents vaguely a head of Gauguin the savage, and accept it from me." At the same time, in letters to Émile Bernard, Gauguin wrote:

All this bile, this gall which I am amassing because of the redoubled blows of the misfortune which oppresses me are making me sick and, at this time I have scarcely the strength, the will to work. And work formerly made me forget. In the end, this isolation, this concentration on myself, especially when all the principle joys of life are excluded, and inward satisfaction is lacking, cries from hunger in a way, like an empty stomach, in the end this isolation is a will o' the wisp, in so far as happiness is concerned, at least without being made of ice, absolutely insensible. In spite of all my efforts to become so, I am not so at all, my first nature returns without cease. Such is the Gauguin of the pot, his

hand suffocating in the furnace, the cry which wants to escape.

.

You have known for a long time and, I wrote it in the *Moderniste*, I look for the character in each material. But the character of the ceramic in stoneware is the feeling of the high firing, and that figure burnt to death in that inferno, expresses, I believe, the character rather strongly. Such an artist half seen by Dante during his visit to the inferno.

Poor devil hunched in upon himself, in order to stand his suffering. Such as it may be, the most beautiful girl in the world can only give what she has.

.

I smiled at the sight of your sister in front of my pot. Between ourselves I did it a little with the express intention of testing in that manner the power of her imagination in such matters, I would like then to give her one of my best things even though not very successful (as to firing).[78]

In 1890 Gauguin painted his *Self Portrait with the Yellow Christ* in which this pot appears in the background.[79] Certainly the work was finished by the winter of 1889–1890, and if it is the pot referred to in the letters to the Bernards, it must have been done before the end of the winter of 1888–1889.

Another piece which can be dated by its appearance in a picture is the toby jug in the Kunstindustrimuseet in Copenhagen, which appears in the *Still Life* in the Ittelson Collection dated 1889 (Cat. Nos. 65, 65a). The jug has the appearance of the Man of Sorrows, an effect heightened by the serrations around the lip, which give a vague suggestion of a crown of thorns, and the mottled red glaze that streams over the face like blood.

The general inspiration for this type of pot was probably derived from the portrait pots of the Peruvians, with which Gauguin had long been familiar. However, it was only after his trip to Martinique that Gauguin began to visual-

ize himself as a rebel against society and as a savage. Actually, a sketch of a toby jug appears in Gauguin's notebook at about this period, together with a number of other sketches in which heads are used as the main theme in the design of a pot.[80]

Gauguin's magnificent ceramic, the *Black Venus* (Cat. No. 91), probably dates from shortly after his return from Martinique on the basis of its subject matter, which is a Negress of that country, but the fact that it is a pure piece of ceramic sculpture and not a pot, argues for a later date. It is executed in a dark chocolate stoneware such as was sometimes used by Chaplet. The actual construction of the *Black Venus* shows a great amount of technical sophistication on the part of the artist. The base of the figure is formed by building up coils of clay, while the upper part in which this technique would have presented difficulties, was modeled in the solid, then cut in half and hollowed out. Finally the two halves were joined together and to the base. By this means Gauguin assured a more uniform rate of firing of the clay, and reduced the danger of cracking. However, on reworking the forms of the torso, he was less successful, for alterations made in the forms of the breasts after the base clay had dried too much has caused spalling. Nevertheless, the piece is a magnificent work, and the soft polychrome of underglaze colors painted on the body and covered with a thick brownish glaze through which the underglaze colors show, produces a harmonious and subtle effect.

An interesting aspect of this figure of a Martiniquan woman is the plant that grows over her knees and into her lap. It has two branches, one of which terminates in what appears to be a flower bud, while the other seems to end in a representation of the artist's head very similar in conception to that appearing on the Copenhagen toby jug. The symbolism of the head and the flower bud recall the story recounted in one of Gauguin's letters to his wife from Martinique:

[78] Malingue, *Lettres*, XCI, XCVI, CVI
[79] Private collection, Paris

[80] *Album Gauguin*, p. 1. (See Fig. 8)

There is no lack of Potphar's wives here. . . .
They go so far as to cast charms on fruit which
they give you in order to ensnare you. The day
before yesterday a young sixteen-year-old Ne-
gress, very pretty indeed, came to offer me a
guava split in half and pressed on the end. I was
going to eat it as soon as the young girl had left
when a yellowish colored lawyer who happened
to be there took the fruit from my hands and
threw it away: "You are a European, sir, and
don't know the country," he said to me, "one
must not eat a piece of fruit unless he knows
where it comes from. For example, this fruit has
a history; the Negress has squashed it on her
breast, and surely you would be in her power
afterwards."[81]

The symbolism on the *Black Venus* indicates all
too clearly that, although Gauguin escaped en-
chantment on one occasion thanks to the timely
aid of the lawyer, he fell prey to the charms of
a Negress at some other time.

Around the base of the statue is a frieze of
plant and animal forms that suggest the lions on
the Corinthian pottery of the sixth and seventh
centuries B.C. However, the transposition from
flat forms to relief, and a wide occurrence of
similar forms in the ancient world, both East
and West, makes the identification of the source
hazardous.

Other indications of the activity of Gauguin
in ceramics are to be found in the works them-
selves, but little documentary evidence is avail-
able concerning the period of their creation. The
single eyewitness account of one of Gauguin's
ceramics in the making is recorded by Roton-
champ:

On a modeling stand emerged from damp
swaddling clothes, opposite a white cloth thrown
over a screen, a sketch in red earth to which the
artist was giving life, a standing Eve, draped in
her opulent loosened hair.[82]

Rotonchamp places this event in Schuffenecker's
studio on the Rue Durand-Claye, which would
date the execution of this piece in the winter of
1890–1891. From the description, it may be the
Standing Nude Woman (Cat. No. 92) which
was probably the figure described as *"statuette,
grès emaillé"* in the catalogue of the show of
Les XX, in which Gauguin was invited to
exhibit in the spring of 1891.[83]

It was probably this same winter, when Gau-
guin was staying in Schuffenecker's studio, that
he executed the *Vase in the Form of the Head
of a Woman* (Cat. No. 67).[84] This work has
always been thought to be a portrait of Mme
Schuffenecker, and it was Gauguin's attempted
familiarity with Shuffenecker's wife at this time
that brought about the ultimate break between
the two friends in the beginning of 1891. This
winter of 1890–1891 seems to have been a very
active one for Gauguin as a ceramicist, for in
addition to the works already mentioned, there
are a number of references to ceramics in Gau-
guin's letters. In August, 1890, while he was
still at Le Pouldu, he wrote Émile Bernard
about a statue on which he was working, en-
closing a photograph with the remark: "I am
sending you a photo of a statue which I have
unfortunately broken. You saw it, besides, at
Filiger's; it doesn't give in this state that which
I had sought in the movement of the two legs."[85]
Though the original has disappeared, the photo-
graph has been preserved and shows a standing
figure in clay, which Gauguin may have hoped
to fire upon his return to Paris (Cat. No. 88).

Gauguin's departure from France in the
spring of 1891 essentially marks the end of his
career as a ceramicist, although he executed a
few pieces after his return from Tahiti.

[81] Malingue, *Lettres,* LIII.
[82] Rotonchamp, *Gauguin,* p. 77

[83] John Rewald, *Post-impressionism* (New York, 1956),
p. 462.
[84] It has been suggested that this vase appears in the
Still Life in the Ittelson Collection. (*Catalogue of the
Gauguin Exhibition,* Chicago Art Institute, Metropolitan
Museum of Art, New York, 1959–1960, p. 36). If this
identification is correct, the vase must have been made
before the summer of 1889.
[85] Malingue, *Lettres,* CXI.

FROM MARTINIQUE TO TAHITI, 1887-1891

AFTER GAUGUIN RETURNED FROM Martinique, he found the artistic circles in Paris in a ferment over Symbolism. Though the official birth of the new movement was in 1886 when Jean Moréas published the Symbolist Manifesto in *Le Figaro*, it was not until 1888 and 1889 that Gauguin came under the influence of the ideas of the new group.[1] Symbolism was not a simple movement, and the complexities of its aesthetics can not be discussed in detail here, but there are certain basic ideas in Symbolism that also form an important part of the ideas on art of Gauguin, even though there is a story that he tended to ridicule the finespun theories of the poets.[2]

One of the most basic elements of the attitude of the Symbolists was the belief that true reality lay beyond the outer appearances of things and was to be found in the idea which was the inner essence of the outward appearances. At least since the time of Plotinus there had been a school of thought that held that the higher reality which lay beyond the outward appearances of things could only be expressed in symbolic form. In the late eighteenth and early nineteenth centuries such men as Swedenborg, Kierkegaard, and Carlyle, held that the visible and material world was only a symbolic embodiment of a higher reality of the spirit eternally shrouded in mystery.

Another important element in Symbolism was the concern with direct sensation, as Mallarmé put it: "Not the thing itself but the effect it produces."[3] In his search for this directness of feeling, the Symbolist poet was greatly dependent on Baudelaire's doctrine of correspondences which is summed up in his statement:

[1] For a more detailed analysis of the Symbolist movement see A. H. Lehmann, *The Symbolist Aesthetic in France 1885–1895* (Oxford, 1950) and the more recent book by H. R. Rookmaaker, *Synthetist Art Theories* (Amsterdam, 1959).

[2] See Chassé, *Gauguin et son temps*, p. 125.

[3] Stéphane Mallarmé, *Oeuvres complètes* (Paris, 1945), p. 869.

Form, movement, number, colors, odors in the world of spirit, as in the world of nature, are significant, reciprocal, converse, correspondent.[4]

Though this statement is brief, it contains the kernal of a whole elaborate doctrine in which there are two basic ideas. One, which Baudelaire may well have developed from the ideas of Swedenborg, is that the world of spirit and nature are analogous, and that there is an intimate correspondence between that which is manifested in the material world and that which is immanent in the world of spirit. For those who follow this belief, the world below is a symbol for the world of the spirit for anyone who can find its inner essence. The second point is more or less a corollary of the first, but is none the less an important point in Symbolist aesthetics, namely, that there is an intimate relationship between the stimuli of the senses, ideas, and states of mind. As the stimulation of each of the senses has its own evocative quality, the Symbolist tried to enrich his work with as many controlled sense stimuli, either real or suggested, as possible. He seeks to incorporate the full richness of sensory experience in his works.

Poets were concerned not only with the meaning of words, but also their sounds, while such men as Rimbaud, Barbey d'Aurevilly, and Mallarmé even experimented with visual effects in the arrangement of the words on the printed page. Even further, there was a general tendency, which reached its peak with the operas of Wagner, to combine all the arts into one which appealed to as many senses as possible.

Another of the most basic means of the Symbolist poet is the creation of visual imagery particularly through the use of metaphor, what Ortega y Gasset has called "a tool for creation that God forgot inside one of His creatures when He made him."[5] In order to understand fully the significance of metaphor in Symbolism, it will be necessary to consider some of the basic aspects of artistic communication. As Suzanne K. Langer has pointed out in her book, *Philosophy in a New Key*, language is a discursive method of communication by means of words that are signs for particular ideas.[6] It is by nature rational, logical, and conceptual. The problem of the poet is that, limited to words, he uses conventional signs that refer to abstract ideas, general categories, and universal qualities that tend to lack the immediate sensuous richness of the particular experience.[7]

It was to solve this problem that metaphor with its imagery was used in an attempt to evoke the uniquely individual quality of an experience.

Three elements of Symbolism are particularly important for our consideration. First, its basic idealism; second, the idea of correspondences and equivalents; and third, the use of imagery to achieve sensuous richness.

Turning to the ideas of Gauguin, we find that he is in complete agreement with the Symbolist belief that the role of art is the revelation of ideas of a higher reality and not the imitation of nature.

Don't paint too much from nature. Art is an abstraction.

.

I avoid as much as possible that which gives the illusion of a thing.

.

I act consciously according to my intellectual nature. I act a little like the Bible in which the doctrine (especially that concerning the Christ) reveals itself under a *symbolic form* presenting a double aspect: one form which immediately materializes the pure Idea in order to render it more sensible, having the appearance of the supernatural; it is the literal, superficial figurative, mysterious sense of a parable; and then the second aspect giving its Spirit. It is the explicit meaning, no longer representational, but represented, of this parable.[8]

[4] Charles Baudelaire, *L'Art romantique*, edited by J. Crépet (Paris, 1925), p. 305.

[5] José Ortega y Gasset, *The Dehumanization of Art* (Garden City, New York, 1956), pp. 32–33.

[6] Suzanne K. Langer, *Philosophy in a New Key* (New York, 1948), pp. 63–83.

[7] Arthur Schopenhauer made the same points (in Th. Ribot, *La Philosophie de Schopenhauer* [4th ed.; Paris, 1890], p. 104).

[8] These quotations are drawn from Malingue, *Lettres*, LXVII, LXXV, CLXXII.

The essence of reality which could only be drawn from nature through insight and meditation, was something that could not be stated explicitly in painting, but could only be mysteriously suggested.[9] "Plato has said: 'To know the creator and father of all things is a difficult undertaking, and when one knows him, it is impossible to tell it to everyone.' "[10] "Ideas are like dreams, an assemblage more or less formed of things or thoughts half-seen."[11] But, "Does not the promise evoke the mystery, our natures not being able to stand the absolute."[12] "For the masses I will be a puzzle, for a few I will be a poet." "I find everything poetic and it is in the dark corners of my heart, which are sometimes mysterious, that I perceive poetry."[13]

Like the Symbolists, Gauguin was deeply concerned with the expressive potentialities of his artistic means. These were, as Gauguin saw them, basically form and color. As Gauguin put it: "Forms and colors, harmoniously established, produce poetry by themselves."[14] Or again, "What beautiful thoughts one can invoke with form and color."[15] The role of line seems to have been regarded by Gauguin as basic to the communication of ideas, while that of color he regarded as analogous to music in that it reflected moods and emotions rather than communicated ideas. Of line Gauguin stated: "I have come to the conclusion that there are noble lines, lying ones, etc. The straight line gives infinity, the curve limits creation."[16] Later on the artist said: "The essential in a work consists precisely in that which is not expressed: thence it follows implicitly from lines without color or words."[17]

For Gauguin, as for most of the Symbolists, music was an ideal art, and he was much occupied by what he called the "musical part of painting," which was color. "Color, which is a vibration like music reaches that which is most general, and at the same time the most vague in nature, its inner force."[18] You may be sure that colored painting is entering a musical phase." "I have always had the desire to carry painting back to music, which, though scientifically incomprehensible, becomes a little comprehensible for me through the relationship in which I place the two arts."[19]

Gauguin was constantly concerned with the inter-relationship of the arts. He speaks not only of the music in painting, but he also speaks many times of the artist as a poet. We have the attempt on the part of the poet to enrich the sensuous appeal of his work by the use of visual imagery. Naturally, this is not a problem for the painter, but an analysis of the painter's mode of communication will point up an analogous problem. Langer has typified language as a discursive method of communication through signs. Painting and sculpture on the other hand are basically a presentational means of communication through images. While the abstract conceptual nature of language deprives it of the immediacy and richness of a particular experience, which is inherent in the visual image, the presentational arts tend to lack the depth of associative meaning inherent in language. While language lacks the immediacy of the particular, the visual arts tend to lack the abstract universality of the concept that lies behind the word. An artist whose interest was drawn by abstract ideas, such as Gauguin, must, at times, have regretted this limitation on his art.

We found that one of the most useful devices that the poet has at his command to partly overcome the limitations of his medium was meta-

[9] Ibid., LXVII; Avant et Après, p. 4.
[10] Avant et Après, p. 96.
[11] Paul Gauguin, Racontars de rapin (Paris, 1951), p. 4.
[12] Segalen, Lettres, LIV.
[13] Quoted in Rewald, Post-impressionism, p. 209.
[14] Ibid., p. 209.
[15] Malingue, Lettres, p. 322, letter dated September, 1888.
[16] Ibid., XI
[17] Ibid., CLXX

[18] Ibid., CLXX. This is very close to Schopenhauer's idea that music was the direct objectification of the Will. Gauguin was quoting Achille Delaroche's article, "D'un point de vue esthétique à propos du peintre Paul Gauguin," L'Hermitage (1895). The ideas so impressed Gauguin that he copied parts of Delaroche's article both in Diverses Choses (MS in Cabinet des Dessins, Louvre) pp. 246 ff. and in Avant et Après, pp. 21–27.
[19] Ibid., CLXXV.

phor, a means of linking the word with an image. We should ask ourselves whether a means exists for linking an image with a word. Turning back to the consideration of the nature of symbolization, we may define two basic categories. One, to which we will apply the term metaphor, includes such methods of linking word and image as allegory, parable, personification, and metaphor proper. The other, to which we will apply the term symbol, includes signs other than words, and symbols proper. The basic characteristic of the method of symbolization classed under metaphor is to be found in the relationship between concept, word, and image. The word is a species of sign that stands for a concept which it evokes. In metaphor this concept is equated with an image. The necessary element in the equation is the existence of a common quality inherent in both the concept and the image. Take for example the metaphor "the king is a lion." Here the very effectiveness of the metaphor depends on the fact that the king is, in reality *not* a lion. When the concept "king" is equated with "lion," the fields of associated qualities tend to cancel out except for those qualities that are common to both lion and king—majesty, bravery, strength, etc. The effect sought, and often achieved, is a vividness of immediate imagery that transcends that of the usual description of qualities.

Turning from the poet's use of metaphorical imagery to the problem of the painter, the same basic principle holds, but with certain modifications that have striking implications. Remember that the fundamental element of metaphor is the linking of concept and image. In painting, where the point of departure is the specific image, the order must be reversed. First comes the image, and then a sign which evokes a concept. It is a device that Gauguin uses many times. Sometimes he makes an outright use of words, either incorporated in his works, or as titles to them, while at other times he uses traditional signs and symbols to evoke the concept.

Gauguin's description of this process in a comment on Puvis de Chavanne is revealing:

> Puvis explains his idea, yes, but he does not paint it. He is a Greek, while as for me I am a savage, a wolf without a collar. Puvis gives a painting the title *Purity* and to explain it will paint a young virgin with a lily in her hand—Known symbol, thus one understands it. Gauguin to the title of Purity would paint a landscape with limpid water; without any blemish of civilized man, perhaps a human figure. . . . Puvis as a painter is a scholar and not a man of letters while as for me I am not a scholar but perhaps a man of letters.[20]

There is one more qualification that Gauguin makes, the visual image should have primacy over the word:

> I have always said, (if not said) thought that the literary poetry of a painter was special and not the illustration or translation, by some forms, of some writing.[21]

.

> I paint my pictures . . . to my fantasy according to the moon and find the title long afterwards.[22]

Returning to the problem of symbols proper, the first point to remember is that the symbol by its nature lies halfway between the word or sign and the image, and takes on a little of the nature of both. When used by the artist it acts clearly as a link with the idea that it symbolizes. In this it tends to replace words. Gauguin uses this type of symbol constantly. Halos, angel's wings, the Cross, the serpent, the peacock, the fox, and dog all appear in his works many times, along with other symbols.

Though Gauguin called Symbolism "another form of sentimentalism"[23] and denied that he

[20] *Ibid.,* CLXXIV. André Fauconnet (*L'Esthétique de Schopenhauer* [Paris, 1913], p. 194) sums up the similar attitude in Schopenhauer in the following words: "Les mauvais symboles trouvent dans l'entendement, les beaux symboles dans l'intuition, leur source et leur fin."
[21] Segalen, *Lettres,* LXXVII.
[22] *Avant et Après,* p. 1.
[23] Paul Gauguin, *Racontars de rapin,* p. 27.

was a member of the Symbolist group, his use of some of the techniques of Symbolism is clear, and his basically symbolic purpose must be kept in mind. Each of his works is in a sense a symbol in itself, and as Gauguin warns us, we must not be content with an interpretation of its ostensible meaning, but must also look for its inner hidden meaning.

The question of the sources of Gauguin's theories remains to be solved. Huyghe has pointed out the artist's debt to Delacroix.[24] The exact extent of the influence of the ideas of Émile Bernard is difficult to assess. However, Gauguin's letter to Émile Schuffenecker in 1885 already shows a considerable development of the basic ideas of his thoughts on art.[25] Though Gauguin later mocked the technique of the Neo-Impressionists, his thinking in the letter of 1885, particularly in his statements about the expressiveness of lines, shows a striking parallel with the ideas of Seurat on the same subject.[26] Recently, Marks-Vandenbroucke has shown how the influences that Gauguin encountered in the circle of his mother's friend Arosa helped shape his artistic development.[27] Some of Gauguin's ideas were certainly influenced by the discussions of the arts at Mallarmé's famous "Tuesdays."

Strangely, there is another pertinent source of Gauguin's ideas that has escaped notice, the book of his friend Bracquemond, which appeared in 1885. Though Bracquemond, through his insistence on the importance of light modeling belongs to an older school of thought than Gauguin, he expressed a number of ideas which closely parallel Gauguin's later thinking.

According to Bracquemond, the purpose of art is to express a poetic idea in a decorative form. While the poet uses conventional signs, words, for the expression of his thoughts, the artist must use methods appropriate to his own medium. In achieving his purpose, the artist must become a creator and must not be satisfied with the copying of nature. Though the source of his inspiration may lie in the natural world, art is an abstraction whose essence, the ornamental principle, is more important than the natural construction of objects.

In the creation of the picture, there are two fundamental elements, drawing and color. In drawing it is line that expresses the ornamental principle as well as the essential qualities of things: "Ce qui dans la nature est geste, mouvement, trait, expression des etres, disposition des choses, devient *lignes* dans l'oeuvre d'art." Among lines, the *trait,* or draughtsman's line, imitates the least and permits the most abstract arrangements. Modeling, on the other hand, can only express visible realities.

Curiously, though Bracquemond devotes a large segment of his book to color, he says little about its ornamental and expressive qualities. He does imply that in the domain of color the ornamental principle is again paramount.

Though the ideas expressed by Bracquemond are to some extent obscured by a mass of more conventional and even academic details, and by his obvious devotion to the beauties of the natural world as they affect the eye, the core of a new aesthetic approach is there for those ready to see it. In 1885, the year of the book's publication, Gauguin was already searching for a new significance in art. In his letter to Schuffenecker in January of that year he expresses ideas that

[24] Huyghe, *Le Carnet de Paul Gauguin* (Paris, 1952), pp. 30 ff.

[25] At least as early as 1886 Gauguin was beginning to think in terms of synthetism, for the painter Delavallée records Gauguin having explained a painting made at Pont Aven that year in the following terms:

Je n'emploie que des couleurs du prisme en les juxtaposant et les mélangeant le moins possible entre elles pour avoir le plus de luminosité. . . . Pour le dessin, je le fais aussi simple que possible et je le synthèse.

(Quoted in Chassé, *Gauguin et son temps*, p. 47.)

[26] Malingue, *Lettres*, XI. There is some question if Seurat's ideas were developed at this time. Probably the common source is to be found in Baudelaire and Delacroix. (Cf. Huyghe, *Le Carnet de Paul Gauguin*, pp. 30 ff.)

[27] Marks-Vandenbroucke, "Gauguin—ses origines et sa formation artistique," in *Gauguin, sa vie, son oeuvre*, edited by Georges Wildenstein (Paris, 1958), pp. 9–61.

indicate a fertile soil in which Bracquemond's theories could take root.[28]

Though we have seen some of the impact of Symbolist ideas in the ceramics of Gauguin, the main expressions of his new esthetic attitude are to be found in his painting and sculpture. Even though he did paint a number of pictures with a clear symbolic intent from 1888 on, he seems to have used symbolism much more extensively in his sculpture. One reason for this may be that Gauguin reversed the normal nineteenth-century attitude that sculpture is a less abstract art than painting. In his painting there is often the expression of the Impressionist's joy in the perception of the visible world, while the abstraction is carried in the direction of the refinement of line and color, in a direction that might be considered ornamental. In general, the development of an *idea* appears first in a painting, then, when it appears later in a sculpture, it is intellectualized to an even higher degree.[29] While Gauguin's painting may be considered his more or less public side—the part of himself that he exhibits freely—his sculpture is in a sense more private. While painting was regarded by Gauguin as his profession, sculpture was often done for his own amusement, and he expressed his inner ideas with less restraint.

Gauguin's interest in sculpture goes back to the earliest days of his artistic career, but between 1884 and 1889 his works are curiously ill documented. During the early part of this four-year period he apparently did little woodcarving, perhaps because of his preoccupation with ceramics after the spring of 1886. Two works, one an *Adam and Eve* and the other a pair of panels of *Christ and the Woman of Samaria* (Cat. Nos. 58, 59) can probably be attributed to this period on the basis of stylistic evidence, but the religious subject matter suggests that they were not executed before 1888, when similar themes begin to appear in the painting. During the four years since 1884 Gauguin's ideas about art had been undergoing a change. As early as 1885 he had begun thinking about art in Symbolist terms. Bracquemond's book, *Du Design et de la couleur*, had emphasized the ornamental function of art. His pottery had led Gauguin to think more boldly in terms of line and color. In 1888 at Pont Aven both Émile Bernard and Gauguin were developing the style of "cloisonism" with its bolder use of line and color. When Bernard began working on a decorative relief carving for an armoire and a corner cabinet (Cat. Nos. A–4, A–4a), Gauguin was undoubtedly interested.[30]

Though the reliefs *Adam and Eve* and *Christ and the Woman of Samaria* are more plastically developed than the very flat reliefs of Bernard, and the rhythms of the lines less obviously decorative, there is a marked relationship to the work of the younger artist in the richness of the carving and in the profusion of the decorative plant forms.

Gauguin's work in sculpture was interrupted in the fall of 1888 by his trip to Arles to stay with Vincent van Gogh, starting in October. In December, after Vincent's attack of madness, Gauguin returned precipitously to Paris. While he was in Paris, Gauguin tended to work in

[28] For the sources of the ideas discussed above, the reader is referred to the following passages in Bracquemond, *Du Dessin et de la couleur* (Paris, 1885): Poetic Inspiration of Art, p. 209; Ornament, pp. 161 ff, 191 ff, 216–17; Relation between Art and Literature, pp. 275 ff; Artist as Creator, pp. 160, 168, 217 ff; Line: Ornamental; p. 143, Expressive, p. 132, *Trait,* pp. 113, 143; Color, p. 169.

It is interesting to note that although Bracquemond rejected the idea of an analogy between color and music, his principle of organizing color in terms of the opposition of warm and cool tones appears in many of Gauguin's paintings.

[29] While Gauguin's early symbolist paintings, such as the *Vision after the Sermon* and the *Yellow Christ,* deal with themes based on the Bible in a more or less impersonal way, his themes in sculpture are much more personal and private. The artist seems to have maintained this distinction throughout his life.

[30] Ernest de Chamaillard had a piece of furniture on the wings of which two reliefs were carved, one by Gauguin (see André Salmon, "Chamaillard et le groupe de Pont-Aven," *L'Art vivant,* July 1, 1925, p. 15). Marcel Guérin (*L'Oeuvre gravé de Gauguin* [Paris, 1927], I, p. xiii) says that Émile Bernard told him it was in 1888, and that he carved the other.

ceramics when he was not painting.[31] Consequently it was not until his return to Brittany in the summer of 1889 that wood carving was again resumed as a major occupation. By this time, Gauguin had passed through the discouraging experience of the exposition of the works of his friends and himself at the Café Volpini at the *Exposition Universelle* of 1889. He had become fascinated with the forms of sculpture produced by exotic peoples. His letters and his notebooks show the breadth of his interests, and sources of future influences. Mayan art, the art of Java and Cambodia intrigued him, as did Oceanic art (Easter Island). Coming at a time when Gauguin was already beginning to reject the ideas of Impressionism in search for a new path, the experiences of the *Exposition Universelle* had a profound influence on the later development of Gauguin's art.

Gauguin probably returned to Pont Aven about the middle of June in 1889, somewhat later than usual because of his preoccupation with the Volpini show and his interest in the *Exposition Universelle*, which did not open until the first of May. Immediately upon his arrival, he may well have started working in wood, but toward the middle of July he decided to move to Le Pouldu, a little fishing village on the coast not far from Pont Aven. At first he stayed at the hotel, but in October he had settled into the pension run by Marie Henry. Meyer de Haan, an amateur Dutch artist whom Gauguin had impressed at Pont Aven, and who had a little money, made common purse with Gauguin. Together the two of them rented a studio in a nearby villa and set to work.

While Gauguin did some of his finest paintings in 1889, it was also a year marked by the production of a great many works of decorative art and wood carvings. The whole group at Le Pouldu, which now included Gauguin, Meyer de Haan, Sérusier, and probably Filiger, set about decorating the dining room of Marie Henry's inn with painting and carving until everything was covered with decorations.[32] In addition, Gauguin executed a number of panels in carved wood. One group of these developed Martiniquan themes that had already appeared in an album of lithographs that Gauguin had executed for the Volpini exhibition. These carvings are marked by a radical change in style and subject matter. At the same time Gauguin was drawing away from Impressionism in his painting toward a broader and bolder interpretation of nature in terms of line and color, he was also leaving behind him the impressionist elements of his sculpture. The artist was no longer involved in a realistic approach toward nature. The carved panels have achieved an aesthetic integrity of their own. They are no longer counterfeits of reality. The liberation of the sculpture from the burden of verisimilitude allows the artist to elaborate certain decorative aspects. Subject matter has not been eliminated, but the artist, rather than trying to represent, begins to communicate through a more sophisticated use of symbols. By being content with the symbolization of reality, the elements of the relief are made freer to express other factors of style. This freedom of the elements from the tyranny of realism does not, of course, mean that they have no expressive function. Indeed, it should not be forgotten that Gauguin constantly emphasized the expressive function of the abstract elements of style. The new and more sophisticated conception of the relief reveals itself in a number of ways. One of the most striking is the aesthetic isolation given to the symbol. In the past, in the occidental tradition, the tendency had been to look upon a picture as a section of reality represented as a continuum cut off by the picture frame in the same manner that reality might be cut off by the frame of a window. In both

[31] The problem of transporting a very fragile unfired pot back to Paris for firing almost precludes Gauguin's having done any considerable ceramic work in Brittany. Certainly no mention is made of it either in his letters or in the accounts of his contemporaries.

[32] The description, given in Chassé, *Gauguin et son temps*, p. 74, almost certainly refers to the state of affairs in 1890.

Martinique and *Les Martiniquaises* (Cat. Nos. 60, 73) the symbol exists as the revealing of a nexus of expressive forms in a block of wood, without essentially changing the nature of the wood itself beyond the demands of symbolization. In both cases there is a gradual decay of symbolic force towards the edges of the panel, allowing the natural wood to reassert its dominant qualities, a dissolution of the representations into their component elements, material and outline, and ultimately wood itself. This tendency was not new. It had been used by Rodin in his sculpture, who in turn got it from Michelangelo. What was new, was the application of such an idea to relief. It is natural that it should develop here if one considers the use of similar effects in the posters of Toulouse-Lautrec and the probable source in Japanese prints. In both Toulouse-Lautrec and the Japanese, such a device is in a sense a completion, an esthetic statement of the self-sufficiency of painting, existing in its own right.

With the development of the technique of framing the symbolic representation within its own substance, there is an emphasis on the quality of the material itself and its response to the carving tools. The grain and the cut of the chisel are left clearly evident—even to the extent of producing a certain "woodenness" in the figures. To be sure, the reliefs are polychromed, but this is done in a manner more closely analogous to the staining of wood than that of easel painting. The color is put on, then rubbed off, leaving a colored tint which seems to be in the wood itself and which does not conceal the wood's character. In addition, like much oriental and medieval carving Gauguin composed his reliefs at this time in such a manner as to preserve the sense of the front plane of the wood block, cutting into it to a more or less fixed depth, giving the effect of a fixed space without any attempt at perspective illusion. In addition to Gauguin's return to the primitive use of the symbol as opposed to the illusion of reality, there is a great increase in the decorative richness of the pieces.

At times there is almost the effect of the primitive wood carver's *horror vaccui* in the attempt to make the surface of the wood carving as rich as possible.

The appearance of this style immediately suggests that the change in his approach to sculpture may have been influenced by primitive carvings in Martinique, but the only native tradition of art in Martinique is a lingering survival of the Carib art of basketry. By a strange quirk of fate, Gauguin, who became so enamored of primitive arts, chose to go to Martinique and Tahiti, where the artistic traditions were the most rudimentary. Yet, it is not necessary to go to the tropics to find an art of this nature. Brittany abounded in material surviving from the Middle Ages that could act as inspiration.[33]

In subject matter, the *Martinique* is somewhat obscure. In the center of the relief appears a seated woman, nude to the waist, her left hand reaching up as if to pick one of the golden fruit hanging from the two great trees whose trunks and branches form the enframement of the panel at the sides and top. In front of her a goat grazes near an exotic red flower, while two monkeys seem to pluck other golden fruit which hang from the branches of the trees forming a tracery over most of the area of the composition. At the top, on both the right and the left, appear two large heads, as if growing out of the trunks of the trees. The head on the right, his hair covered by a flowing white cap, seems to regard the right-hand monkey malevolently, while the head on the left, with its ferocious crop of uncovered hair, appears to regard the left-hand monkey with an evil grin. Gauguin specifically indicates Martinique as the locale of the scene in his title; however, the monkeys, which are not found on the island, indicate a broader scope to the subject. The general tenor of the scene suggests a source in a fairy tale, perhaps dealing with the theme of forbidden

[33] See V. H. Debidour, *La Sculpture bretonne* (Rennes, 1953).

fruit, and most probably drawn from the native folklore of Martinique. Though monkeys do not exist in Martinique itself, they do exist in the folklore, which is more or less uniform over most of the islands of the Lesser Antilles, on many of which monkeys are found. Unfortunately, it has so far been impossible to relate the theme of the panel to any particular story, but the general atmosphere and the characters of the protagonists are consistent with Caribbean folklore.[34]

The other wood panel associated with Martinique, *Les Martiniquaises*, though it deals with a more conventional scene, is more developed in its composition. Yet, even if the ostensible subject seems to be that of two Martiniquans resting and gossiping, there are a number of anomalous elements. One of the most striking is the figure of the child on the left. Though the figure of a child is usual enough around a couple of conversing women, Gauguin's treatment of the figure is unusual. Only the upper part of the child is seen, while the rest seems to dissolve into nothingness. Where the breasts would be, there are two strange flowers, and another similar flower, but larger, rises on a curved stem from a shell-like leaf to a point that would correspond with the belly of the child. Though the child's right arm fades away to nothing, the left arm is shown in strong relief, with the hand supporting an enormous flower growing at the end of a branch. Other elements of an ambiguous nature are the two flowers, one above each of the major figures in the foreground. That on the left is not easily interpreted, as it is so irregular that it almost suggests a flying bird, while the flower on the right seems to have an animal's head. These "symbolic" additions may have some deep significance, but they seem more in line with Gauguin's famous self-portrait, executed in 1889, in which he surrounds himself with all sorts of symbols—a halo, a pair of apples, a snake-swan, and a strange plant with square

flowers—whose intent seems more of the order of a joke and an attempt to mystify.[35]

Les Martiniquaises is interesting in another way, for it is an early example of Gauguin's tendency to use motifs in several media. In this case the two central figures are closely derived from the two foreground figures of the *Les Cigales et les Fourmis*, one of the lithographs that Gauguin executed early in 1889 for the exhibition at the Café Volpini (Cat. No. 72a). Of these figures, the one on the left, was, in turn taken from the picture *La Jeune Martiniquaise*, which he had painted in 1887.[36] On this basis, the most probable date of execution for the piece would be in the fall of 1889.

If the date in the fall of 1889 is correct, *Les Martiniquaises* lies in one of the periods in which Gauguin's style in painting was undergoing a radical change with such important works as *The Yellow Christ*,[37] *Le Calvaire breton*,[38] and *La Belle Angèle*,[39] which continued his development from such paintings of the previous year as *Jacob and the Angel*[40] and the *Still Life with Puppies*.[41] Though the number of reliefs executed before this period is very small for purposes of comparison, we should expect to find a number of the developments in painting having their effect on the organization of the sculptured panels. One of the most striking developments in the sculpture is the abstract organization of the space. The decorative self-enframement of the scene is carried to a much greater point, with the clear preservation of the front plane of the wood in the forms that are contiguous with the frame. Within the scene itself, the space is no longer based on the work-

[34] Elsie Clews Parsons, *Folklore of the Antilles*, Memoires of the American Folklore Society, XXVI (1933).

[35] Chester Dale Collection, The National Gallery of Art, Washington, D.C.
[36] Illustrated in Malingue, *Gauguin* (Paris, 1948), plate 114.
[37] Collection of the Albright Art Gaillery, Buffalo.
[38] Collection of the Musées Royaux des Beaux-Arts, Brussels.
[39] Musée du Louvre, Paris.
[40] National Gallery of Scotland, Edinburgh.
[41] Museum of Modern Art, New York.

ing out of an impressionist perspective space in terms of sculptured relief, but rather in terms of an abstract organization in which there are evidences of a third dimensional ambiguity. For example, the seated figure on the right is largely contained in a rounded trapezoidal area, which, though it draws its boundaries from a number of the bordering objects, seems to have an abstract significance of its own that is difficult to conceive in relation to a rational space arrangement. Another point of abstraction which parallels that of the painting of the period is the strong emphasis placed on a sinuous, undulating line that creates a rhythmic theme over the surface of the panel. It is perhaps this new concern with abstract shapes, which begins to make itself felt here, that leads to such spatial ambiguities as the figure of the child on the left and the small head immediately beneath the flower on the upper right. It may be that this concern with the expressive outline is the reason that we find the seated figure on the left used for the third time in Gauguin's works.

In the beginning of September, Gauguin wrote to Émile Bernard:

> I have also made a large panel of "30" in sculpture in order to execute it later in wood, *when I have the money* to buy the wood. Not a penny in the cash box. It is also the best thing I have done in sculpture, and the most strange. Gauguin (as a monster) taking the hand of a woman who holds back, saying to her: Be loving, you will be happy. The fox Indian symbol of perversity, then in the interstices some little figures. The wood will be colored.[42]

From then to the end of November, Gauguin's letters are full of his project for sculpture. In another letter to Émile Bernard in October he said:

> I am working on a large wood carving (panel of "30" with some nude figures). I have seduced a new countess here; she is infatuated with im-

pressionism and ought, in Paris, to bring many of her acquaintances to that point of view (Rouvier, Minister of Finance among others) whom she wants to make buy my sculpture. Finally, one must live on hope for lack of reality.[43]

Not only did the countess fail to interest her friends, but the piece which Gauguin called his best work, and from which he had such high hope, never was sold. It ended, as did so many of his ceramics and early sculpture, by being amiably stored by his friend Schuffenecker.

Gauguin worked rapidly on his great relief. Already by the end of August he speaks of having the model finished, and by the early part of November he had shipped the finished piece to Van Gogh at Goupil's in Paris where he urged his friends to see it.

Soyez amoureuses et vous serez heureuses was a major project in wood carving (Cat. No. 76). Instead of working on any scrap of wood that he could find, as was his usual custom, he went to considerable trouble and expense to get a fine piece of linden wood. As we have already said, he was disappointed in his expectations of the piece as far as the public was concerned, but the full measure of the public's rejection did not, perhaps, appear until the early spring of 1891, when Gauguin sent his great sculptured panel to the exposition in Brussels of *Les XX*. In general the policy of *Les XX*, under the influence of Octave Maus, had been favorable to modern art, but in 1891 a strong reaction took place among the Belgian critics. One critic called Gauguin an "erotico-macabre temperament of a genius of lewdness, a dilettante of infamy who is haunted by vice." His *Soyez amoureuses* was called "the deformed sculpture of a sadistic faun, whose kisses are slobbery and disgusting, whose forked tongue sensuously licks a beard impregnated with slime."[44] Though the criticism itself seems more the product of a "dilettante of in-

[42] Malingue, *Lettres*, LXXXVII. Malingue states that there was a sketch of the subject in the letter. The panel is Cat. No. 75.

[43] *Ibid.*, LXXXIX

[44] Excerpts from the Belgian press quoted in *L'Art moderne*, February 15, 1891. Quoted from Rewald, *Postimpressionism*, p. 463.

FIG. 19. *Aux Roches noires* (1889) by Paul Gauguin. Lithograph.

famy haunted by vice," it is certain that the subject matter of Gauguin's great sculpture departs from the normal tenor of his works and is not altogether pleasant to contemplate. It is apparent at first glance that Gauguin's brief description of the work in his letter to Émile Bernard is incomplete, and that there is much more in the work than a simple illustration of the admonition "Be in love and you will be happy."

In considering the development of the subject in the relief, it is well to note at the very beginning that Gauguin himself indicated in his letter to Émile Bernard that it had a subject, and that he considered the subject an important part of the work. It is, in other words, a work of art with a message, and the message was considered important enough to incorporate the words "Be in love and you will be happy" in the body of the relief itself, not simply as a title, but as an essential element of the composition. Every indication leads to the conclusion that the visual presentation should be a reinforcement of the verbal one. But the visual presentation of the theme is contradictory. Essentially the title consists of two elements that are equated—love and happiness—yet there is no expression of happiness in the sculpture. There is instead the expression of a psychological conflict.[45]

The nature of the symbols, as well as the na-

ture of the composition, lead to the conviction that the key to the scene is to be found in a conflict within Gauguin himself. In the first place there are a number of signs that Gauguin at this time identified himself with the fox, "the Indian symbol of perversity," and used it as his symbol.[46] Thus it is possible to reach a first level of meaning in the idea: "Be in love and you will be happy. I say this, and I am perverse." Further analysis of the content of the relief tends to bear out this interpretation. The principal theme of the composition centers about the main figure of the woman in the left foreground. It is this figure that Gauguin takes by the hand, saying "Soyez amoureuses et vous serez heureuses," yet the figure is that of a mulatto with wide staring eyes expressive of fear, and her left hand, which seems to draw back her right as if to break the grasp of her seducer, prominently displays a wedding ring. Just to the right of the mulatto figure appears a smaller crouching figure expressive of fear. This figure was used by Gauguin earlier in *Aux Roches noires*, which appeared as an illustration in the catalogue to the Volpini show the previous spring. In *Aux Roches noires*, the figure used in *Soyez amoureuses* appears in the center crouching in front of a great black rocklike form, while on the right another female figure abandons itself to the waves of the sea (Fig. 19).

In Brittany in particular, innumerable superstitions are associated with the great black basal-

[45] "Ce bas-relief ironiquement libellé: *Soyez amoureuses et vous serez heureuses,* ou toute la Luxure, toute la lutte de la chair et de la pensée, toute la douleur des voluptés sexuelles se tordent et, pour ansi dire grincent des dents." (Albert Aurier, "Le Symbolisme en peinture: Paul Gauguin," *Mercure de France,* March, 1891, p. 165.)

[46] See Appendix A, "Gauguin's Use of Animal Symbols."

tic rocks—menhirs—set up by the pre-Christian inhabitants. Not only are the menhirs themselves objects of superstition, but by extension, other great masses of rock are the object of veneration by the less enlightened Bretons. In most cases these rocks are the center of rites performed to assure marriage and fertility. In short, the old phallic worship, that was found everywhere in Europe before the civilizing effect of Christianity made itself felt, still has a place in the superstitions of the Armorican peninsula.[47] In the light of these popular beliefs, one is led to suspect that the significance of *Aux Roches noires* is, like *Soyez amoureuses*, to be found in the relationship of women to love. In the one case, the figure on the right abandons itself to caresses of the mysterious sea, while the other, in the shadow of the black rock, crouches as a symbol of fear and reluctance.[48] That the significance of the crouching figure in *Soyez amoureuses* is of the same nature is suggested not only by its similarity to the previous figure, but also by the fact that immediately behind, and somewhat surrounding the crouching figure, there is a representation of a tree in flower. Like the menhir, the tree in flower is a symbol of love and fertility.

One of the most ambiguous elements of the main part of the foreground composition is the figure of the fox—"the Indian symbol of perversity"—which dominates the lower right hand side of the panel. While the other figures of the relief are all absorbed in their own emotions and feelings, the fox, with its back to the scene, stares at the observer.

So far, we have considered only the main

figures in the foreground, but the relief is divided into three areas by the diagonal branches that lead from the side up to the title, placed centrally at the top of the scene. Both of the two upper areas are to a large extent spatially distinct from the lower area, but in both cases they are linked to it by a hand that extends from one zone to the other. On the upper right Gauguin has portrayed himself *comme un monstre*. The figure is asleep, mouth half-open, with his thumb in it. This last gesture is that associated with a forlorn and rejected child, and the effect is that of a face, crushed and defeated, not so much asleep as withdrawn from the overwhelming awareness of the antagonistic world. But the gesture of the thumb also suggests another significance—that of defiance. Crushed as he appears, Gauguin still "bites his thumb at the world."

Behind and above the crushed features of the artist floats another face, also asleep, and more savage. As early as 1888, shortly after his return from Martinique, Gauguin had written to his wife from Brittany: "There are two natures in me: the Indian and the sensitive. The sensitive has disappeared, which permits the Indian to walk straight ahead and firmly."[49] It is perhaps not too much of a stretch of the imagination to see in this figure behind that of the artist, the other side of his nature, the savage, still dormant but unsubdued.

On the upper left there are a number of ambiguous symbols combined in an air of unreality. It is into this zone that the hand that we are told is Gauguin's is trying to draw the figure of the mulatto. The hand seems to draw her over a strange contorted figure, with one hand on its breast and a Negroid face with closed eyes on a head that appears to be detached from the body. Between the hand and the contorted figure is another figure of a woman with bare breasts, whose features recall those of some barbarian idol. Placed in a dominant position overlooking the whole zone there is the strange and ambigu-

[47] P. Sebillot, "Tradition de la Haute Bretagne," *Les Littératures populaires* (Paris, 1882), tome IX, part 1, pp. 3–64.

[48] This figure was used many times by Gauguin throughout his career (see Georges Wildenstein, "L'Idéologie et l'esthétique dans deux tableux-clés de Gauguin," *Gauguin, sa vie, son oeuvre* (Paris, 1958). In all cases the emotional overtones express unhappiness. The closest in general tenor of meaning is probably the *Eve bretonne* (McNey Art Institute, San Antonio, 1889), where the pose represents the response of fear and trepidation on the part of Eve to the temptation of the serpent.

[49] Malingue, *Lettres*, LXI.

ous figure of a crouching ram.[50] The whole effect suggests that the hand of Gauguin is trying to draw the figure of the mulatto into a region of strange lusts and barbarous passions, but a region in which there is no expression of the promised happiness.

Going back to the main zone of the relief, there are a few elements that remain to be considered. Some of them are far from clear in significance, but they seem to fit into the general atmosphere created by the scene. In back of the strange barrier, behind the figure of the woman, and at the very top of the lower zone, an ugly face with a long nose peers over a wall. This figure surely suggests that of the typical gossip spying disapprovingly (and usually hypocritically) on those in love. Next to this figure appears another, that of a contorted and apparently recumbent woman dominated by another disembodied and primitive face. The symbolism of this group is not clear, but it produces a general sense of brutality. Finally there remains the small figure of the fox that fills the lower part of the tongue-like projection on which the word *heureuses* of the inscription appears. In the same manner in which the main zone of the panel is dominated by the fox, the symbol of perversity, this symbol is associated with the word happiness in the inscription. Again the thought arises that perversity is somehow associated with the idea of happiness in amorousness, and a free transposition of the symbolic forms into words might run as follows: "The tongue which says that you will be happy if you are in love is perverse."

The problem remains: What does all this mean? In searching for a solution to this, it is well to remember that the fall and winter of 1889–1890 was one of the blackest for Gauguin. In January 1890 Gauguin wrote to Schuffenecker:

There are moments when I wonder if I would not do better to break my head: I must admit there is reason to throw in the towel. I have

never been as discouraged as I am at this moment, also I work very little, saying to myself: "What's the use and what result!" You believe that the Dutchman feeds me here? He has asked me to leave Pont Aven to come to Pouldu in order to get him going with impressionism and, as I haven't even credit, he pays my board and room as a loan, while waiting for a sale by Goupil. I deprive myself of smoking, which is painful for me; I wash a part of my linen surreptitiously; finally, except for the common board, I am stripped of everything. What's to be done about it? Nothing, unless it is to wait like a rat, on a cask in the middle of the water.[51]

Not only was Gauguin in the depths of despair about his artistic career, but also his relations with his family were becoming more and more strained. They had now been separated for five years, except for a short visit from Mette in the Spring of 1887. In June he had complained to his wife that it had been more than six months since he had had any news of the children.

Like so many men of the nineteenth century, Gauguin distinguished physical love and love for his family. Twenty years after his wife had left him to return to her family in Denmark, Gauguin still said bitterly in *Avant et Après*:

I also like women when they are vicious and let them be fat: their spirit annoys me, that spirit too spiritual for me. I have always wanted a mistress who was large and never have I found one. To spite me they are always with little ones.

That is not to say that I am insensible to beauty, but it is the senses which don't want it. As one can see I don't know love and to say I love you I would have to have all my teeth broken.[52]

It is the bitter cry of a man prematurely old, ill, and about to die, who feels himself disowned by his family; a man who had loved once but refuses to love again.

Certainly, though Gauguin was no worse than his contemporaries, he is not always above

[50] The same motif appears on a vase (Cat. No. 18).

[51] Malingue, *Lettres*, pp. 322–23.
[52] *Avant et Après*, p. 2.

reproach; yet his art is extraordinarily free of lascivious elements. His concern with the avoidance of improper implications in his paintings is shown very clearly in his own description of two of his paintings, *Manao Tupapau* and *Que sommes-nous?* In describing the first Gauguin says:

> A young Kanaka girl is lying on her stomach, showing part of her frightened face. She is lying on a bed covered with a blue *pareo* and a yellow cloth. . . .
>
> Fascinated by a form, a movement, I paint with no other preoccupation than to execute a bit of a nude figure. As it stands, it is a study of a nude that is slightly indecent, and yet, I want to make a chaste painting of it, giving the Kanaka spirit its character, its tradition.[53]

Of the second, he says: "My nudes are chaste without clothes."

If Gauguin did not intend to create an obscene work of art, what then is the import of the erotic elements in his sculpture, *Soyez amoureuses?* Part of the ideas that went into the picture were undoubtedly an inheritance from those of his grandmother, Flora Tristan. His grandmother had fought for the liberation of women from what she held to be the unfair domination of men in marriage, and she advocated free love. She had protested against the restraint of women while men enjoyed sexual freedom and against the hypocritical social restraints that were placed on women. Yet, although the ostensible subject of the panel is a plea for more freedom in love, the true subject goes deeper into the conflict within the artist's own mind.

As we have already said, this period of Gauguin's life was one of the most difficult. Love had become a necessity to him. It was no longer simply a matter of satisfying his physical appetites. He desperately sought the affection of the women around him. But here, too, his pride was made to suffer. Marie Henry, his landlady, scornfully rejected his advances as those of a

married man, while she complacently accepted those of the deformed Meyer de Haan.[54] The next year his friend Schuffenecker was to forbid him his studio on the suspicion that he was making improper advances toward Mme Schuffenecker. Only in the case of Madeleine, the sister of Émile Bernard, did Gauguin find a woman who did not reject his affection—so long as it was kept on the basis of that of a brother for a sister:

> In spite of all the social conventions which separate a young girl from every friend, do not fear to ask my advice in times of misfortune or sadness. At that time I would like to give you pleasure and sign a contract of brotherhood.[55]

Gauguin, unable to demand solace in his troubles from Madeleine, offered her his instead. Crushed, rejected on every side, he savagely revolted against society, proclaimed himself a lone wolf and an outlaw, and yet found no pleasure in his rebellion, only guilt and suffering.

In its execution Gauguin's new panel is by far the most ambitious piece of sculpture that he had undertaken so far. Not only did he take great pains to have a suitable piece of wood with which to work, but he seems to have been at great pains to work out the composition. In his letter to Émile Bernard he spoke of having completed a model which he hoped to execute in wood. In many cases the compositions that are found in Gauguin's sculpture appear as more or less secondary uses of themes that he had developed in paintings, but in this case the conception of the work of sculpture seems to be entirely original. To be sure, such isolated elements as the crouching woman, borrowed from *Aux Roches noires*, and the fox, appear in other works, but there is no painting which resembles the sculpture either in theme or in the manner of composition. The composition itself derives many elements from his earlier work, *Les Martiniquaises*, but it develops them much further.

[53] Gauguin, *Notes éparses,* quoted from Morice, *Gauguin,* p. 199.

[54] See Chassé, *Gauguin et son temps,* p. 85.

[55] Malingue, *Lettres,* XCVI. Gauguin even went so far as to contemplate the abduction of Madeleine.

Two elements, the idea of the inclusion of a complex framing element within the composition and the decorative emphasis on the title as part of the composition, though not without precedent, are given a marked emphasis that anticipates some of the developments of *Art Nouveau*.[56] Another important factor in the composition is the freely ambiguous treatment of space. Though this quality is present to some degree in *Les Martiniquaises*, it is more developed here. It is a frank anticipation of the modern method of pictorial organization known as *montage*, where a number of elements are composed with regard to their subjective relationships, rather than on the basis of their spatial homogeneity. To be sure, artists, partly under the influence of the Japanese prints and other related forms of art, had begun to reject the preeminence that had been given in occidental art to the representation of the third dimension, but Gauguin goes further. While previous artists had tended to content themselves with the reduction of the natural world to its two-dimensional aspect—or the creation of a fictitious two-dimensional reality—Gauguin has abrogated the order of the natural world in all its dimensions in favor of a world organized according to ideas.

[56] The relationship of Gauguin to *Art Nouveau* is not entirely clear. The official commencement of the movement in France was the opening of S. Bing's shop of that name in 1895, shortly before Gauguin left France forever. Nevertheless, some of the organizational principles used by Gauguin in his panel *Soyez amoureuses* are very similar to those that appear in the great stoneware portal that the sculptor Jean Carriès undertook for the Princess Scey-Montbéliard, and for which Grasset was making sketches in 1889. (See Arsène Alexandre, *Jean Carriès, imagier et potier* [Paris, 1895], pp. 134–35; ill. p. 163.) Grasset was one of the great leaders in developing the *Art Nouveau* style. Gauguin certainly took part in the revival of handicrafts, as did Grasset, and he was certainly concerned not only with the creation of a new art, but also with its decorative function.

Almost all his close associates in the *École de Pont-Aven* became leaders in the movement. The final position of Gauguin himself vis-à-vis *Art Nouveau* must await a better understanding of that movement itself, but there seem to be two points on which Gauguin differs from the majority of the group. One is his avowed objection to "prettiness" in art, and the other is his rejection of any formula in art.

Technically, *Soyez amoureuses* differs from Gauguin's other wood carving of 1888–1889 in its high degree of finish. Though the artist was well aware of the expressive potential of the rough textured surface of the wood produced by the gouge, as for example in the figure of the fox, most of the forms have been smoothed and polished. Part of this effect may be attributable to the nature of the linden wood itself, which differs from the oak wood that had been used for most of his previous work. But it is more probable that the importance of the piece in Gauguin's eyes led him to finish it more carefully. Another reason may be that, while the decorative aspect of the work of art had tended to be emphasized in his earlier works, in this piece an important part of Gauguin's purpose lay in giving his symbolic forms as complete an objectification as possible, even to the surface qualities of the expressive elements.

From his very first attempts at sculpture in wood, color had been an important element of his plastic work to Gauguin, and *Soyez amoureuses* is no exception. Though the color is rich, Gauguin continued to avoid the effect of a painted relief by working the color into the wood, and then wiping it off wherever possible to produce a quality of color that seems to be a part of the wood surface itself, rather than a superficial addition. Yet in this relief there is a striking exception to this general practice where it might least be expected. The flesh of the figure of the woman in the left foreground has the soft tones of a very lightly colored linden wood, which gives admirably the quality of skin coloration of a mulatto. To this surface Gauguin has added reflective highlights in gold paint at a number of points. This addition is interesting in two ways. The first and most obvious is the point that Gauguin should be interested in the surface accidents of lighting on the figure. The second, and more significant, is that the approach is fundamentally unsculptural in conception. This latter point brings us to an important consideration in Gauguin's career as a sculptor. After his

early works, he shows a definite preference for the relief as opposed to sculpture in the full round. He seems to have had little interest in the quality of sculptural form per se. Working in wood, he sought to enrich his fundamental conception of painting. Even in sculpture, he tended to think in terms of line and color rather than in abstract formal elements. As can be seen in some of his last works, form was used to accent line and give the illusion of the third dimension, through the control of light. It may seem strange today that an artist who devoted a large part of his creative output to sculpture used this approach, but it should be remembered that such pre-eminent sculptors of the Italian Renaissance as Donatello and Desiderio da Settignano often appear to have conceived of relief sculpture in the same way. Another aspect of this same attitude which Gauguin shares with the sculptors of the Renaissance is the idea of interchangeability of materials. Many of Gauguin's compositions were executed in paintings and in prints without any considerable basic changes. To him, the expressive idea was predominant and could be expressed in several media without losing its significance. Even though he was one of the first modern artists to recognize the expressive potential of the material with which he dealt, he seemed to feel that the material medium should be subordinate to the idea.

We have little information about Gauguin's activity as a sculptor in 1890. It was probably in the fall of that year that Gauguin executed his *Bust of Meyer de Haan* (Cat. No. 86) in a section of oak log. On the ninth of September he wrote to Schuffenecker asking that Schuffenecker get him a piece of linden wood the size of a canvas of 30.[57] This must have been the panel for *Soyez mystérieuses* (Cat. No. 87).

This relief which Gauguin carved as a sort of companion piece to *Soyez amoureuses* is quite different from the latter in its conception. One recognizes at once the figure of the "woman in the waves"[58] which had appeared in *Aux Roches noires* of the previous spring, but the composition itself is far different. On the upper right appears a luminous face with an enframement formed in part by the hair of the strange head and in part by the surrounding foliage, giving the effect of an aureole. On the lower left another face, enshrouded in flowing hair, seems to emerge half-revealed from the wood of the panel itself. Between these two figures, and linking them, is the figure of the woman. The three figures form a strong axis in which the luminous figure on the upper right forms one pole, and the shrouded figure on the lower left forms the other. The composition, like others of the period, is relatively simple, giving a strong effect of an ornamental surface achieved without any great preoccupation with the rendering of space. But the title, *Soyez mystérieuses*, incorporated within the relief itself on the upper left, suggests the need to explore the meaning that lies behind this work of art.[59]

Perhaps the first clue to the mysterious element behind the ostensible forms of the relief is the strongly polar composition. To find a suggestion to what this polarity may mean, we must turn to *Noa-Noa*, where Gauguin, in explaining the religion of the Polynesians, states that there are "two only and universal principles of life which are . . . ultimately resolved into a supreme unity. The one, soul and intelligence . . . is male; the other . . . matter . . . is female."[60]

From Gauguin's exposition we may show that he considered a number of polarities which are linked:

Matter	*Spirit*
Female	Male
Negative	Positive
Dark	Luminous

[57] The original letter is in the Cabinet de Dessins of the Louvre. The date is on the cover. (R.F. 28 884)

[58] Collection of Mr. and Mrs. W. Powell Jones, Gates Mills, Ohio.

[59] Albert Aurier, in his article "Le Symbolisme en peinture: Paul Gauguin" (*Mercure de France*, March, 1891, p. 165), says: "*Soyez mystérieuses*, qui célèbre les pures joies de l'ésotéricisme, les troublantes caressements de l'énigme, les fantastiques ombrages des forêts de problème."

[60] *Noa-Noa*, p. 147.

In *Noa-Noa* Gauguin based his ideas about matter and spirit in the Polynesian religion on the book of J. A. Moerenhout, *Voyages aux Iles du Grand Ocean*, which he quotes almost verbatim.[61] According to Gauguin's footnote to the manuscript of *Noa-Noa*, this book was lent him by M. Goupil of Papeete, but there is strong evidence that Gauguin was familiar with the ideas of Moerenhout as early as the fall of 1890.

The idea expressed by Moerenhout concerning the duality of matter and spirit was essentially an old one in European culture, which one suspects had more or less influenced Moerenhout's interpretation of the Polynesian religion.[62] Perhaps the clearest ancient source is to be found in Plutarch's *De Osiridae*. It is also found in other essays by Plutarch in which he dealt with the cosmology that Plato set forth in his *Timaeus*.

With the development of the interest in mythology and the history of religion in the beginning of the nineteenth century, the ideas of Plutarch were revived and expanded. Richard Payne Knight, in his book, *The Symbolical Nature of Ancient Art and Mythology*, quotes the ideas of Plutarch.[63] At about the same time, the French writer, Charles Dupuis, one of the first writers on the history of religion, used this cosmic dichotomy as the basis of his interpretation of ancient religions throughout the world in his book *L'Origin de tous les cultes*.[64]

It may have been from Dupuis that Moerenhout got his ideas. In any case, this interpretation of ancient religion had gained a wide currency by the middle of the century and was probably known to Gauguin even before he read Moerenhout.[65] But when, in the summer of 1890, Gauguin became interested in Tahiti, he almost certainly discovered Moerenhout's interpretation of Polynesian religion. That summer he wrote:

> I have a book from the *Départment des Colonies* giving a lot of information on life in Tahiti. Marvellous country in which I would like to end my days *with all my children*. I shall see later on about having them come. There is in Paris a *Société de Colonization* which obtains the transportation free. . . . I only continue living here in that hope of the promised land, de Haan, Bernard and I and perhaps later my family.[66]

The author has been unable to identify the book that Gauguin read exactly, but the most definitive travel book on Tahiti at that time was Le-Chartier's *Tahiti et les colonies française de la Polynesie* which was published in Paris in 1887. Not only does LeChartier mention Moerenhout's book, but he also gives a résumé of Moerenhout's discussion of the Polynesian religion in which he quotes the passages relevant to his elaboration of the idea of the duality of matter and spirit.[67]

In view of the seriousness with which Gauguin and some of his friends were discussing the possibility of going to Tahiti, it is probable that Gauguin read LeChartier's book, and possibly also Moerenhout's, which, though published in 1835, had still remained the most extensive study of Tahiti throughout the nineteenth century.

[61] In the manuscript copy of *Noa-Noa* in the Louvre, Gauguin says "Je complète la leçon de Tehura à l'aide de documents trouvés dans un recueil de Morenhout (*sic*) l'ancien consul. Je dois à l'obligeance de Monsieur Goupil colon de Tahiti la lecture de cette édition" (p. 131). René Huyghe ("Presentation de l'*Ancien Culte mahorie*," in Paul Gauguin, *Ancien Culte mahorie* [Paris, 1951], p. 25 ff) points out that Gauguin has drawn heavily on Moerenhout not only in the *Ancien Culte mahorie,* but also in *Noa-Noa.*

[62] E. C. S. Handy, in his book, *Polynesian Religion* (Bulletin XXXIV, Bernice Pauahi Bishop Museum; Honolulu, 1927), does not find the idea of the duality of matter and spirit to be fundamental to the religion of the Polynesians.

[63] Richard Payne Knight, *The Symbolical Nature of Ancient Art and Mythology* (London, 1818).

[64] Charles Dupuis, *L'Origin de tous les cultes, ou la religion universelle* (Paris, 1794).

[65] The same interpretation appears, for example, in Flaubert's *Salammbô.*

[66] Quoted in Arsène Alexandre, *Paul Gauguin* (Paris, 1930), p. 110.

[67] LeChartier, pp. 92 ff. Gauguin may also have known at this time of the book by M. Mativet (Monchoisy), *La Nouvelle Cythère* (Paris, 1888). Mativet mentions Monsignor Tépano [Jausson], who was trying to translate the Easter Island script and lived at Papenoo (p. 58). He also speaks of Teiura Henry, who was the leading authority at that time on Tahitian folklore, as well as giving excerpts of the legends (p. 161).

Working back from these ideas expressed in *Noa-Noa*, it remains to be seen if the strong polarity of the composition of the relief *Soyez mystérieuses* can be explained in terms of a polarity between matter and spirit. In the first place, the face in the upper right corner with its circular enframement may easily be identified with one of the celestial luminous bodies, either the sun or the moon. The features are masculine. At the other pole of the axis we find a figure scarcely emerging from the matrix of the panel, whose long enshrouding hair seems to flow into the earth itself. It is a figure with closed eyes, making with her hand a sign of negation. Here we have a marked correspondence between the two poles of the composition and the two poles of the cosmic reality—spirit and matter.

It remains to be seen what the role of the figure of the woman in the middle is. This figure, which seems to rise out of the earth itself, rises with an expression of affirmation toward the luminary in the upper right-hand corner. The search for an explanation of this symbol leads us back to *Noa-Noa*: "When once we have a clear view of this phenomenon out of which the two universal currents proceed, we see that in the fruit are united and mingled the generative cause and the matter which has become fecund."[68]

It is the age-old symbol of woman, as the mother, the link between inanimate matter and the fecondating, vivifying spirit, the mother goddess. Woman in giving her assent to spirit is the crucible in which spirit and matter are fused, bringing forth life.

Certain other elements in the composition lend a degree of confirmation to this hypothesis. In Gauguin's letter to Schuffenecker on January 14, 1885, he speaks of the symbolism of directions: "Lines to the right advance, those to the left recede. The right hand strikes, the left is on the defensive."[69] In this way we may surely see a similarity with the polarity of positive and negative, one of the polarities of spirit and matter. If we add to this the common idea of superior and inferior, the placing of the poles in itself becomes significant. Another substantiation of the hypothesis is found in the general treatment of the plant forms which constitute an important element of the decoration of the panel. If one traces the flow of movement of these forms, one finds that the hair of the figure in the lower left-hand corner flows down, losing itself in the matrix of the panel, but that the movement is not arrested. As this flow continues to the right and upward, the shapes, at first amorphous, begin to become more and more highly differentiated into vital plant forms as they rise to surround the radiant figure in the upper right. On the upper left, near the title, *Soyez mystérieuses*, appears the ancient Christian symbol of the triumphant soul, the peacock. Again, this seems to be a symbolic representation of the vivifying influence of the sun's radiance, a symbol of the spirit, on inert matter.

While, as Albert Aurier pointed out in 1891, Gauguin's panel *Soyez amoureuses* is bitter and ironical, this one is not. *Soyez amoureuses* may be regarded as giving expression to a very personal and crushing sense of rejection and defeat through its use of almost exclusively negative symbols. Here, in *Soyez mystérieuses*, Gauguin expresses his belief in the ultimate triumph of the human spirit on a more philosophical level.

Looking back over the three works, *Aux Roches noires*, *Soyez amoureuses*, and *Soyez mystérieuses*, the question naturally arises whether we are not in fact dealing with a sort of trilogy in plastic form, in which the artist deals with the problem of the affirmation and negation of life. In the first, *Aux Roches noires*, we see the problem posed in the two figures, one affirmative and one negative. In the second, *Soyez amoureuses*, we find Gauguin giving expression to his own personal feelings of negation and defeat. In the third, *Soyez mystérieuses*, Gauguin expresses a deeper and more imper-

[68] *Noa-Noa*, p. 148.
[69] Malingue, *Lettres*, XI.

sonal sense of the ultimate triumph of the affirmation of life.

There is an interesting corollary to the theory that a constant theme runs through the three pieces executed by Gauguin in 1889 and 1890. Since the same images keep reappearing with a symbolic content that remains more or less constant, we will be justified in suspecting that this may be true of certain other habitually recurring images in Gauguin's sculpture.

In its execution, the relief *Soyez mystérieuses* marks a further step in the development of Gauguin as a sculptor. Though Gauguin had begun to break away from the idea of the representation of consistent illusionistic space in his work *Les Martiniquaises*, even his panel *Soyez amoureuses*, executed at the end of 1889, continues to use such elements as the overlapping of planes of composition and diminution of scale which suggest depth in space. In *Soyez mystérieuses* these elements have disappeared. The figures are arranged in a shallow and determinate space box, all bound between the front plane of the

original block and the background. All are of the same scale. This type of organization, which is typical of much of the later sculpture of Gauguin, goes a great deal farther in destroying the western tradition of the illusion of space than does any of his easel painting. In his painting at this time Gauguin was coming more and more under the influence of the flat color and linear pattern of the Japanese print. As a rule, the Japanese use neither modeling or linear perspective in their prints, but they do use the overlapping of planes to create the feeling of space together with a change of scale with distance. If, on the other hand, we turn to Japanese panel carving, it is apparent that they have the same basic characteristics as Gauguin's panel. In addition, the panels, being frankly ornamental in purpose, use a far more decorative stylization of natural forms than do the prints, a characteristic that is also apparent in Gauguin's panel (Fig. 20).

Not only are these elements to be found in Japanese carving, but they are common to most

FIG. 20*a*. Japanese colored wood carving. *Artistic Japan*, XII (1889).

FIG. 20*b*. Detail of an unidentified Japanese temple showing the carved decorative screens.

oriental relief sculpture. In addition to Japanese work, Gauguin had undoubtedly seen art from a number of other oriental countries in 1889. In the first place, the Musée Guimet had opened in Paris that year in conjunction with the opening of the *Exposition Universelle*. The exposition itself had material from a number of countries:

> The colonial department includes Cochin-Chinese, Senegalese, Annamite, New Caledonian, Pahouin, Gaboonese and Javanese villages, inhabitants and all. Very great pains and expense have been taken to make this ethnographic display complete and authentic.[70]

Besides the villages set up by the French Colonial Department, there was a display of the *History of Human Habitation* illustrated by forty-four models representing the dwellings of all ages, including the Aztec and the Inca.[71] Further material that undoubtedly interested Gauguin was to be found in the display of the *History of Writing*, which included an inscription from Palenque and examples of the Easter Island pictographs.[72]

During the Exposition, Gauguin mentioned the Javanese village many times, and even acquired a piece of carving that fell off the cornice of the building.[73] He also spoke of having photographs of Cambodian works,[74] and, according to Paul Serusier, spent time sketching the material from Mexico.[75]

The effects of these exotic influences can also be seen in another work that Gauguin surely executed in 1890 or perhaps early 1891. That is the wooden version of the clay figure *Luxure*, which he had had made in 1889. The Danish sculptor Willumsen describes visiting Gauguin in his lodgings near the Odeon. The one ornament of the room was a statuette, which Gauguin called *Luxure*, which he exchanged with Willumsen for one of the latter's paintings (Cat. No. 88).[76] In this sculpture, the features are surely based on Mayan prototypes.

[70] William Walton, *Chefs d'oeuvre de l'Exposition universelle de Paris, 1889* (Paris and Philadelphia, 1889), p. xiii.

[71] *Ibid.*, pp. xxv ff.

[72] Thomas Wilson, "Anthropology at the Paris Exposition in 1889," *Report of the U.S. National Museum for the Year Ending June 30, 1890*, pp. 668–70.

[73] See Charles Chassé, *Gauguin et le group de Pont-Aven* (Paris, 1921), pp. 40–41.

[74] Paul Gauguin, *Lettres de Paul Gauguin à Émile Bernard*, edited by M. A. Bernard-Fort (Geneva, 1954), letter V, Paris, 1889.

[75] Marcel Guérin, *L'Oeuvre gravé de Gauguin* (Paris, 1927) I, 20.

[76] Rewald, *Post-impressionism*, p. 467.

CHAPTER 3

THE FIRST TAHITIAN YEARS, 1891-1893

AS EARLY AS THE FALL OF 1888, Gauguin had been thinking of leaving France again for the tropics. At first he had considered returning to Martinique, but during his stay with Vincent van Gogh in Arles he met the Zouave, Millet, who had just returned from Tonkin, and for a while Gauguin seriously considered going to French Indo-China. When it appeared that it would not be possible for him to receive government support for such a project, he suddenly decided, in the spring of 1890, to go to Madagascar. That summer he turned his hopes toward Tahiti. He hesitated for a time over the expense of such a trip, but by the fall of the year his mind was made up to go to Tahiti. In February, 1891, he finally wrote his wife concerning his plans:

> The day may come (and perhaps soon) when I shall flee to the woods on an island in Oceania, to live there on ecstasy, on calm and on art. Surrounded by a new family, far from this European struggle for money. There in Tahiti I will be able, in the beautiful silence of the tropical nights, to hear the soft murmuring music of the movements of my heart in loving harmony with

the mysterious beings of my surroundings. Free at last, without worries about money, and I will be able to love, to sing and to die.[1]

On the fourth of April, Gauguin set sail for Tahiti and on the twenty-eighth of June he arrived in Papeete after a stopover of two weeks in Noumea.

The outward record of the events of Gauguin's stay in Tahiti is a sufficient justification for the discouragement of any artist. Yet, in spite of ill health, financial difficulties, and neglect by his friends, this period finds Gauguin reaching maturity as an artist. During a brief and troubled two years he produced sixty-six paintings and a number of works in sculpture of which the ten or so known today are only a fraction.

Not long after his arrival Gauguin set out to learn the native language. His friend Jénot introduced him to Cadousteau, the official inter-

[1] Malingue, *Lettres,* C. This letter must date from the winter of 1890–1891, as Gauguin gives his address as Schuffenecker's house, 12, Rue Durand Claye. Rotonchamp (*Ganguin,* p. 76) states that it was not until that winter that Schuffenecker moved to the Rue Durand-Claye.

preter of the governor, who knew the various dialects of the region.[2] Being half-Tahitian himself, Cadousteau could also help Gauguin in his desire to supplement the knowledge that he had gained from reading about Tahiti by a more direct knowledge of native culture.

Gauguin did not start painting at once, for as he said:

> In each country I need a period of incubation, to grasp each time the essence of plants, of trees, in short, of all the nature so various and so capricious, never wanting to let itself be predicted and surrender.[3]

Instead he made innumerable sketches and sought to study the native arts. But when he asked Jénot where he could find some figures carved in either stone or wood, he was greatly disappointed to learn that Jénot knew of none to be found in Tahiti. Gauguin had seen a stone figure from Easter Island, together with a certain amount of other Polynesian art, at the *Exposition Universelle* of 1889, and he apparently assumed that he would find material of a similar nature in Tahiti. But Gauguin had chosen to go to the one group of islands in the Pacific that was extraordinarily poor in native art. Even the early travelers had found little. Captain Cook's records of his voyages note almost no art from Tahiti, although he was careful to describe in some detail the arts of the other islands that he visited. All that Cook mentioned was a number of broad thin pieces of wood, roughly carved, that stood around the *marae*,[4] or sacred platform, and presumably represented the spirits of dead priests and chiefs, and the carved heads on the

war canoes. Moerenhout, writing in 1835, gives very little information about the arts of Tahiti. He describes the images of the gods called *toos* as follows:

> The *toos* were the images of the *Atouas*. These images, before which the priests placed the offerings, prayed and presented the victims, were preserved with the greatest care on the *Marais*. Cut in stone or in wood, it was all that one could imagine of the most ridiculous and brutal art. The first were actually in most cases nothing but a column or a triangular block, covered with cloth. The second were pieces of wood hollowed out on the interior, having almost no form or visage, or showing horrible features, arms and legs either monstrous or only indicated. On the whole, the images of the *Atouas* were much less finished than those of the *Tiis*, their inferiors, some of which, as guardians, were supposed to be found around the temples.[5]

The most authoritative account we have of ancient Tahiti is Teiura Henry's publication of the amplified and annotated records of her grandfather, Henry Orsmond. Orsmond was one of the first missionaries on the Island, but even he mentions few items of native art.[6] In general, true images were not made of the major gods, though Henry does mention one image of 'Oro, carved of ironwood, and one stone image of a crude nature.[7] In addition to these, there were a few simply carved utensils and images of tikis. In the Polynesian language the word *tiki* admits of several interpretations, which leads to a certain amount of confusion. In the first place, Tiki is the name of the first man, the Polynesian Adam. *Tiki*, as a noun, also refers to the product of any artistic activity, from sculpture to tattooing. Finally, tikis were small carved images constituting the outward forms of the familiar spirits

[2] New light has been thrown on Gauguin's first trip to Tahiti by the manuscript of Jénot ("Le Premier séjour de Gauguin à Tahiti," *Gauguin, sa vie, son oeuvre*, edited by Georges Wildenstein [Paris, 1958], pp. 115–26). This material has necessitated a reevaluation of Gauguin's purported account of his stay as recorded in his book *Noa-Noa*. In the light of Jénot's recount, *Noa-Noa* takes on more of the color of a romance in the manner of Pierre Loti than a factual account.

[3] *Avant et Après*, p. 10.

[4] James Cook, *A Voyage to the Pacific Ocean* (3rd ed.; London, 1895), II, 33.

[5] Moerenhout, *Voyages*, I, 471 (see Fig. 21).

[6] It is a curious fact that Miss Henry lived in Tahiti from 1847 to 1890, when she moved to Hawaii. She remained in Hawaii until 1905, and then returned to Tahiti. Her absence from Tahiti almost exactly coincides with the period during which Gauguin was there.

[7] Teiura Henry, *Ancient Tahiti,* (Bulletin XLVIII, Bernice P. Bishop Museum; Honolulu, 1928), pp. 236, 244.

FIG. 21. Stone idols from Tahiti. The British Museum.

of sorcerers. These spirits acted as messengers in the execution of spells—the verb *tiki* means to send. According to Henry these images existed in Tahiti, carved in stone, coral, and pua wood, but they were generally small.[8] As the power of the sorcerer was due to his control of the image, they were usually kept hidden.

After the arrival of the missionaries, and the establishment of the converted Pomare I as paramount chief, the tikis, along with the *toos*, were either destroyed as outward evidences of paganism, or they were very carefully concealed.

In the absence of any native material in Tahiti, Gauguin had to draw on other sources for his creation of an art paralleling what he believed to be the ancient native tradition. During his stopover in Noumea, he may have had a chance to study the strange and powerful art of the New Caledonian Melanesians. In Tahiti, the administrative and commercial center of the

French colonies in Oceania, Gauguin probably found a number of curios that traders had brought back from the other islands of the area. Actually, one such collection is recorded by Lady Brassey in her book *Tahiti*, where she mentions a colonist who had "succeeded in collecting a number of gods or idols, paddles, masks, and other curiosities."[9]

It is amply attested by his work that Gauguin saw a fair amount of such material, particularly objects coming from the Marquesas. Huyghe has shown the influence of the native arts on the decorations of Gauguin's book *Ancien Culte mahorie*, and it is evident in the sculpture executed during his first stay in Tahiti.[10] In addition to studying native objects, or photographs of them, Gauguin must have begun collecting them

[8] *Ibid.,* 208.

[9] Lady Brassey, *Tahiti* (London, 1882), p. 53.
[10] René Huyghe, "Presentation de *l'Ancien Culte mahorie*," in Paul Gauguin, *Ancien Culte mahorie* (Paris, 1951).

for himself, for on his return to France he took with him enough objects to form a major part of the decoration of his studio in Paris.[11]

Actually Gauguin started wood carving even before he started painting. One of his first works was the decoration of a native bowl for holding poi that belonged to his friend Jénot. On it he carved patterns based on the designs of Marquesan tattoos. Jénot has left us a description of Gauguin at work on this piece:

> He then displayed some photographs of Marquesans with all or half of their bodies covered by tattooing of which he admired the design and was amazed that artists capable of tattooing such figures had never dreamed of reproducing them in wood or stone. Consequently, full of the object of our conversation, he took up his work again by translating some of the Marquesan designs with the chisel and the gouge.
> Gauguin took the object, examined it, turning and returning it, then all at once, without preparation, choosing a tool, he started to carve it.... When he worked Gauguin was silent and even deaf.[12] (Cf. Cat. No. 142)

Gauguin's carving did not long restrict itself to decoration. He soon began to carve works in which he sought to give expression to his ideas about the Polynesian gods. In his style he tried to communicate the primitive nature of the conceptions of the culture and to preserve the air of mystery of the gods of a people whose past was already fast disappearing from their memory.

Gauguin's first works were executed in guava wood (*Psidium guajava*), which was available in Papeete, but the artist had been impressed by the beauty of the wood used by the natives in making their utensils, and he soon sought to

find pieces of that material suitable for carving.[13]

Though Gauguin speaks in *Noa-Noa* of going to the mountains himself to cut the wood for his sculpture, he first obtained it from an old native Tahitian who lived in the mountains behind Papeete and descended occasionally to town to sell the products that he had gathered there. Generally these pieces of wood were in the form of small freshly-cut logs.[14] Unfortunately, their lack of curing has led some of the sculptures to crack badly.

There are reasons for believing that the *Idole à la perle* (Cat. No. 94) was one of the first of a series of sculptures that Gauguin executed dealing with the theme of Polynesian mythology. Though the date of this piece can only be fixed accurately as lying within the period of Gauguin's first trip to Tahiti, there are certain indications that tend to place it early during his stay. It is the only one of his wood carvings surviving from that period in which he uses the technique he had used in his figure of *Luxure* in the winter of 1890, that of adding a figure in a separate piece of wood. Here the main figure in the posture of yoga has been carved separately and nailed on as was the figure of the fox in *Luxure*.

The subject matter of this piece is obscure, but there are certain clues that lead to the possibility of suggesting what it represents. By no means all the elements of this interpretation can be rigorously demonstrated, but it has the virtue of being consistent with the ideas about religion that Gauguin has expressed in many places. Not a few of these ideas appear in his first book, *Noa-Noa*, for which he was gathering material at this time.

As a point of departure, we may well choose the figure in the pose of yoga. This figure is most certainly derived from a representation of enlightenment of the Prince Siddartha, his

[11] Rotonchamp, *Gauguin*, p. 141.
 Sur les murs, balafrés de toiles barbares, s'entrecroisaient des trophées d'accessoires guerriers: casse-têtes, boomerangs, haches, piques, lances, le tout en bois inconnus: rouges sombres, oranges, noirs.

[12] Jénot, "Le Premier séjour de Gauguin à Tahiti," pp. 121–22. There is a picture frame by Gauguin in the Musée de la France d'Outre-mer which holds a photograph of a tattooed Marquesan (see Cat. No. 142).

[13] See Appendix B for the identification of the woods used by Gauguin in Polynesia.

[14] Jénot, "Le Premier séjour de Gauguin à Tahiti," p. 122.

achievement of Buddhahood.[15] As we shall see, the actual phase of this enlightenment is of some significance in the interpretation of this piece. The other figures on the sculpture differ markedly in their execution from this first figure and reveal Gauguin's attempt to give a plastic realization to the forms of the ancient gods of Polynesia.

The link between these Polynesian deities—Te Atua—and the Buddha in Gauguin's mind is clearly shown by his attempt, more imaginative than scholarly, to derive the term Te Atua from Tathagata, one of the appellations of the Lord Buddha.[16]

In *Noa-Noa* Gauguin gives the theogony of the Polynesian gods and comments on it. Primarily he is concerned with three major gods: Ta'aroa, Hina, and Te Fatou. Though his interpretation may be wrong in certain aspects, it is, nevertheless, a fairly concise statement of his ideas at about the time he was carving *l'Idole à la perle.*

Ta'aroa:
> Male, Soul, Intelligence, Spirit, Light, Sun.

Hina:
> Female, Matter, Moon.

These are "The two unique and universal principles of life. . . . One, soul and intelligence, Ta'aroa, is male; the other purely material and constituting in a certain way the body of the same God, is female; it is Hina."[17]

So far Gauguin has said little about the third god, Te Fatou—literally "the Lord"—who does not seem to fit neatly into this scheme. Gauguin treats him as the "god of the earth, the earth itself," and generally relegates him to a second order of importance as a lieutenant, and at times, perhaps an alter ego of Ta'aroa. He is, however, with Hina, one of the two gods specifically identified in Gauguin's representations of the Polynesian deities.

To return to the representation of Buddha, we must turn next to the Lalitavistara, which tells us that the being who was to be the Prince Siddhartha upon his incarnation, had achieved through his previous incarnations the perfection of a boddhisattva, and the right, being free of the world of matter, to pass into Nirvana.[18] However, his compassion had led him to decide to descend once more into the world of matter and come to the aid of suffering mankind as a Buddha—an "Enlightened One." The event that Gauguin has chosen to represent is that in which, after many tribulations, the Prince Siddhartha has reached Benares and seated himself under the bodhi tree, and in final meditation, achieved Buddhahood. The instant Gau-

[15] Apparently Gauguin had at least two representations of this scene in his possession. One was a reproduction of the *Assault of Mara* from the temple of Borobudur in Java, which was found among his effects at the time of his death. (See Bernard Dorival, "The Sources of the Art of Gauguin from Java, Egypt and Ancient Greece," *Burlington Magazine*, April, 1951, pp. 118–22.) The other representation has apparently disappeared, but not without leaving its trace. It appears in one of Gauguin's wood engravings (Guérin No. 63) and in the upper left background of a photograph of a Marquesan woman taken in Gauguin's studio in 1901 (Segalen, *Lettres*, plate 12). Gauguin has shown a knowledge of Buddhism at least as early as about 1890 when he executed the watercolor of Meyer de Haan with the title *Nirvana* (see Jean Lemayrie, *Paul Gauguin* (Basle, 1960), p. 14).

The Theosophical Society, which had been founded in New York in 1875 by H. S. Olcott and H. P. Blavatsky, had established a Paris branch in 1883 with Lady Caithness, Duchess of Pomar, as its president. In 1883 the French Society published a translation of H. S. Olcott's *Le Bouddhisme*, translated by D. A. C. [Lady Caithness] (Paris, 1883). Lady Caithness published *Théosophie bouddhiste* (Paris, 1886) and *Fragments glanés dans la théosophie occulte d'Orient* (Nice, 1884). By 1888 the Theosophical Society was one of the most active popularizers of a neo-Buddhist religion. (See Julien Vinson, *Les Religions actuelles* [Paris, 1888], pp. 575–77.) In view of the fact that Gauguin usually portrayed Meyer de Haan as a contemplative mystic, it seems plausible to asume that Meyer de Haan was interested in oriental religions, and it may have been through him that Gauguin's interest was aroused.

[16] *Noa-Noa*, p. 38.

[17] *Ibid.*, 147–48. See also Moerenhout, *Voyages*, I, 423 ff. Though Gauguin's emphasis on these fundamental principles was undoubtedly based on Moerenhout, these ideas seem to be more at home in Mediterranean mythology than in Polynesia (see E. S. C. Handy, *Polynesian Religion* (Bulletin XXXIV, Bernice P. Bishop Museum; Honolulu, 1927).

[18] See C. M. Pleyte, *Die Buddhalegende in den Skulpturen des Tempels von Boro-Budur* (Amsterdam, 1901).

guin has chosen is that in which the Buddha withstands the attacks of Mara the Lord of Death and Desire, taking the earth as witness of his right to sit under the bodhi tree.[19] It is the moment of the perfection of the union of the spirit with the material world, and the moment at which the Naga King Muçilinda, an earth deity, spread the protection of his great cobra hood over the Enlightened One, now truly fulfilling the prophecy that he would become a Çakravarthin, a Lord of the Wheel of Death and Rebirth. As such, the Buddha becomes the perfect symbol, according to Gauguin's conception, of the god Ta'aroa, the spirit, made manifest in matter, Hina. The figure is androgynous, as Gauguin's theology demands. It has the symbols of light and spirit, the gold star and the pearl representing the *usnisa*, the third eye of enlightenment. It has female characteristics, because Ta'aroa, the spirit, can only manifest itself through its descent into matter, Hina.[20]

The problem of identifying and interpreting the other figures still remains. From Gauguin's discussion of Polynesian theology it is apparent that he considered Ta'aroa, Hina, and Te Fatou as the most important divinities, and we might well expect that if there are other divinities among the representations on the sculpture that we should find these two represented. Earlier, Te Fatou was defined as the god of the earth, the earth itself. Now, in the legend of the enlightenment of Buddha, the earth appears twice, once when the Prince Siddhartha takes the earth

to witness for his right to sit under the bodhi tree with the very gesture that Gauguin has portrayed, and again when the earth spirit, the Naga King Muçilinda, spreads his protective hood over the Buddha. There is a striking parallel between the entities representing the earth in this legend and the definition given by Gauguin for Te Fatou, which permits us to tentatively identify the visage which seems to emerge from the block of wood at the top right with Te Fatou. In the first place, the quality of emerging from the material of the sculpture is the epitome of the idea of a chthonic god; second, the relatively gigantic size relates this figure to Gauguin's conception of Te Fatou as expressed in his painting *Hina Te Fatou* of 1893.[21] At first one might be deceived in thinking the figure to be that of a female because of the flowing nature of the hair, but a reference to the picture *Hina Te Fatou* will show the similarity in the treatment of the head.

Finally, the figures on the back of the sculpture remain to be explained. Here there is little difficulty, for the representation, given the exigencies of a different material, is essentially that of *Hina maruru* ("The Feast of Hina") of 1893.[22] In *Noa-Noa* Gauguin remarks that "the moon had an important part in the metaphysical speculations of the Maoris. It has already been stated that great feasts were celebrated in her honor."[23] While on the front of the piece we see a representation in symbolic form of the metaphysical essence of Gauguin's conception of the Polynesian religion, on the back we find a representation of its outward form. Again there is the contrast between idea and form, spirit and matter.

The execution of the *Idole à la perle* is interesting in that it marks an important step toward the full development of the technique of wood carving that Gauguin used on most of his sculpture in the round in Tahiti, and later in the

[19] The right hand of the Buddha is making the gesture, or *mudra*, called the "earth-witnessing" gesture.

[20] In Gauguin's woodcut entitled *Te Atua*, or "The Gods" (Cat. No. 94b), three representations of the Tahitian deities appear. On the right is the figure of Hina taken from the sculpture group of *Hina with a votary* (Cat. No. 97). On the wood original the figure is entitled *Hina* by Gauguin. On the left appears a group of two figures taken from the cylinder *Hina and Te Fatou* (Cat. No. 96). That this scene represents the two gods is proven by the watercolor in which the identification is given by the artist himself (Rewald, *Gauguin Drawings,* plate 85). The central figure, which is taken from the front of the *Idole à la perle,* is not identified by the artist, but its central position, and the title of the woodcut —"The Gods"—suggest the conclusion that Ta'aroa, the third and most important of the Polynesian gods, is represented.

[21] Collection of the Museum of Modern Art, New York.

[22] Present whereabouts unknown. Illustrated in Rewald, *Post-impressionism,* p. 522.

[23] *Noa-Noa,* pp. 146–47.

Marquesas. Perhaps the first consideration should be that of the nature of the material. Here Gauguin has used a piece of native tamanu wood. The wood was furnished to him in the form of small logs; and, as in the case of his *Bust of Meyer de Haan*, one of his last works in wood in the round before departing for Tahiti, Gauguin has preserved the essential form of the original block to a considerable degree (Cat. No. 86). Though the figure on the front is in very high relief (as already mentioned, it is made of a separate piece of wood), the rest of the figures appear to be freed from the wood to only a slight degree. Actually, the back of the work, the *Feast of Hina*, is carved very shallowly with almost no attempt to establish the volumes of forms beyond the representation of outline and a few basic planes. Gauguin has used a manner of working that is characteristic of his later works. He has ornamented the cylindrical surface of a block of wood with a relief without destroying the sense of the underlying geometrical form. After his early beginnings as a wood carver, Gauguin had shown a marked predilection for the form of the relief, and one might say that, although Gauguin was perfectly capable of producing sculpture in the full three dimensions with a high quality, he had relatively little interest in doing so. His chief concern was the decoration of a surface, in much the same way he had developed his painting.

Though Gauguin attempted to give a sense of the primitive in his works, it should be noted that they differ in a number of ways from the true productions of a primitive people. As Gauguin was among the very first artists to show a real appreciation of the arts of so-called primitive peoples, it will be rewarding to investigate the relationship between those of his works in a primitive vein and the productions of a primitive artist.[24] The first difference is to be found in the very conception of the nature of the work of art. For the true primitive (we are not speaking here of the highly sophisticated artists of Indonesia

and the continent of Asia), the image serves a primarily magical purpose. It is a vessel for the accumulation of the mana of the deity it represents, and to a certain extent the control of the image represents a control of the deity. The image stands *in loco dei*. As the deities of primitive people are almost always the anthropomorphization of the forces of nature, these images are simple and timeless symbols of a purely conceptual idea. As they embody the idea itself, they do not represent relational or casual activities or events. As with all generalization, this is subject to exception, but it none the less forms the general rule. Gauguin had an intuitive realization of this to some extent when he wrote De Monfreid: "Sculpture . . . very easy when one looks at *nature* very difficult when one wants to express himself a little bit mysteriously in parables, *to find forms*."[25] Yet this very difficulty that Gauguin experienced is utterly foreign to the primitive artist, and marks a clear difference between this idea and those of Gauguin. The primitive idol is a clear, well-understood, conventionally determined symbol. The idea behind it may, or may not, have a certain mysteriousness for the primitive mind, but the symbol does not.

Another aspect of the difference between Gauguin and the primitive is to be found in the fact that Gauguin almost always tried to generalize an event to give a suggestion of the idea behind it in very personal ways. He sought to suggest a parabolic meaning behind the experience of events in nature. Though this step had its part in the creation of the gods of the primitive pantheon, it is not a step which concerns the primitive artist. For him, the idea exists free of the mass of phenomenal events from which it was drawn. His problem is not to show the relation of the idea to events, but only to create an adequate symbol for the embodiment of the idea according to a long-determined tradition. Gauguin wished to abstract from nature; the primitive artist does not concern himself with this; thus nature plays for him an entirely different role.

[24] In *Diverses Choses*, p. 223, Gauguin wrote: "Vous trouverez toujours le lait nourricier dans les Arts primitifs."

[25] Segalen, *Lettres*, XXXVII.

This difference in the conception of the sculpture is accompanied by a number of differences in execution. Basic to these differences is the fact that Gauguin was abstracting from nature, while the primitive is rendering concrete that which is already abstract. When Gauguin removed various aspects of the material particular, he approached a non-material idea. The primitive, by attributing to the aspect certain aspects of the physical world, renders that which is non-material concrete. The first difference is in the use of the third dimension. It is interesting that Gauguin, even when working in sculpture in the round, tended to treat the log as a cylindrical surface which was to be enriched with relief. In creating his relief, he used many of the sophisticated means of the western artist in producing the effect of the third dimension on a flat surface. Indeed, his work is essentially an abstraction of the third dimension by means of overlapping planes and foreshortening, which preserves in symbolic form the asymmetrical relationship of natural events on the real world. On the other hand, the native craftsman tends, as a part of the concretization of his idea, to give full volume to his figures. Departing from the abstract, he tends to conceive of his form primarily in ideally abstract terms. As his idea is beyond the scope of time, he chooses a static pose, one of pure frontal symmetry, which is only then modified in terms of the realization of specific attributes that can not be embodied in a purely symmetrical image. In the hands of the primitive artist, the image has undergone a further evolution. As it is a pure symbol, it has passed through a process in which the unessential has been eliminated, and the essential has been emphasized almost to the point of caricature. The process of creating the symbolic stereotype is similar to that by which the pictographic writing of the Egyptians, through countless repetitions through a period of time, eliminated all but the essential elements from the natural objects that were the original sources of their hieroglyphics. The importance of this long process in the creation of a stereotype should not

be underestimated. It means that generations of artists have contributed, not to the invention of new forms, but the refinement of old and thoroughly understood ones. Gauguin, on the other hand, though he uses stereotypes to an extent that is new in nineteenth-century art, does not repeat the same work of art *in toto*. He may use the same figure as an element in a number of compositions, and even in different media, but in almost every case the stereotype is an element in a larger idea that is drawn from the world of direct experience.

Perhaps the difference in attitude between the primitive and Gauguin can be seen most clearly in another of his carvings from his first trip to Tahiti. Again the piece is roughly a cylinder preserving the form of the original piece of tamanu wood from which it was carved (Cat. No. 96). The subject is the discussion between the goddess Hina and Te Fatou—*Parau Hina Te Fatou*—which Gauguin describes in *Noa-Noa*:

> It was evening, the moon was rising, and in looking at it I recalled this sacred dialogue, in the very place that legend assigns as its setting:
> "Hina said to Te Fatou: 'Bring man back to life when he dies.'
> "The God of the *Earth* replied to Goddess of the Moon: '—No I shall never bring him back to life. Man shall die, the vegetation shall die, also those that are nourished by it, the earth shall die, the earth shall end never to be reborn again.'
> "Hina replied: '—Do as you wish. As for me, I shall bring the *Moon* back to life.'
> "And that which belonged to Hina continues to be, that which belongs to Te Fatou dies and man must die."[26]

Gauguin saw in this legend a deep philosophical idea:

> The moon . . . was only extinguished to be re-lit, it died only to be reborn; and it will always be thus; perpetually, according to the laws that govern matter, in which everything is trans-

[26] *Noa-Noa*, pp. 88–89. Gauguin got this passage from Moerenhout, *Voyages*, I, 428–29.

formed, but nothing perishes. Hina represents then, *par excellence*, matter, and the Maori doctrine affirms that matter is eternal. The sun also; Ta'aroa, the spirit will endure forever, will forever demand matter in movement and uniting itself with it will always engender life again. But man and his terrestrial habitation, which are the result of the fecund union of Ta'aroa, with Hina, the earth and man which only constitute an episode in the universal poem of life, the earth will end and man will die never to be reborn.[27]

Essentially what he found was a parable, an idea as the hidden essence of an historical event —for in primitive society the boundary between history and myth becomes indistinguishable. It is this allegorical scene which he represents. Now to the native image maker this parable has no significance. The legend tells everything, and there is no purpose to be accomplished by transmuting it into the solid substance of wood. The image would have no utilitarian purpose, for it would serve no magical function, and would have no mana. Thus in the native art in Oceania there are no carvings of such a subject.

Naturally, none of this can be considered as a criticism of Gauguin's work. On the contrary, it would be absurd for an educated European to seriously undertake the carving of idols for a religion whose outward forms he could hardly credit with truth, no matter how much philosophy he might read into their inner essence; what Gauguin was trying to do was something entirely different. Perhaps what he sought to do can be best described in terms borrowed from his explanation to De Monfreid of his picture *Nevermore*: "I wanted . . . to suggest a certain barbarous luxury of times past. . . . It is neither silk nor velvet nor batiste, nor gold which forms this luxury but purely matter become rich by the hand of the artist."[28] The sculptures were strange, barbarous figures suggesting the half-unknown mysteries of the religions of a primitive people, executed in the most sumptuous woods

of tropical trees of unknown species with euphonious Polynesian names—toa, tamanu, miro, nono, pua. Of course the barbarous mysteries existed only for the foreigner, a man with a different tradition, who had in his heritage the legacy of Herodotus, for whom the lands beyond the borders of knowledge were peopled by strange half-human monsters.

Before we can evaluate the nature of Gauguin's sculpture in Tahiti, we must consider certain aspects of his total work in the South Seas. Here the most important point is that an element of the flowering of Gauguin's art is to be found in the tragic drama of the conflict of two cultures, not only materially, but also spiritually in the mind of the artist. Gauguin, the educated and sophisticated European, found himself rejected, and the fruits of his civilization turning bitter to his taste. Rejecting his Age of Iron, he turned to Tahiti to rediscover the Age of Gold. As a European *deraciné* he was impressed by the Polynesians' chthonic quality. As the product of a civilization obsessed with the idea of decadence, he saw in them a child-like innocence, a simplicity of animal grace, which seemed to reflect the innocence of a sinless paradise before the fall of man. As one who saw the world of the spirit retreating before the attacks of ever-growing materialism, he saw the Tahitian as the heroic embodiment of the spirit at peace with the world of matter.

Yet, the world of Tahitian was remote and mysterious to him. It was not easy to slough off his background and enter into it. At times, as he expressed in his painting *Contes barbares*[29] with its brooding and frustrated figure recalling that of Meyer de Haan, Gauguin seemed to feel that it was impossible for the European to regain the innocence of those who have never lost it.

In any case, as he himself remarked, time was necessary for an adjustment before he could hope to create paintings expressive of the savage poetry of Tahiti. He must make his peace with the Tahitian spirit, learn their philosophy, and make his offerings to the native gods.

[27] *Noa-Noa*, pp. 149–50. In the text Gauguin elaborates the idea much more.

[28] Segalen, *Lettres*, XXIX.

[29] Collection of the Folkwang Museum, Essen.

FROM FRANCE TO POLYNESIA, 1893-1903

GAUGUIN RETURNED TO FRANCE with great hopes for the success of his Tahitian works, and set about having them exhibited at once. The first few months of his return were taken up with business arrangements for his exhibition and the settlement of an inheritance from his uncle Zizi. By the spring of 1894, when his business matters were settled, and he had time to devote himself to his work, he had suffered a number of discouragements. The public, and for that matter his own friends, had failed to appreciate the paintings and sculpture that he had brought back from Tahiti. His wife's constant demands for money, and her refusal to come to Paris to see him, were making him aware of the irremediable nature of the break between himself and his family. Shortly after his arrival in Pont Aven in April he had a disaster. His ankle was badly broken in a fight with some sailors at Concarneau, and he was confined to his bed for a considerable time.

When he had returned to the Brittany that

had played such an important part in the development of his ideas previous to his trip to the South seas, he found everything changed. He was discouraged, he needed time for readjustment, and the digestion of the ideas he had developed in Tahiti. As a result very few works were done during the period of his return. The few paintings that he executed have a strange flavor. His Bretons have the nostalgic appearance of Tahitians from the South seas disguised as French peasants. Like the artist, they too seem to have lost contact with their homeland. Unfortunately, Gauguin never had time to make the necessary readjustment, for the fight at Concarneau made it impossible for him to continue his painting.

While he was immobilized by his accident he turned his attention to other fields. This time it was not the usual wood carving that he executed in Brittany, but rather the making of a magnificent set of wood cuts which he probably intended to use as illustrations for *Noa-Noa*. As

with every medium to which he turned his hand, Gauguin brought a stimulating new vision to the art of making wood cuts, and his prints have had a great influence in the rebirth of that form of art in the hands of the modern artist. However, there are almost no examples of wood relief done at this period.

The one carved relief that can be attributed to this last period of activity in France has been given the title of *Pape Moe*—"Mysterious Water" (Cat. No. 107).[1] The subject was taken from a painting of 1893, now in the Bührle Collection in Switzerland. The painting in turn, was based on a photograph that Gauguin probably obtained in Tahiti.[2] *Pape Moe* was the title of a poem by Charles Morice, which begins with the lines:

> Source tahitienne! Eau lustrale! Eau divine!
> Source de verité, ton éclat m'illumine
> Source de volupté, tes conseils sont vrais
> Je t'écoute, et ta voix m'enseigne, les Secrets
> Source mystérieuse, eau divine, eau lustrale.[3]

However, the drawing that Gauguin added to the manuscript of *Noa-Noa*, apparently as an illustration of Morice's poem, is a variant of this theme in which the figure is seated, rather than standing, and the carved panel antedated the completion of Morice's poem.

In this version of *Pape Moe* Gauguin has added a number of elements that were not in the painting of 1893, and changed the expression of the work of art to a great extent. Instead of a rather straightforward representation of a Tahitian drinking from a small waterfall, Gauguin has made the figure a part of a whole complex of Polynesian elements ranging from the half-seen head on the upper right of the main panel through the figure of Hina appearing above the mysterious source of the waterfall, through the idyllic element of the *vivo* players, to the awesome idol on the left and the scene of worship in the lower panel. Actually, the imagery of the relief approaches that of the poem sufficiently to suggest a close relationship in theme, and perhaps a relationship to a story in *Noa-Noa* which probably inspired the poem:

> All of a sudden, at a sharp turn I saw standing against the rock wall which she caressed rather than held in her hands, a young girl, nude: She was drinking from a spring gushing, very high, among the rocks. When she had finished drinking, she took some water in her hands and let it run between her breasts. Then, though I had made no noise, like a fearful antelope which senses a stranger by instinct, she turned her head and stared at the bushes where I was hidden. And my glance did not meet hers. Scarcely did she see me before she dived immediately, crying the word: Taehae (ferocious)! Hurriedly I looked in the water: no one, nothing but an enormous eel which slithered among the pebbles of the bottom.[4]

Gauguin recounts this scene as an occurrence he witnessed while climbing up the valley of the Punaruu River to reach the peak of Mt. Aorai. At that time he was probably living at Punaauia, and may have had in mind the legend of the valley concerning a princess who escaped an unwanted intrusion by diving into a hole in the river which ultimately led her to the Polynesian underworld, *Po*.[5] The appearance of the eel in place of the vanished girl may be an addition from the legend of the royal eel, king of Lake Vaihiria. The lake is the source of a stream of the same name running through Mataiea, where Gauguin says he lived during his first stay in Tahiti.[6]

Some aspects of *Pape Moe* suggest the influence of Gauguin's experiments with the technique of the woodcut. His usual composition in relief sculpture was based on a back plane that

[1] The title *Eau mystérieuse* seems to have been dervied from a suggestion by Achille Delaroche. See Gauguin, *Diverses Choses*, p. 266.

[2] Richard Field, "Gauguin plagiaire ou créateur," p. 165.

[3] *Noa-Noa*, p. 87.

[4] *Ibid.*, p. 89.

[5] Henry, *Ancient Tahiti*, p. 592 ff. In *Noa-Noa* Gauguin does not mention staying in Punaauia, but Jénot states that it was one of the places he stayed during his first trip ("Le Premier séjour de Gauguin à Tahiti," p. 125).

[6] Henry, *Ancient Tahiti*, p. 615 ff.

was fairly flat, and figures that become more completely realized in the round as they approach the front plane set by the limits of the dimensions of the block. In the main panel of *Pape Moe*, as in a woodcut, the original surface of the wood is the dominant plane which has been cut away to produce light and shadow. Also characteristic of the woodcuts is the use of the texture of the cut of the gouge to produce areas of an indeterminacy suggestive of an atmosphere of mystery. In *Pape Moe*, Gauguin has used this device on the upper right-hand part of the panel, where the forms are hardly realized at all as sculpture, but rather as line, tone and texture. Neither is there any real sculptural plasticity in the pool at the feet of the main figure. Taking the main panel as a whole, one is struck by the general dependence on visual effects rather than the usual sculptural emphasis on tactile values. Though this tendency has been apparent in some of Gauguin's sculpture from the early 1880's on, it is stronger here, and marks the development of an attitude toward sculpture that is particularly characteristic of his later work in Tahiti and the Marquesas.

Pape Moe is a strange work, and we do not know what the original conception of the artist was. In its present state the panel has been cut into four pieces and they have been dispersed. Even in the reconstruction, the panel does not seem to be complete, for the empty space in the center must have been intended for some purpose. Apparently the polychromy was never completed. The main panel is colored, as are two rocks in the spring from which the water flows in the upper frame panel. The rest of the work is uncolored.

The composition is not coherent in style. While the three frame panels are similar in execution to Gauguin's other works, the main panel is quite different. Perhaps the fact that the original source of the motif was a photograph may explain why Gauguin has used a much greater degree of illusionism in this panel. The necessity of including a waterfall may have influenced the artist, for the scene does not give the effect of integral self-sufficiency of his works of 1889 and 1890. Instead, the composition gives the impression of a return to the Renaissance approach toward pictorial space as a part of an infinite continuum delimited by the frame as if seen through a window.

The ceramics that Gauguin executed after his return from Tahiti were not numerous, and all of the works of this period which are known reflect the influence of Tahitian themes. They show several radical changes in outlook. While some of the early pots suffer from having too much of the quality of *bibelots*, these works, which were the last ceramics ever produced by Gauguin, are marked by a high degree of economy and relevance in the creation of the esthetic symbol.

For the first time Gauguin may have given up the practice of making each piece by hand and started using molds from which a number of more or less identical pieces could be made. His *Square Vase with Tahitian Gods* exists in at least three closely similar versions (Cat. No. 115), and there are at least two copies of Catalogue number 114.

The finest piece of this period, and the one marking the highest achievement of Gauguin as a ceramicist, is *Oviri* (Cat. No. 113). This piece, probably executed in the winter of 1894–1895, is not only the largest piece of ceramics that Gauguin ever undertook, but it is also the most technically perfect.

The theme of *Oviri* is death, savage and wild.[7] Oviri, towering above the body of a dead she-

[7] This interpretation of the symbolism of *Oviri* depends on many sources. That the theme is death is corroborated by Gauguin's reference to *la tueuse* in a letter to Vollard (John Rewald, "The Genius and the Dealer," *Art News*, LVIII:iii [May, 1959], p. 62). Further evidence is found in Gauguin's desire that *Oviri* be placed as a monument over his tomb (Segalen, *Lettres*, LXVIII). In Tahitian mythology *Oviri-moe-'aihere* ("Wild-one-who-sleeps-in-the-wilderness") is one of the gods that presides over death and mourning (Henry, *Ancient Tahiti*, p. 293). The Great-Lady-of-Night, who would seem to refer to the moon and thus Hina, was the goddess of death who dwelt in the underworld (Handy, *Polynesian Religion*, p. 118).

wolf, crushes the life from her whelp. Oviri is no ordinary woman, and she performs no ordinary act. She is indeed a goddess, and the act is symbolic. She is woman the destroyer, the sphinx of the Oedipus legend, and Kali the destroyer, avatar of Parvati the creative mother. All mythologies have created symbols for these two aspects of woman, and Oviri is the other aspect of Hina, the grey one, the Goddess of the night and love. While Ta'aroa, the sun, is the life-giving spirit, Hina is matter, the dust from which man is formed, and the dust to which he must return—the womb and the grave.

The starkness of the effect is increased by the strange inversion of images. The wolf, the savage killer, is here the symbol of the mother, while the woman, Oviri, in all her exotic voluptuousness, is the symbol of death. Birth and death are the two limits of life, and they meet in this strange figure in which the full, warm female figure is surmounted by a death's-head. Gauguin has based the features, dominated by the great staring empty eyes, on two sources, the features of a Marquesan idol, and the mummified skull, eye sockets filled with mother-of-pearl, of a great chief who has passed beyond death to become a god.[8]

Mother Nature, the life-giver, in her savage aspect, *la tueuse*, is more savage than the wolf, as remorseless as death herself. She has a special meaning for Gauguin. Nature, on whose warm bosom he wishes to escape from the bitter trials of his return to Paris, can also kill. Gauguin, the savage, the wolf himself, may find that when at last nature clasps him to her breast it is the cold clasp of death and not the clasp of love.[9]

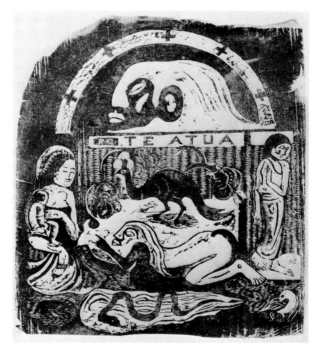

Fig. 22. *Te Atua* by Paul Gauguin. Woodcut (Guérin number 61). Courtesy of the Museum of Fine Arts, Boston.

[8] Gauguin used the motif of the death's-head with long flowing hair many times in a religious context. One of the best examples is found in the print entitled *Te Atua* (Fig. 22).

[9] During the last years before his departure for Tahiti, Gauguin used the fox, "Indian symbol of perversity," as his personal symbol. After Degas characterized him as the lone wolf in La Fontaine's fable (*Avant et Après*, p. 74), Gauguin identified himself with the wolf. Later, in Tahiti, Gauguin substituted native animals for their European counterparts, the snake became the lizard and the wolf became the dog (see Appendix A, "Gauguin's Use of Animal Symbols").

In one aspect, *Oviri* is an expression of the profound disillusionment and discouragement of Gauguin. He was now forty-seven years old, and he had been devoting his whole strength to a career of art for twelve years, and it appeared to him that he was making no progress. His return to France had involved him in a series of disasters, and he began to long for the escape of the South seas. In September he wrote his friend William Molard:

> For two months I have had to take morphine each evening and I am actually becoming coarsened; to avoid insomnia I must give myself up to alcohol which lets me sleep four hours a night. But that makes me brutish, and disgusts me. Yes, I can hobble along with a cane and it is hopeless for me to not be able to go far to paint a landscape; nevertheless I started to take up my brushes a week ago. All these misfortunes in succession, the difficulty of gaining my livelihood *regularly* in spite of my reputation. Helped by my love of the exotic, I have taken the irrevocable decision. This is it.
>
> In December I will return and I shall work every day to sell all that I own in a "block" or possibly piecemeal. When I have my capital in my pocket, I am leaving again for Oceania, this time with two comrades from here, Seguin and an Irishman. It is useless down there to give me advice. Nothing will stop me from leaving and it will be forever. How stupid an existence the European life is.[10]

True to his word, Gauguin departed from France toward the end of March, 1895. It was forever, but again he went alone.

On the trip to Tahiti Gauguin was delayed for several days in Auckland, and he had a good opportunity to study the art of the Maori of New Zealand at first hand.[11] Though Gauguin's adaptation of native motifs in his art shows little influence of the decorative spirals of Maori art, he did obtain a photograph of a Maori house showing its complicated wood carving.[12] For

years Gauguin had been collecting photographs of works of art from all sources, which he used as the basis of compositions or motifs in his own works, and native works were no exception to the rule. As early as his first trip to Tahiti he had acquired a photograph of a Marquesan chief, whose tattooed designs he used as motifs in his carving. Bodelsen has recently shown that he copied a photograph of an important Marquesan tiki, and many other examples would undoubtedly be known if a large majority of Gauguin's papers had not been lost.[13]

In addition to photographs and sketches of native works, Gauguin had also collected a number of objects themselves. Unfortunately, in most cases these have been dispersed without any adequate record of their nature.

We also know that Gauguin made some rubbings of the decorative patterns on Marquesan objects, for a number of them were included on pages 126, 168 and 169 of his manuscript edition of *Noa-Noa* as decorations to fill up the spaces left for the material of Charles Morice, which never came.

Undoubtedly much material was lost among the possessions Gauguin left behind in Tahiti when he moved to the Marquesas. Finally, the lists of Gauguin's possessions at his death record a large amount of native art. The inventory made in Atuona lists:

> Item 54: 1 lot curiosités indigènes comprenant:
>
> Une soupière sculptée
> Un coco
> Deux couvercules de calebasse
> Un tiki doré
> Deux tikis en pierre

At the sale in Papeete additional information is given. Twelve objects identified as tikis were sold (items 32, 33, 34, 48, 55, 60, 61, 62, 63, 64, 66 and 67). In addition to the tikis, there were four boar's teeth (items 43 and 44), two Marquesan bowls (items 38 and 50), an amulet

[10] Malingue, *Lettres*, CLII.
[11] *Ibid.*, CLVIX.
[12] A copy is in the collection of Mme Huc de Monfreid (see Fig. 23).

[13] Merete Bodelsen, "Gauguin and the Marquesan God," *Gazette des Beaux-Arts*, March, 1961, pp. 167 ff.

Fig. 23. Photograph of a Maori house. Found among the papers
of Paul Gauguin. Collection of Mme Huc de Monfreid.

(item 42) and two objects simply as *objets travaillés* (item 36).[14]

Though these various sources give us an idea of the range of material that Gauguin may have studied, it does not tell us how much more he may have seen, and, as most of these things were in his possession at the time of his death, they give us little or no idea when he may have acquired them.

In discussing the sculpture done during Gauguin's second stay in Tahiti, the researcher suffers under a severe handicap, for the amount of sculpture that can be surely attributed to this period is very small. On the other hand, we have every reason to believe that his output was large. First, the period was long, and Gauguin

had avowed his intention of devoting himself to wood carving. Certain notices in the letters, as well as the accounts of Tahitians that knew him, all indicate a considerable production. Matters were further complicated by the fact that after Gauguin's death in the Marquesas all his possessions that were judged to have any value were transported to Tahiti where they were sold at auction. As a result, all the works of his last period in the Marquesas, except those bought by Victor Segalen, passed through the hands of Tahitians. In most cases it is not possible to tell at what period they passed into these hands— whether on his departure for the Marquesas, or at the time of his death.

In certain cases, Gauguin's letters are of help in trying to re-establish what he may have produced during this period, but, again, the material is meagre.

[14] The inventory and the auction catalogue are given in Georges Wildenstein, *Gauguin, sa vie, son oeuvre*, p. 205 ff.

In a letter to De Monfreid in April, 1896, Gauguin mentions "two coconut tree trunks carved in the form of Kanaka gods" which formed a part of the *décor* of his first house in Tahiti. In November he again wrote De Monfreid that he had decorated his property with sculpture: "Sculpture . . . I am putting it everywhere on the lawn . . . of earth covered with wax . . . a female nude, then a superb lion . . . with her little one." In this case a photograph of Gauguin's house, which he sent to De Monfreid, furnishes a rough idea as to the size and pose of the female nude (Cat. No. 119).[15] As he had had to move a year later, these pieces probably were destroyed. The nature of the material almost inevitably made the sculpture ephemeral. These few references constitute all that can be gleaned from the letters about the sculpture of the period except for the correspondence concerning *La Guerre et la Paix*, which Gauguin executed in the winter of 1900 for Gustave Fayet.

In 1937 and 1938 Renée Hamon was able to discover the fate of a number of Gauguin's sculptures and to record the memories of the then surviving inhabitants who had known Gauguin.[16] Lenore, the guardian of the cemetery in Papeete, who had known him, stated that Gauguin carved everything, no matter what: trunks of trees, boxes of conserves, even the staves of wine barrels. Lenore also remembered that on his departure for the Marquesas Gauguin had given him some statues, but having no use for them, he used the wood to make a pig sty, where they promptly rotted away. In an interview with the son of the man who bought Gauguin's house on his departure for the Marquesas, Hamon records that "The house was surrounded by 'Tikis' carved by the painter." Because they had frightened the new owner at night he had had the tikis as well as three trunks of papers

carried out and dumped into the sea beyond the reef.[17]

For the most part, the record of Hamon is a tale of wholesale destruction, which is of little use to us except to point out the amount of sculpture from this period that must have been lost, and to give rise to the hope that of such a quantity of material a few pieces may still survive that will someday be discovered.

There are only four pieces that can be surely dated in this period, though some of the material that was collected from Gauguin's personal possessions after his death may have been made at this time. On the basis of internal evidence the great sculptured cylinder of *Christ on the Cross* must belong to this phase of Gauguin's work. *La Guerre et la Paix*, made for Gustave Fayet, is recorded in the letters, and can be accurately dated. The third piece, a version of *La Guerre et la Paix*, in the collection of Alex Maguy, may well be contemporary with the Fayet panels. A fourth bas-relief, in the collection of Henry Dauberville, is probably slightly later than the painting *Que sommes-nous?* (Boston Museum of Fine Arts), on the basis of an iconographic and stylistic similarity (Cat. Nos. 125–128).

Perhaps the earliest major work in sculpture after Gauguin's return to Tahiti was the cylinder with the representation of the Christ on the Cross in the collection of Mme Huc de Monfreid. This piece combines elements symbolizing the extreme physical suffering of the artist with the mood of religious exaltation of the winter of 1897. At that time Gauguin was contemplating suicide while writing *L'Esprit moderne et le Catholicisme* and painting his great philosophical allegory *Que sommes-nous?* On one side of this cylinder of Casuarina wood appears the figure of the crucified Christ on a somewhat stylized cross. The whole is placed against a background of designs taken from a Marquesan war club enriched with motifs from the patterns of Marquesan tattooing and ideograms from

[15] Segalen, *Lettres*, XXI, XXVI. The photograph of Gauguin's house is in the collection of Mme Huc de Monfreid.

[16] Renée Hamon, *Gauguin, le solitaire du Pacifique* (Paris, 1939).

[17] *Ibid.*, pp. 27, 29.

Easter Island writing.[18] Actually the preponderance of non-Tahitian elements in this work might lead one to think that it might have been executed after Gauguin's departure for the Marquesas. Though this may be the case, it does not infallibly point to this conclusion. As has already been remarked, on his first arrival in Tahiti, Gauguin was disapointed with the lack of native decorative arts to be found there. For lack of a better source, he began using elements from Marquesan tattooing. As early as 1893, in his painting *The Ancestors of Tehamana*,[19] Gauguin showed himself familiar with the Easter Island script.[20] The problem of the Marquesan war club resolves itself through the same method of reasoning. As Gauguin remarked in *Avant et Après*:

> Today, even for gold, you can no longer find any of those beautiful objects in bone, rock, ironwood which they used to make. The police have *stolen* them all and sold them to amateur collectors.[21]

Actually, there was at least as good a chance of seeing a Marquesan war club in the hands of a collector in Tahiti as of seeing it in the Marquesas themselves.

On the other side of the *Christ on the Cross* the same motifs are repeated in a different order with the exception that the figure of Christ on the Cross has been replaced by the figure of a Polynesian.[22] On either side, the two panels between the front and back panels are filled with Polynesian figures arranged in the totem-like manner sometimes found in Marquesan carving (Cat. No. 125*d*). At the top of these totem-like arrangements, there is a head executed in the European manner, with a beard, which we may tentatively identify with Gauguin himself. On the other side, placed in a similar manner is a foot, also executed in a European manner.

If we now proceed to make an inventory of the elements in terms of their subject matter we find the following: On the front we have a crucifixion. Here we may define the subject as the representation of a victim sacrificed by mankind to appease the wrath of an angry God, together with the instrument of sacrifice. On the back we have the representation of a human being, the typical victim sacrificed by the Polynesians to pacify their gods, together with a war club, the usual instrument of sacrifice. Taking the two side panels together, we have on one side the representation of Gauguin's head and on the other side his foot.

In both the Christian and the Polynesian sections of the sculpture there is the theme of sacrifice, a human ordeal ending in death. Surely the head and foot of Gauguin can only refer to the human ordeal through which he was passing because of his infected foot, his "instrument of martyrdom," which he expected to bring about his death.[23]

As in the case of *Oviri*, Gauguin has succeeded in creating a symbol out of the fusion of elements from his own cultural background combined with those of Polynesia. No longer is the sculptured image simply a reflection of a mysterious world to which the European is a stranger. The two worlds are absorbed in a universal humanity which finds its outward manifestations in both, and in which the individuality of

[18] See Robert Goldwater, *Primitivism in Modern Art* (New York, 1938), pp. 162, 172, note 22.

[19] Collection of Mrs. Chauncey McCormick, Chicago.

[20] Examples of Easter Island script had been exhibited at the *Exposition Universelle* of 1889. Monsignor Tépano Jaussen, Bishop of Axierri, for a long time stationed in Tahiti, had published a study of Easter Island script in his book *L'Ile de Pâques* (Paris, 1893). See also A. Piotrowski, "Deux tablettes avec les marques gravées de l'Ile de Pâques," *Revue d'ethnographie et des traditions populaires*, VI (1925), p. 425.

[21] *Avant et Après*, p. 50.

[22] Goldwater (*Primitivism in Modern Art*, p. 172, note 22) suggests that the figure shows similarities with the ancestral figures from Easter Island.

[23] As early as 1889 the theme of martyrdom appears in such works as the *Cup in the Form of a Head* (Cat. No. 65) and the *Christ in Gesthemane* (Norton Gallery of Art, West Palm Beach) where the features of the Christ reflect those of the artist. The same idea of personal martyrdom is expressed in a letter to Dr. Gouzer, written in March, 1898 (Malingue, *Lettres*, CLXVIII):

> The martyr is often necessary to all revolution—my work considered as an immediate and pictorial result, has only little importance compared with the definitive and moral result. . . .

the artist is absorbed. While in the case of *Oviri*, the synthesis was achieved largely in terms of the artistic vocabulary of the European—Charles Morice put it, "She is a savage Diana"—the synthesis of the *Christ on the Cross* is achieved in more purely Polynesian terms.

One of the carved panels executed during Gauguin's second stay in Tahiti has been entitled *Que sommes-nous?* on the basis of its similarity with the painting of that title. This suggests that the logical point of departure in an interpretation of the meaning of this sculpture must be taken from the subject of the painting. Fortunately Gauguin himself has given us an insight into the significance of the painting in his letters describing it to his friends. On the right of the painting appears a group of three women, a child and a dog which Gauguin entitles *Where do we come from?* in his letter to Charles Morice, with the explication: Source—child—life begins. The next group Gauguin places under the rubric *What are we?* with the comments:

> Daily life—the man of instinct wonders what it all means. Two sinister figures, clothed in purple expressing sadness, confiding to each other their thoughts on their destiny, walk in the shadow of the tree of knowledge. Their sadness is caused by that knowledge itself in comparison with the simple beings in a virgin nature which could be a paradise of human conception if they would let themselves go in the joy of living. A voluntarily large figure, and in spite of perspective, crouching, raises its arms in the air and watches, astonished, those two persons that dare to think upon their destiny. A figure in the middle gathers fruit. Two cats near a child, a white goat complete the group. Again, to the left appears an idol, arms raised mysteriously and with rhythm, which seems to indicate that which is beyond. The idol is there, not as a literary explanation, but as a statue, less statue perhaps than the animal figures; also less animal, being embodied in my dream, in front of my house with the whole of nature, reigning in *our primitive soul*, imaginary consolation for our suffering in that which they have of vagueness and

incomprehensibleness before the mystery of our origin and our fate.

> Farther to the left a crouching figure seems to listen to the idol. An old woman near death seems to accept, to be resigned to that which she thinks ends the legend. The allegory ends with a stupid, strange white bird at her feet, which holds a lizard in its claw, representing the vain futility of words.[24]

Obviously the main theme of the painting centers around the great mystery of birth, life and death, but there is also a second theme that runs through it, and that is the fall of man. Gauguin looks longingly back to the innocence and faith of man before he had eaten of the fruit of the tree of knowledge, before his intelligence had been awakened to the questions: "What are we? where do we come from? where are we going? In interpreting this second theme, which is an integral part of the first, we must remember that at this time of his life Gauguin was preoccupied with the idea of death. This painting was to be his final statement of his philosophy before he killed himself.[25] The painting is the outcome of a philosophical crisis in Gauguin's mind, and to fully understand it, it must be placed against the background of his philosophy as he expressed it earlier in his life.

From such philosophical works as *Soyez mystérieuses* we know that Gauguin regarded the essential reality of the universe to be composed of the two elements of spirit and matter, the one active, the other passive. In recording the famous dialogue between Hina and Te Fatou, he had emphasized that the spirit in man shall die, but that matter, the realm of the moon-goddess Hina is eternal. In the picture *Que sommes-nous?* the whole theme is expressed in the central figure of a man picking the fruit that surely represents the fruit of the tree of knowl-

[24] For a more complete explication, the author has combined descriptions found in three places: Letter to De Monfreid, February 1898 (Segalen *Lettres*, XL); Letter to Andre Fontainas, March, 1899 (Malingue, *Lettres*, CLXX); Letter to Charles Morice, July, 1901 (*Ibid.*, CLXXIV).

[25] Segalen, *Lettres*, XL.

edge, the symbol of man's awakening intellect, that embodiment of spirit that sets man apart from the animals. It is this intellectual awareness that causes him to propound the three great questions. Man's awareness, which separates him from the rest of the realm of nature, is essentially tragic, for at this time Gauguin sees all man's intellectual efforts as futile, and the intellect, which has risen from matter, as ultimately returning to matter. This explains the true meaning and significance of the symbols to the left. First there is the image of Hina, the moon-goddess, who is also the mother goddess of fertility and nature. As the mother goddess, Hina reigns over birth. But since matter imbued with spirit becomes alive, so it must in turn die, returning to the realm of Hina the goddess of matter in her role as goddess of death. This ultimate mystery, the extinguishing of the human intellect in death and the ultimate triumph of Hina, is very close to the tenor of Gauguin's thoughts at this period just before his attempted suicide. The curious symbol of the "strange white bird holding a lizard in its claws, which symbolizes the vain futility of words," expresses even more clearly the mystery of death. The bird symbols used by Gauguin are often ambiguous, but this type is generally associated with the female and symbolizes her sexuality.[26] Birds have always been the attribute of the mother goddess in the Mediterranean world, and in Polynesia the white gull is the "shadow" of the goddess Hina.[27] The snake, on the other hand, has always been a male symbol, and a symbol of knowledge. Here, conforming to the Polynesian fauna, Gauguin has substituted the lizard, but the pair, the gull and the lizard, symbolize the transcience of human intellect and life before the immortality of blind matter. "From dust thou wast made, and unto dust thou shalt return."

Though the diversion into the interpretation of Gauguin's painting has been rather long, the time will not be wasted, for it has in it the key to the interpretation of the panel. At first glance, the two central figures of the bas-relief appear to be copied from those of the painting, and their similarity is a strong indication that the sculpture was executed after the painting. The fact that the hands of the standing figure extend beyond the frame, rather than being composed within it, confirms the conclusion that the figure in the painting is the earlier conception of the two. However, when the end motifs of the sculpture, both on the right and the left, are taken into consideration, there are very considerable differences between the panel and the painting. The complex on the left, consisting of a coconut tree and a bull, cannot be related to anything in the picture. The stylization of the group strongly suggests a more or less abstract symbol with a specific meaning. Though the Roman and Christian meaning of the palm was victory, it must be remembered that originally the tree was sacred to Ishtar, the mother goddess, and was a fertility symbol.[28] Its association here with the bull, an almost universal symbol of fertility,[29] suggests that the artist is using it here in that manner. This interpretation is further supported by the fact that the fronds of the palm are so arranged as to form a yoni, the Indian symbol for the female generative organ, and the tree and bull together form a *crux ansata*, the ancient Mediterranean symbol for the generative forces of nature. This symbolization on the left-hand side, in which the generation—and not death— is the preoccupation of the artist, confirms the dating of the piece after the painting, for as Gauguin said, his attempt at suicide was undertaken immediately after he had finished the painting. After his failure at suicide, Gauguin seems to have been less preoccupied with the theme of death, and in a sense this bas-relief

[26] See Appendix A, "Gauguin's Use of Animal Symbols."

[27] Henry, *Ancient Tahiti*, p. 387.

[28] In India the coconut palm specifically is a symbol of fertility (Sir James Frazer, *The Golden Bough* [abridged edition; New York, 1958], p. 137).

[29] The snakes at the feet of the bull suggests the possibility that Gauguin may have been familiar with the significance of the bull in the Mithraic cult (cf. "Mithras" *Encyclopaedia Britannica*, 11th edition).

suggests the re-establishment of his philosophical outlook. As early as his carved panel *Soyez mystérieuses*, he had used a left to right symbolization for the element of matter and spirit in his composition. What was striking about the painting *Que sommes-nous?* was the inverse order of progression—from right to left, from birth to death. In this it is essentially a picture which speaks of the death of the spirit, and the triumph of Hina in the role of death-goddess that Gauguin assigns her. In this bas-relief, the generative aspect is emphasized on the left.

Passing over the central group for the time being, we turn next to the analogous symbolic complex on the right. Here again there are essentially two elements to the symbol. One is the bird taking flight, the other is a stylized representation of a sunflower. The bird in flight is an almost universal symbol of the human spirit. It appears not only in Mediterranean mythology and Christian symbolism, but also in that of India and in Polynesia.[30] The sunflower is an unusual symbol, but this sun-seeking plant had become a symbol of the southern sun in the works of Vincent van Gogh at the time when Gauguin was staying in Arles, and it must have occurred to Gauguin when he sought a symbol for the sun similar to the palm tree symbol of the Earth-Goddess. Together the two symbols, the sunflower and the bird taking flight, suggest the other pole of Gauguin's philosophy. While matter at one pole is symbolized by the generative principles and the Earth-Goddess, spirit and light at the other pole are symbolized by the flower and the bird.

After obtaining some idea of the significance of the symbolic representations at either end of the panel, it remains to be seen what the meaning of the central group is. There are two clues that appear at the very beginning. One is the similarity to the central group in the painting *Que sommes-nous?*; and the other is the conviction that the meaning of the central group ought

to be related to the ideas symbolized by the end groups. The basic theme of the painting is man's place in the universe; his relationship to the two great principles, matter and spirit. Given the symbolization of these forces in the carved panel, and the similarity of the central figures to those of the painting, we may well assume that we are again dealing with the drama of man's relationship to the cosmos. On the left, just below the symbol of fertility kneels a woman regarding a bird similar to the white bird in the painting. As we saw in the painting that the bird was probably a symbol of Hina, we may assume that it is a representation of the same goddess of the earth in the bas-relief. Here the woman and the bird, placed near the fertility symbol, suggest woman's role as the earthly nourisher of the divine spirit, giving substance to the spark of life. Behind the group of the woman and the bird rises a strange tree, and to the right is a figure with arms upraised. In the painting this figure is in the act of picking a fruit from a tree. Here the idea of reaching upward remains, but the fruit is gone. However, when we give closer attention to the tree next to this figure, with its conspicuously offered fruit and entwining snakes, the suggestion of man picking the fruit of the tree of knowledge is strong. This hypothesis is further confirmed by the appearance, half-concealed, of the head of a male diety within the tree.[31]

Still farther to the right appears the figure, only slightly altered, of the painting that Gauguin described as a figure that "watches, astonished, those two persons that dare to think upon their fate." Gauguin, in his wording, suggests that those who "walk in the shadow of the tree of knowledge" are sad, while by implication man in his natural state of innocence is more in harmony with the universe. In the sculpture we should expect the same figure to express a similar idea in the same general context of question

[30] For the Polynesian myths, see Handy, *Polynesian Religion* p. 131.

[31] The image of a deity in the tree is again found in the Mythraic myths (see "Mithras," *Encyclopaedia Britannica*, 11th edition).

of man's relationship to the elemental principles of the cosmos. But in the carved relief this figure is not concerned with those "who dare to think upon their fate," but appears to be regarding a group of three disembodied heads that float to the left of the symbol of the universal spirit. Now a universal characteristic of what Gauguin regarded as natural man is his profound belief in the survival of the spirit after death. Just as dust returns to dust in the domain of Hina, spirit returns to spirit in the domain of Ta'aroa.

The painting *Que sommes-nous?* reflected Gauguin's pessimism just before his attempt at suicide. In it an essentially tragic view of life was represented by the triumph of matter and the final extinction of the human spirit. In contrast, the bas-relief is essentially optimistic. Instead of starting on the right and ending in death on the left, as does the painting, the relief starts on the left with symbols of the generative role of nature and progresses to the right with symbols of the ultimate triumph of the human spirit.

The other great sculpture that Gauguin executed during his second stay in Tahiti was *La Guerre et la Paix.* During the fall of 1900, a new collector, Gustave Fayet, Conservateur du Musée de Béziers, had bought two of Gauguin's works. On the first of December 1900, De Monfreid wrote Gauguin:

> I hope, next week, to go to Béziers, which is near here and see Fayet, whose enthusiasm is at its peak. Your two canvases, which he knows how to appreciate at their true artistic value, go admirably well in his collection, between a magnificent Cézanne and a Degas. . . . Now, Fayet would like very much to possess one of your *ceramics* or one of your *sculptures.* Couldn't you execute out there some sort of handsome woodcarving and send it to him?[32]

On the twenty-fifth of February, 1901, Gauguin replied:

> I am busy looking for some wood to carve, and that is not an easy thing in Tahiti; for, though

they grow easily, the trees are not, as at home, put to use: Finally I have found a panel in two pieces of a meter in all, and four centimeters thick, which obliges me to use little relief; as a result to make the figures a little small. It doesn't matter, I hope to make something that will please Mr. Fayet if he is not too frightened by my bizarrities.[33]

In June Gauguin wrote De Monfreid that he had sent the two sculpture panels to Fayet. Though none of Gauguin's sculptural work seems ever to have been made on the basis of a commission, this one comes the closest to it, and that fact may have had an influence on its execution and the choice of subject matter, to a certain extent.

Though there are many tantalizing elements in the two panels, their meanings remain obscure. It has been suggested that the two panels are not War and Peace, but that only the lower panel deals with this subject. There are a number of points that argue against this theory. In the first place, the two panels have always been associated with each other since their carving. If they were independent pieces, one would expect at least a signature, and perhaps a title, on the upper panel, both of which are lacking. It has been suggested that the upper panel represents a "judgment of Paris," and certainly the composition falls into the traditional form of that subject.[34] But there are two points that argue against such an interpretation. One is the fact that, though he used Greek sculpture as models for his figures at times, Gauguin considered the influence of Greek art to be pernicious, and he avoided subjects from Greek mythology. The other point that argues against an interpretation of the subject as a judgment of Paris is the presence of a halo around the head of second figure from the left, as well as the attitude of adoration

[32] Segalen, *Lettres,* p. 215.

[33] *Ibid.,* LXXII.

[34] The suggestion that the upper panel represents a "judgment of Paris" was made by Hans Graber in his book *Paul Gauguin* (Basel, 1946), p. 392, note 2. It is not clear on what evidence he attributed this title to the relief. Actually, an equally good argument could be made for the interpretation of the scene as an annunciation.

expressed by the hands of the other figures on the left. These figures, and their gestures, are borrowed from the scene of Buddha's meeting with Ajivaka, from the Lalitavistara as represented on the Javanese temple of Borobudur.[35] In any case, the tenor of the upper scene seems to be Christian, and religious, even though the presence of Gauguin's favorite symbols, the fox (perversity) and the bird (concupiscence), makes the subject matter even more obscure.[36]

In the case of the lower panel, we are somewhat better off, for the title *La Guerre et la Paix* must certainly have some reference to the events represented here. The problem still remains as to what particular scenes are represented. Certainly the large head in the middle is apparently the Man of Sorrows, in whose visage the features of the artist are suggested. The scene on the right is certainly warlike. The main figures in it are drawn from the *Assault of Mara* in the Lalitavistara, while others, as well as certain elements of style, are drawn from scenes on the Column of Trajan.[37] Though these figures fit in well with the general conception of a battle scene, there are others that do not. The great chthonic head on the right, with its enigmatic smile, as well as the red dog above it, are difficult to interpret. The group of three figures on the left, in which the central figure again has a halo, also remains obscure.

Finally, we may question the significance of Gauguin's title. Certainly the head of Christ would suggest a moral and Christian tone to the representation, but as an allegory, it still remains obscure. Various possibilities may be that the

representation is of the final battle between Christ and Anti-Christ, Armaggedon. A more plausible reference might be to Tolstoi's great book, *War and Peace*, which had been translated into French in 1884. Or simply, the theme may be that of the battle between good and evil. The trouble is that none of these hypotheses appear to throw any light on the meaning of the symbols that Gauguin has used, and we must resign ourselves to leaving the riddle unsolved for the present.

The execution of the relief, as has already been pointed out, was affected by the fact that it was done for a specific patron with every expectation of a purchase. Actually, after his unfortunate experience with his early reliefs and the sculpture that he had brought back to Paris after his first trip to the South seas, Gauguin seems to have had little hope of making money from his carved works. His personal style had developed in a manner that followed his own fancy even more than that of his paintings, on which he depended for his daily bread. Other pieces in relief that Gauguin executed in Polynesia were generally done on ordinary planks in a style that conformed well with their primary function of fulfilling his wish that his house should be decorated with carved wood. The pieces that he executed in wood that were not considered primarily as elements to decorate his house were almost exclusively executed in the round, and not in relief. In conformity with the beauty of the woods which he had been to such trouble to find, Gauguin generally used a very restrained polychrome when working with native material. However, when he was working with softwood planks, which he used to decorate his house, he generally used stronger colors. In the case of *La Guerre et la Paix*, though the wood is fine, and its color and texture are exploited in important areas, such as the background, Gauguin has used a stronger polychrome than was his custom on native woods. This may again reflect the fact that this piece was done for another person, and may reflect a harking back

[35] Gauguin is known to have had a photograph of this scene among his collection of photographs of the Temple of Borobudur. Cf Bernard Dorival, "Sources of the Art of Gauguin from Java, Egypt and Ancient Greece," *Burlington Magazine,* XCIII (April, 1951), 188–22. (Cat. No. 95*a*)

[36] See Appendix, "Gauguin's Use of Animal Symbols."

[37] Bernard Dorival, "Sources of the Art of Gauguin from Java, Egypt and Ancient Greece" (Cat. No. 94*c*). I am indebted to Mr. Richard Field for the copy of the photograph of the Column of Trajan found among the papers of Gauguin which are now in the collection of Mme Joly-Segalen (Cat. No. 127*a*).

to the works that he had executed earlier in France, such as the *Soyez amoureuses* of 1889 and the *Soyez mystérieuses* of 1890.

A sculpture that Gauguin executed during his second stay in Tahiti, which would be of prime importance among the works of the artist if it had not unfortunately been destroyed in World War II, was a mask of a Tahitian, possibly his *vahine*, Pahoura (Cat. No. 129).³⁸ Fortunately, a drawing of this work, made by Victor Segalen, has been published by Mme Joly-Segalen, and a photograph of the piece itself is in the collection of Mme Huc de Monfreid. This wood carving, which was sold to Goupil, Gauguin's colonist friend in Tahiti before he left for the Marquesas, is particularly valuable: it is the last piece in a long series of portrait sculptures that he executed during his life, except for the three caricatures of *Thérèse*, *Père Paillard*, and *Saint Orang* (Cat. Nos. 135–37), which he did in the Marquesas. At the same time that Gauguin's relief style, with the exception of the piece done for Fayet, was tending to become flatter and more painterly in its conception, his development of a style in sculpture in the round was marked by a finer and subtler feeling for form than in any of his previous works. Though the treatment of the form is marked by a certain sense of simplification and abstraction, there is nothing primitive about the work, and no intention to suggest a primitive quality. It is beautifully modeled and finished, and if one can imagine the rich sheen of the original wood, it must have been one of the most quietly beautiful pieces of sculpture that Gauguin ever executed.

Another interesting phase of Gauguin's work during his second stay in Tahiti is to be found in the decorations that he carved for his house. Of these works only one is known with fair certainty, the panel now in the National Museum in Stockholm (Cat. No. 121), which has a pedigree extending back to the owner of Gauguin's house in Tahiti before 1907. The similarity of this panel with those with which Gauguin decorated his house in the Marquesas is strong. It would be even stronger if, unfortunately, it had not at one time been painted over, necessitating the later removal of the polychrome. Yet, in spite of this misfortune, it is easy to distinguish the development of a new stage in Gauguin's handling of decorative relief. As in his later work in the Marquesas, the relief seems to have been cut to strengthen the effect of line and shadow in the polychromy, rather than to emphasize the sculptural form. Originally the piece consisted of one plank about ten inches wide and about seven feet nine inches long, of a rough softwood, cut by the artist in a manner conforming to the quality of the material— boldly, without much detail, and preserving the quality of the grain of the wood on the surface as an enriching texture. Probably the relief was fairly heavily painted in bright colors rather than in the subdued tinting that Gauguin used when working in fine woods.

The position and use of the panel is not clearly known. Records tell us that it came from the dining room of Gauguin's house in Tahiti. That it escaped the destruction of his movable possessions that were thrown over the barrier reef by the son of the purchaser of the house, may indicate that it was nailed down and formed an integral part of the structure. The fact that it was at one time painted over also tends to confirm this hypothesis. Another strong confirmation of this, plus an idea of the placement of the relief, are found in the painting *Te Reri Oa* of 1897.³⁹ In this picture, which may show the interior of Gauguin's house in Tahiti, a sculptured plank, similar but not identical to this panel, is shown forming a sort of dado at the bottom of the wall.

The subject of the relief, if we may judge

³⁸ Renée Hamon (*Gauguin le solitaire du Pacifique*, p. 30), reproduces a photograph of Pahoura taken about 1938. Though forty years have changed much, there is still a suggestion of the same underlying bony structure that appears in the mask.

³⁹ Collection of the Courtauld Institute of Art, London (Cat. No. 123*b*).

from later similar panels which decorated Gauguin's house in the Marquesas, was developed around the theme of Gauguin's two great exhortations, "Be amorous," and "Be mysterious." On the left of the panel appears the head and shoulders of three figures, two of which, after undergoing a number of modifications, ultimately appear again in the painting *L'Appel* of 1902.[40] On the right, the composition centers around the figure of a woman lying on her stomach. To the left of the figure is a bird, which, like the bird in *Nevermore*,[41] appears to regard the reclining woman, and is perhaps a symbol of concupiscence. Above the figure of the reclining woman appears a dog, which, as Gauguin's personal symbol, acts as a sort of signature.

"Farewell painting! My house shall be of carved wood." These words, written in the fall of 1895 when Gauguin lay at Pont Aven with his broken ankle, were, to some extent, to be realized in the Marquesas. In his new home Gauguin did very little painting. It is true that not long after his house was set in order his health began to fail, but there is another reason. The Marquesas exhale a far different spirit from that of Tahiti. Tahiti has been described as an emerald surrounded by a chaplet of pearls, a fertile green and sunny island lying in calm blue waters and protected from the fury of the ocean by coral reefs. Its atmosphere is gay, relaxed, and inviting. On the other hand, the Marquesas rise sheer and abrupt from a thundering ocean; great craggy black masses of rock tower to impenetrable heights, on which vegetation and man seem barely able to maintain a foothold. Only where the precipitously falling streams have formed a fertile valley on the coast by the endless process of erosion and sedimentation does man find the luxurious and inviting tropical vegetation that forms the natural setting of the culture of the Polynesian. Aside from the brooding splendor of the island, far different

from that of Tahiti, the people themselves are different. Though they are of the same Polynesian stock, they have not the gaity of the Tahitian. They are gentle, affectionate, kind, but also melancholy, sad, and without hope. Even fifty years before, when Admiral Dupetit-Thouars claimed the islands for France, Max Radiquet described this nostalgic melancholy.[42] The Marquesan seems to have been forsaken by the old gods long before the arrival of the missionaries of a new God. They were a race already far gone in the half-conscious process of extinction. The brave sailors and hundreds of thousands of warriors of their legends had become no more than a pitiful handful. At the time of Gauguin's arrival only a scant five thousand natives were left in the whole archipelago. This strange, slow cataclysm of extinction which Gauguin saw taking place, as it were, before his eyes, undoubtedly aroused in him a desire to protect these sad remnants from the officious and unfeeling oppression of a colonial bureaucracy. It also caused his painting to be permeated with a strange meditative melancholy, as well as a deeper human understanding than his works at Tahiti. It is a somber art, in spite of its vivid colors, and the quality of its mood replaces his earlier joy in painting.

In a way Gauguin's sculpture also reflects this. Charles Morice's poem written for *Noa-Noa* begins with the words:

"The gods are dead in Atuana
And Atuana dies of their death."[43]

Except for a little clay statue, which fell to pieces soon after its creator's death, Gauguin apparently made none of those mysterious representations of the native gods that marked his sculpture during his first visit to Tahiti. Instead he decorated his house by carving a series of redwood planks, which enframed the door (Cat.

40 Collection of the Cleveland Museum of Art.
41 Collection of the Courtauld Institute of Art, London.

42 Max Radiquet, *Les Derniers sauvages*, with an introduction by Jean Dorsenne (Paris, 1929), p. 1.
43 This is the version that Gauguin wrote on the piece of paper attached to the carved plank *Te Atua* in the Marquesas. The original version (*Noa-Noa*, p. 120) has Tahiti instead of Atuana, Gauguin's personal spelling for the name of the town Atuona.

Fig. 24. Native Marquesan wood carver in his shop. From Karl von den Steinen, *Die Marquesaner und ihre Kunst.*

No. 132). Above the door appeared a panel with the inscription *Maison du Jouir*, flanked on the left by the head of a Polynesian woman, and on the right by a head with a visage of an Indian that may represent Gauguin himself; a peacock appears with the head.[44] Strangely, all the figures face left. On either side of the door, with more or less the appearance of caryatids, were carved two large figures of Polynesian women. Below, the base of the door was flanked on the left by a panel bearing the title *Soyez mystérieuses*, and on the right by another bearing the title *Soyez amoureuses et vous serez heureuses.* The latter panel is decorated by the heads and shoulders of three female figures, of which the central group of two appears in Gauguin's picture *L'Appel* of 1902 (reversed), and again as a print in *Avant et Après.*[45] The inscription is at the extreme right, partly surrounded by the coils of a snake, Gauguin's symbol for the tempter, the serpent of the Garden of Eden. All the panels are executed in the very shallow relief that he used in his works after his return to Tahiti, with the exception of the relief executed for Fayet, *La Guerre et la Paix.* Rather than the

[44] The title *Maison du jouir* strongly suggests the Polynesian *fare popi*, or "pleasure house," that was used by the unmarried young people as a sort of club where they gathered to play and sing, and to sleep and have intercourse (cf. Bengt Danielsson. *Love in the South Seas,* translated by F. H. Lyon [New York, 1956], pp. 93–4).

[45] *Avant et Après*, p. 165.

use of the carved surface to produce three-dimensional form, Gauguin used his abrupt and sharply planar cuts to produce a reinforcement of the line of the drawing and a modulation of the light on the painted surface. The relief was used as an enrichment of painting rather than an exploration of form for its own sake. As has been suggested, these redwood planks, lacking the intrinsic beauty of the native woods, were probably polychromed quite heavily, although not heavily enough to prevent the enrichment of the surface of the relief by the texture of the coarse grained planks. As they were exposed for a considerable time to the ravages of the Marquesan sun and rain, only a delicate trace of this polychrome is left, producing an effect, which it must be admitted has its own appeal.

As early as 1889 at Le Pouldu, Gauguin had taken an interest in enriching his living quarters with sculpture, but one of the influences on his conception of his decorative work on his house in the Marquesas was probably the tradition of carved woodwork on the native Maori house. A photograph of such a house was found among Gauguin's effects at the time of his death (Fig. 23).

Another interesting piece of sculpture that was not actually part of Gauguin's house, but related in style and conception to that sculpture, is a panel entitled *Te Atua* (Cat. No. 133). The panel was found by Victor Segalen over a shelter for a clay statue in front of Gauguin's house at Atuona when Segalen visited it shortly after the artist's death. In the center of the panel is pasted a copy in Gauguin's hand of the poem *Te Atua*, by Charles Morice, which had originally appeared in *Noa-Noa*:

> Les Dieux sont morts et Atuana meurt de leur mort
> Le Soleil autrefois qui l'enflammait l'endort
> D'un sommeil triste, avec brefs réveils de rêve:
> L'Arbre alors du Regret point dans les yeux de l'Eve
> Qui, pensive, sourit en regardant son sein,
> Or stérile scellé par les divins desseins.[46]

To the left of the panel is carved an animal that may be a cat, or possibly a rat, which has been

[46] *Noa-Noa* p. 120.

painted red. To the right is carved an exotic bird, which seems originally to have been painted green, white, and red. When we consider the fact that these two figures adorn a panel which laments the death of the old gods, and the death of the Marquesan people, we must wonder why the bird and the cat were associated with this idea in Gauguin's mind. The cat is not indigenous to Polynesia, but in the same manner the larger imported animals have been given names compounded with the Polynesian word for pig, *pua'a*; the smaller animals, the cat among them, have been given names compounded with the native name for rat, *'iore*. Thus, in the native mind, there exists a certain identification between the cat and the rat. Now, in Polynesian mythology, the native brown rat, the *'iore-ma'ohi*, is the *ata*, or "shadow" of ghosts.[47] Red is the color sacred to the gods.[48] Birds are minor deities in the Polynesian pantheon.[49] One of the usual words for bird, *moa*, also means sacred. The particular bird that Gauguin has represented does not lend itself to easy identification, but with its resplendent plumage, it may well represent a "shadow" of one of the Polynesian gods. The "shadow" of Ta'aroa was the *arevareva*, a bird of paradise, and Ta'aroa was regarded by Gauguin as the chief of the Polynesian gods. The *arevareva* was a bird of ill-omen associated with sickness and death,[50] and it is possible that Ta'aroa's "shadow" here represents him in his guise as the ruler of the afterworld.[51]

Aside from the series of panels in Gauguin's house that were providentially bought by the poet Victor Segalen at the sale of Gauguin's possessions in Tahiti after his death, and which now belong to the Louvre, there are a number of pieces in the round that Gauguin carved from native woods. Perhaps the best-known and most often mentioned of these are the famous pair, *Thérèse* and *Père Paillard* (Cat. Nos. 135, 136). The events that led to the carving of this pair have been recorded by Gauguin in his book *Avant et Après*:

> A chicken had come along, and war had begun. When I say a chicken I am modest, for all the chickens arrived, and without any invitation.
>
> His reverence is a regular goat, while I am a tough old cock and fairly well seasoned. If I said that the goat began it I should be telling the truth. To want to condemn me to a vow of chastity! That's a little too much; nothing like that Lizette.
>
> To cut two superb pieces of rosewood and carve them after the Marquesan fashion was child's play for me. One of them represented the horned devil, the other a charming woman with flowers in her hair. It was enough to name her Thérèse for everyone without exception, even the school children, to see in it an allusion to the celebrated love affair.
>
> Even if this is all a myth, still it was not I who started it.[52]

In the Marquesan fashion: "Figures . . . carved with a great naïvité. An over-size head formed by itself the third of the total height."[53] Such indeed are the proportions of Gauguin's sculpture in rosewood—of *Père Paillard* and *Thérèse*. But this, and a certain static frontal symmetry, are the only primitive aspects of these figures. In contrast to his use of native motifs in the carving of his cylindrical pieces from his first stay in Tahiti, these works are more typically European in their conception. Even the proportions of the figures, with their gradual organic diminution, reminds one more of those caricatures, so common at the end of the nineteenth century, in which a large head is placed on a diminutive body. In the case of *Père Paillard*, the figure, with its diabolical horns and

[47] Henry, *Ancient Tahiti*, p. 383. Living as he had, for nearly ten years in close contact with the natives, Gauguin could hardly be ignorant of their superstitions about the dead.

[48] Handy, *Polynesian Religion*, p. 131.

[49] Henry, *Ancient Tahiti*, p. 384.

[50] *Ibid.*, p. 385.

[51] Handy, *Polynesian Religion*, pp. 75–79.

[52] *Avant et Après*, pp. 45–46. The story of Thérèse and the bishop is also recorded in Francois Guillot, *Souvenirs d'un colonial en Océanie* (Annency, 1935), quoted in Chassé, *Gauguin et son temps*, pp. 99 ff.

[53] Radiquet, *Les Derniers sauvages*, p. 22.

sanctimoniously clasped hands, is a satirical caricature in a purely European tradition. It is a magnificent piece, done with a sureness of hand in the carving and portrayal of the unfortunate Monsignor Martin. This, and the even more brutal caricature, *Saint Orang*, which may represent the gendarme Claverie, whom Gauguin characterized in *Avant et Après* as "a hairy gendarme . . . who is a faune in secret," were probably the last pieces of sculpture that Gauguin executed (Cat. No. 137).[54]

After a lifetime of trying to escape the tyranny of civilization through flight to the far corners of the earth, Gauguin had at last, in the Marquesas, found flight to be useless. His sympathy for his fellow sufferers, the natives, decided him to fight. Though in the past Gauguin's art had been devoted to the realization of its own ideals, it showed that on this occasion it could fight a battle against the tyranny of his oppressors through brutally revealing caricature.

In his final acts Gauguin showed himself to be faithful to the crusading tradition of his grandmother Flora and his father Clovis.

For twenty-five years, from the time he was a young man of thirty already established as a successful banker, until his death at fifty-five in the Marquesas, Gauguin devoted a large share of his artistic creativity to sculpture. During that period he underwent an almost unparalleled development, and he succeeded in a way that is given to few artists to succeed, for he created a myth. His vision was so penetrating, and his personality so strong, that reality has become the reflection of his idea. No one who has experienced the impact of Gauguin's paintings of the South seas can visualize the Polynesian and his land in terms other than those dictated by Gauguin. True, the real native, and the real landscape, often disappoint one, but this is because they fail to live up to the ideal—Gauguin's ideal.

Yet Gauguin did not have the impact on modern art that the importance of his ideas warranted. He was too remote, his principles were left to the lesser hands of his followers to interpret, and his art was too impersonal in its ideals for a period in which artists were becoming more and more concerned with the expression of their own personalities and feelings. If his painting was not appreciated at its true worth by his contemporaries, his contributions in sculpture are still largely unappreciated. The trend of modern sculpture has followed some of the principles of Gauguin's works, but it has been left to others to rediscover them.

Gauguin was one of the first to appreciate the sculptural richness of the art of non-European traditions. He was the first to appreciate the sculpture of primitive peoples, but the influence of primitive art traces, not from the discoveries of Gauguin, but from Picasso and his discovery, not of Polynesian art, but that of Africa. Seventeen years before Picasso discovered the art of the African natives and began studying its artistic potentialities, Gauguin had already started studying the art of Polynesia at the *Exposition Universelle* of 1889. While Picasso's discoveries had immediate influence on the course of art, not one of Gauguin's contemporaries saw the significance of his discovery.

Though decorative sculpture was to see a rebirth of its popularity under the influence of *Art Nouveau*, its saccharine forms stem from the tradition of Rosetti and Morris, and not from Gauguin. Even that sculptor who was closest to Gauguin, Maillol, shows no influence of the barbaric power of Gauguin. As a potter, Gauguin's fate is even more obscure. Scarcely a book on modern ceramics even mentions his existence, and no modern potter has followed his ideas.

Perhaps it is too late for modern art to rediscover the genius of Gauguin, for it has progressed too far, and its course is set in other directions, but it is not too late to appreciate his art as the expression of a great and original personality.

[54] *Avant et Après*, p. 4.

APPENDIX A

GAUGUIN'S USE OF ANIMAL SYMBOLS

A CERTAIN NUMBER of animals occur in Gauguin's works again and again. The regularity with which they appear in certain contexts strongly indicates that, at least in a number of cases, they have a symbolic significance. One of the first of these animals to appear, and one that Gauguin used constantly throughout his career, is the snake. As early as the period of his return from Martinique this figure begins to appear in paintings and drawings associated with scenes that can hardly be interpreted in any other way than the temptation of Eve by the serpent in the Garden of Eden. One of the earliest version of this scene with the serpent is found in *Eve bretonne* of 1889.[1] A more common representation is that of the standing Eve with the serpent whispering in her ear. This latter version is repeated many times through Gauguin's career, with certain modifications.[2] After his sojourn in the South seas, Gauguin tended to substitute the lizard for the snake, for, as there are no snakes in Polynesia, the missionaries translated this symbol of the devil as "lizard without legs." The lizard, however, does not entirely displace

the snake as a symbol, for Gauguin continued to use the latter in his works both in Tahiti and in the Marquesas. In every case, the symbolic meaning of both the snake and the lizard seems to consist of evil temptation.

Another symbol that makes its appearance in 1889, the year in which Gauguin began experimenting extensively with symbolism, is the fox. Gauguin tells us that the fox is the "Indian symbol of perversity." He uses this symbol in *Loss of Innocence* (1890–1891) in a way that allows the fox to be identified as a symbol of Gauguin himself.[3] Again, in *Soyez amoureuses*, done in the fall of 1889, Gauguin has apparently used the fox both as a symbol of perversity and as a symbol of his own perverse nature. One may also suspect that in the wood carving done in the winter of 1890, *Luxure*, the fox has the same significance (Cat. Nos. 76, 88). After Gauguin's return from his first trip to the South seas, he was strongly impressed by Degas' application of the fable of the *Wolf and the Dog* to him.[4] As Gauguin had already begun to regard himself as a savage, one might well expect the symbol of the wolf to be combined with his personal symbol the fox. After his return to the South seas, Gauguin may well have changed the

[1] Collection of the Marion Koogler McNay Art Institute, San Antonio, Texas. Reproduced in Rewald, *Post-impressionism,* plate 22.

[2] The earliest version seems to be a watercolor done in 1890 (reproduced in Rewald, *Post-impressionism,* p. 464), but a more typical example is found in the woodcut *Navenave Fenua* (Guérin No. 28), done about 1894–1895.

[3] Collection of Walter P. Chrysler, Jr., New York.

[4] Gauguin recounted the incident in *Avant et Après,* p. 74.

fox-wolf symbol in the same manner that he changed that of the snake to the lizard. As there were neither foxes nor wolves, he may have adopted a fox-wolf-dog equation for his symbol in order to give it a form appropriate to the environment. This metamorphosis runs counter to La Fontaine's fable, but the fact that it took place is supported in a striking manner by two bits of evidence. One is that, according to Timo, the son of Tioka, who knew him intimately in the Marquesas, Gauguin's dog was named Pegau, diminutive of Paul Gauguin.[5] Though Timo (or perhaps LeBronnec, who recorded Timo's reminiscences) spelled the dog's name Pegau, one may well suspect that it was in fact the equivalent of Gauguin's famous signature, P. Go. That the dog himself represented in a sense the artist is confirmed by a drawing in the manuscript of *Avant et Après* entitled *Ia Orana*.[6] In the foreground of this drawing appears a native with his hand shielding his eyes and looking to the right where a dog appears with the words written above it "Bonjour Monsieur Gauguin." This raffish little dog appears a number of times in painting and sculpture done at this time, notably the second version of *Soyez mystérieuses*, which is not otherwise signed, and in the panel *Te Fare Amu*, where the dog appears next to the signature (Cat. No. 122). Another place that this symbol appears is in the picture *Adam and Eve*, dated 1902.[7] Dogs appear in a great number of Gauguin's other works, but it is not probable that they are symbols in every case. However, in pictures which seem to have a particular symbology, such as the ones mentioned above, it is quite possible that

the dog is a symbol. In a number of these works the dog is associated with the snake, as in *Te Fare Amu* and *Adam and Eve*. In the case of *Soyez mystérieuses*, the snake appears on the companion panel *Soyez amoureuses*, neither of which are signed (Cat. Nos. 76, 87). In other examples, such as the upper panel of the Fayet pair (Cat. No. 127) the dog appears with a strange bird, which is also present in the painting of *Adam and Eve*.

The significance of the bird is more difficult to determine, but that it has a significance is clearly demonstrated by at least two of Gauguin's references to birds in his paintings: *Nevermore* (1897), where Gauguin says that the bird represents the "bird of the devil waiting," and *Que sommes-nous*, where Gauguin said that the bird represented "the vain futility of words."[8] Both these examples are late in date, but there are other examples of an early period in which we may assume that the bird also has a symbolic significance. One of these is to be found in the theme of Leda and the Swan, which Gauguin repeated several times during the period of his stay in Le Pouldu about 1889.[9] Another is the strange form of the rooster sitting on the head of the carved wood head of Meyer de Haan (Cat. No. 86). Another more specific example of the bird symbol is found in the watercolor of the temptation of *Eve*, done in 1890, where in addition to the snake, there is a rooster copulating with a hen. In *Avant et Après* Gauguin himself gives us an insight into the significance of this scene:

> I have a cock with purple wings, a golden neck, and a black tail. . . . I have a silver-grey hen, with ruffled plumage; she scratches, she pecks, she destroys my flowers. It makes no dif-

[5] G. LeBronnec, "Les Dernières années," *Gauguin, sa vie, son oeuvre*, edited by Georges Wildenstein, (Paris, 1958), p. 199. Also note that in the signature of the *Still Life* dedicated to the Countess de Nimal (reproduced in Rewald, *Post-impressionism*, p. 303) Gauguin included a little dog. We know that the original model of this little dog was a fox in Gauguin's sketchbook (Huyghe, *Carnet*, p. 195). Perhaps Gauguin considered it wiser in this case to use the dog, symbol of fidelity, as his sign rather that the fox, symbol of perversity.

[6] *Avant et Après*, p. 167.

[7] Reproduced in Malingue, *Gauguin* (Paris, 1948), plate 239.

[8] The painting *Nevermore* is in the collection of the Courtauld Institute of Art, London. The quotation is from a letter to De Monfreid (Segalen, *Lettres*, XXIX). *Que sommes-nous?* is in the Museum of Fine Arts, Boston. The quotation is again from a letter to De Monfreid (*ibid.*, XL).

[9] The ceiling of Marie Henry's inn was decorated with this motif, and the artist also used it in the design of a plate and a ceramic (Rewald, *Post-impressionism*, pp. 295, 300).

ference. She is droll without being prudish. The cock makes a sign to her with his wings and feet and she immediately offers her rump. Slowly, vigorously too, he climbs on top of her. . . . The children laugh, I laugh.[10]

From the general series of bird symbols it seems clears that at least one of the meanings of the this sign is concupiscence. It is also a bird of ill omen, associated, as is the snake, with the Devil as the great seducer. That the bird may have other symbolic meanings is not only possible, but probable. One is stupidity. Again we find the idea expressed in La Fontaine's fable of the *Fox and the Crow*, and suggested in Gauguin's interpretation of the bird on the far left in his painting *Que sommes-nous?* as representing the "vain futility of words."

Another bird that appears constantly in Gauguin's works is the peacock. This bird was one of the favorites of the Pre-Raphaelite Brotherhood and begins to appear in Gauguin's art about 1890. Though the symbol of the peacock has many meanings in various cultures, the sense in which Gauguin appears to use it is as the early Christian symbol of the triumphant spirit. In the panel *Soyez mystérieuses* of 1890 the peacock lends itself to this interpretation.[11] In the woodcut *Te Atua* (Fig. 22) the peacock is the central figure in a group in which Polynesian mythological symbols are combined with figures of the Christian religion. The bird of paradise, the *arevareva*, is the "shadow" of Ta'aroa, whom Gauguin regarded as the embodiment of the universal spirit.[12] Possibly in this case Gauguin is using the peacock as the symbol of the same universal spirit. The peacock also appears a number of times associated with male heads that apparently represent Gauguin's savage nature, and one suspects that in this case the artist used the bird as a symbol of the triumph of his own spirit, or his rebirth as a man freed from the bonds of European civilization.

One other bird appears regularly in Gauguin's works around 1890. It is an elegant crested blue bird with a long tail. Possibly the bird is an abstraction of the peacock, and the blue color simply an aspect of the symbolization of the spirit, but the significance of the symbol, if any, escapes me.[13]

Birds are by far the most numerous animals of Tahiti, where they exist in great variety. In the culture of the South seas almost all animals are associated with supernatural beings as their symbol or "shadow."[14] It seems inevitable that Gauguin would have taken over some of these symbols for his own use. There is some evidence that this is true, and that Gauguin may have used birds as symbols in their native sense. The case of the possible equation of the bird of paradise, the symbol of Ta'aroa, with the peacock, has already been mentioned, but there is one other case in which the bird may be used in a manner consonant with the ideas of the Polynesian. The gull, which is the "shadow" of the goddess Hina, appears in the painting *Que sommes-nous?*[15] Gauguin regarded Hina as the goddess of the moon and matter, equating her with the Mediterranean idea of the mother goddess. Through this equation, the bird again becomes the symbol of the feminine aspect of nature and matter, as opposed to spirit and intellect, which Gauguin regarded as male.[16]

Other Polynesian animals that Gauguin may have used with symbolic significance include the lizard and the rat. The lizard was a minor diety in the Polynesian pantheon, but in

[10] *Avant et Après*, p. 17.
[11] The lintel decoration of Gauguin's house in the Marquesas also has a peacock associated with a barbaric male head (Cat. No. 132).
[12] *Noa-Noa*, p. 147.

[13] Blue was the generally accepted color of the spirit among the Symbolist poets. Maeterlinck's *Blue Bird* is brought to mind, but Gauguin's blue bird seems to antedate Maeterlinck's work, which was published nineteen years later.
[14] Teiura Henry, *Ancient Tahiti*, pp. 382 ff. The word *ata*, which Henry translates as *shadow*, also has the meanings of *image* and *spirit* (Edmund and Irene D. Andrews, *A Comparative Dictionary of the Tahitian Language* [Chicago, 1944]). Dordillion, in addition to these meanings, also gives *portrait*, *statue*, and *effigy* (Monsignor René Ildefonso Dordillion, *Grammaire et dictionnaire de la langue des Iles Marquises* [Paris, 1931]).
[15] Henry, *Ancient Tahiti*, p. 387. Also see the discussion in the text on page 154.
[16] *Noa-Noa*, p. 147.

this case the native significance of the symbol is obscured by its use as the equivalent of the European snake.[17] The native rat, the *'iore ma'ohi,* was the "shadow" of ghosts, and it may appear in this role as one of the animals in the panel *Te Atua.* Though the identification is not clear, its significance is consistent with the subject of the poem by Charles Morice lamenting the passing of the native gods.[18] The only other mammals indigenous to Polynesia are the pig and the dog. Apparently Gauguin did not make symbolic use of the pig, while he had already appropriated the dog as his personal symbol. He may not have found it contradictory that in Tahiti the dog was the shadow of the jovial elf To'a-hiti, who inhabited the depths of the valleys and was the friendly protector of the natives, for he, too, lived apart from civilization and regarded himself as a defender of the natives against the repressions of the colonist.[19]

Other animal symbols may occur in the work of Gauguin. Occasionally such animals as the rabbit, the owl, and the goat appear to take on symbolic significance, but they are hardly charged with enough mystery to appeal to the artist, and their occurrence is infrequent (Cat. No. 71).

[17] Henry, *Ancient Tahiti,* p. 383. The Tahitian word for lizard is *m'oa,* which also means *sacred* and *holy* (Andrews and Andrews, *Dictionary of the Tahitian Language*).

[18] Henry, *Ancient Tahiti,* p. 383.

[19] *Ibid.,* p. 383.

TYPES OF WOOD USED BY GAUGUIN

IN SOME CASES the woods used by Gauguin in the South seas can be identified exactly. In other cases it is possible to make a tentative identification on the basis of the nature of the wood and the descriptions from various sources of the woods available in Tahiti. Gauguin himself speaks of working in ironwood in a letter to De Monfreid in March, 1893 (see Cat. No. 99). In *Avant et Après* Gauguin tells us that the two figures *Thérèse* and *Père Paillard* were carved in rosewood (Cat. Nos. 135, 136). In addition, the wood of *The Leper* (Cat. No. 138) has been identified as tou, and the wood of the *Bust of a Tahitian Girl* (Cat. No. 101) has been identified as the Tahitian wood tamanu. The panels from the front of Gauguin's house in the Marquesas (Cat. No. 132) have been identified as redwood, and his table (Cat. No. 131) has been said to be of apitong. Two other woods, pua and nono, are tentatively identified on the basis of the description of their characteristics.

APITONG (*Dipterocarpus grandiflorus* or *D. vernicifluus*)

A wood exploited in the Philippines; one of the types sometimes called Philippine mahogany. The author has not found it reported in Tahiti. It is possible that, like the redwood, it was sometimes imported. (See S. J. Record, "Some Trade Names of Woods," *Tropical Woods*, 3 [September 1925] p. 7)

IRONWOOD (*Casuarina equisetifolia*) (Toa)

"T'oa or ironwood, now called 'aito . . . is the emblem of the warrior, who bears its name, toa, or 'aito and the warrior god 'Oro. From its hard wood were made the image of 'Oro and war weapons. . . . The wood, at first a delicate salmon color, gradually becomes black." (Henry, *Ancient Tahiti*, p. 51)

NONO (*Morinda citrifolia*)

"The wood of the nono is close grained and yellow and bears a high polish." (*Ibid.*, p. 59)

PUA (*Fragraea berteriana*)

"The wood is light brown, close grained, bears a high polish, and is much valued for furniture." (Henry, *Ancient Tahiti*, p. 60) Drums and *ti'is* were made of pua wood which was sacred to the god Tane, whose image was made of it. (*Ibid.*, pp. 156, 203)

REDWOOD (*Sequoia sp.*)

This wood was imported from California, the only locale in which the sequoia and the related redwood are exploited for timber.

ROSEWOOD (*Thespesia populnea*) (Miro)

"The wood resembles rosewood and is much the same texture. Formerly the tree was held sacred. An indispensable tree on the *marae*." (*Ibid.*, pp. 58, 382)

TAMANU (*Callophyllum inophyllum*)

"The wood, durable and having beautiful undulating shades of bright brown, bears a high polish." (*Ibid.*, p. 48) Moerenhout states (*Voyage*, II, 90) that the Tahitian platters and bowls were always made of this wood.

TOU (*Cordia subcordata*)

"The wood is hard and close grained and beautifully marked with various shades of brown in spots and streaks." (Henry, *Ancient Tahiti*, p. 54)

COLOR PLATES

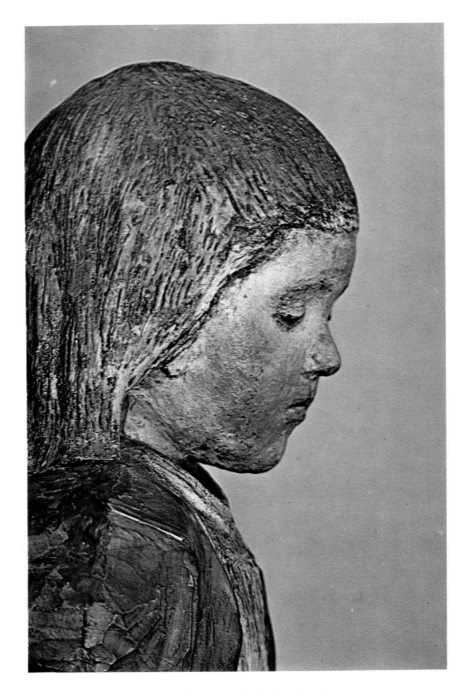

Plate I. Portrait of Clovis (Cat. No. 6)

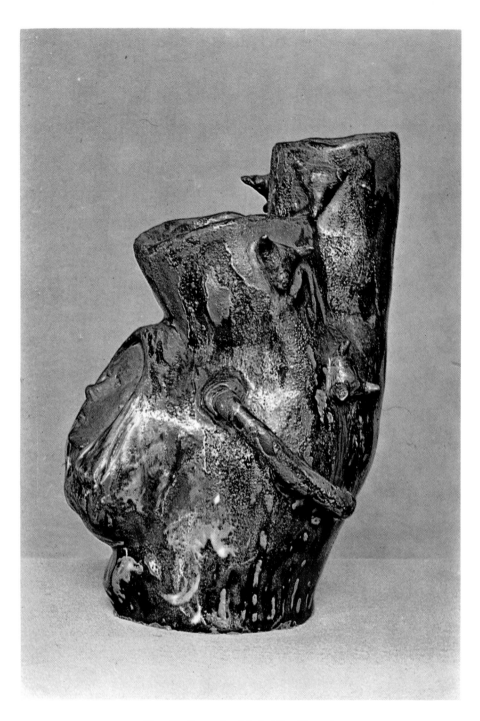

Plate II. Pot with a Mask (Cat. No. 10)

Plate IV. Rectangular Jardiniere Decorated in Barbotine (Cat. No. 44)

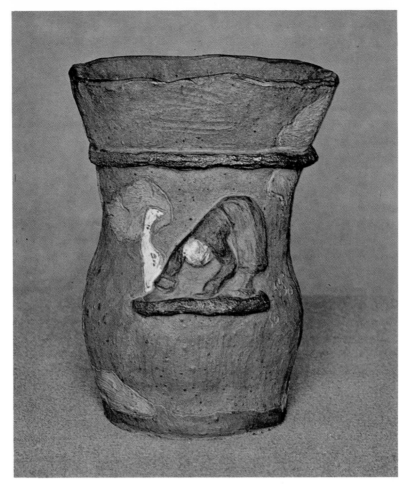

Plate III. Pot Decorated with the Figure of a Breton Woman (Cat. No. 38)

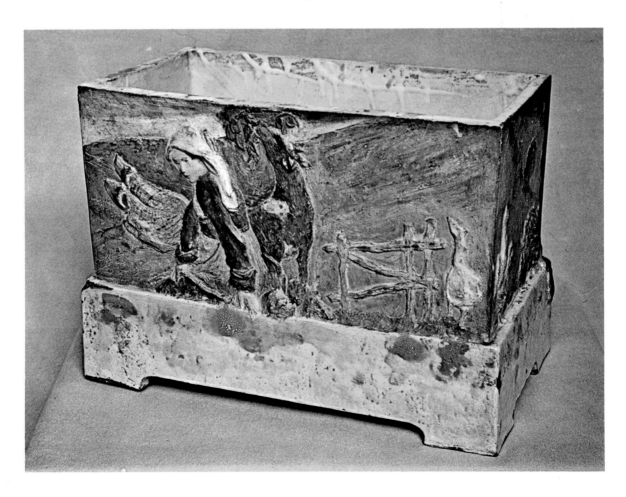

Plate V. Barrel (Cat. No. 84) Photograph Courtesy of the Marlborough Galleries, London

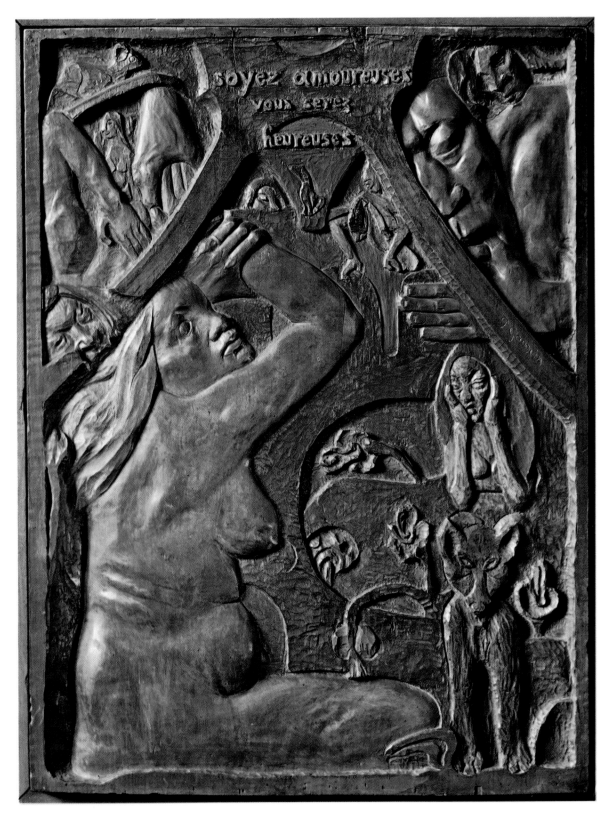

Plate VI. *Soyez amoureuses et vous serez heuereuses* (Cat. No. 76)

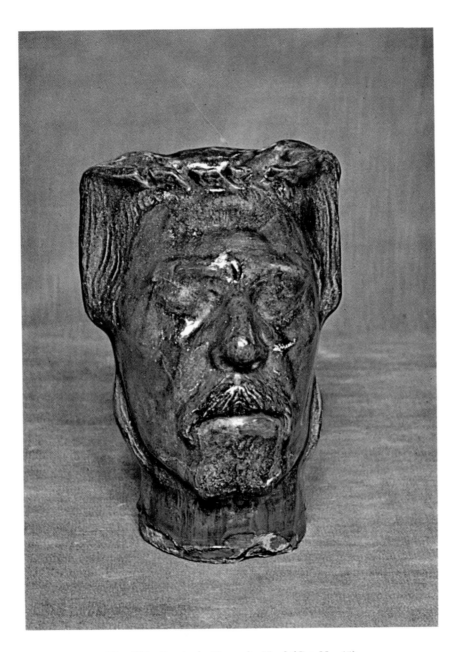

Plate VII. Cup in the Form of a Head (Cat. No. 65)

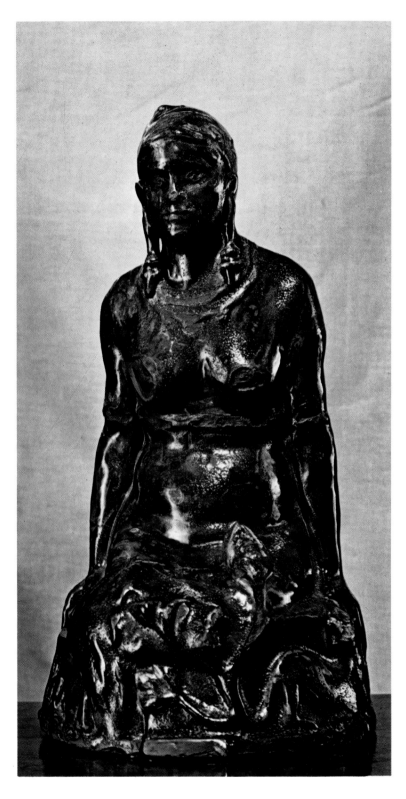

Plate VIII. *Black Venus* (Cat. No. 91)

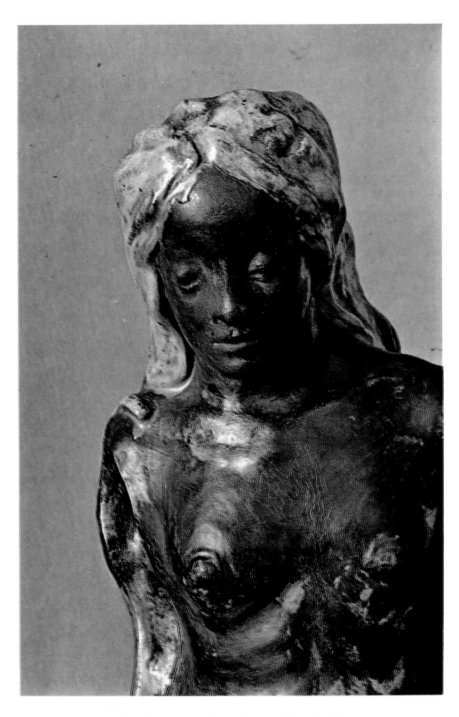

Plate IX. Standing Nude Woman (Cat. No. 92)

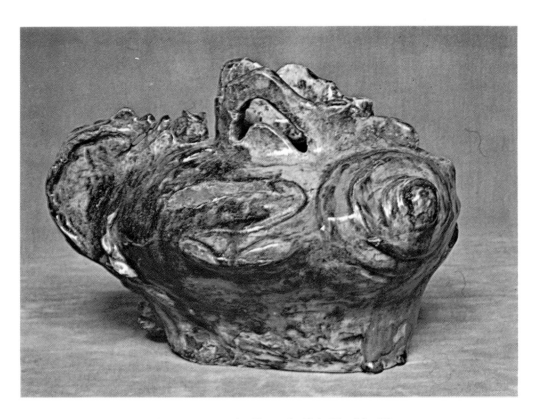

Plate X. Vase in the Shape of a Fish (Cat. No. 93)

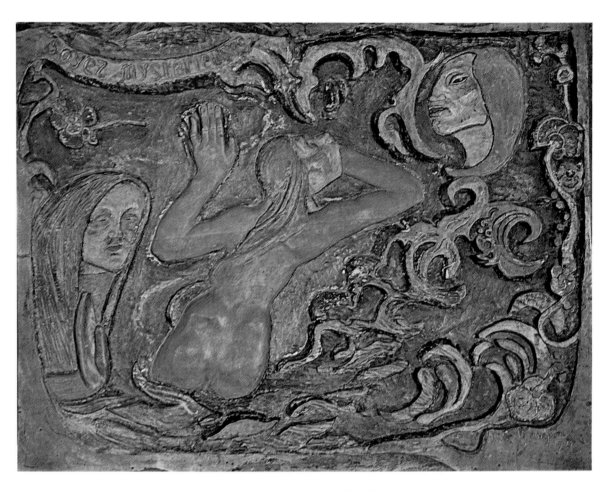

Plate XI. *Soyez mystérieuses* (Cat. No. 87)

Plate XII. *Idole à la perle* (Cat. No. 94)

Plate XIII. *L'Après-midi d'un faune* (Cat. No. 100)

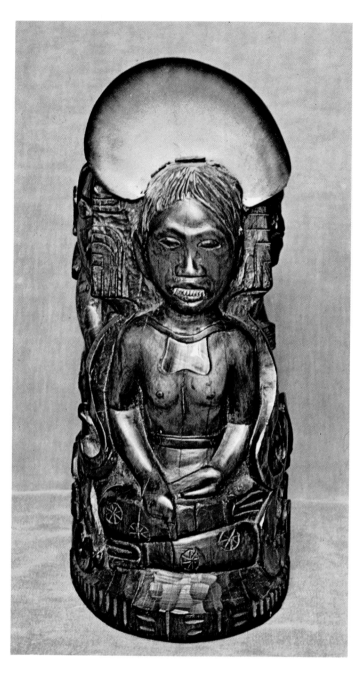

Plate XIV. *Idole à la cocquille* (Cat. No. 99)

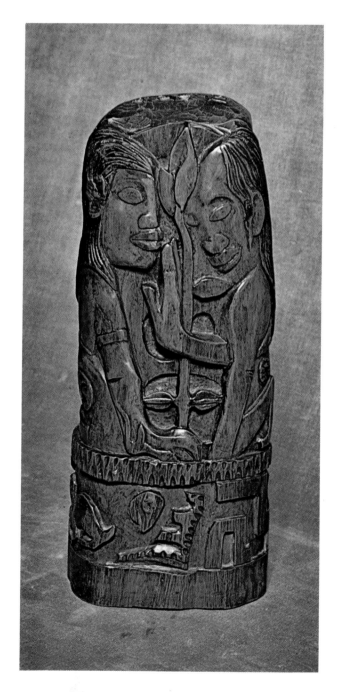

Plate XV. *Hina and Te Fatou* (Cat. No. 96)

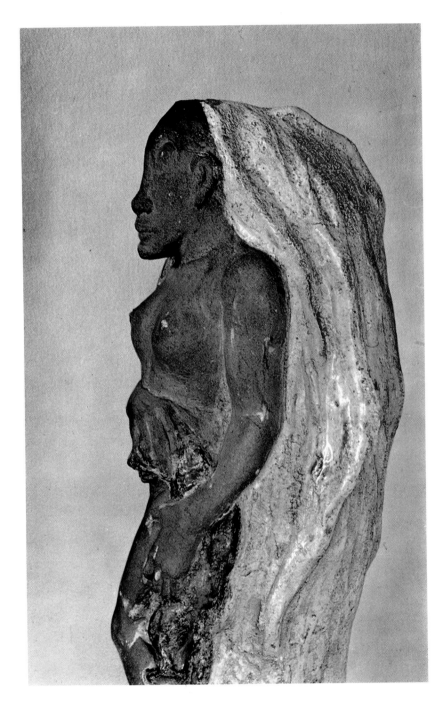

Plate XVI. *Oviri* (Cat. No. 113)

Plate XVII. *Parau Hano-hano* (Cat. No. 134)

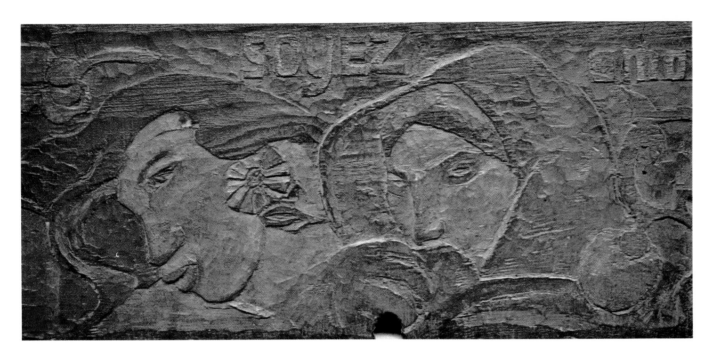

Plate XIX. Detail of the Carved Door Frame from Gauguin's House in the Marquesas (Cat. No. 132)

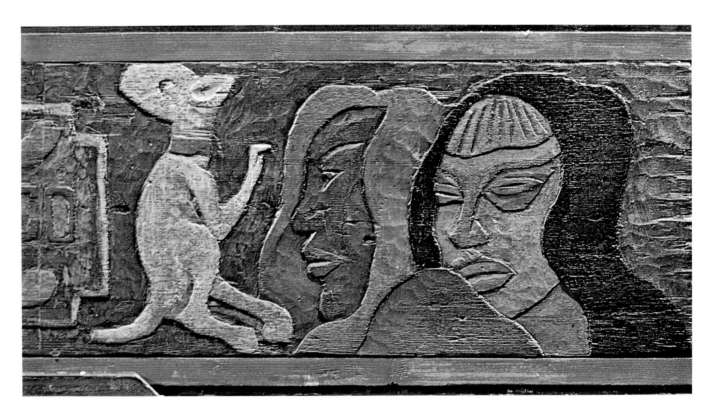

Plate XVIII. Detail of *Te Fare Amu* (Cat. No. 122)

Part II The Catalogue

In so far as practicable, I have tried to arrange the works in the Catalogue in more or less chronological order, grouping the sculpture and ceramics separately within each period.

Certain works which either I have not been able to study sufficiently, or about which sufficient information was lacking, I have included at the end as works attributed to Gauguin. In each case, as in the Catalogue proper, I have tried to present such information as I have been able to find, and my own conclusions on the basis of style. The inclusion of works in this part of the Catalogue should not be interpreted as their being of doubtful authenticity. I would rather render the Scottish verdict "not proven." I might also add that I have found no documented case of a forgery among the sculpture and ceramics attributed to Gauguin.

LIST OF CATALOGUE ENTRIES

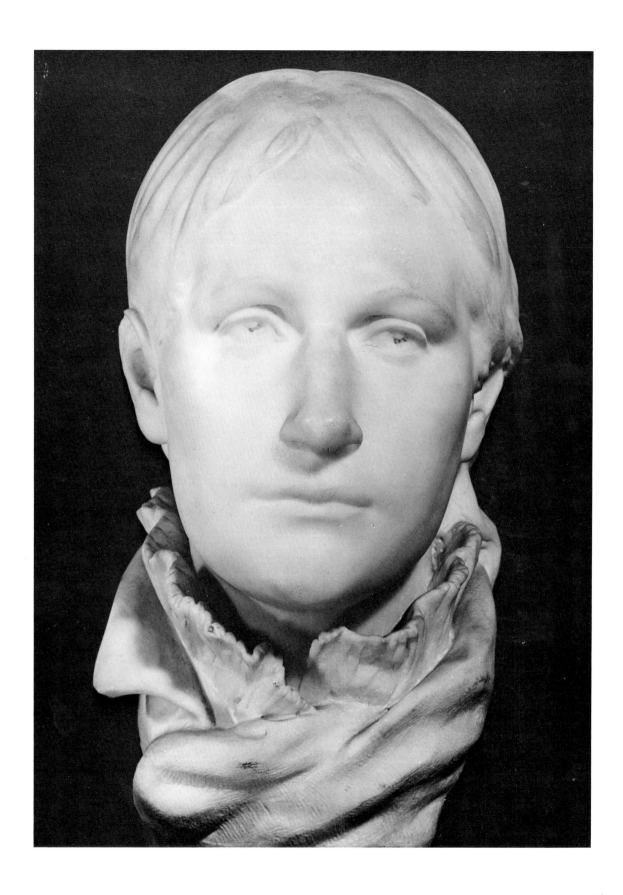

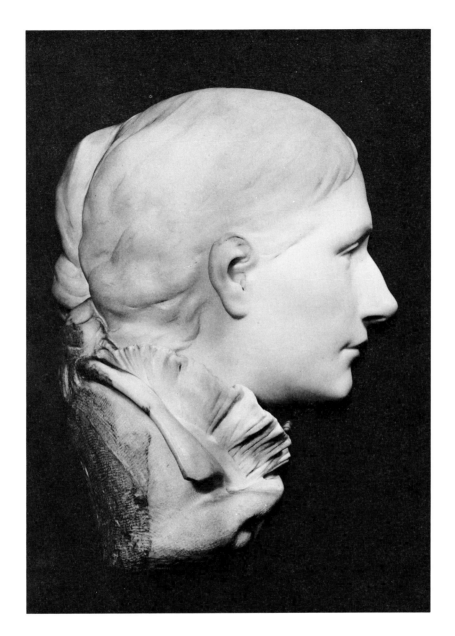

1 PORTRAIT OF METTE GAUGUIN

H. 34 cms. White marble. Signed: P. GAUGUIN on the collar.

Collections: Mette Gauguin, Copenhagen; Courtauld Institute of Art, London.

Exhibitions: Fifth Impressionist Exhibition, Paris, 1880; Gauguin Exhibition, Weimar, 1905; B–Leister Galleries, London, 1924; 72–Tate Gallery, London, 1955; 4–Galerie Charpentier, Paris, 1960.

References: Fénéon, "Impressionisme," *L'Art moderne,* September 19, 1886; Rotonchamp, *Gauguin,* p. 18; Pola Gauguin, *My Father,* p. 45; Burnett, *Life of Paul Gauguin,* p. 28(ill.), p. 32; Paul Gauguin, *Letters, to his wife and Friends,* edited by Maurice Malingue, translated by Henry Stenning (New York, 1949), p. 16(ill.); Malingue, *Gauguin* (1948), p. 14(ill.); Marks-Vandenbroucke, "Gauguin, ses origines et sa formation artistique," p. 53(ill.); Loize, *Amities de Monfried* (Paris, 1951), #463.

Photograph: Courtesy of the Home House Trustees.

Notes: (See text, p. 1)

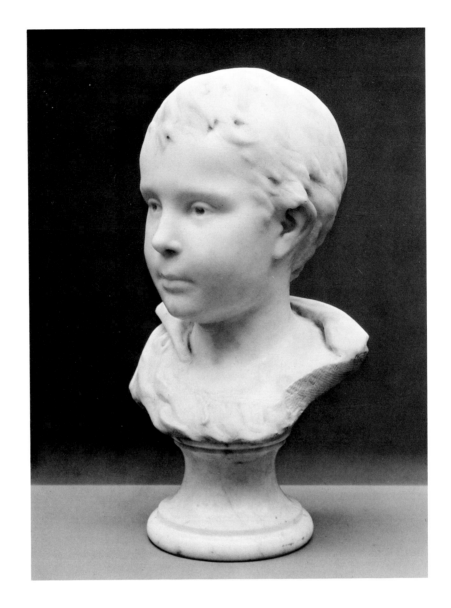

2 PORTRAIT OF ÉMIL GAUGUIN

H. 41 cms. White marble.

Collections: Mette Gauguin, Copenhagen; Émil Gauguin, Copenhagen; Chester H. Johnson, Chicago; Mrs. Joseph M. May, New York.

Exhibitions: Probably number 62–Fifth Impressionist Exhibition, Paris, 1880: *"Buste marbre"*; probably in the Gauguin Exhibition, Weimar, 1905; 131–Wildenstein Exhibition, New York, 1946; 73–Tate Gallery, London, 1955; 98–Wildenstein Exhibition, New York, 1956; 115–Chicago Art Institute and the Metropolitan Museum, New York, 1959.

References: Rotonchamp, *Gauguin,* p. 18; Pola Gauguin, *My Father,* p. 45; Malingue, *Gauguin* (1948), pp. 53–56; Loize, *Amities,* #463; Read, "Gauguin and the Return to Symbolism," *Art News Annual,* 1956; Marks-Vandenbroucke, "Gauguin, ses origines et sa formation artistique," p. 53(ill.).

Photograph: Courtesy of the Metropolitan Museum of Art, New York.

Notes: (See text, p. 1)
 At the time he sold this bust, in 1925, Émil Gauguin wrote: "If I am not mistaken, my father only made two sculptures in marble; one of my mother and this one." (From a copy of the letter, courtesy of Wildenstein and Co.)

3 "LA CHANTEUSE"

Diameter 53 cms. Mahogany. Signed: P. Gauguin. Dated 1880.

Collections: Mette Gauguin, Copenhagen; Oda Nielson, Copenhagen; Kay Nielson, Los Angeles; present whereabouts unknown.

Exhibitions: 38–Sixth Impressionist Exhibition, Paris, 1881; 75–Ny Carlsberg Exhibition, Copenhagen, 1948.(?)

References: Huysmans, "L'Exposition des Independents en 1881," reprinted in *L'Art moderne* (new edition; Paris, 1908), p. 267.

Photograph: Courtesy of John Rewald.

Notes: (See text, pp. 2–3)
 In his article on the Impressionist Exhibition of 1881, Huysmans mentions "un medallion de plâtre peint, une *Tête de chanteuse* qui rapelle un tantinet le type de femme adopté par Rops."

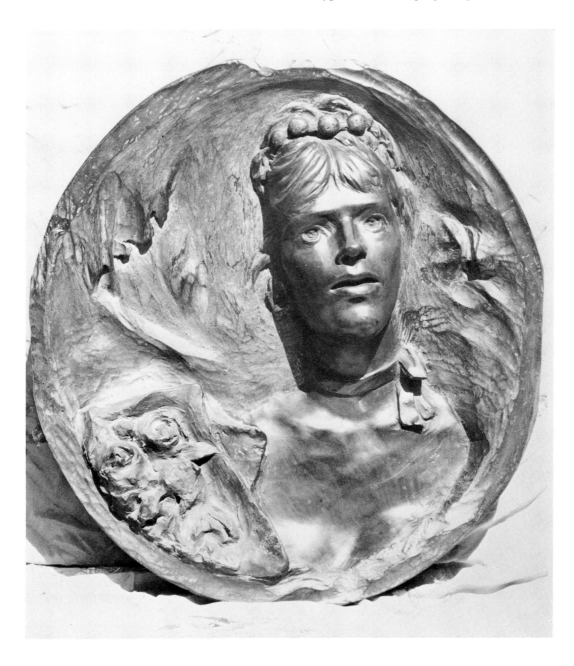

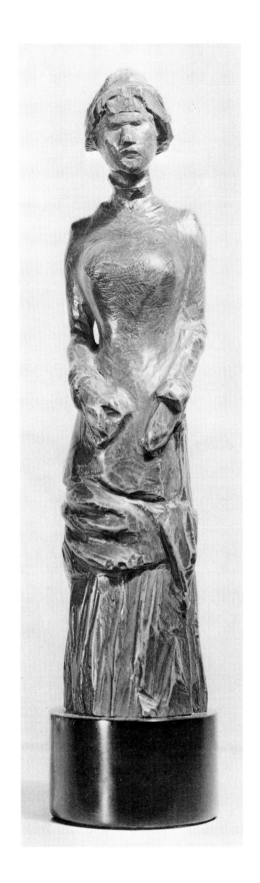 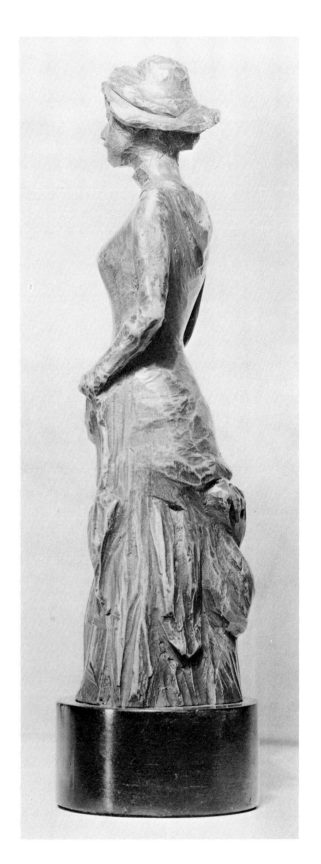

I

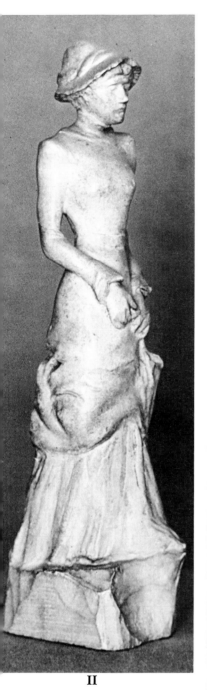

II

4 STANDING WOMAN "LA PETITE PARISIENNE"

I: H. 25 cms. Wood stained red.

Collections: Mette Gauguin, Copenhagen; Karl Ernst Osthaus, Essen; Guenter Franke, Munich; Edward M. M. Warburg, New York.

Exhibitions: 39–Sixth Impressionist Exhibition, Paris, 1881: *"Dame en promenade"*; 100–Wildenstein Gallery, New York, 1956; 116–Chicago Art Institute and the Metropolitan Museum, New York, 1959.

References: Huysmans, *L'Art moderne*, p. 267; Morice, *Gauguin*, p. 62.

Photograph: Frick Art Reference Library and the author.

Notes: (See text, pp. 2–3)
 This statuette exists in at least two other versions.

II: H. 27.1 cms. Bronze. Signed on the front of the base: P. Gauguin.

Collections: Ambroise Vollard, Paris; Walter P. Chrysler, Jr., New York.

Exhibitions: 1850–1950. The Controversial Century. Paintings from the Collection of Walter P. Chrysler, Jr., The Chrysler Art Museum of Provincetown, Mass. 1962 (not in catalogue).

Photographs by the author.

Notes:
 The caster and the size of the edition are not known. The bronze was cast from an original modeled in wax on a base of wood. A plaster cast from the wax original is in a private collection in Paris. The plaster was also bought from Vollard according to the owner.
 Apparently Vollard ordered the bronze cast just before his death.

III: H. 27 cms. Terra cotta. Signed on the front of the base: P. Gauguin.

Collections: Present whereabouts unknown.

References: Sales catalogue: *Collection Andre Derain et à divers amateurs*, Galerie Charpentier, March 22, 1955, No. 137, reproduced, plate XXXIV.

Notes:
 If this is, indeed, a terra cotta and not a plaster, it apparently was made from the same original as the bronze. I have not been able to see it.

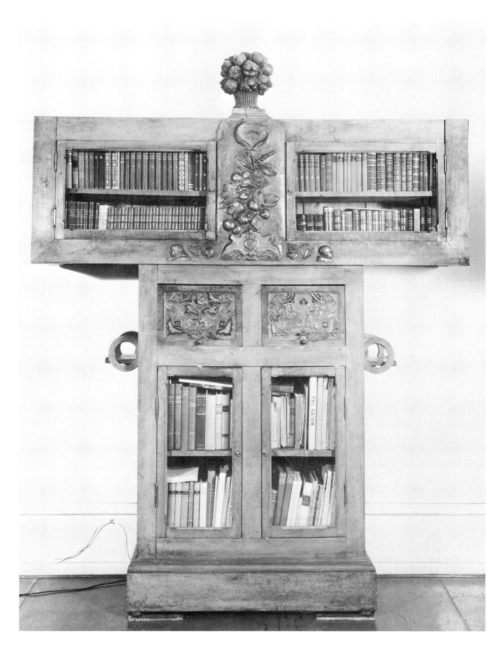

5 CABINET

Top section: H. 60 cms. W. 182 cms. Bottom section: H. 139 cms. W. 93.5 cms. Pearwood. Signed on top section: GAUGUIN FECIT.

Collections: Mette Gauguin, Copenhagen; Pola Gauguin, Copenhagen.

References: Lindberg-Hansen, "Discovering Paul Gauguin the Woodcarver," *College Art Journal,* XII:ii (Winter, 1953), 117–20; Bodelsen, *Gauguin Ceramics in Danish Collections,* p. 4.

Photographs: Courtesy of Merete Bodelsen and the Carlsberg Foundation.

Notes: (See text, pp. 3–4)

The basket of fruit on top of the cabinet was not original with Gauguin, but an old piece from the eighteenth century. The heads are of Gauguin's children, Clovis and Jean. Plaster copies of them were made by Pola Gauguin about 1904 (Loize, *Amities,* #452). The copies are in the collection of Mme Huc de Monfreid. (According to Maurice Malingue, Pola Gauguin stated that he made only one set of casts. Private conversation June 19, 1961.)

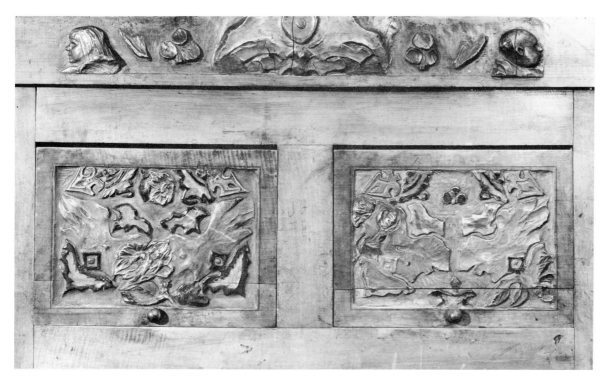

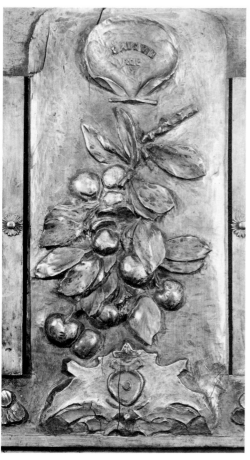

a. Godwin: Illustration from <u>Art Furniture</u>, 1877.

6 PORTRAIT OF CLOVIS

H. 40 cms. Head of wax, painted, torso of carved walnut. Inscribed on front of collar: CLOVIS. Signed: P. Gauguin on lower right shoulder. (Plate I, p. 87)

Collections: Mette Gauguin, Copenhagen; Ambroise Vollard, Paris; Private Collection, Paris.

Exhibitions: Possibly Seventh Impressionist Exhibition, Paris, 1882: "*30—Clovis (buste). Sculpture.*"

Reference: Loize, *Amities,* p. 56.

Photographs by the author.

Notes: (See text, p. 4)

 I am indebted to Samuel Wagstaff for pointing out the similarity of the composition of this piece to the so-called *Portrait of Aline* (watercolor) in a private collection in Switzerland. (See Jean Leymarie, *Gauguin,* plate 1.)

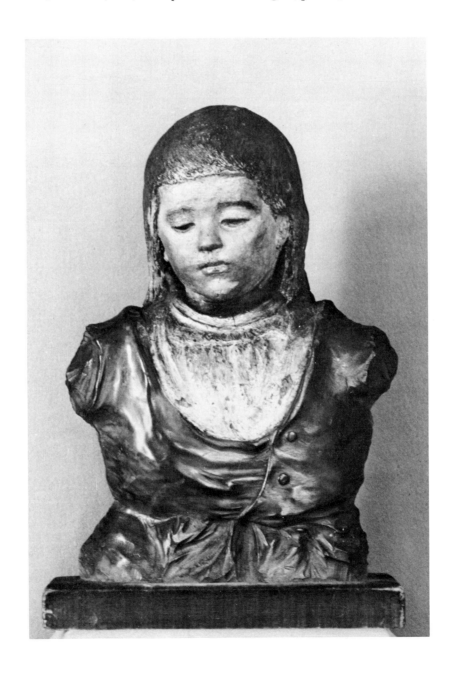

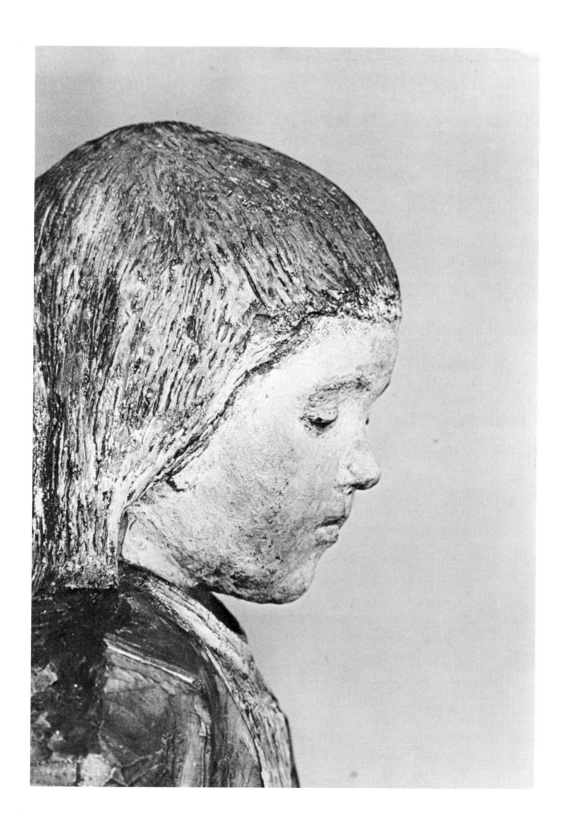

117

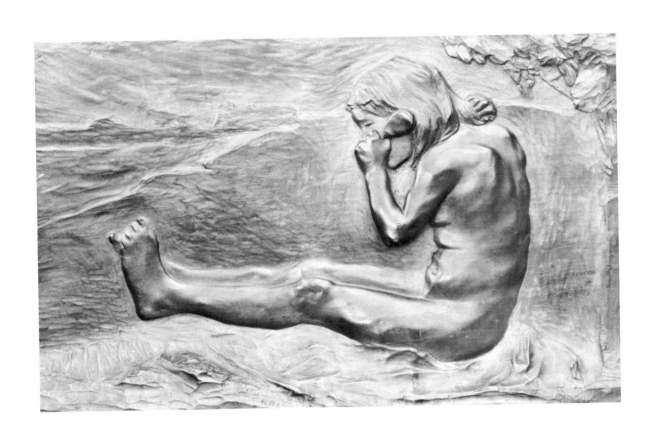

7 "LA TOILETTE"

H. 34 cms. L. 55 cms. Pear wood. Dated 1882.
Inscribed: À MON AMI PISSARRO. Signed:
P. Gauguin.

Collections: Camille Pissarro, Osny; Coste, Paris;
Private Collection, Paris.

Exhibitions: Eighth Impressionist Exhibition, Paris,
1886; 6–Luxembourg, Paris, 1928.

References: Félix Fénéon, *Les Impressionistes en 1886*
(Paris, 1886).

Photographs by the author.

Notes: (See text, pp. 4, 23)

. . . Sur du poirier que nous avons le regret de
voir monochrome, sa femme nue s'enlève en demi-
relief, la main aux cheveux, assise rectangulairement
dans un paysage. Seul numero de sculpture. Rien
en bois colorié, en paté de verre, en cire. (Félix
Fénéon, *Les Impressionistes*)

Though Fénéon mentions *La Toilette* in the Impres-
sionist Exhibition in 1886, it does not appear under
the list of Gauguin's works exhibited, unless it is
the item identified only as a portrait (see Venturi,
Archives de l'Impressionisme [Paris and New York,
1939], II, 270.)

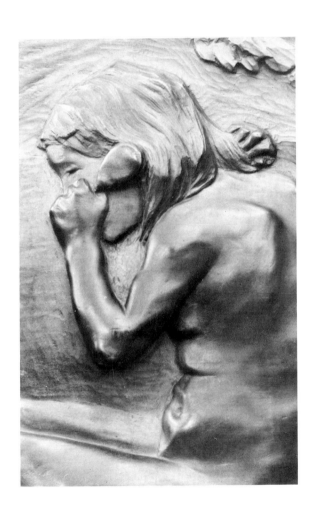

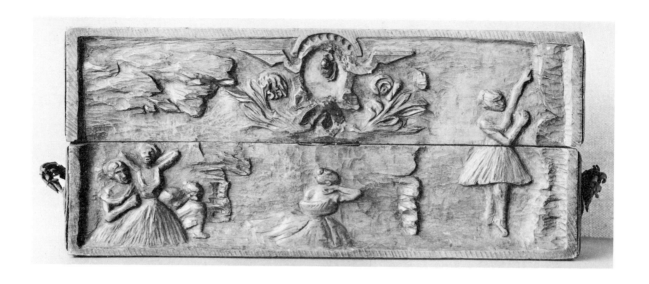

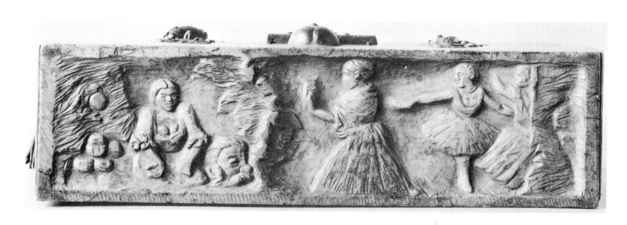

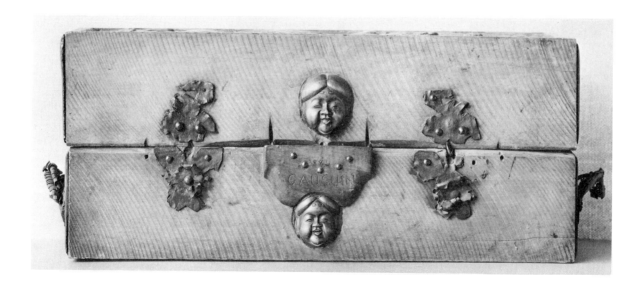

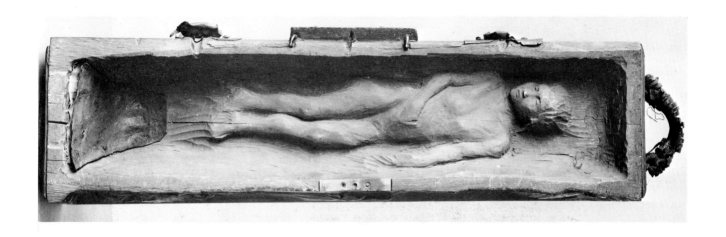

8 WOODEN BOX WITH CARVED RELIEFS OF BALLET DANCERS

L. 51½ cms. W. 14.8 cms. H. 22 cms. Signed on the back: 1884 Gauguin.

Collection: Pola Gauguin, Copenhagen; Halfdan Nobel Roede, Oslo.

References: Pola Gauguin, *My Father,* p. 67(ill.).

Photographs: O. Vaering

Notes: (See text, pp. 4–5)

This work was executed in a light-colored grainless wood which was originally in the form of two squared blocks 14.8 x 11 cms., and the back still shows the marks of the rough sawing. The ends of the blocks are covered over with thin sheets of wood to cover the end grain, and they show traces of red stain, as do the backgrounds of the carved panels. The hinges of the box are of iron, and the handles are of string with cut leather ornament. Cut leather was also used at the feet of the figure on the interior and to cover the ends of the top on the interior. The inlaid *netsuke* on the back are of wood, as is the added plaque bearing the inscription.

9 VASE IN "STILL LIFE WITH A PORTRAIT OF CHARLES LAVAL"

References: Bodelsen, *Gauguin Ceramics in Danish Collections,* pp. 5, 25.

Painting: Collection of Mr. and Mrs. Walter B. Ford, II.

Photograph: Courtesy of Wildenstein and Co.

Notes: (See text, pp. 12, 18, 25)

A sketch of this pot appears in a letter Gauguin wrote to his wife dated "6–XII–87," which is now in the Bibliotheque Doucet. In the letter the sketch appears with the comment "pas moins que 100 francs," while in the letter itself Gauguin asked: "As-tu emporte aussi un pot de ma fabrication; conserves-le moi precieusement, j'y tiens à moins que tu ne trouves à le vendre (un bon prix 100 frs.)."

Bodelsen believes that this piece was actually taken to Denmark by Mette, but she has been unable to trace it there.

Mme Jeanne Schuffenecker identified this as a piece that had been in her father's collection under the title *Tête d'un Clown.* If Mme Schuffenecker is indeed correct, then this piece is probably the one that was exhibited as number 9 in the *Gazette des Beaux-Arts* exposition in Paris in 1936.

The *Portrait of Charles Laval* is signed and dated 1886.

The same pot also appears in Gauguin's *Portrait of a Woman* (1886) in the Ishubashi Collection, Tokyo.

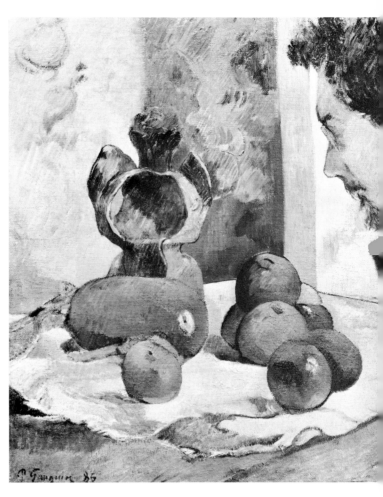

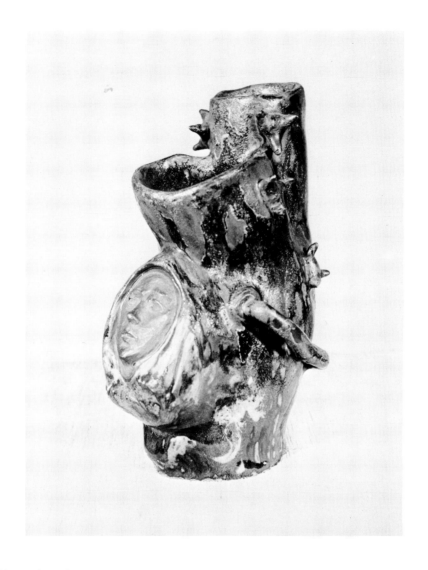

10 POT WITH A MASK

H. 19.5 cms. Brown stoneware, glazed in a mottled green, brown, and red, with touches of gold. (Plate II, p. 88)

Collections: Ambroise Vollard, Paris; Private Collection, Paris.

Exhibitions: Possibly number 2877 in the *Exposition Universelle,* Paris, 1900: Paul Gauguin: "Pot avec masque en grès emaillé (appartient à M. Schuffenecker)."

Photographs: André Ostier and the author.

Notes: (See text, pp. 12, 18, 19)

This ceramic appears in the painting *Fleurs sur une commode* dated in 1886 by Malingue (*Gauguin,* 1949, plate 106b). The glaze, which has some of the qualities of *flammé,* may be one of Chaplet's early experiments in that direction. The interior shows traces of the coiling process by which the pot was made, and is glazed a sage green with spots of black and brown. This aspect of the glaze is typical of a transition glaze, colored with the metallic oxides of iron. In the reduced state the ferrous salts are greenish, while in the oxidized state ferric salts are yellow, red, brown, or black, depending on their concentration and physical state. Chaplet is known to have been experimenting with copper transition glazes at this time, and the present pot is evidence that he was also experimenting with the iron transition glazes of the basic type of the Chinese celadon. It also seems probable that the fundamental glaze on the exterior of the pot is of the same type, with a greater degree of variegation, and possibly an enrichment with the use of other colored glazes in certain areas (see Cat. No. 25).

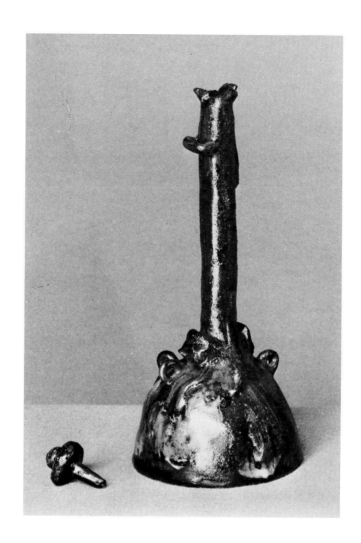

11 TALL BOTTLE WITH STOPPER

H. 20 cms. Signed: P Go on the middle of the shoulder. Brown stoneware with a mottled glaze ranging through greyish, black, and reddish brown. Areas outlined in gold.

Collections: Ambroise Vollard, Paris; Private Collection, Paris.

Photograph by the author.

Notes:

The treatment of the appendages and the glaze invite comparison with Catalogue number 10, which can be dated in the spring of 1886 on the basis of its appearance in a painting of that year.

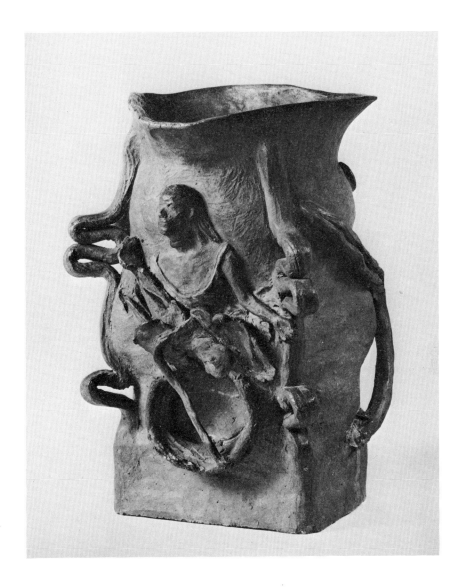

12 VASE DECORATED WITH THE HALF-LENGTH FIGURE OF A WOMAN

H. 21.6 cms. Signed; P Go. Numbered: 19. Brown unglazed stoneware. The dress of the figure is painted with white slip. The necklace is dark blue, and the leaves are green.

Collections: Mette Gauguin, Copenhagen; Karen Hannover, Copenhagen; Kunstindustrimuseet, Copenhagen (B 17/1943).

Exhibitions: Exhibition of French art at Kleis's in Copenhagen, March, 1893; Mrs. Karen Hannover's sale, Winkel and Magnussen, Copenhagen, 1943; 76–Ny Carlsberg, Copenhagen, 1948.

References: Berryer, "À propos d'un vase de Chaplet," *Bulletin des Musées Royaux d'art et d'Histoire,* January–April, 1944, p. 27; Bodelsen, *Gauguin Ceramics in Danish Collections,* Cat. No. 2, p. 25.

Photograph: Kunstindustrimuseet, Copenhagen.

Notes: (See text, pp. 12, 19)
Bodelsen states that the leaves are painted with green glaze, but that is probably due to the vitrification of the slip from the high temperature at which stoneware is fired.

This is the lowest number of the numbered series of pots that has been reported.

I am indebted to Mr. Samuel Wagstaff for pointing out that the woman's figure is probably based on a Degas drawing of a ballet dancer.

13 VASE DECORATED WITH A FISHING SCENE

H. 15 cms. Signed: P Go. Numbered: 20. Coffee-colored unglazed stoneware. The hat of the woman is painted with a darker brown slip. The foliage of the tree is done in grey-blue barbotine. On the reverse of the pot are three bonnets painted in white slip.

Collections: Musée de la France d'Outre-mer (gift of Lucien Vollard).

Photographs by the author.

Notes: (See text, pp. 12, 19)

There seems to be no suggestion of Breton influence in this pot. That and its low number suggest a date among the first of Gauguin's works in 1886.

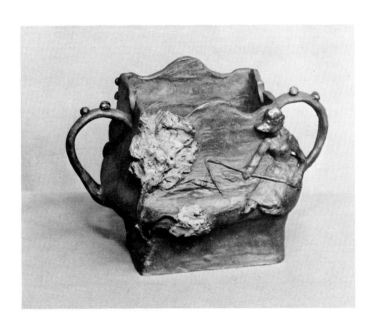

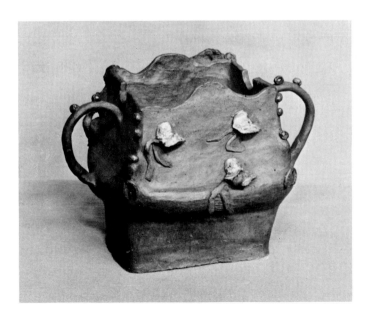

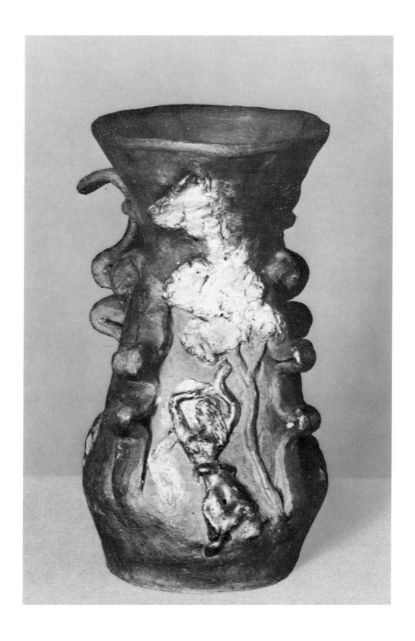

14 VASE DECORATED WITH THE FIGURE OF A DANCER

H. 13 cms. Signed P Go back of sheep on right side. Russet-colored stoneware. Decorated on the front with the figure of a dancing woman. The woman's scarf is painted with white slip, the dress with traces of black glaze and gold. The tree foliage is greyish white. On the sides are two sheep painted with white slip speckled with black glaze and touches of gold. On the back, three rosettes are painted with a brownish-green glaze accented with gold.

Collections: Ambroise Vollard; Private Collection, Paris.

Photograph by the author.

Notes:

The figure of the dancing woman recalls Gauguin's words in *Avant et Après* (p. 187; "Ces nymphes . . . gaies, vigilantes d'amour de chair et de vie, près du lierre qui enlace à Ville-d'Avray les grands chênes de Corot."

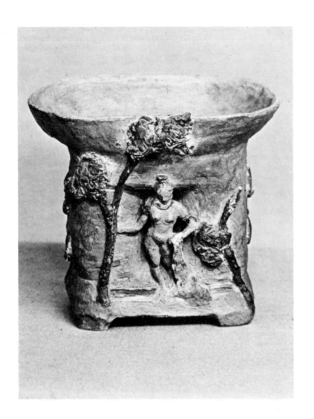
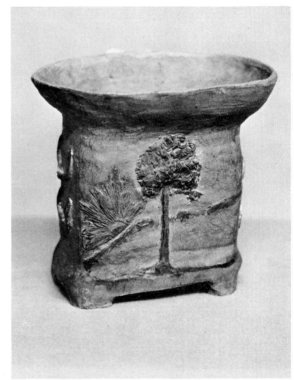

15 POT DECORATED WITH THE FIGURE OF A WOMAN UNDER A TREE

H. 13.5 cms. Signed: P Go. Buff-colored stoneware. Unglazed. The hair of the woman, the trees and leaves are painted with brown slip. The woman's robe is greyish blue-green. Accents in gold appear in places.

Collections: Musée de la France d'Outre-mer (gift of Lucien Vollard).

Photographs by the author.

Notes: (See text, p. 19)

The general similarity of the conception of this pot with that numbered 20 in the same collection (see Cat. No. 14) should indicate a date in the winter of 1886–1887. The barely visible accents of gold indicate a second firing at a lower temperature, as the gold would not stand the temperature of the firing of the stoneware.

The motif of the sunrise with radiating rays appears on a number of other pots of the period (Cat. Nos. 16, 23, 36).

The figure of the bathing woman is similar to that of the main figure in the scene of the *Arrival at Nandana* from the reliefs at Borobudur (see Cat. No. 95a). If this similarity is not a coincidence, it indicates that Gauguin had already acquired reproductions of the reliefs at Borobudur as early as 1887.

128

16 DOUBLE POT WITH HANDLES

H. 18 cms. Signed: P Go. Brown stoneware. One side of the pot is decorated with interlaced circles, the other with a figure of a mounted Arab. Above the figure of the Arab is a sunburst with a crescent. On one end a circle appears on the top of the middle throat and four loops near the top of the lower throat. On the other end a double ogive pointing upward appears on the center throat, and a starlike interlace on the lower throat. There are traces of grey glaze on the handles and on the rays of the sun. The ogive is painted in white slip, and the circle is glazed brown. The star interlace is grey-black glaze. Accents of gold appear on the sun disk.

Collections: Ambroise Vollard; Private Collection, Paris.

Photographs by the author.

Notes: (See text, p. 19)
The mounted Arab suggests the influence of Delacroix, from whose works Gauguin borrowed extensively throughout his life.

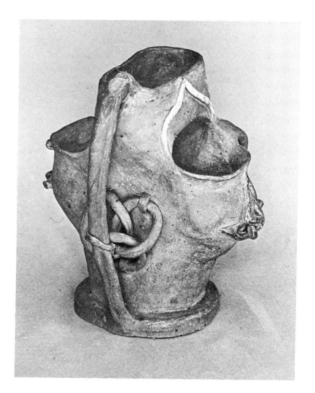

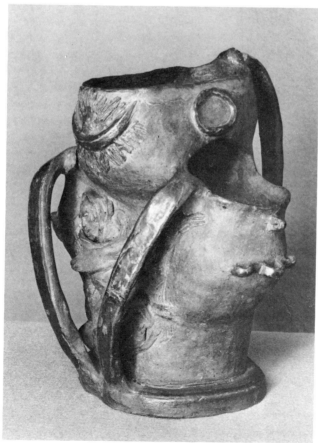

129

17 POT DECORATED WITH A LANDSCAPE OF PONT AVEN

H. 17 cms. Not signed. Brown stoneware. Unglazed.

Collections: Gustave Fayet, Béziers; Léon Fayet, Arles.

Photograph: Musées Nationaux.

Notes:

The landscape on this pot dates from 1886 (see Wildenstein, "Gauguin en Bretagne," *Gauguin, sa vie, son oeuvre,* Fig. 1). The scenic style in relief is typical of the early works of Gauguin, and this jar probably dates from the winter of 1886–1887. At the base of the handles appear two geese in relief.

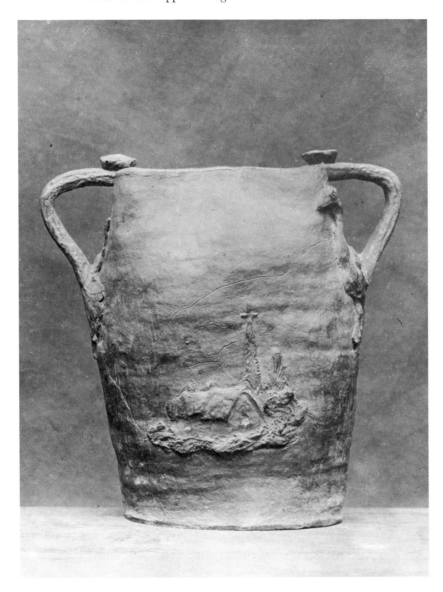

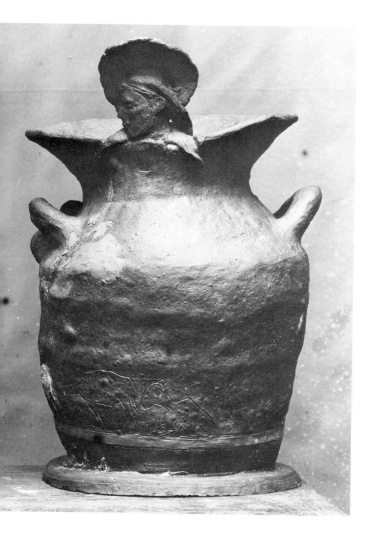

18 POT WITH A HEAD
PEEPING OVER THE RIM

H. 23 cms. Reddish-brown stoneware. Unglazed. Decorated with scene of women tending geese in incised line and slip. Tree and blue sky in background. Signed: P. Gauguin.

Collections: Gustave Fayet, Béziers; Léon Fayet, Arles.

References: Malingue, *Lettres* (1946), illustrated facing page 80.

Photograph: Musées Nationaux.

Notes:

 The figure of the ram, drawn in incised lines, is similar to the ram in the upper left corner of the panel *Soyez amoureuses* (Cat. No. 76).

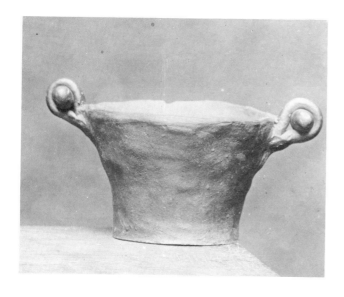

19 POT IN THE FORM OF A
CUP WITH TWO HANDLES

Photograph: Musées Nationaux.

Notes:

 This pot, together with Catalogue number 20, appears in the same photograph (Vizzavona No. 20653) as the *Pot with a Landscape of Pont Aven* (Cat. No. 17). As the latter pot was in the collection of Gustave Fayet, and many of the Vizzavona photographs of the Fayet pots show the same table, it is probable that this pot also was in the Fayet Collection. Its present location is unknown.

 The pot is apparently undecorated and unglazed.

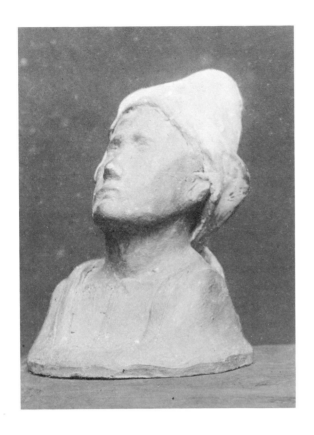

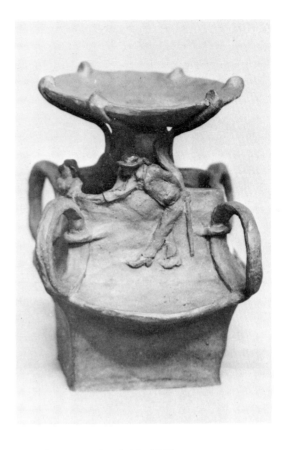

20 POT IN THE SHAPE OF A MAN'S HEAD AND SHOULDERS

Photograph: Musées Nationaux.

Notes: (See notes under Cat. No. 19)

The style of this pot suggests that of an early work. If this pot actually dates from 1886, it is perhaps Gauguin's earliest work in ceramic sculpture.

The sculpture is apparently unglazed, but may be decorated with colored slip. Its present location is unknown.

21 POT IN THE SHAPE OF A FOUNTAIN

H. 17 cms. Signed: P Go. Coffee-colored stoneware. Unglazed. The clothes of the man and woman are painted in colored slip. The man's hat is black, his coat brown, and his trousers are greenish blue-grey. The woman's hair is black, her blouse light blue, and her skirt is brown.

Collections: Musée de la France d'Outre-mer (gift of Lucien Vollard).

Photograph by the author.

Notes:

This elegant double pot is a masterpiece of hand potting. The complexity of its form suggests a higher degree of sophistication than Gauguin's earliest known pots, and it is possible that it may belong to the period after his return from Martinique.

22 VASE IN THE SHAPE OF THREE GOURDS

H. 17.5 cms. Stoneware with a dark variegated glaze, accented with touches of gold. Signed: P Go. in gold on the back of the large gourd.

Collections: Ambroise Vollard, Paris; Private Collection Paris.

Photograph by the author.

Notes:

The glaze ranges through olive green, brown, and black. The figure of the man on the large gourd should be compared with that of the man on Catalogue number 21.

This is one of the examples in which Gauguin may have been influenced by the figurative pots of the ancient Peruvians, such as the pot shown below which comes from the Chicama Valley in Peru (Collection of the Peabody Museum, Harvard University).

23 JAR WITH FOUR LEGS

H. 18 cms. Stoneware. Glazed in a mottled red-brown-green. Touched with gold. Lid ornamented with a woman and a goose.

Collections: Gustave Fayet, Béziers; Mme d'Andoque, Béziers.

Photograph by the author.

Notes: Another of the rare examples in which Gauguin furnished his pots with a lid. This type of glaze is found on a number of pots, one of which can be dated in 1886 (see Cat. No. 10).

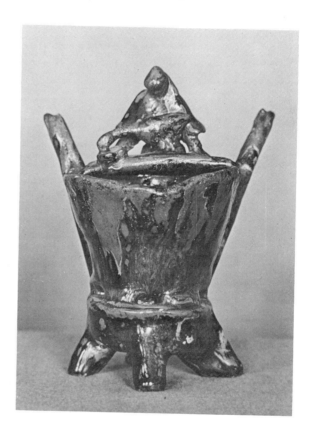

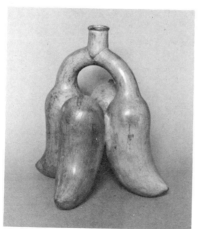

24 POT WITH WOMAN WASHING HER HAIR

Photograph: Musées Nationaux.

Notes:
This photograph shows both the markings of the Bibliothèque Nationale (BN) and those of Druet. It is among a number of photographs that Vizzavona bought from Druet in 1910 as photographs of the works of Gauguin. Its present location is unknown.

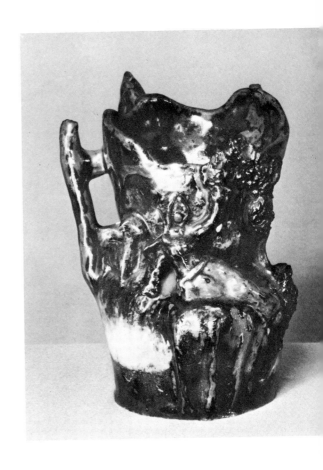

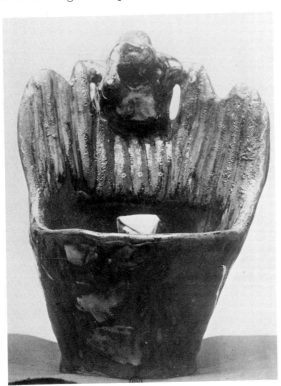

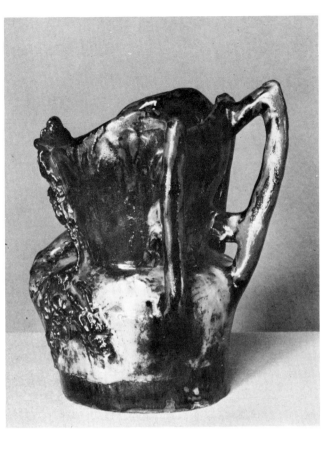

25 PITCHER WITH THREE HANDLES

H. 18 cms. Glazed brown stoneware. Signed: P Go on the side of bottom shoulder in gold. The number 47 is incised on the bottom of the pot. In addition to the three handles, the decoration of the pot consists of a semi-reclining woman on the front, reaching upward toward a mass of shrubbery. Behind her is a sheep. The figure of a goose appears between the first and second handles on the right side. The basic glaze of the pot varies from sage green to black and brown. The blouse of the woman is glazed a mottled blue, the shrubbery, green. Accents of gold appear on the blouse, on the handles, outlining the figure of the goose, and outlining various areas of color on the body of the pitcher. The interior of the pitcher is glazed a sage green with spots of dark and light brown.

Collections: Ambroise Vollard; Private Collection, Paris.

Photographs by the author.

Notes: (See text, p. 13)

The interior of the pitcher, with its greenish glaze changing in spots to brown-black, is characteristic of an iron transition glaze, in which the basic iron glaze is largely in a reduced state, in which the ferrous salts are greenish, while in spots where oxidation appears, the brown to black colors of the ferric iron salts are produced. It seems evident that the exterior of the pot is glazed with the same glaze, but that the areas of blue (the *Bretonne's* blouse) and green (the shrubbery) are produced by the use of other glazes in those areas.

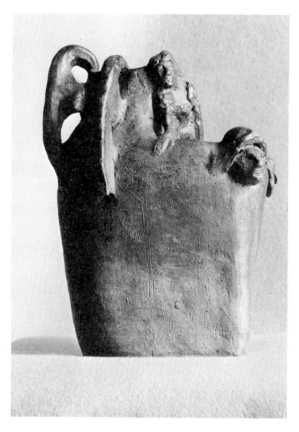

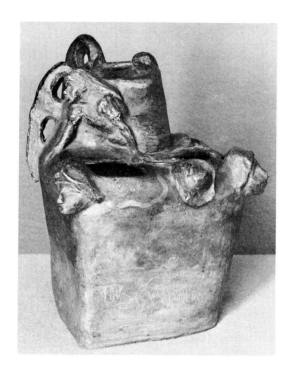

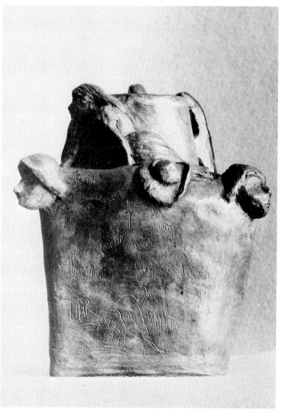

26 RUSTIC POT WITH RECLINING FIGURE

H. 16.5 cms. Leather-colored stoneware. Signed: P Go on the rim at the left front. The pot is modeled by hand on a heart-shaped base, whose characteristic form disappears above. The lower shoulder has two apertures, and is ornamented with a semi-reclining figure of a girl with a hat held by its ribbons in her left hand. The corners of the shoulder are decorated with two heads, on the lower front and left side the pot is decorated with an incised landscape. Accents of gold appear on the dress of the *Bretonne* and around the rim of the pot. The hat band is greenish black, and the three handles are decorated with black lines.

Collections: Ambroise Vollard; Private Collection, Paris.

References: Bodelsen, "Gauguin's Cézannes," *Burlington Magazine,* CIV (May, 1962), 204–11.

Photographs by the author.

Notes: (See text, pp. 14–16)

The figure of the *Bretonne* and the three handles are reminiscent of the same elements in Catalogue number 25.

This pot is apparently that shown on page 25 of the *Album Gauguin* in the Cabinet des Dessins of the Louvre (see Fig. 9c).

Bodelsen has recently shown that the scene engraved on the body of the pot was drawn from one of the paintings by Cézanne that was in the collection of Gauguin.

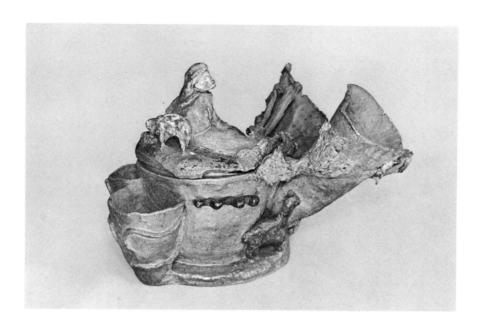

27 POT WITH A BRETON SHEPHERDESS ON THE COVER

L. 24 cms. Stoneware. Unglazed and decorated with colored slip. Signed: P Go. The shepherdess' dress is brown, the foliage is grey-green. One sheep is black, the other is irregularly covered with white slip. The decorative motif near the black sheep is blackish green.

Collections: Ambroise Vollard, Paris; Private Collection, Paris.

Photographs by the author.

Notes:

There are at least three pots of this type (Cat. Nos. 27–29). They are all marked by a very complex form and the unique horn-shaped elements. All of them are decorated with *Bretonnes*. The little figure of the shepherdess on this pot strongly recalls a number of works with a similar pose that Gauguin executed in 1886, which center around the figure in the painting *La Bergère bretonne,* executed in 1886. A more detailed discussion of the sources of this figure will be found in the notes to Catalogue number 42.

The form of the pot may have been inspired by the forms of Chinese carved steatite vases (see Fig. 13).

28 FANTASTIC POT DECORATED WITH THE FIGURE OF A "BRETONNE"

H. 13.5 cms. Brown stoneware. Signed: P Go. One side is decorated with the figure of a *Bretonne* leaning against the lower of the pot forms. Behind her is a sheep. Three geese troop clockwise around the lower pot form; on the other side of the lower pot form appears a sunburst. The *Bretonne's* bonnet is white, as are the geese. Her dress is painted in blue slip, while the shrubbery is grey-green.

Collections: Ambroise Vollard; Private Collection, Paris.

Photographs by the author.

Notes: (See text, p. 19)
See notes under Catalogue number 27.

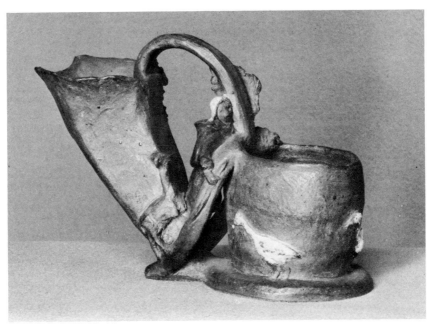

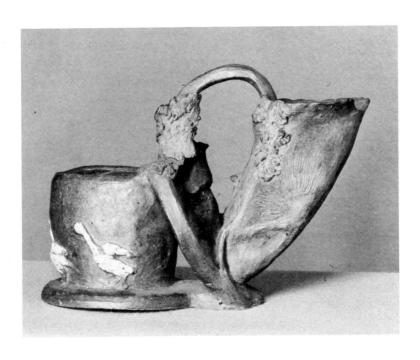

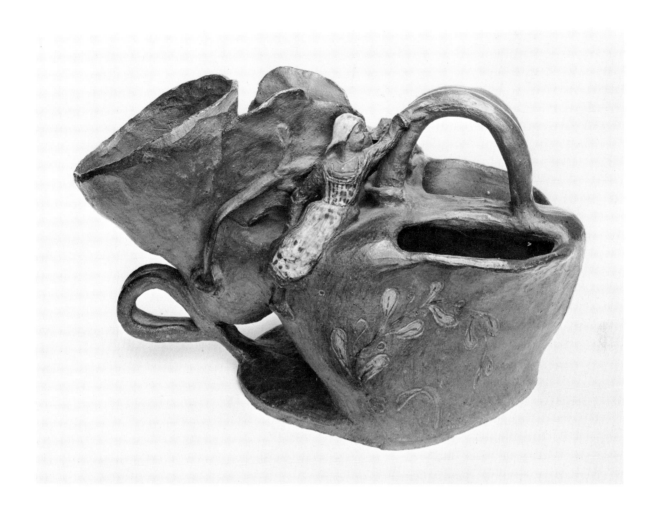

29 POT DECORATED WITH THE FIGURE OF A "BRETONNE"

L. 24 cms. H. 15 cms. Light coffee-colored stone-ware. Signed: P Go. The body consists of two joined pots. The larger is furnished with a double aperture at the top and a handle formed of two coils of clay. The smaller, funnel-shaped pot connects with the interior of the larger pot. One side of the pot is decorated with leaves joining together between the bodies of the two parts, the figure of a seated *Bretonne,* and incised foliage. The leaves are colored with sage-green slip. The jupe of the *Bretonne* is white with black spots, the dress is brown, and the bonnet white. The incised foliage is colored with light-green and bluish-black slip. On the opposite side are a couched sheep colored with white slip and a standing dog colored dark brown, as well as what appears to be patterns of incised foliage and the signature.

Collections: Mette Gauguin, Copenhagen. (Dr. Edvard Brandes, Copenhagen)?; Dr. Holger Børge, Helsinge; Povl Lunøe, Helsinge.

Exhibitions: Possibly 137–Den frie Udstillung, Copenhagen, 1893: "Jar in burnt clay 1887. Belongs to Dr. E. Brandes"; 430–Mit bedeste Kunstvaerk, Copenhagen, 1941; 77–Gauguin Exhibition, Ny Carlsberg Glyptothek, Copenhagen, 1948.

References: Bodelsen, "The Missing Link in Gauguin's Cloisonism," *Gazette des Beaux-Arts,* May–June, 1959, reproduced in Fig. 5, p. 333; Bodelsen, *Gauguin Ceramics in Danish Collections,* No. 6, pp. 27–28.

Photograph: Courtesy of Merete Bodelsen and the Carlsberg Foundation.

Notes: See notes under Catalogue number 27.

30 DOUBLE POT

H. 15.5 cms. Reddish-brown stoneware. Unglazed. Signed: P Go. The form of the bottom vase is built up by hand from a square base. The upper vase is funnel-shaped and supported by four S-shaped loops fastened to the lower vase near the rim. The fastened front of the pot is decorated with the figure of a *Bretonne* surrounded by a circle of clay. Above her are two geese with crossed necks. Below and to the left is the incised figure of a goose. Around the upper rim are two incised lines. The band between the lines at the top, the geese, and the *Bretonne* are painted with white and blue slip, accented with touches of gold. The two parts of the back of the pot are connected by three bars on which rests what appears to be a bird's nest and a bird (stork?).

Collections: Mette Gauguin, Copenhagen; Georg Achen (bought at Kleis's in 1893); Mrs. Johanne Buhl, Randers.

Exhibitions: Exhibition of French art at Kleis's art shop in Copenhagen, March, 1893.

References: Bodelsen, *Gauguin Ceramics in Danish Collections,* No. 5, p. 27.

Photographs: Courtesy of Merete Bodelsen and the Carlsberg Foundation.

Notes:

I am indebted to Merete Bodelsen for the information about this piece.

The motif of the geese with the crossed necks also appears on Catalogue number 31. The figure of the *Bretonne* enclosed in a circle is very similar in its conception to the composition within a circle (or part of one) that appears on a pair of Gauguin's *sabots* (see Cat. No. 81).

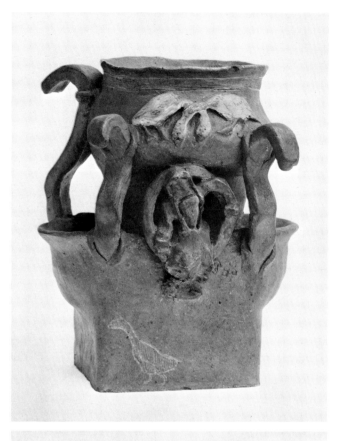

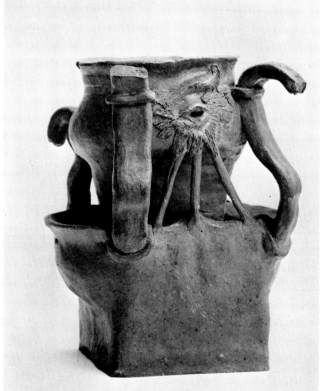

31 VASE WITH MEDALLION

H. 24.4 cms. Stoneware. Decorated with incised lines and colored slip. Not glazed. Signed: P Go. Roughly cylindrical in form built up by hand from a circular base. On one edge of the rim is a loop of clay supporting a nearly vertical disk with the figure of a crab (?) in relief. Below is the figure of a *Bretonne* with outstretched arms. Above the figure of the *Bretonne* is another disk with the figures of two geese executed in incised lines. The sides of the jug are ornamented with handle-like loops of clay. The bonnet of the *Bretonne* is colored in white slip, and her bodice in blackish blue. Her skirt is indicated by incised lines. The crescent of the disk above the incised geese is colored white. Along the upper rim of the pot are a series of irregular forms, outlined with incised lines with traces of colored slip and possibly glaze.

Collections: Mette Gauguin, Copenhagen; Emil Hannover, Copenhagen (probably bought at Kleis's in 1893); Mrs. Karen Hannover, Copenhagen; Kunstindustrimuseet, Copenhagen (B 16/1943).

Exhibitions: Exhibition of French art at Kleis's art shop in Copenhagen, March, 1893; Mrs. Karen Hannover's sale; Winkel & Magnussen, Copenhagen, 1943 79–Gauguin Exhibition, Ny Carlsberg Glyptothek, Copenhagen, 1948.

References: Bodelsen, *Gauguin Ceramics in Danish Collections*, No. 3, p. 26.

Photograph: Kunstindustrimuseet, Copenhagen.

Notes: (See text, p. 19)

I am indebted to Merete Bodelsen for the documentation of this piece.

The curious loops which decorate the sides of the pot are similar to those on Catalogue numbers 10 and 11.

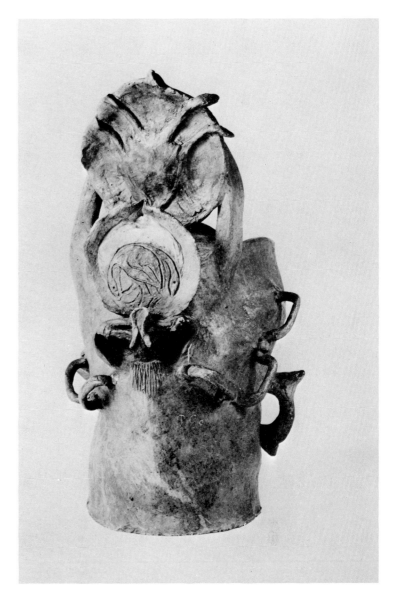

The figure of the *Bretonne* with outstretched arms is one that Gauguin used many times. She appears on other pots catalogued under the numbers 32–36. Perhaps the first appearance of this figure is on page 98 of a sketchbook that Gauguin used in Brittany in 1886 (ed. Cogniat) where the little *Bretonne* is drawn accompanied by a goose. On page 73 of the same sketchbook she appears on the decoration of two drawings for pots, one of which can be identified with Catalog number 35. A drawing of the same figure appears in the *Album Gauguin* in the Cabinet des Dessins of the Louvre on page 4, and another, together with a sketch of a pot on which the figure is used, appears on page 25. The motif on page 25 of the *Album Gauguin* was also used on a pair of Gauguin's *sabots* (see Cat. No. 81).

141

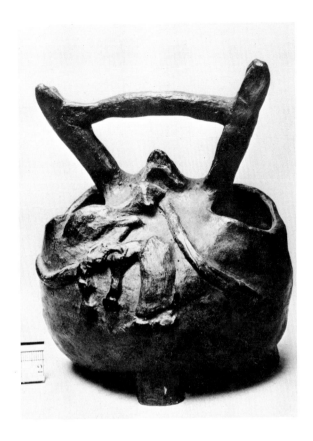

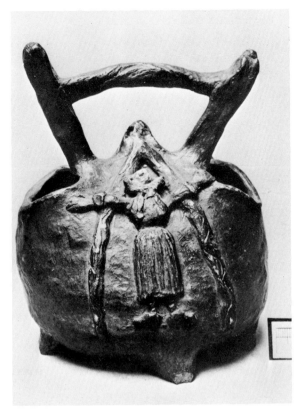

32 POT WITH STIRRUP HANDLE

H. 15 cms. Stoneware? Unglazed? The pot has a round body with two apertures, a stirrup-like handle, and four feet. One side is decorated with the figure of a *Bretonne* with arms outstretched and passing in front of a pointed arch formed of strips of clay with a braidlike pattern on their surface. On the other side appears a *Bretonne* in the position of a gleaner, again framed by garland-like strips of clay. Above her and to the left is the form of a sheep.

Collections: Amédée Schuffenecker, Paris; Boucheny-Bénézit, Paris; present location unknown.

Photograph: Giraudon.

Notes: (See text, p. 19)

Information about this piece was furnished by Mme de la Chapelle, sister of Mme Boucheny-Bénézit.

The decoration combines the *Bretonne* with outstretched arms (see notes under Cat. No. 31) with the gleaner which also appears on the pot listed under Catalogue number 38.

The form of the pot is based on that type of pot found in the Nazca region of Peru, of which an example is shown (below left). (Collection of the Peabody Museum, Harvard University.)

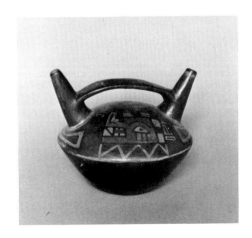

142

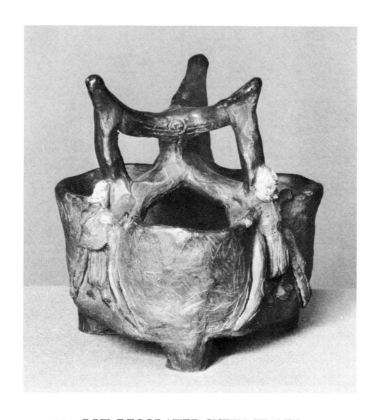

33 POT DECORATED WITH THREE "BRETONNES" AND A TRIPLE HANDLE

H. 15 cms. Brown stoneware. The pot is decorated with the figures of three symmetrically placed *Bretonnes* with garland-like motifs that flow from their waists to the ground. In the areas between the women there are figures of incised geese. A zig-zag motif runs around just under the lip of the pot. The triple handle is incised with graining and a knot to look like tree branches. The *Bretonnes* have white caps and buff jackets with blue-grey skirts, all painted in slip.

Collections: Ambroise Vollard; Private Collection, Paris.

Photograph by the author.

Notes: (See text, p. 19)
See notes under Catalogue number 31. Compare Catalogue number 32 for the use of similar motifs.

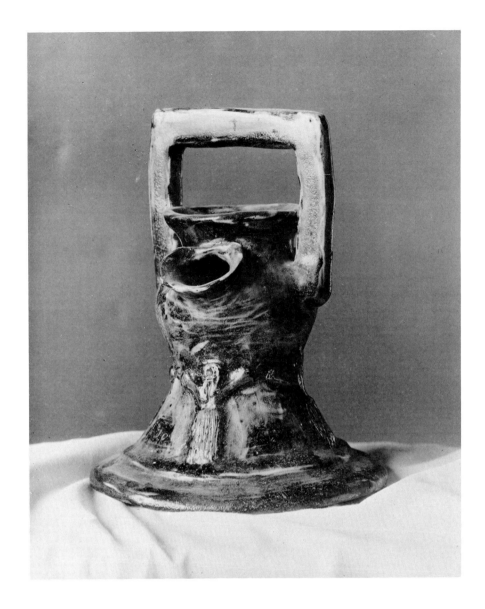

34 WATER JUG WITH A SQUARE HANDLE, DECORATED WITH THE FIGURES OF THREE "BRETONNES"

Stoneware. Decorated with colored slip and glazed.

Collections: Private Collection, Oslo(?).

References: Berryer, "À propos d'un vase de Chaplet," *Bulletin des Musées Royaux d'Art et d'Histoire,* January–April, 1944, p. 18(ill.), p. 19.

Photograph: O. Vaering, Oslo.

Notes: (See text, pp. 19–20)
Berryer describes the piece as follows: "Bretonnes

vêtues de jupes bleuatres, rehauts d'or." The motif of the *Bretonne* with outstretched arms appears on a number of vases (see notes under Cat. No. 31).

I have been unable to locate this very important vase which apparently has not been recorded since Berryer's article in 1944. Though in general form this pot conforms to those typical of the pots Gauguin executed in the winter of 1886–1887, the glaze seems not to be the type of iron transition glaze that he used on most of his glazed works of that period. The only other known example of a more or less uniform glaze from this period is the jardiniere catalogued under number 41.

What may be a preliminary sketch for this pot appears in one of Gauguin's sketchbooks for 1886 (see Fig. 10c).

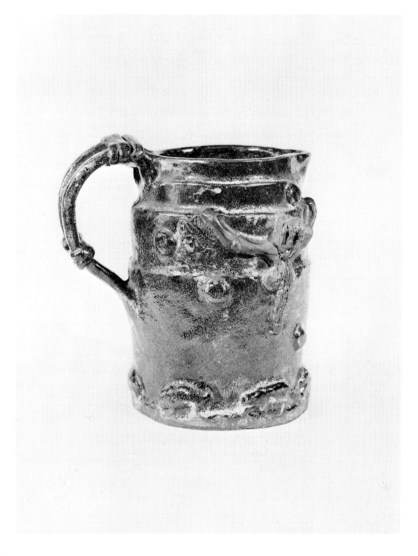

35 PITCHER

H. 16 cms. Stoneware. Glazed an irridescent brown. Decorated with barbotine and touches of gold. Not signed.

Collections: Ernest Chaplet; Union Centrale des Arts Décoratifs (No. 16983); Musée des Arts Décoratifs, Paris.

Exhibitions: Probably #2876 in the *Exposition Universelle,* Paris, 1900: "Paul Gauguin—un pichet modelé, execution de M. Chaplet, 1887, appartient à M. Chaplet."

References: Bodelsen, "The Missing Link in Gauguin's Cloisonism," *Gazette des Beaux-Arts,* May–June, 1959, pp. 329–41 (ill.).

Photograph: Musée des Arts Décoratifs, Paris.

Notes: (See text, pp. 18–20)

This piece was given by Chaplet to the Union Centrale des Arts Décoratifs, and later passed to the Musée des Arts Décoratifs. Though the catalogue of the *Exposition Universelle* of 1900 suggests that Chaplet had a hand in the making of this pot, the appearance of a sketch for this pot in Gauguin's *carnet* (ed. Cogniat) on page 73 (Fig. 10c), where it is associated with other material from the fall of 1886, suggests that the work is, except for the firing, the sole production of Gauguin. The motif of the *Bretonne* with outstretched arms is discussed under Catalogue number 31.

The date, which was given the piece during Chaplet's lifetime, is significant in establishing the chronology of Gauguin's work in ceramics.

36 VASE DECORATED WITH THE FIGURE OF A BRETON WOMAN

H. 14 cms. Signed: P Go. Numbered: 49. Reddish-brown stoneware. Unglazed. Decorated with a figure of a Breton woman with upstretched arms, three handles, and sunbursts on the rim at the side. The bodice of the Breton woman is painted with slip a bluish grey-green, her head covering is painted in white slip. She stands on a brown base in which her feet are incised. The handles are dark brown, and the ornaments incised and painted black and green in slip.

Collections: Mette Gauguin, Copenhagen; Emil Hannover, Copenhagen (probably bought at Kleis's, 1893); Karen Hannover, Copenhagen; Kunstindustrimuseet, Copenhagen (B 15/1943).

Exhibitions: Exhibition of French art at Kleis's art shop, Copenhagen, 1893; Mrs. Karen Hannover's sale, Winkel & Magnussen, Copenhagen, 1943; 78-Gauguin Exhibition, Ny Carlsberg Glytothek, Copenhagen, 1948.

References: Berryer, "À propos d'un de Chaplet," *Bulletin des Musées Royaux d'Art et d'Histoire,* January–April, 1944, Fig. 22, pp. 16, 19; Bodelsen, *Gauguin Ceramics in Danish Collections,* Cat. No. 4, Fig. 4, p. 26.

Photographs: Kunstindustrimuseet, Copenhagen, and the author.

Notes: (See text, pp. 13, 19)
The figure of the *Bretonne* should be compared with the similar figures mentioned under Catalogue number 31.

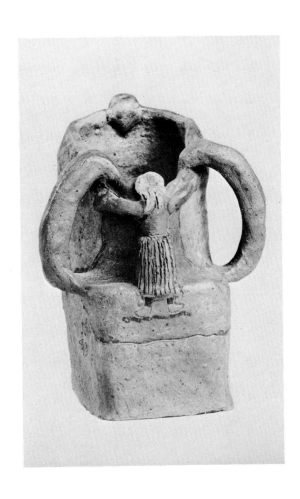

37 POT GIVEN TO THEO VAN GOGH

H. 15.5 cms. W. 13.5 cms. Depth 9.5 cms. Stoneware. Signed: P. Go. Front decorated with a reclining nude figure with flowers. Back decorated with a tree with swine on either side rooting in the ground. The upper part of the pot is glazed.

Collections: Theo van Gogh, Paris; Ir. V. W. van Gogh, Laren.

References: Bodelsen, *Gauguin Ceramics in Danish Collections,* p. 1, note 2; M. E. Tralbaut, "Rond een pot van Gauguin," *Mededelingenblad, Vrienden van de nederlandske Ceramiek,* No. 18 (April, 1960), pp. 15–19; *Album Gauguin,* Cabinet des Dessins, Louvre, p. 25.

Notes: (See text, p. 16)

This pot was given to Theo van Gogh by Gauguin and is almost certainly that mentioned in his notebook (ed. Huyghe) on page 223: "Van Gog (*sic*) pot donné."

The theme on the front is apparently based on Puvis de Chavanne's painting entitled *Hope.*

A drawing which is probably a preliminary sketch for this work appears on page 73 of the Gauguin *carnet* edited by Raymond Cogniat (see Fig. 10c). Another drawing of this pot appears in the *Album Gauguin* in the Louvre (see Fig. 10c).

As the author has not been able to see this pot, the description is based on the publication of Tralbaut, and conversations with Bodelsen.

The presence of the sketch for the pot in the *carnet* edited by Cogniat suggests that it was probably made in the winter of 1886–1887.

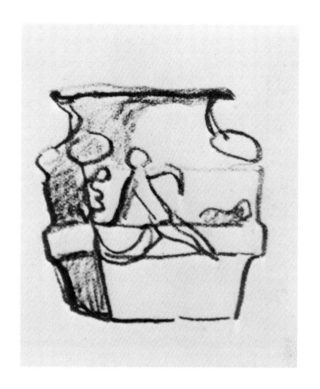

38 POT DECORATED WITH THE FIGURE OF A BRETON WOMAN

H. 13 cms. Signed: P Go. Numbered: 50. Dark-brown, unglazed stoneware. Decorated with a figure of a Breton woman in a landscape. Her bonnet is painted in white slip, her skirt in deep green. The tree trunk is white, the foliage green. (Plate III, p. 89)

Collections: Odilon Redon, Paris; Ari Redon, Paris.

References: Rewald, *Post-impressionism*, p. 446; Huyghe, *Carnet de Gauguin*, II, 159, 201, 222.

Photographs by the author.

Notes: (See text, p. 13)

Gauguin gave this pot to Odilon Redon in an exchange about January, 1890. After the sale at the Hotel Drouot on February 22, 1891, Gauguin made a list of the disposition of his works in recent years and listed among them:

Redon – Pot – échange

(Huyghe, II, 222).

The figure of the woman sharply bent over, apparently gleaning, is in a pose that seems to have intrigued Gauguin in 1888, as it appears in several variations in his sketchbook at that time (*ibid.*, pp. 159, 201).

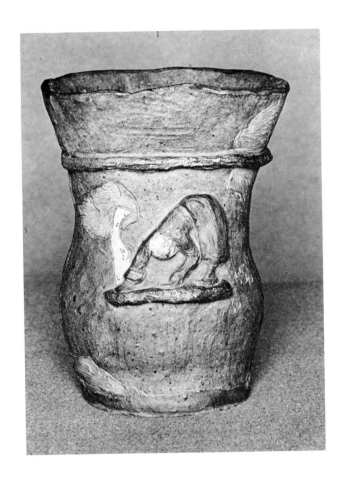

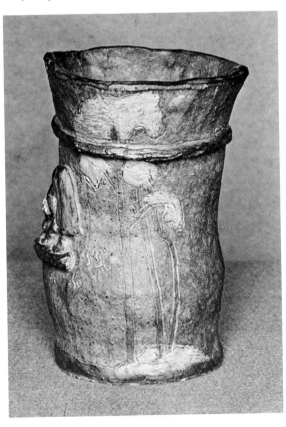

39 POT IN THE FORM OF THE HEAD OF A "BRETONNE"

H. 14 cms. Brown stoneware. Cap painted in black slip and ornamented with gold dots. Signed on the handle: P Go. Numbered (on the handle): 54.

Collections: Mette Gauguin, Copenhagen; Dagfin Werenskiold, Oslo.

Exhibitions: 59–Kunstnerforbundnet, Oslo, 1955.

Photographs: O. Vaering and the author.

Notes: (See text, pp. 13–14, 24)

According to Mr. Werenskiold this vase was brought to Oslo by Mette Gauguin's sister, Pylle Gad, who acted more or less as Mette's agent in seeking to sell Gauguin's works in that country. The number 54 on the ticket on the bottom suggests that the numbering which appears on some of the pots corresponds with the number of pots that Gauguin had executed at that time. Otherwise, it would seem too great a coincidence to have another numbered series on the tickets in which the number 54 corresponded with the pot with the incised number 54 on the pot. See text p. 13 for a further discussion of the significance of this numbering.

This pot marks a break with the usual manner in which Gauguin made his pots, for, instead of being built up as a pot from a base, this head was modeled in a solid mass of clay and hollowed out in the back of the head afterward. This procedure seems to indicate that Gauguin had conceived the piece as ceramic sculpture, and only afterward considered turning it into a pot, partly, perhaps to reduce the thickness of the body in order to permit its firing without danger of breaking. In this new approach to his ceramics, Gauguin is already anticipating his increased interest in ceramic sculpture after his return from Martinique.

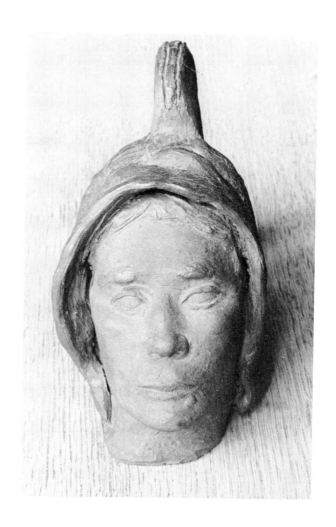

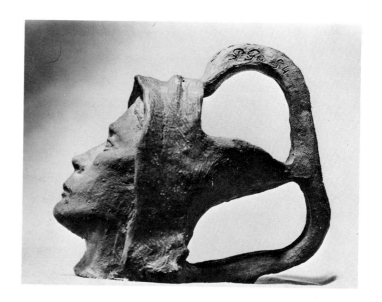

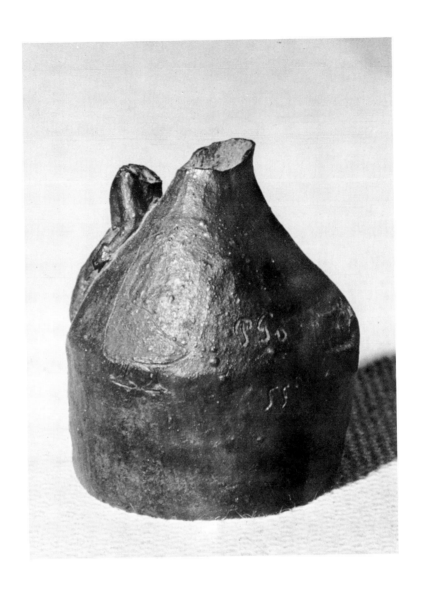

40 POT NUMBERED 55

H. 9.5 cms. (broken state). Signed: P Go. Numbered: 55. Reddish-brown stoneware. Not glazed. The pot is decorated with the figure of a *Bretonne* painted with slip and some glaze with accents of gold. The stick which the girl holds is gold. Incised geese appear on either side of the girl.

Collections: Mogens Ballin, Copenhagen; Esther Bredholt, Copenhagen; Private Collection, Denmark.

Exhibitions: Possibly 168–Den frie Udstilling, Copenhagen, 1893: "Jar in burnt clay. Belongs to the painter Mogens Ballin."

References: Bodelsen, *Gauguin Ceramics in Danish Collections,* Cat. No. 7, p. 28.

Photograph: Courtesy of Merete Bodelsen.

Notes: (See text, pp. 13–14)
The jar has been broken, and the upper part of the neck and lip as well as the head of the *Bretonne* are now missing.

41 RECTANGULAR JARDINIERE DECORATED WITH BRETON SCENES

H. 27 cms. L. 40 cms. W. 22 cms. Stoneware decorated with colored glaze. Signed: P. Gauguin. Stamped with Chaplet's seal (rosary) with H & Co (Haviland and Company) in the center.

Collections: Émile Schuffenecker, Paris; Amédée Schuffenecker, Paris; Jeanne Schuffenecker, Paris; Private Collection, Brittany; Oscar Ghez, Geneva.

Exhibitions: Possibly No. 174–Gauguin Retrospective, Paris, 1906: *"Jardinière émaillé*–Schuffenecker Collection"; 39–Luxembourg, Paris, 1928; 20–*Gazette des Beaux-Arts,* Paris, 1936; 23–Auction sale, Palais Galleria, Paris, December, 1960 (illustrated in the exhibition catalogue, plate XII).

Photographs: Courtesy of the Galerie Urban.

Notes: (See text, pp. 23–24)

The presence of the Chaplet rosary with the H & Co indicates a date in the fall of 1886, for we know that Chaplet had stopped working for Haviland in 1887. The presence of Breton motifs indicates that the piece could not have been executed before the fall of the year. The signature, P. Gauguin, now missing, is recorded in the catalogue of the Luxembourg Exhibition in 1928.

Though this piece was badly damaged in World War II during the bombardment of Cherbourg, it still retains two of its sides and the bottom intact. Chaplet's mark on the bottom indicates that the body was made by him, while the decoration was executed by Gauguin. The Breton scenes formed in part in relief, and in part by incised lines, have been painted in glaze colors, and some of the outlines have been emphasized by the use of gold lines. The background is a darkish bluish-green turning to brown in certain areas. In places the foliage has been glazed dark green. The figure on the front is glazed in parts with a salmon color changing to a whitish pink. The geese below the figure on the front are bluish grey outlined with white. On the broken end, the water jug held by the boy is a brown red. The base is a greenish brown.

The glaze has run heavily, and it is probable that the colors have changed in the firing from what was intended by the artist. The fact that the glaze has

(continued next page)

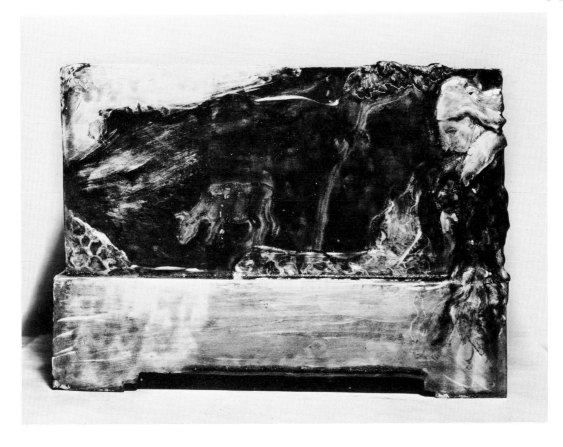

run so heavily indicates that it was probably a lead glaze.

The figure of the boy with the red jug is based on a drawing in colored crayon which appears in one of Gauguin's *carnets* (Paul Gauguin, *Carnet de croquis,* text by Raymond Cogniat, foreword by John Rewald [New York, 1962], p. 38 (see Cat. No. 41*a*).

The figure of the cow on the front is probably based on a sketch in the same notebook on page 99.

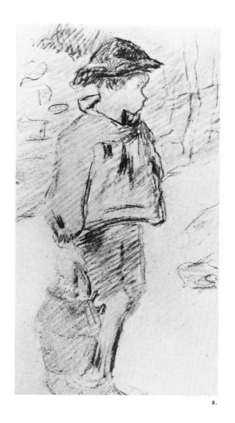

a.

153

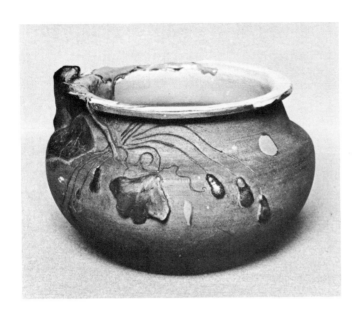

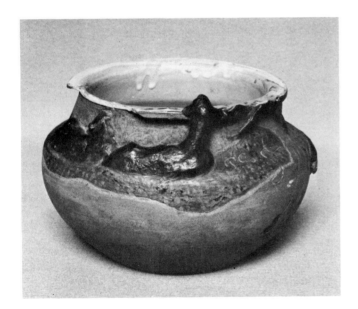

42 VASE IN STONEWARE DECORATED WITH SHEEP

H. 10.6 cms. Buff stoneware. Signed: P Go. Stamped on the bottom with Chaplet's seal surrounding H & Co. The exterior is ornamented with two sheep modeled in relief, and plant forms incised and in relief. The sheep are dark brown with gold accents. The ground under the sheep is dark green. Both colors are partly vitrified. The leaf is dark green with gold accents; the "fruit" are brown (either vitrified slip or glaze); to the right and left of the fruit are two drops of salmon-colored glaze outlined in gold. The interior is glazed grey with spots of salmon-colored glaze on the interior and on the rim near the sheep.

Collections: Gustave Fayet, Béziers; Mme P. Bacou, Paris; Jean Pierre Bacou, Paris.

References: Bodelsen, *Gauguin Ceramics in Danish Collections*, p. 33, note 11.

Photographs by the author.

Notes: (See text, pp. 18, note 47, 23)

This vase, in which the body was made by Chaplet and the decoration was added by Gauguin, recalls the stoneware that was being made by Haviland under Chaplet's supervision. This pot is closely similar in conception to Catalogue number 35.

The larger sheep is very similar to the sheep that appears in the left foreground of Gauguin's painting, *La Bergère bretonne,* which served as a model for the decoration of the rectangular jardiniere catalogued under number 44. The source of this sheep is probably to be found on the page of drawings of sheep in Gauguin's sketchbook of 1886 (ed. Cogniat, p. 101).

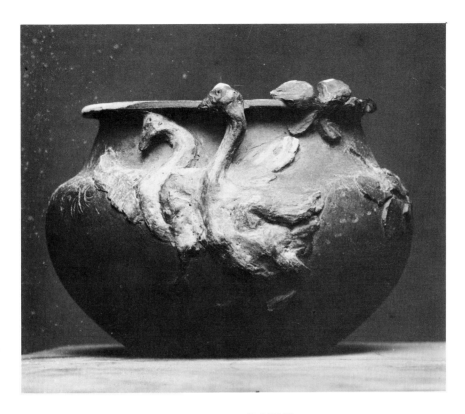

43 VASE IN STONEWARE DECORATED WITH GEESE

H. 12 cms. Chocolate-colored stoneware. Glazed grey with touches of red on the interior. Exterior decorated with relief modeling in colored barbotine, and accented with incised lines and touches of gold. Signed: P Go on the shoulder. Signed on the bottom with Chaplet's stamp (rosary) with H & Co (Haviland and Company) in the center. Stamped number: 31(?) on bottom.

Collections: Gustave Fayet, Béziers; Mme d'Andoque, Béziers.

Exhibitions: Possibly number 56–Gauguin Retrospective, Paris, 1906: *"Oies (vase)."*

References: Bodelsen, *Gauguin Ceramics in Danish Collections,* p. 33, note 11.

Photograph: Musées Nationaux.

Notes: (See text, p. 23)
 One of a small group of vases in which the body was made by Chaplet and the decoration was executed by Gauguin. This vase is very close to Catalogue number 42. The Chaplet mark with H & Co indicates a date in 1886.

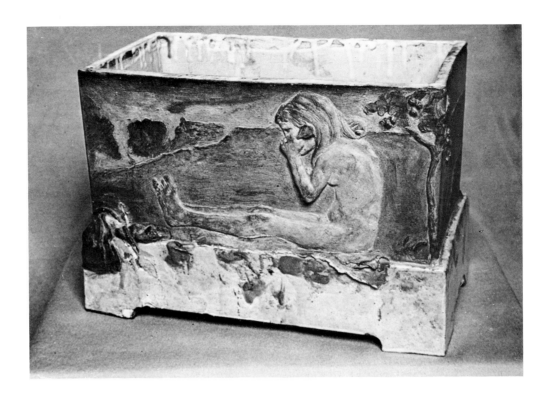

44 RECTANGULAR JARDINIERE DECORATED IN BARBOTINE

H. 27 cms. L. 40 cms. W. 22 cms. Stoneware decorated with barbotine and glaze. Signed: P. Gauguin. On one side is the figure of a girl seated in a landscape brushing her hair. On the other side is a *Bretonne* with a cow and a goose. The shepherdess has a white bonnet, a black jupe, an orange apron, and a grey skirt with black stripes. The goose is white, and the fence light brown. The grass is green, and the distant landscape whitish; on one end the landscape continues with a black sheep, and on the other with two leaden-colored geese. On the back, the figure is buff with reddish hair, the grass is green, and the distant house brown. The foliage is a blackish green. The base is glazed ivory with reddish areas. The interior is glazed a light grey. (See Plate IV, p. 89)

Collections: Gustave Fayet, Béziers; Mme P. Bacou, Paris; Mlle Roseline Bacou, Paris.

Exhibitions: Possibly number 54–Gauguin Retrospective, Paris, 1906: *"Jardinière (sujets de Bretagne)"* (Collection Gustave Fayet).

References: Read, "Gauguin and the Return to Symbolism," *Art News Annual,* 1956, pp. 152–58(ill.).

Photographs by the author.

Notes: (See text, p. 24)

This magnificent jardiniere, whose only defect is a crack in firing on the base at the feet of the seated nude figure, is a pair with that of Catalogue number 41. However, this piece does not bear Chaplet's seal as did Catalogue number 41.

There are a number of factors that help in the dating of this piece. Its similarity to that catalogued under number 41 suggests that it was made about the same time. The use of barbotine indicates that the failure of the glaze technique in the earlier work imposed the use of a coloring material that would not run on firing. In the circular jardiniere catalogued under number 45, Gauguin used a system of cloisons to control the running of the glaze, so it seems probable that this piece was executed sometime between Catalogue numbers 41 and 45, probably early in 1887.

The scene on one side is based on the relief panel *La Toilette* of 1882 (Cat. No. 7). The scene on the other side is apparently based on the painting *La Bergère bretonne* of 1886 (see Cat. No. 44a). Preliminary drawings of the figures appear in Gauguin's sketchbook for 1886 (see Paul Gauguin, *Carnet de croquis,* text by Raymond Cogniat [New York, 1962], pp. 101–4, 106–9).

A working drawing of this jardiniere was in the collection of Ernest Chaplet (Cat. No. 44b).

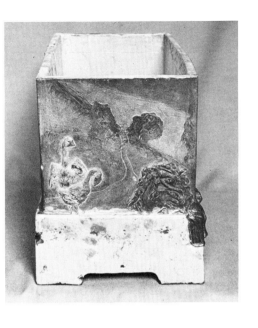

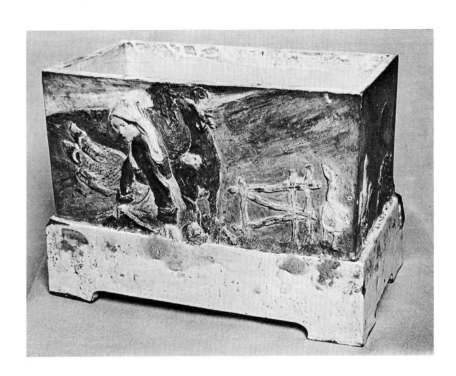

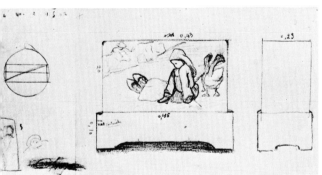

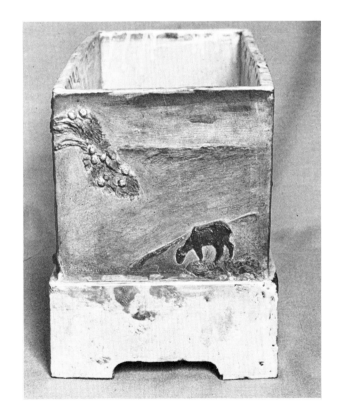

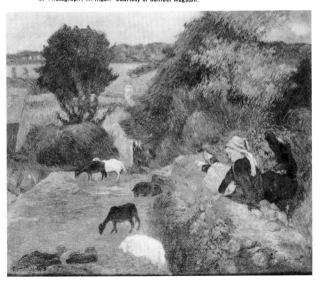

a.

157

45 VASE DECORATED WITH BRETON SCENES

H. 29.5 cms. Chocolate-colored stoneware decorated with colored glazes, incised outlines and lines in gold. Signed: P Go in gold on the lower edge of the decorated zone. Stamped with Chaplet's mark and the number 21 on the bottom. The background is white, foliage blue, tree trunks brown, ivy green. The flesh tones are salmon colored.

Collections: Ernest Chaplet, Choisy-le-Roi; Musées Royaux d'Art et d'Histoire, Brussels (bought in 1896).

Exhibitions: 77–*La Libre Esthétique,* Brussels, 1896; 87–Orangerie, Paris, 1949.

References: Berryer, "À propos d'un vase de Chaplet," *Bulletin des Musées Royaux d'Art et d'Histoire,* January–April, 1944, pp. 13–27; Bodelsen, "Gauguin's Bathing Girl," *Burlington Magazine,* CI:dclxxiv (May, 1959), 187; Bodelsen, "The Missing Link in Gauguin's Cloisonism," *Gazette des Beaux Arts,* May–June, 1959, pp. 329–44.

Photographs: Copyright A.C.L. Brussels.

Notes: (See text, pp. 18, 24, 29)
Bodelsen (1959) has shown that this work is closely related to the techniques that Chaplet was using in his workshop on the Rue Blomet, before his move to Choisy-le-Roi in the beginning of 1888 to devote himself to the rediscovery of the secrets of oriental *flammé* glazes. As Chaplet seems to have used the H & Co of Haviland in his stamp in the fall of 1886 and it does not appear here, the presumption must be that this piece dates from a period not earlier than 1887. Bodelsen has also shown that the motifs of the decorations are drawn from *Les Bretonnes* (Munich, Bayerische Staatsgemäldesammlungen), signed and dated 1886, and the drawing *Breton Girl* (Art Institute, Chicago, reproduced in Rewald, *Gauguin Drawings,* No. 6), which also probably dates from 1886. We can say with some assurance that the work was not done before 1887, but the statement that it could not have been done later because Chaplet was no longer working in this manner after Gauguin's return from Martinique is less sound, for at least one other piece done in the same technique in which Chaplet and Gauguin collaborated can be attributed to a period after the painter's return from Martinique (see Cat. No. 64).

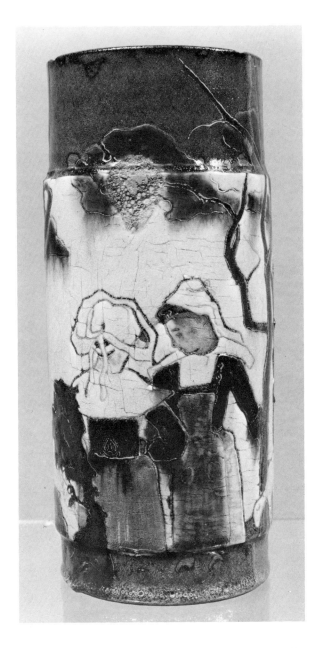

The technique of this ceramic is interesting, and differs from the usual methods of Chaplet. It is apparently an elaboration of a technique which the potter Theodore Deck had developed in 1874, which he called *"émaux cloisonnés":*

> Un travail dont la décoration est ornée d'un trait en relief; les creux sont remplis d'émaux colorés transparents. (Théodore Deck, *La Faience,* p. 266)

However, the actual technique used here is a further modification in which a line of a greasy resist, rather than a raised line, is used to prevent the colors from flowing.

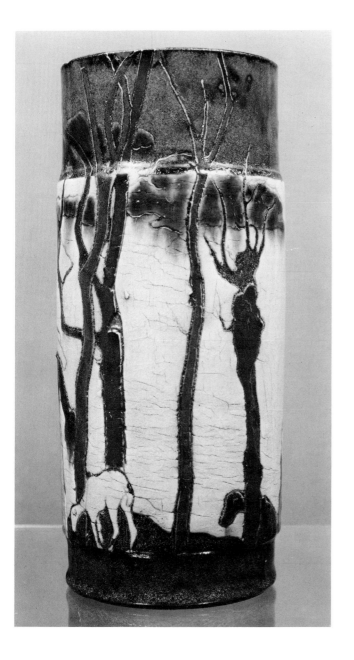
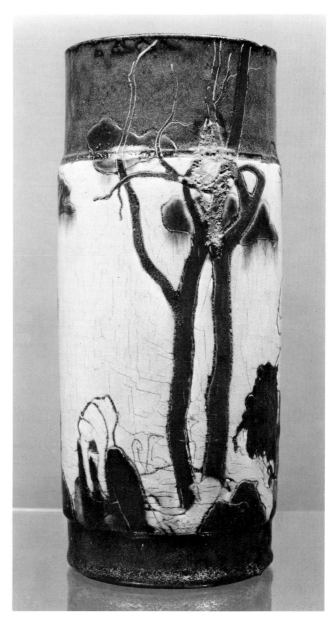

46 RECTANGULAR POT

H. 15 cms. Stoneware. Glazed with a blackish-brown mottled glaze with accents of gold. Signed: P Go. Marked 56 on the bottom.

Collections: Gustave Fayet, Béziers; Private Collection, France.

Exhibitions: Possibly No. 59–Gauguin Retrospective, Paris, 1906: *"Petit Sarcophage* (Collection G. Fayet; Céramiques)."

Photograph by the author.

Notes: (See text, pp. 13–14)

The glaze on this pot, typical of a number of Gauguin's works in 1886–1887, is a dark mottled color, ranging from reddish to greenish with occasional touches of bluish. The glaze does not cover the pot well, producing the effect of water on a greasy surface, gathering in some spots and running off others. Bodelsen has suggested to me that the signature was originally in gold, and that the gold has rubbed off leaving only the black.

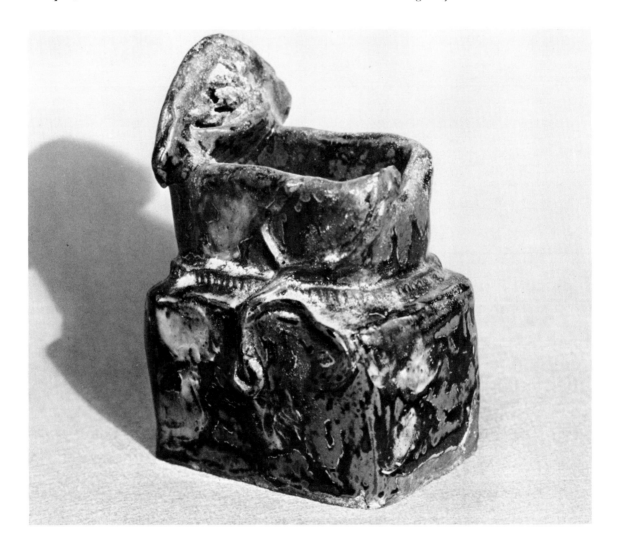

47 DAGGER WITH SHEATH

L. 20 cms(?). Blade made of a bayonet. Handle carved wood. Sheath of bamboo decorated with designs burnt in with a hot iron. Signed: P. Go.

Collections: Émile Schuffenecker, Paris; Amédée Schuffenecker, Paris; Mme Jeanne Schuffenecker, Paris; present whereabouts unknown.

Exhibitions: 29–Nunes et Fiquet, Paris, 1917; 30–Luxembourg, Paris, 1928; 226–Thannhauser Gallery, Berlin, 1928; 250–Kunsthalle, Basel, 1928; 66–*Gazette des Beaux-Arts,* Paris, 1936.

References: Varenne, "Les Bois gravés et sculptés de Paul Gauguin," *La Renaissance de l'Art française,* December, 1927, p. 524(ill.).

Photograph: Musées Nationaux.

Notes: (See text, p. 25)
Though there has been some confusion in recording the dimensions of this dagger, the bamboo sheath with the burnt decoration identifies this dagger with Martinique.

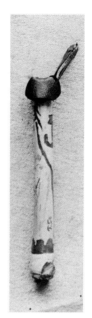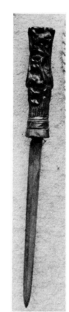

48 BRUSH HOLDER

H. 20 cms. Bamboo. Decorated with designs burnt with hot iron. Signed: P Go. Inscribed: "Á l'Ami Schuff." "Martinique 1887."

Collections: Émile Schuffenecker, Paris; Amédée Schuffenecker, Paris; Galerie St. Étienne, New York.

Exhibitions: 26–Nunes et Fiquet, Paris, 1917; 99–Wildenstein, New York, 1946.

References: Zolotoe Runo, I:i (1909), 5–14(ill.).

Photograph: Galerie St. Étienne.

Notes: (See text, p. 25)

According to the statement of J. B. de la Faille, this piece was sold by Amédée Schuffenecker in 1926.

Another piece of bamboo decorated in the same manner formed a sheath for one of Gauguin's daggers (see Cat. No. 47).

49 VASE IN THE FORM OF THE UPPER PART OF THE TORSO OF A WOMAN

H. 26 cms. Chocolate-colored stoneware. Signed: P. Gauguin. Numbered: 56. The woman's necklace is glazed in black and green with accents of gold and the eyelashes and eyebrows painted in black slip. The hair is dark brown, and there are green discs over the breasts. The hands(?) are painted black and green, while the tail is painted black and green with accents of gold.

Collections: Ambroise Vollard, Paris; Private Collection, Paris.

Photographs: André Ostier and the author.

Notes: (See text, pp. 13–16, 23–24, 29)

This pot is represented in a charcoal and wash drawing in the collection of Mr. and Mrs. Henry R. Stern, Mineola, New York. The drawing bears the inscription: "Pots en grès Chaplet" (see Cat. No. 49a). Another representation of this pot appears on page 27 of the *Album Gauguin* in the Cabinet des Dessins of the Louvre (see Fig. 9d).

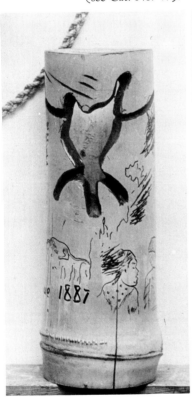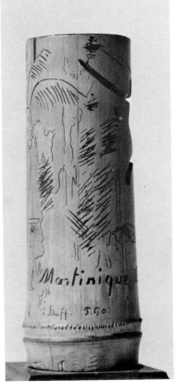

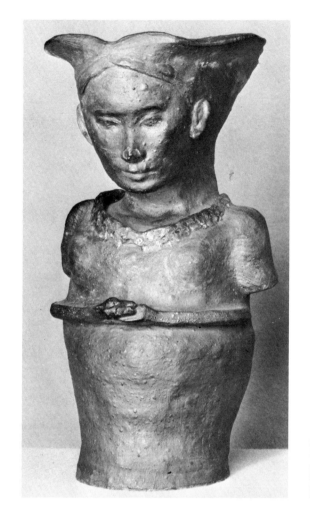

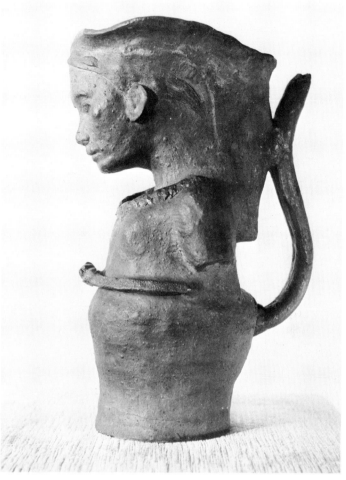

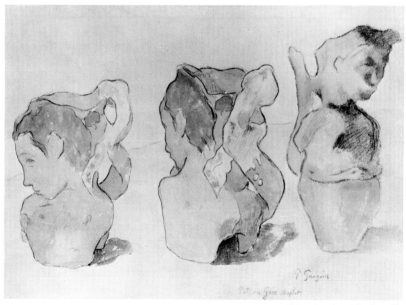

163

50 CUP DECORATED WITH THE FIGURE OF A BATHING GIRL

H. 29 cms. (with base). W. 29 cms. Stoneware with a dark mottled glaze. The figure is painted with white slip under the glaze. Some of the leaves and foliage are green. Whitish areas within the bowl are outlined in gold as are the stems of the water-lily leaves.

Collections: Mogens Ballin; Mrs. Esther Bredholt, Copenhagen.

Exhibitions: Exhibition of French Art at Kleis's art shop, Copenhagen, 1893; 81–Ny Carlsberg Glyptothek, Copenhagen, 1948.

References: Haavard Rostrup, "Gauguin et le Danemark," in Georges Wildenstein, *Gauguin, sa vie, son oeuvre,* pp. 79–80; Bodelsen, "Gauguin's Bathing Girl," *Burlington Magazine,* CI:dclxxiv (May, 1959), pp. 186–90; Bodelsen, *Gauguin Ceramics in Danish Collections,* No. 8, pp. 28–29.

Photograph by the author.

Notes: (See text, pp. 28–29)

The glaze appears to be similar to the iron glaze on a number of Gauguin's pots, in which the color has been modified by the effects of the firing. Here the range is more restricted than on many. On the under side of the cup the glaze ranges from a red-brown to black. In the cup itself it ranges from a dark greyish brown to slightly greenish. In certain areas in the cup there are lighter areas that have been outlined with gold to give the effect of the reflection of clouds in water. The water-lily leaves have apparently been colored with a dull greenish glaze.

Two of the legs of the vase, as well as the handle, have been broken and mended. The base has been furnished with a wooden socle to reinforce and level it.

Bodelsen has shown in the article in the *Burlington Magazine* that the motif of the bathing girl was taken from a drawing done in Brittany in 1886 (*Bathing Girl,* collection of the Chicago Art Institute), and that the work cannot be later than the spring of 1888, for it is shown in a still life dated that year (*ibid.,* Fig. 42).

There are two letters by Gauguin that apparently refer to this ceramic. In a letter of February, 1891, Gauguin wrote his wife: "Ton ami Ballin me doit 250 frs j'ai reporté cette dette á ton compte et il te paiera peut-être le mois prochain" (Bodelsen, *Gauguin Ceramics in Danish Collections,* p. 29).

The other letter is one from Gauguin to Odilon Redon:

> Mon cher Redon,
>
> Si vous avez été heureux de votre à moi revient l'honneur.
>
> Vous n'êtes pas poète à demi, mais en tout.
>
> La proposition de votre ami Fabre me flatte mais je ne puis le satisfaire pour le pot qu'il désire. C'est un pot que Schuffenecker m'a acheté ansi que tous ceux qui sont dans le salon et dont il ne veut se desaissir à aucun prix. J'ai quelque-uns chez Goupil, notamment une *Coupe* que je regarde comme une *pièce rare,* vu la difficulté de les cuire à cause de l'affaisement probable à la chaleur. Puis une tête de homme.
>
> Si votre ami s'arretait à une de ces pièces je le prendrais chez Goupil afin de ne pas avoir à payer les 25% de commission. Le coup je céderais à 150 Frs et la tête à 100.
>
> En tous cas grand merci de votre visite et de votre proposition.
>
> Cordialement tout à vous
>
> Paul Gauguin

(Collection of Ary Redon—Courtesy Mlle Roseline Bacou.)

Unfortunately the letter is not dated, but Mlle Bacou thinks that it must have been written in 1888 or 1889.

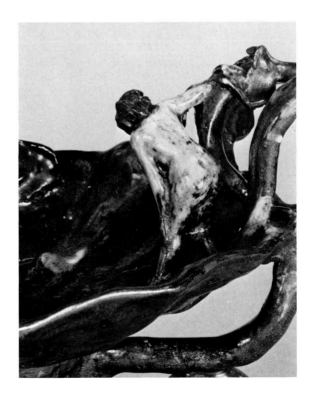

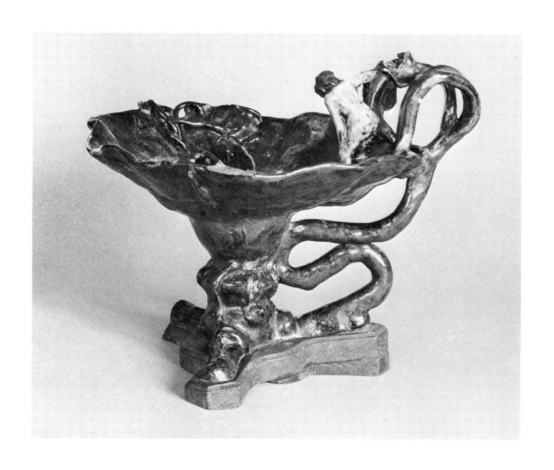

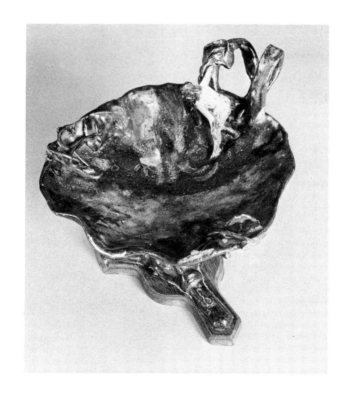

51 VASE WITH THE FIGURE OF A GIRL BATHING UNDER THE TREES

H. 20 cms. Reddish-brown stoneware covered with a dark brown–green mottled glaze. Figure not glazed. Signed: P Go (center of the back).

Collections: Gustave Fayet, Béziers; Léon Fayet, Arles.

Exhibitions: Probably No. 55–Gauguin Retrospective, Paris, 1906: *"Grès, femme sous des arbres"* (Collection Fayet).

References: Zolotoe Runo, I:i (1909), pp. 5–14(ill.); Morice, *Gauguin*, p. 129(ill.).

Photograph: Musées Nationaux.

Notes: (See text, pp. 28–29)
The figure of the bathing girl is the same as that on Catalogue number 50.

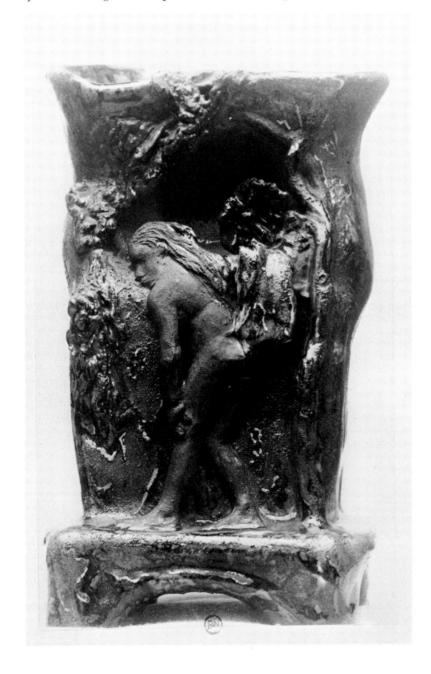

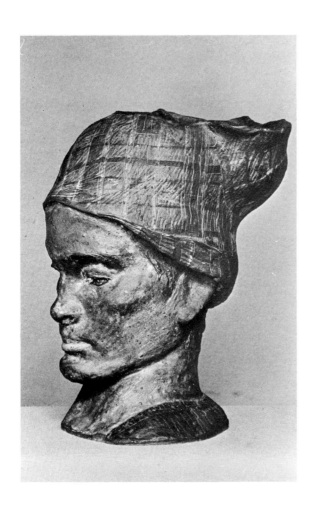

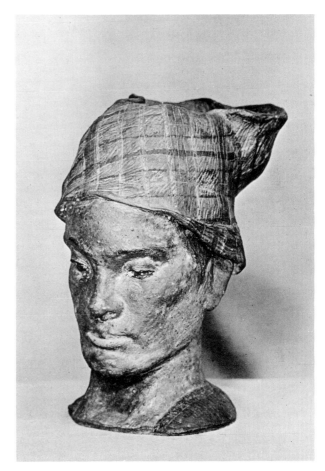

52 POT IN THE SHAPE OF THE HEAD OF A MARTINIQUAN WOMAN

H. 18 cms. Stoneware. Unglazed. Decorated with colored slip. Signed: P. Gauguin on the left shoulder. Numbered: 64. The face is colored a dark brown, the bandanna is painted in grey-green and dark-brown slip. The collar is dark green.

Collections: Ambroise Vollard, Paris; Private Collection, Paris.

Photographs by the author.

Notes: (See text, pp. 13–14, 29)

A sketch of this pot appears in the *Album Gauguin* of the Cabinet des Dessin of the Louvre on page 20 (see Fig. 9a).

53 DOUBLE-MOUTHED VASE

L. 25 cms. Stoneware. Unglazed medium brown body. Decorated with black slip and incised animals and foliage.

Collections: Gustave Fayet, Béziers; Antoine Fayet, Védilhan; Private Collection, France.

Photograph: Musées Nationaux.

Notes:

This vase betrays by its shape and its wide mouths Gauguin's concern with the making of original containers for flowers, in which the drab color of the body and the rustic shape serve as a foil for the blossoms.

The dating of this pot after Gauguin's return from Martinique is only tentative. On the basis of the sketches in the *Album Gauguin* in the Cabinet des Dessins of the Louvre, we should expect to find at least twenty-five pots that are similar to those done in the winter of 1886–1887, i.e., those in the numbered series from number 56 through number 80 (see text, pp. 13, 29). The extensive use of the incised line seems to be characteristic of pots executed after his return from Martinique (see Cat. No. 63), though it does appear on some of those that must be dated tentatively in the winter of 1886–1887 (see Cat. No. 18).

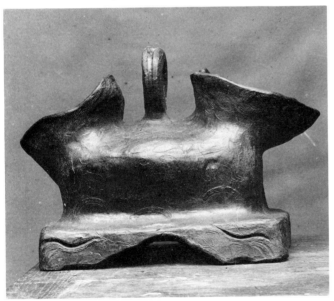

54 POT IN THE FORM OF A TREE STUMP ORNAMENTED WITH TWO HEADS, AN INCISED FIGURE OF A WOMAN, AND BIRDS

H. 23 cms. Stoneware. Signed: P Go in blue. The hair of the two heads protruding from the stump is brown, and there are gold accents on the faces. All the birds are blue with gold accents. The patches of ground under the lower birds are dull green. The zone below the figure of the woman is dark blue with gold accents. The figure's hair is highlighted with gold, and the mirror is dark blue. All colors except the gold are painted in slip.

Collections: Ambroise Vollard; Musée de la France d'Outre-mer, Paris (gift of Lucien Vollard).

Photograph by the author.

Notes:

This pot is marked by an extensive use of the incised line which is characteristic of Gauguin's ceramics after his return from Martinique. The two heads springing from the stump recall the two heads springing from tree trunks in the wood relief *Martinique* (Cat. No. 60). The bird in the upper zone of the pot suggests the blue bird in the watercolor *Les Folies de l'amour* (formerly in the collection of Mr. and Mrs. John Rewald, New York).

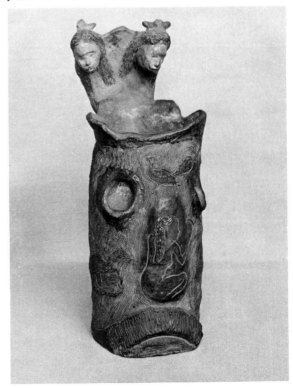

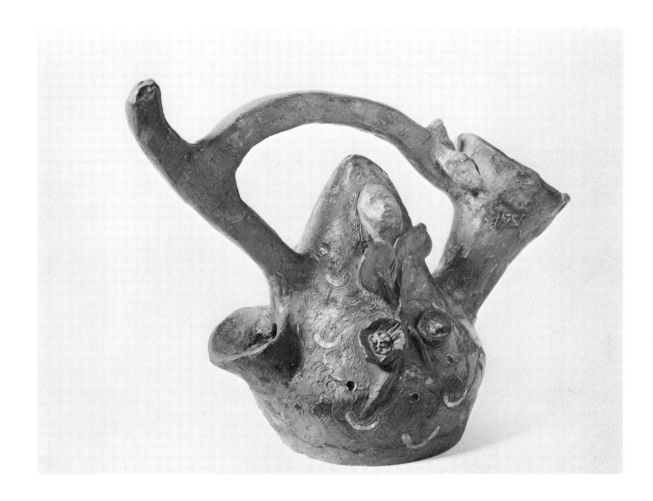

55 POT IN THE SHAPE OF A GOURD

H. 20 cms. Coffee-colored stoneware decorated with colored slip, glaze and touches of gold. Signed: P Go. Numbered: 80.

Collections: Mme Juliette Cramer, Paris.

Photograph: Robert David.

Notes: (See text, pp. 12–14)

Gauguin has used gold, glaze, and colored slip to produce a decorative effect. The glaze, a dark green, is used to fill the incised areas and is outlined with gold. A sketch of the pot appears in the *Album Gauguin* (p. 27) in the Cabinet des Dessins of the Louvre (see Fig. 9*d*).

The form of the pot may have been suggested by the type of stirrup-handled pot found in Peru, such as that from the Chicama Valley shown at right (in the collection of the Peabody Museum, Harvard University).

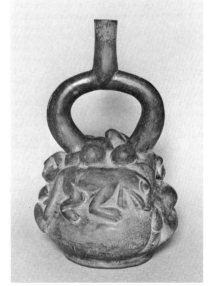

a.

56 POT DECORATED WITH THE HEAD OF A WOMAN WITH A TIARA

H. 17.5 cms. Brown stoneware, glazed. Signed with an incised P Go on the front just below the head. The pot has a flaring lip and a decorative flat ring around its narrowest part. It is furnished with a triple handle, one branch running from the back to meet the other two which run from the side toward the central axis of the pot. The front is decorated with the mask of a woman with a tiara with a goose in the middle. The face of the mask is not glazed.

Collections: Ambroise Vollard, Paris; Mme Contamin; Oscar Ghez, Geneva.

Exhibitions: 42–*Cinquantenaire de Paul Gauguin,* Pont Aven, 1953.

Photographs by the author.

Notes:

This piece is accompanied by a certificate given by Jean Cailac on December 3, 1960. The glaze is typical of that on a number of Gauguin's pots at this period, ranging from olive grey to yellow, orange-red, and black. In addition to the glaze there are accents of gold.

Though there are some marked differences, notably the decorative ring around the middle, this pot is similar to the drawing of a pot shown on page 27 of the *Album Gauguin* in the Cabinet des Dessins of the Louvre (see Fig. 9*d*).

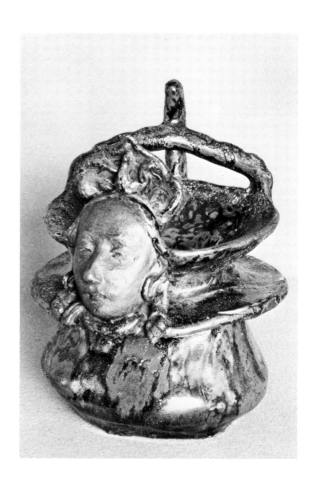

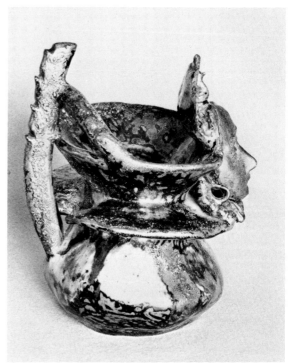

57 POT IN THE "STILL LIFE
WITH FAN"

Photograph: Agraci.

Notes:

This pot which appears in Gauguin's painting *Still Life with Fan* (Louvre) also appears in the artist's *Portrait of Mme Kohler* (reproduced in Malingue, *Gauguin* [1948], plate 143). Apparently a sketch of this pot is in the *Album Gauguin* in the Cabinet des Dessin of the Louvre (see Fig. 9a). Though they do not appear in the paintings, the sketch shows two rats' heads which suggest that this may be the pot that Gauguin took to Arles in October 1888 when he visited Vincent van Gogh. Vincent mentions the pot in a letter to Theo: "Il [Gauguin] a fait revenir de Paris un pot magnifique avec deux têtes de rats" (Vincent van Gogh, *Verzamelde Brieven*, No. 562 F).

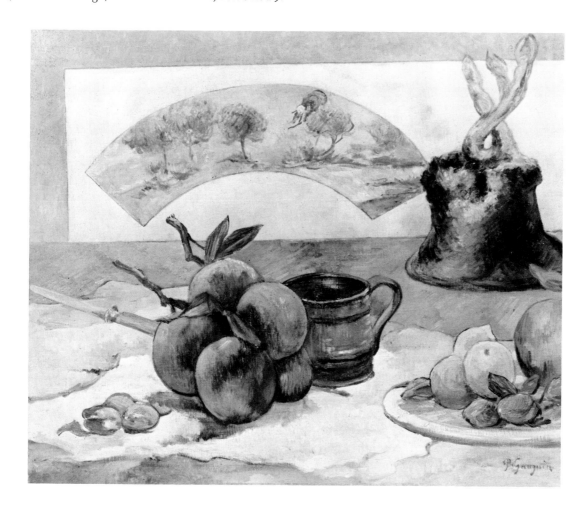

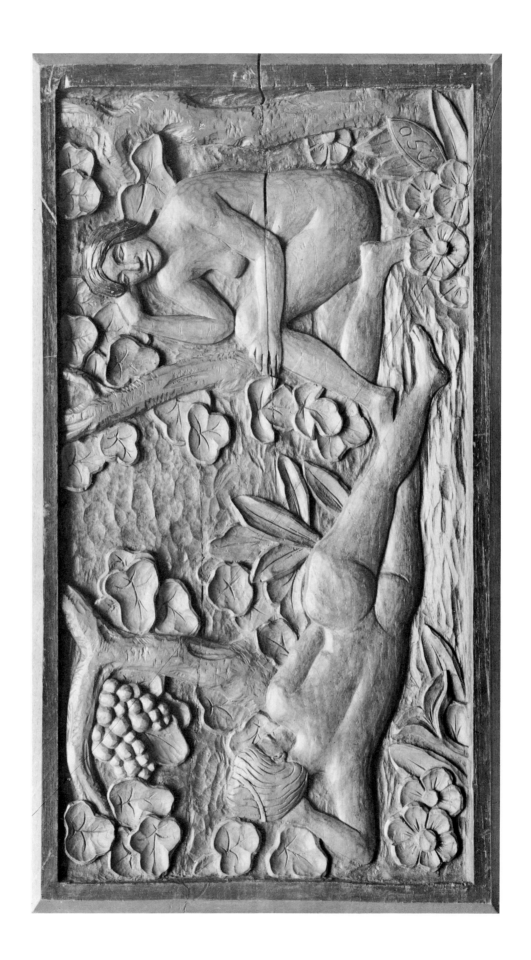

58 ADAM AND EVE

Oak. Polychromed(?). Signed: P G O.

Collections: Émile Schuffenecker, Paris; Amédée Schuffenecker, Paris; Mme Boucheny-Bénézit, Paris; present location unknown.

Exhibitions: 20–Nunes et Fiquet, Paris 1917: *"Adam et Eve—bois sculpté."*

Photograph: Giraudon, Paris.

Notes: (See text, p. 38)

As I have not been able to ascertain the present location of this piece, I am indebted to Mme de la Chapelle, sister of Mme Boucheny-Bénézit, for information concerning its history.

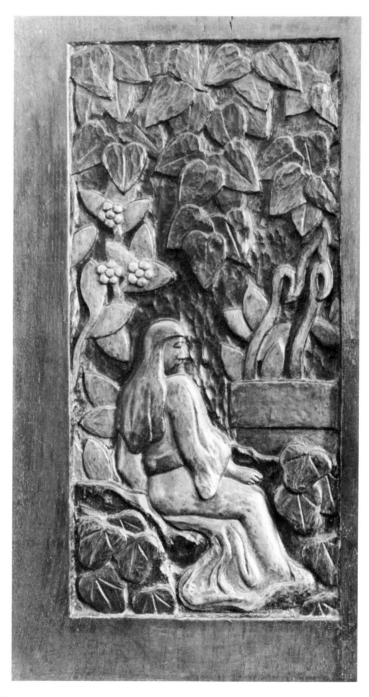

59 CHRIST AND THE
WOMAN OF SAMARIA

Left panel: Over-all dimensions: H. 52.8 cms. W. 28.2 cms. Area of relief: H. 45 cms. W. 21.2 cms. Oak wood with oil paint polychrome. Not signed. The figure of the Christ is seated to the left of the well, facing right. The panel is enriched with carved foliage and flowers. The robe of the Christ is red, with a dark-green belt. The foliage at the top is green with orange shadings toward the tips of the leaves. Other leaves are grass-green. The flowers are orange-red. The background is dark brown.

Right panel: Over-all dimensions: H. 52.8 cms. W. 28.2 cms. Area of relief: H. 44.6 cms. W. 21.2 cms. Oak wood with oil paint polychrome. Not signed. In the

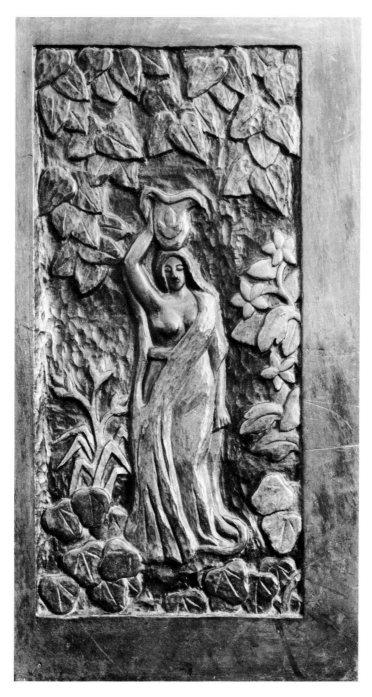

center of the panel is the figure of a woman holding a pitcher on her head with her right arm. The figure is surrounded by foliage and flowers. The robe of the woman is red, the pitcher brown. The foliage and flowers are treated in the same manner and in the same colors as the foliage on the left panel.

Collections: Marcel Heskia, Paris; Dr. and Mrs. Harry Bakwin, New York.

Photographs by the author.

Notes: (See text, p. 38)

The asymmetrical placement of the carved parts of these two panels suggest that they may have been part of the ornamentation of a cabinet at one time. Though I have been unable to trace the early history of these pieces, the subject matter and the style suggest that they were executed in 1888.

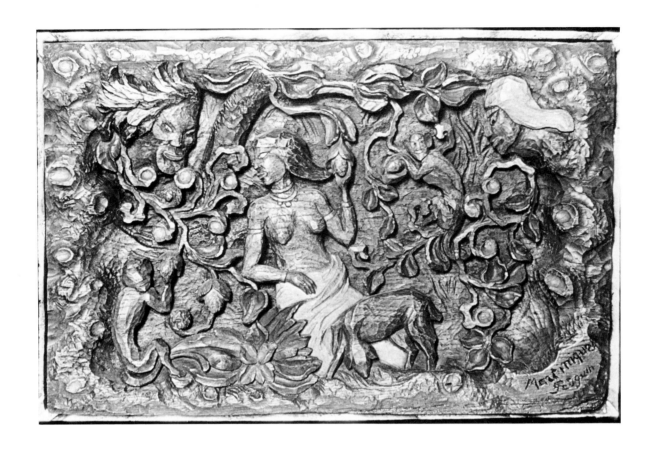

60 "MARTINIQUE"

H. 30 cms. L. 49 cms. Oak, carved and painted.
Inscribed: MARTINIQUE. Signed: Gauguin.

Collections: Tyge Møller, Paris; Helge Jacobsen,
Copenhagen; Ny Carlsberg Glyptothek, Copenhagen
(Inv. No. 1781).

Exhibitions: Probably No. 17–Spring Exhibition, Na-
tional Gallery, Budapest, 1907: *"Among the Animals
(Martinique) Woodcarving"*; 80–Ny Carlsberg Glypto-
thek, Copenhagen, 1948.

References: Rostrup, *Franske billedhuggere frå det 19
og 20 Aarhundrede,* p. 80.

Photograph by the author.

Notes: (See text, pp. 40–41)

61 FIGURE OF A MARTINIQUAN NEGRESS

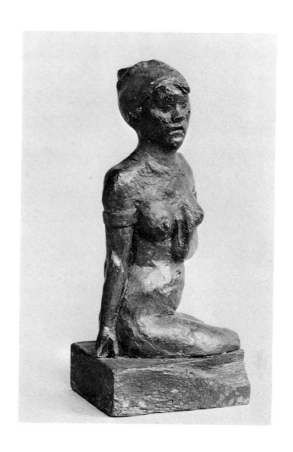

H. 20 cms. Wax. Painted and decorated with necklace of gold paper and arm bands of ribbon. Base of wood.

Collections: Marie Henry, Le Pouldu; Galerie Zak, Paris; Henry Pearlman, New York.

Exhibitions: 28–Galerie Barbazanges, 1919; 54–Luxembourg, 1928 (collection of Marie Henry).

References: L'Art aujourd'hui, Winter, 1927; Chassé, *Gauguin et son temps,* p. 74.

Photographs by the author and Jack Stevens.

Notes:

This piece is mentioned in the *Luxembourg Catalogue* (1928): "Cette statuette figurait, au Pouldu auprès du buste de Meyer de Haan." Chassé placed it on the mantel of the dining room of the pension run by Marie Henry.

This little statuette, which Gauguin gave a greenish patine similar to the *verde antique* of bronze, is strikingly similar in conception to the ceramic statuette the *Black Venus* (Guggenheim Collection). Its less finished nature argues that it may well have been an earlier exploration of the conception.

The figure appears in a still life in the collection of the Musée de Reims, which was probably executed between 1888 and 1889. The statuette has also been cast in bronze in two editions. The first edition of six was made by the Galerie Zak before World War II. A second edition of six was cast about 1957 by the Modern Foundry, Astoria, Long Island. This latter edition bears the numbers A–1 through F–6 on the back of the right hand.

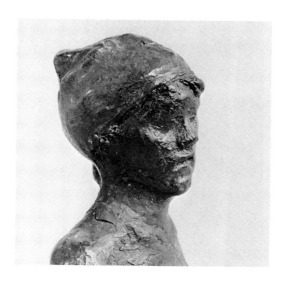

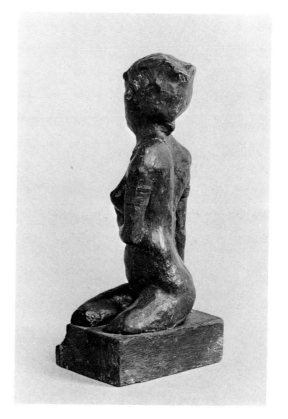

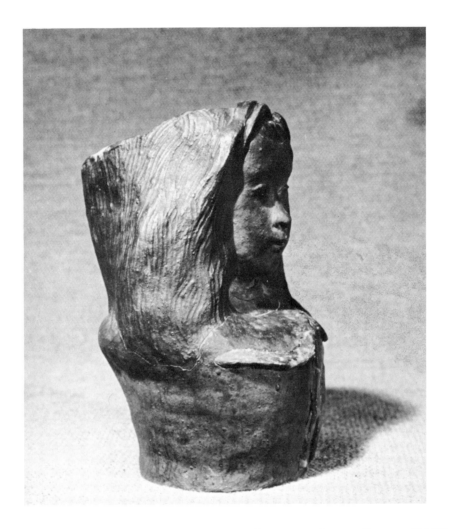

62 POT IN THE FORM OF THE BUST OF A YOUNG GIRL

H. 19 cms. Coffee-colored stoneware. Inscribed: À MON AMI SCHUFF. Signed: P Go. The hair is painted with dark-brown slip, the eyes are black, and the neck ribbon is a yellowish green. No glaze.

Collections: Émile Schuffenecker, Paris; Gustave Fayet, Béziers; P. Bacou, Paris; Jean Pierre Bacou, Paris.

Exhibitions: Possibly No. 2878, *Exposition Universelle,* 1900: *"Tète en grès mat"* (apartient à M. Schuffenecker).

References: Malingue, *Gauguin* (1943), Fig. 150.

Photographs: Musées Nationaux and Merete Bodelsen.

Notes:

This pot may be a portrait of Schuffenecker's young daughter, Jeanne. A drawing of this pot appears on page 27 of the *Album Gauguin* in the Cabinet des Dessins of the Louvre (see Fig. 9*d*).

On the bottom is a blue ticket with the inscription:

Vendu Nr 100

A ticket with the number 54 and the price 49 francs appears on the bottom of Catalogue number 39, which is also numbered 54 in incised numerals on the handle of the pot. If, as seems probable, Gauguin's pots were numbered *seriatim,* and that the numbers on the tickets corresponds with the numbers of the pots, this would be number 100.

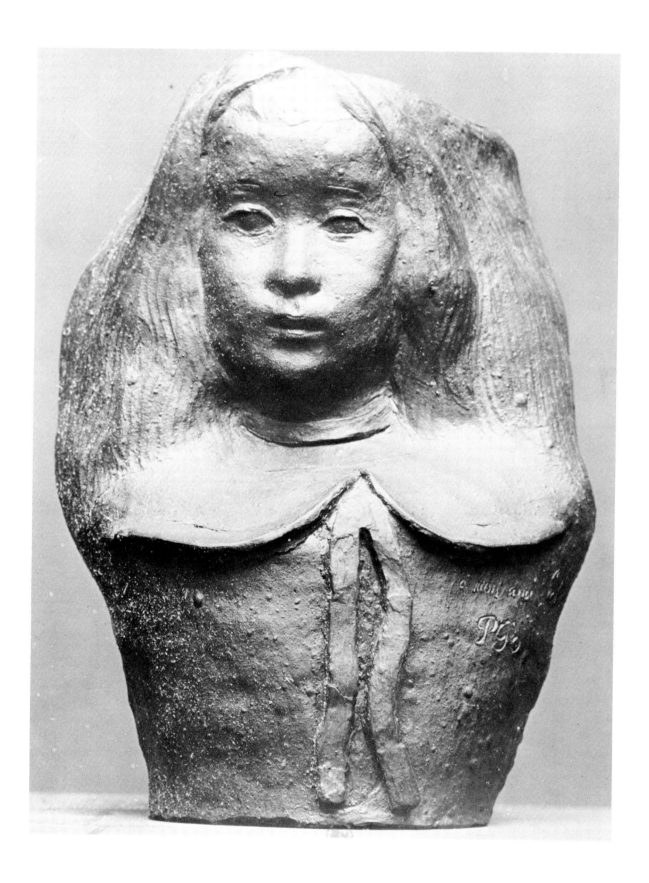

179

63 POT IN THE SHAPE OF THE HEAD AND SHOULDERS OF A YOUNG GIRL

H. 20 cms. Stoneware. Signed: P. Gauguin just below the chin of the girl. The body of the ware is coffee-colored. The eyes and hair of the girl are painted in blackish slip, while the head and body of the swan are white, and the beak the natural color of the pot. The swan's wings spread across the girl's back like a hair ribbon. Around the middle of the pot is a light blue zone decorated with incised geese. At the top of the zone are floral patterns in dark-blue slip. On the base, which is the color of the body, are groups of geese with incised outlines and painted in yellow-green glaze.

Collections: Camille Pissarro; Coste; Private Collection, Paris.

Exhibitions: 37–Luxembourg, Paris, 1928; 66–Auction sale, Versailles, June 7, 1961 (not sold).

References: Read, "Gauguin and the Return to Symbolism," *Art News Annual,* 1956, pp. 152–58(ill.).

Photograph: Archives Photographiques, Paris.

Notes: (See text, p. 29)

The pot is formed by a combination of slabs and coiling. The only glaze, the yellow-green on the geese around the base, is very similar to that used on some of the stoneware made at Limoges under the technical direction of Chaplet.

Two representations of this vase appear in a drawing in the collection of Mr. and Mrs. Henry Root Stern (Cat. No. 49a). A sketch of a subject identical with this pot also appears in page 20 of the *Album Gauguin* in the Cabinet des Dessins in the Louvre (see Fig. 9a).

The theme of this vase recalls the motif of Leda and the Swan which appeared in a lithograph (see below) exhibited in the exhibition at the Café Volpini in the summer of 1889 (courtesy of the Museum of Fine Arts, Boston). The same theme was used again in the decoration of Marie Henry's pension at Le Pouldu in the fall of 1889.

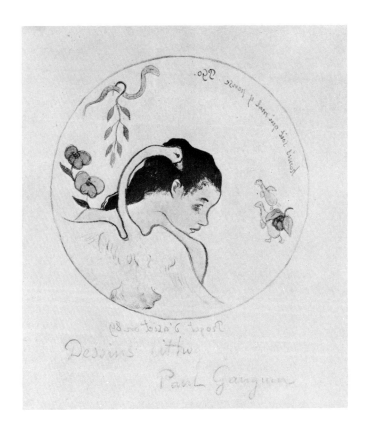

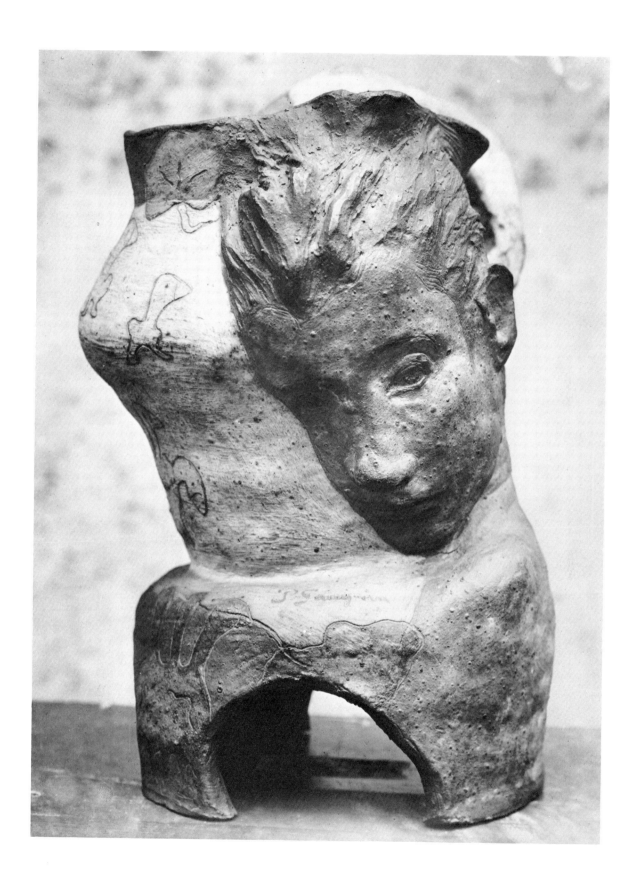

64 VASE DECORATED WITH FOLIAGE, GRAPES, AND ANIMALS

H. 24 cms. Dark-brown stoneware. Decorated with colored glaze and incised lines. Stamped on the bottom with Chaplet's seal. Not signed by Gauguin. The ornamentation is executed in maroon-red and green glazes on a grey, glazed background.

Collections: Gustave Fayet, Béziers; Private Collection, France.

Photograph by the author.

Notes:

The body of this pot was wheel thrown, and the decoration in colored glaze and incised outlines was done by Gauguin. The technique is essentially the same as that of Catalogue number 45. The style of the decoration and the motifs used suggest that this piece was not executed before the winter of 1888–1889. The snake, which appears in the decoration of this pot, is a motif particularly associated with Gauguin's work from 1889 on when he began to use forms in his pictures with a clearly symbolic intent. The bird is similar in conception to the bird that appears in the background of the *Still Life with Oranges* of about 1890 (Collection Brown-Boveri, Baden, Switzerland, reproduced in Rewald, *Post-impressionism*, p. 303). A similar bird appears in Gauguin *Design for a Plate*, executed in 1890 (in a private collection, New York, reproduced in Rewald, p. 300).

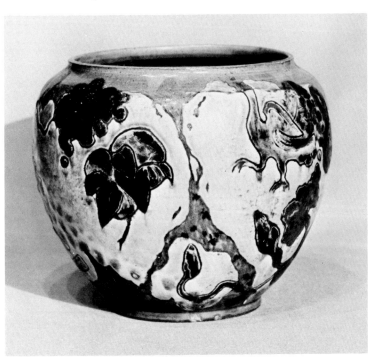

65 CUP IN THE FORM OF A HEAD

H. 19.5 cms. Stoneware covered with a transparent greyish-green glaze mottled with red. (See Plate VII, p. 92)

Collections: Mette Gauguin, Copenhagen; Pietro Krohn, Copenhagen; Kunstindustrimuseet, Copenhagen (acquired in 1897—B49/962).

Exhibitions: 138–Den frie Udstilling, Copenhagen, 1893: "Portrait of the Artist. 1887. Jug in burnt clay"; 82–Gauguin Exhibition, Ny Carlsberg Glyptothek, Copenhagen, 1948.

References: Pola Gauguin, *My Father, Paul Gauguin,* p. 96(ill.); Rostrup, *Franske Billedhuggere, frå det 19 og 20 Aarhundrede,* Fig. 45; Berryer, "A propos d'un vase de Chaplet," *Bulletin des Musées Royaux d'Art et d'Histoire,* Nos. 1–2 (January–April, 1944), Fig. 21, p. 16; Rewald, *Post-impressionism,* p. 442(ill.); Bodelsen, *Willumsen i Halvfemsernes Paris,* Fig. 8; Bodelsen, *Gauguin Ceramics in Danish Collections,* Fig. 9, Cat. No. 9, p. 14.

Photographs: Kunstindustrimuseet and the author.

Notes: (See text, pp. 24, 30–31)

The head, which has been formed by modeling and hollowing out, rather than coiling, recalls Catalogue number 39 in conception and techniques. The red glaze appears to be a copper reduction glaze which has been painted on in parts, while the greyish-green glaze is probably a clear glaze which has picked up iron from the body of the stoneware and produced a celadon effect in the process of reduction.

Bodelsen (*Gauguin Ceramics,* p. 29) states that this jug was probably made in the early months of 1889. Certainly this is as late as it can have been made, for the work appears in a still life that was painted in 1889 (see text, p. 24). The sculptural style, the use of glaze in a more or less painterly manner, and the mood of the self-portrait suggest a period in 1889 (see text, pp. 30–31). However, there is a certain amount of evidence that points to a date in the spring of 1887. In the first place, this is the date assigned to the jug in *Den frie Udstilling* in Copenhagen during 1893. Second, its resemblance in execution to Catalogue number 39 and the fact that it suggests the type of pot Fénéon saw in December, 1887 (see text p. 24) argue for the possibility of its having been done in the spring of that year.

Bodelsen (*Gauguin Ceramics,* p. 14) thinks that Gauguin may have been referring to this pot when

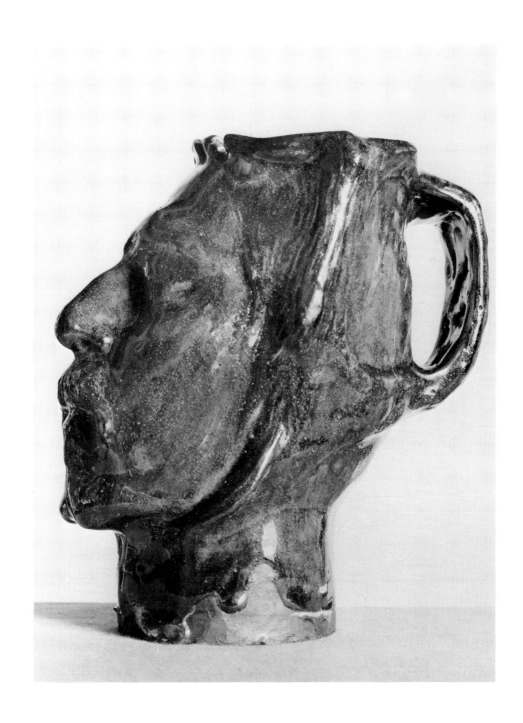

he wrote Émile Schuffenecker on September 1, 1889: "J'ai reçu le pot que vous avez envoyé et qui est très réussi." But it should be noted that this pot is represented in the *Still Life with Head-shaped Vase* (1889) in the Ittelson Collection (Cat. No. 65*a*) together with day lilies and what appear to be sprays of flowering rhododendron. The flowering range of day lilies is from May to August, while rhododendrons seldom flower as late as August. It is difficult to see how the painting could have been commenced so late in the year.

Though the form of this pot is common in the European tradition of ceramics, Gauguin may have had in mind the Peruvian head pots of the type shown in Catalogue number 65*b*, which came from the Chicama Valley in Peru (collection of the Peabody Museum, Harvard University).

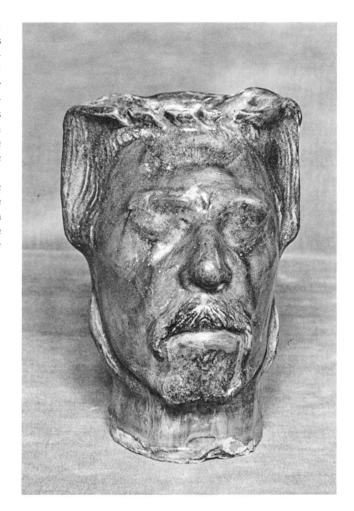

b.

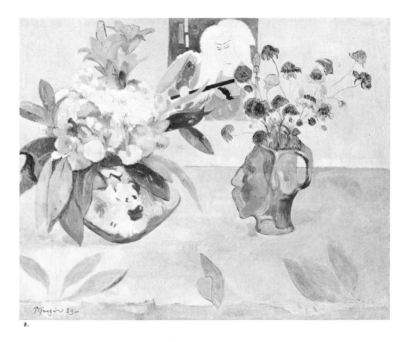

a.

66 JAR IN THE FORM OF A GROTESQUE HEAD

H. 28 cms. Stoneware. Glazed dark brown. On the bottom of the interior of the pot is a card with the inscription: "La sincérité d'un songe à l'idéaliste Schuffenecker. Souvenir Paul Gauguin."

Collections: Émile Schuffenecker; Amédée Schuffenecker; Mme Jeanne Schuffenecker; Musée du Louvre (gift of Jean Schmidt).

Exhibitions: 66–Galerie Dru, Paris, 1923; 34–Luxembourg, Paris, 1928; 8–*Gazette des Beaux-Arts,* 1936; 86–Orangerie, Paris, 1949; 20–Quimper, 1950.

References: Chassé "Synthétisme de Gauguin," *Amour de l'Art,* 1938, p. 127; Berryer, "À propos d'un vase de Chaplet," p. 19; Bodelsen, *Willumsen,* Fig. 6, pp. 26–27.

Photograph: Musées Nationaux.

Notes: (See text, pp. 24, 30–31)

This jar may have been one of the ceramics in the exposition of the *Société Nationale des Beaux-Arts* (Loize, *Amities,* #123; Rewald, *Post-impressionism,* p. 487). It may also have been number 177 in the Gauguin Retrospective in 1906. This piece also appears in Gauguin's *Self Portrait with Yellow Christ* (1890) in a private collection in Paris.

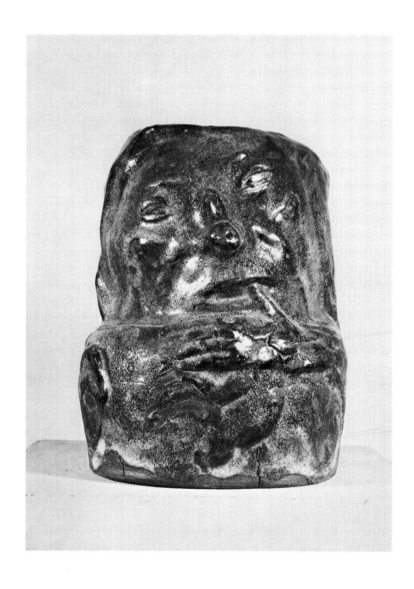

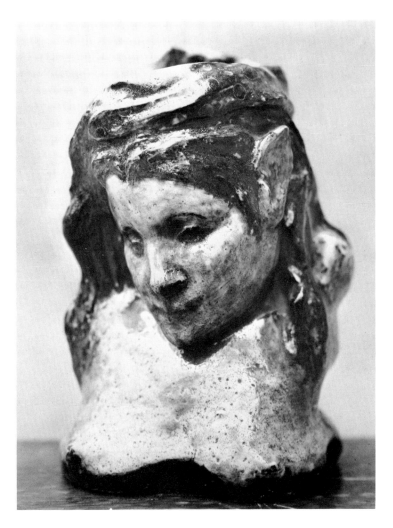

67 VASE IN THE FORM OF THE HEAD OF A WOMAN

H. 23 cms. Pinkish-red stoneware. The piece is glazed with a transparent glaze over underglaze colors. The colors are pink, light and dark blue, grey, with accents of gold.

Collections: Émile Schuffenecker; Emery Rêves, Roquebrune-Cap-Martin.

Exhibitions: Possibly 175–Gauguin Retrospective, Paris, 1906, "Céramique: Un Buste de Femme" (Schuffenecker?); Possibly No. 10–*Spring Exhibition,* National Gallery Budapest, 1907: *"Woman's Head* (ceramic)"; 64–Galerie Dru, Paris, 1923; 21–*Gazette des Beaux-Arts,* Paris, 1936.

References: Malingue, *Gauguin* (1943), p. 150(ill.); Rewald, *Post-impressionism,* p. 442(ill.); Goldwater, *Gauguin,* p. 36(ill.); the Art Institute of Chicago and the Metropolitan Museum of Art, New York, *Catalogue of the Gauguin Exhibition* (Chicago and New York, 1959–1960), p. 36.

Photograph: Archives Photographiques, Paris.

Notes: (See text, p. 32)
This piece has always been considered to be a portrait of Mme Schuffenecker. The Catalogue of the Gauguin Exhibition of the Art Institute of Chicago and the Metropolitan Museum of Art in New York suggests that this vase may appear in the painting *Still Life with a Head-Shaped Vase* in the Ittleson Collection, New York (p. 36). As the painting is dated 1889, this vase must have been made not later than the winter of 1888–1889 if it does appear there.
The treatment of the form of the pot, the glaze and coloration, suggest that it was done at about the same time as Catalogue numbers 68, 69.

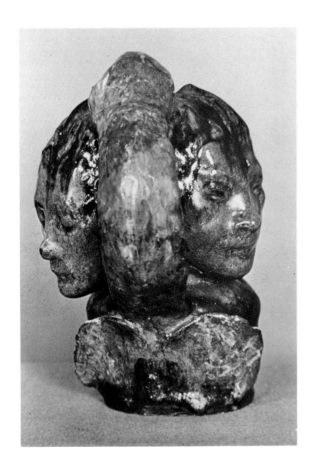
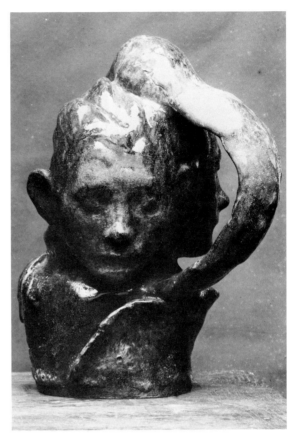

68 DOUBLE-HEADED VASE

H. 20.75 cms. Stoneware. Greyish transparent glaze
over blue underglaze paint.

Collections: Possibly Émile Schuffenecker, Paris;
Gustave Fayet, Béziers; Mme d'Andoque, Béziers.

References: Zolotoe Runo, I:i (1909), pp. 5–14;
Varenne, "Les Bois gravés et sculptés de Paul Gau-
guin," *La Renaissance de l'art française,* December,
1927, p. 523(ill.).

Photographs: Musées Nationaux and the author.

Notes:

Varenne erroneously attributes this piece to the col-
lection of Amédée Schuffenecker, but it has been in
the collection of the Fayet family since at least 1909.
However, in 1957 Mme Jeanne Schuffenecker identi-
fied a photograph of this pot as that of one that had
been in her father's collection. This pot could never
have been in the collection of Amédée, for Gustave
Fayet, who bought it, died before Amédée bought his
brother's collection in 1926. There is a possibility that
there may be two very similar pots.

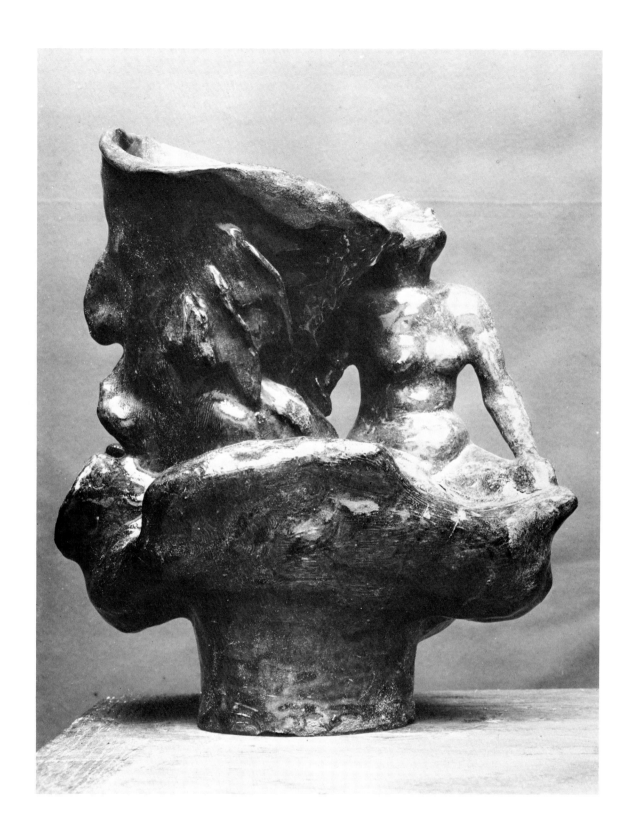

69 FANTASTIC VASE WITH A GROTESQUE HEAD AND THE FIGURE OF A NUDE WOMAN

H. 25 cms. Stoneware. Glazed with a transparent glaze over a cream-colored body, grading to grey with underglaze color on the woman's hair, parts of the grotesque face, and on the lower part of the vase.

Collections: Gustave Fayet, Béziers; Mme P. Bacou, Puisallicon; Mme Guy Viennet.

Photographs: Musées Nationaux and Merete Bodelsen.

Notes:

The treatment of the pot and the glaze are very similar to Catalogue number 68. Mlle Bacou suggests the influence of Rodin on this work of Gauguin and says that it was always known by the title, *Le Marchand des Esclaves.*

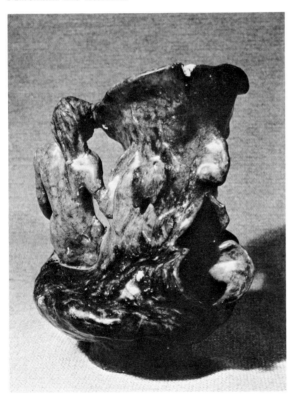

70 CERAMIC

L. 23 cms. W. 14.5 cms. H. 5.5 cms. Stoneware. Apparently decorated with colored slip and covered with a transparent glaze.

Collection: Mme J. Altounian-Lorbet, Mâcon, France.

Photograph: Courtesy of Mme Altounian-Lorbet.

Notes:

According to Mme Altounian-Lorbert this ceramic was given to her husband by a friend of Gauguin. I am indebted to Mr. Samuel Wagstaff for the discovery of the piece, and I have not seen it myself. From its shape, it would seem to have been the cover of some kind of receptacle.

The dating of this work of Gauguin is difficult, but the figure on the upper left is clearly related to one of the figures on the barrel carved by Gauguin (Cat. No. 84). As no specifically Polynesian motifs appear in either the barrel or in the ceramic, it seems most probable that the latter was executed about 1889–1891.

The significance of the scene represented remains obscure, but the part of the ceramic appearing at the bottom part of the photograph is decorated with the male and female symbols of generation.

The style of the compositions, with its free combination of elements in a non-rational space suggests that of Gauguin's reliefs of 1889–1890 (see particularly Cat. Nos. 76 and 87).

71 EVE AND THE SERPENT

Photograph by the author.

H. 34.5 cms. L. 20.5 cms. Oak wood, lightly polychromed. Signed: P Go.

Collections: Mette Gauguin, Copenhagen; Helge Jacobsen, Copenhagen; Ny Carlsberg Glyptothek (Inv. No. 2614).

Exhibitions: 19–Spring Exhibition, National Gallery, Budapest, 1907: *"Eve with Serpent—woodcarving"*; 88–Gauguin Exhibition, Ny Carlsberg Glyptothek, Copenhagen, 1948: *"Eve with Serpent."*

Notes:

The theme of Eve and the Serpent appears many times in the painting of Gauguin. One of the earliest versions, if not the earliest, is the pastel and water-color in the Marion Koogler McNay Art Institute, San Antonio, Texas (see Leymarie, *Paul Gauguin*, p. 11). According to Leymarie, this piece could not have been done later than the spring of 1889.

The present relief, with its representation of the moon, the goat, the owl, and the rabbit, as well as the snake and Eve, is much more complex symbolically than any of the painted versions.

72 "LES CIGALES ET LES FOURMIS"

Wood (Oak)? Signed: P Go. Inscribed: LES CIGA-
LES ET LES FOURMIS.

Collections: Émile Schuffenecker, Paris (?); Amédée
Schuffenecker, Paris; Boucheny-Bénézit, Paris; present
location unknown.

References: Charles Chassé, *Gauguin et le groupe
de Pont Aven* (Paris, 1921), p. 46.

Photograph: Giraudon.

Notes: (See text, p. 41)
 Information on this piece was furnished by Mme
de la Chapelle, sister of Mme Boucheny-Bénézit.
Henri Motheré states that according to Marie Henry's
recollection of the works of Gauguin at her pension
at Le Pouldu:

> Les sculptures comprenaient notamment plusiers
> bas-reliefs sur bois, entre autres, celui ayant pour
> sujet les négresses de la Martinique, d'après la
> lithographie sur papier jaune. (Chassé, p. 46)

Apparently the lithograph referred to is that of the

a.

same title, *Les Cigales et les Fourmis.*
 There is a photograph of this relief in the *Album
Schuffenecker* in the Cabinet des Dessins of the
Louvre.
 It is probable that the relief was executed in 1889,
shortly after Gauguin's arrival at Le Pouldu.

73 "LES MARTINIQUAISES"

H. 78 cms. L. 95 cms. Wood (oak?). Painted
Signed: P. Gauguin (upper right).

Collections: Mme Clouet-Warot; present whereabouts
unknown.

Exhibitions: 7–Luxembourg, 1928; 15–*Gazette des
Beaux-Arts,* 1936; 52–Galerie Kléber, 1949.

References: Rotonchamp, *Paul Gauguin,* p. 70; Rey,
"Bois sculptés de Gauguin," *Art et Décoration,* LIII
(February, 1928), 57–64.

Photograph: Courtesy of Art et Décoration.

Notes: (See text, pp. 41–42)

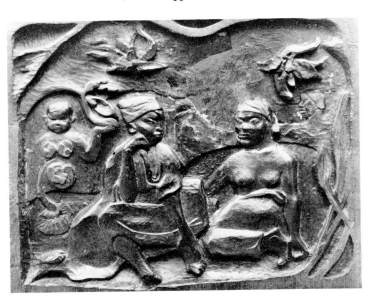

74 RECLINING WOMAN WITH A FAN

L. 45 cms. H. 35 cms. Oak panel, thinly poly-
chromed. Signed on the lower right: P G O.

Collections: Tyge Møller, Paris; Helge Jacobsen,
Copenhagen; Ny Carlsberg Glyptothek, Copenhagen
(Inv. No. 1909).

Exhibitions: 15–Spring Exhibition, National Gal-
lery, Budapest, 1907: *"Negro Woman with Fan—
woodcarving";* 87–Gauguin Exhibition, Ny Carlsberg
Glyptothek, Copenhagen, 1948.

References: H. Rostrup, *Franske Billedhuggere,* p.
80(ill.).

Photograph by the author.

Notes:

Rostrup dates this piece after 1896 on the basis of
the similarity of the composition to that of Gauguin's
painting *Te Arii Vahine* done in 1896 (Collection
of the Museum of Modern Art, Moscow) (Cat. No.
74*a*). However, the style of the relief is not that of
Gauguin's second stay in Tahiti, but that of the period
between 1888 and 1889. The motif of the painting,
Te Arii Vahine, is strikingly similar to the *Sleeping
Nymph* of Lucas Cranach the Younger in the National
Gallery, Oslo (Inv. No. 522) (Cat. No. 74*b*) even
to the doves at the feet of the figure. The *Sleeping
Nymph* in the Oslo Museum was acquired in 1899
from an Italian collection, and it is difficult to see
how Gauguin could have known it, unless by means
of a reproduction. However, this particular painting
was the last of a series of similar works from Cranach's
studio, of which the first was executed in 1518. (Cf.
Posse, *Lucas Cranach d. Ä,* No. 44, p. 57.) It is not
impossible that Gauguin may have seen another
version, or had a reproduction of it.

In the relief, the reclining figure is definitely not
Polynesian, for Gauguin has painted it black. It
belongs among a number of works that Gauguin
executed after his return from Martinique in which
he used Negro models (see Cat. Nos. 61, 76,
90, 91).

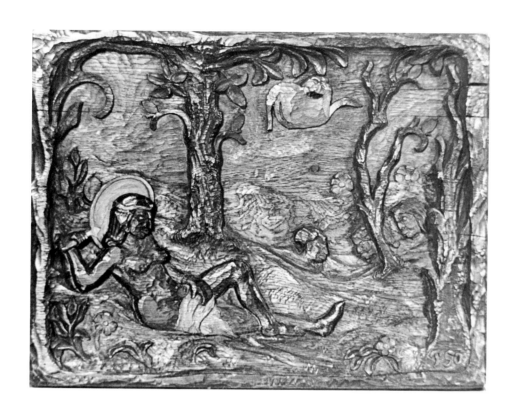

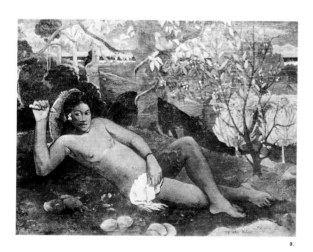

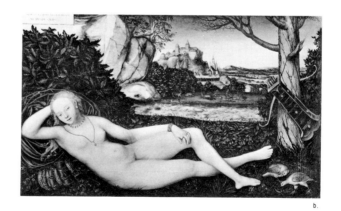

a.

b.

193

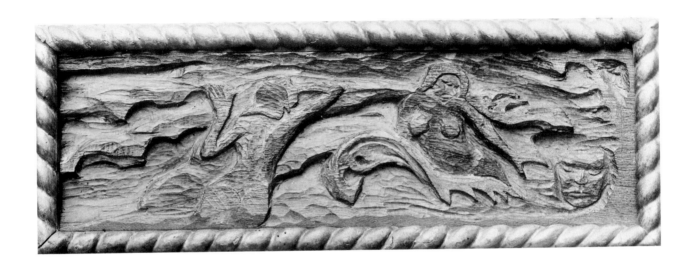

75 "LES ONDINES"

H. 18 cms. L. 57 cms. Oak, blackened and tinted green.

Collections: Countess de Nimal (?); Gustave Fayet, Béziers; Mme P. Bacou, Puissalicon.

References: Segalen, *Lettres,* LXXIX, pp. 201–3, 227, LXXXI.

Photograph: Musées Nationaux.

Notes:
This piece was given by Gauguin to the Countess de Nimal, who later sold it to Gustave Fayet (Segalen, *Lettres,* LXXXIX).

The panel is probably an earlier experimentation with the theme of the panel *Soyez mystérieuses* of 1890. The figure on the left, the "Woman in the Waves," was used many times by Gauguin. She first appears in the lithograph *Aux Roches noires* in the album at the Volpini Exhibition in the spring of 1889. A painting, *Woman in the Waves* (1889), in the collection of Mr. and Mrs. Powell Jones, Gates Mills, Ohio, repeats the figure. She appears again in the gouache *Nirvana* (Wadsworth Atheneum, Hartford) and in *Soyez mystérieuses* of 1890 (Cat. No. 87).

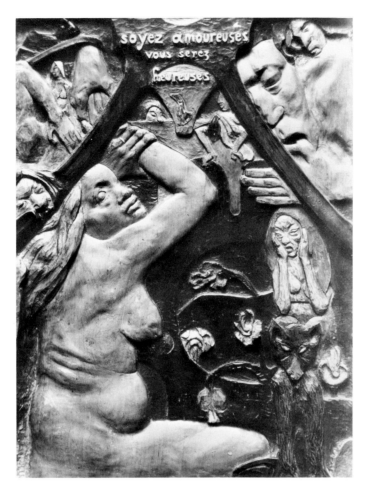

76 "SOYEZ AMOUREUSES ET VOUS SEREZ HEUREUSES"

H. 97 cms. L. 75 cms. Linden wood, carved and painted. Signed: P. Gauguin. Inscribed: SOYEZ AMOUREUSES ET VOUS SEREZ HEUREUSES. (See Plate VI, p. 91)

Collections: Émile Schuffenecker, Paris; Amédée Schuffenecker, Paris; Mme Jeanne Schuffenecker, Paris; Museum of Fine Arts, Boston.

Exhibitions: Boussod et Valadon, Paris, 1889; *Les XX,* Brussels, 1891; *Société Nationale,* Paris, 1891; 18–Galerie Nunes et Fiquet, Paris, 1917; 9–Luxembourg, Paris, 1928; 47–*Gazette des Beaux-Arts,* Paris, 1936; 80–Orangerie, Paris, 1949; 54–Galerie Kléber, Paris, 1949; 68–Kunstmuseum, Basel, 1949–1950; 120–Chicago Art Institute and the Metropolitan Museum of Art, New York, 1959.

References: Malingue, *Lettres,* LXXXVII, LXXXIX, XC, XCIII, XCV; Champel, "Le Carnaval d'un ci-devant," quoted by Rewald, *Post-impressionism,* pp. 463–64; Aurier, "Le Symbolisme en peinture," *Mercure de France* March, 1891, pp. 155–56; Aurier, "Les Symbolistes," *Revue encyclopédique,* April, 1892, p. 478(ill.); Meier-Graefe, *Entwicklungsgeschichte der Modernen Kunst,* I, 378; *Zolotoe Runo,* I:i (1909), 5–14(ill.); Rotonchamp, *Gauguin,* p. 74(ill.); Morice, *Gauguin,* p. 167; Alexandre, *Gauguin,* p. 109(ill.); *L'Art aujourd'hui,* Winter, 1927, (ill.); Boudot-Lamotte, "Le Peintre et collectioneur Claude-Émile Schuffenecker," *L'Amour de l'Art,* 1935, p. 284; Malingue, *Gauguin,* 1943, p. 145(ill.); Malingue, *Gauguin,* 1948, p. 55(ill.); Loize, *Amities,* pp. 93, 94; Dorival, "Sources of the Art of Gauguin from Java, Egypt and Ancient Greece," *Burlington Magazine,* XCIII (April, 1951), 118–22; Dorra, "Émile Bernard and Paul Gauguin," *Gazette des Beaux-Arts,* April, 1955, p. 244; Rewald, *Post-impressionism,* pp. 441, 463–64, 487; Goldwater, *Gauguin,* p. 145(ill.).

Photographs: Musées Nationaux and the Museum of Fine Arts, Boston.

Notes: (See text, p. 42 ff)

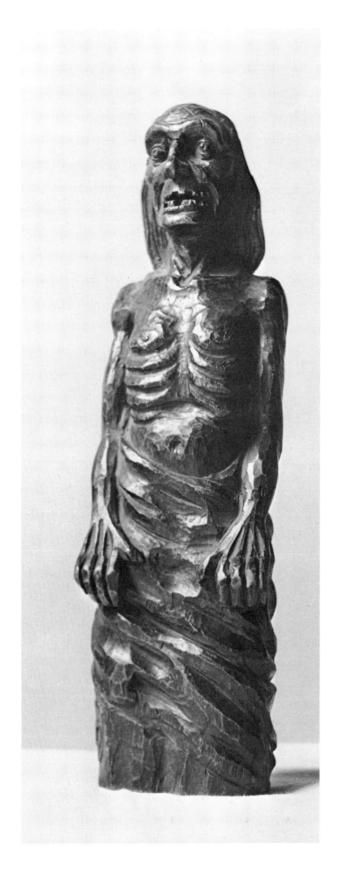

77 STANDING FIGURE OF AN OLD WOMAN

H. 30 cms. Wood (Oak?). Stained green. Signed: P Go (right side).

Collections: Émile Schuffenecker, Paris; Amédée Schuffenecker, Paris; Galerie St. Étienne, New York.

Exhibitions: 101–Wildenstein's, New York, 1956.

References: Life, December 13, 1954 (ill.).

Photograph: Galerie St. Étienne, New York.

Notes:

According to the statement of J. B. de la Faille, this piece was given to Émile Schuffenecker by Gauguin and was sold by Amédée Schuffenecker in 1926. (Statement courtesy of the Galerie St. Étienne.)

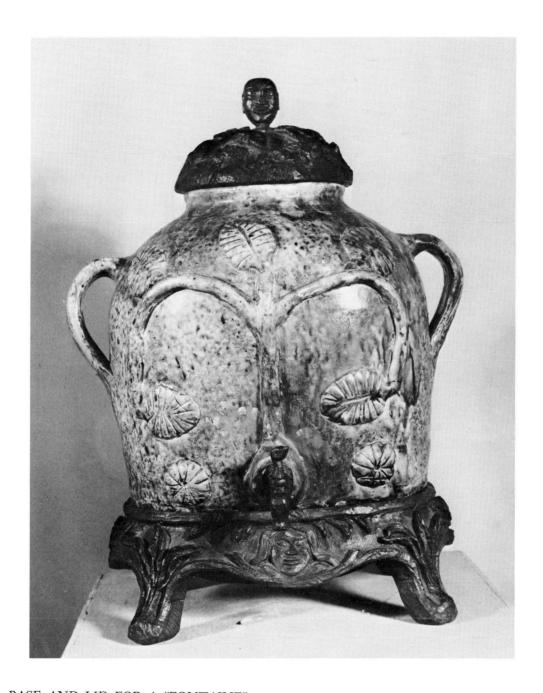

78 BASE AND LID FOR A "FONTAINE"

H. 43 cms. (complete). Wood, stained dark brown.
Signed: P. Go.

Collections: Émile Schuffenecker, Paris; Amédée
Schuffenecker, Paris; Mme Jeanne Schuffenecker,
Paris; Louvre (RF 905).

Exhibitions: 10–Gazette des Beaux-Arts, Paris, 1936;
88–Orangerie, Paris, 1949; 21–Quimper, 1950.

References: Berryer, "À propos d'un vase de Chaplet,"
1944; Malingue, Lettres, 1946, plate 10.
Photograph: Musées Nationaux.
Notes:
 The fontaine itself appears to be a traditional piece
of utilitarian stoneware with the usual green glaze,
which Gauguin has enhanced by the addition of a
carved lid and base of wood. The piece was given
to the Louvre by Jean Schmit.

79 WOODEN JUG IN THE FORM OF A BEER STEIN

Polychromed wood.

Collections: Émile Schuffenecker (?); Alden Brooks.

Photographs: Musées Nationaux and Alden Brooks.

Notes:

According to Mr. Brooks, he bought this piece in Paris about 1919 from the dealer Vidrac. Mme Jeanne Schuffenecker believes that it was at one time in her father's collection.

The head of the goat on the right side should be compared with the head of the goat in the panel *Eve and the Serpent* (Cat. No. 71). The head of the woman is similar to the head of the seated nude woman on the barrel decorated by Gauguin (Cat. No. 84).

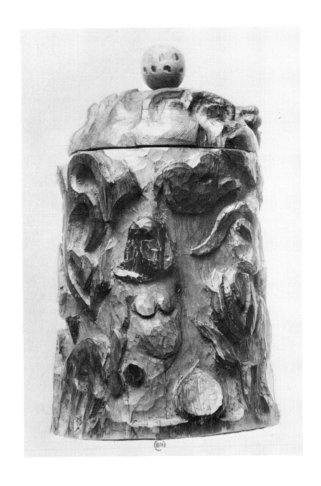

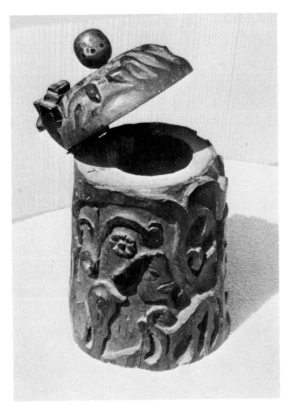

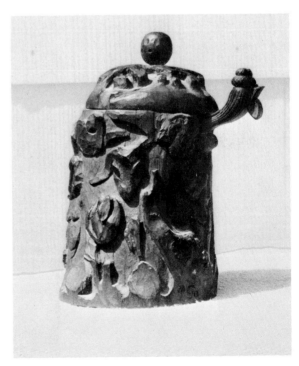

L. 90 cms. Boxwood, inlaid with mother-of-pearl. Heavy pointed iron tip.

Collections: Ernest Ponthier de Chamaillard, Paris; Miss Adelaide Milton de Groot, New York.

Exhibitions: 118–Chicago Art Institute and the Metropolitan Museum, New York, 1959; 76–Galerie Charpentier, Paris, 1960.

Photograph: Metropolitan Museum of Art, New York.

Notes:

This, the first of a surviving series of canes made by Gauguin, was probably given to his painter friend Chamaillard. The *sabot* at the top, which contains a secret compartment, identifies the cane with Brittany, while the figure below bears a resemblance to the Negress in *Soyez amoureuses* (Cat. No. 76).

The snake coiling around the shaft of the cane recalls the motif of Eve and the Serpent that Gauguin used constantly, but the unusual motif of the snake issuing from the mouth of a lizard is unique. The animal is very close in conception to the lizard on a Peruvian pot that was in the collection of Gustave Arosa (Demmin, *Guide de l'amateur de faiences & porcelaines, poteries, terres cuites, peinture sur lave et emaux,* Fig. 4, p. 1067). See below.

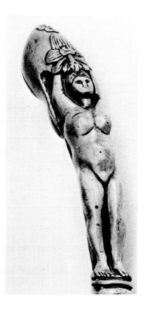

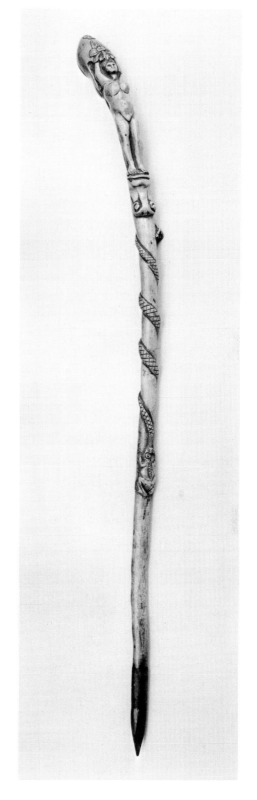

81 A PAIR OF WOODEN SHOES

Carved and painted gold, blue, and vermilion. The right shoe is decorated with two standing Breton figures. The left shoe is decorated with a goose, a crescent, and fruit.

Collections: Marie Henry; Étienne Bignou, Paris; Chester Dale, New York.

Exhibitions: 29–Galerie Barbazanges, Paris, 1919; 27–Luxembourg, Paris, 1928; 104–Wildenstein, New York, 1956; 117–Chicago Art Institute and the Metropolitan Museum of Art, New York, 1959.

References: Rotonchamp, *Gauguin,* p. 71; Morice, *Gauguin,* p. 18; Malingue, "Du nouveau sur Gauguin," *L'Oeil,* LV/LVI (July–August, 1959), 37.

Photograph: Chicago Art Institute.

Notes:

Morice states that Gauguin caused a sensation by wearing Breton *sabots* in Paris.

The design for the right foot appears in the *Album Gauguin* in the Louvre (see Fig. 9c).

It has not been generally recognized that there are three pairs of *sabots* decorated by Gauguin. This pair seems to have belonged to Marie Henry, for Maurice Malingue has a photograph taken in 1889 that shows these *sabots* together with the clay *Figure of a Martinique Negress* (Cat. No. 61), which was formerly in the collection of Marie Henry. In the exhibition at the Galerie Barbazanges in 1919, three pieces of sculpture were shown. Numbers 27 and 28, the *Bust of Meyer de Haan* and *Femme de Martinique,* both belonged to Marie Henry. Number 29, *Sabots,* probably also came from her collection. Apparently they passed into the collection of Étienne Bignou before the Luxembourg Exhibition of 1928, and then eventually into the collection of Chester Dale.

82 A PAIR OF WOODEN SHOES

Carved, possibly painted. The right shoe is signed: P Go.

Collections: Schuffenecker Collection, Paris; present location unknown.

Exhibitions: Probably No. 32–Nunes et Fiquet, Paris, 1917; Probably No. 62–Galerie Dru, Paris, 1923.

References: Morice, *Gauguin,* p. 18(ill.); Michel Puy, "Paul Gauguin," *L'Art décoratif,* p. 188(ill.).

Photograph: Musées Nationaux.

Notes: (See notes under Cat. No. 81)
This pair of *sabots* is shown in a photograph in the *Album Schuffenecker* in the Cabinet des Dessins in the Louvre.

83 A PAIR OF WOODEN SHOES

Length: 33 cms. Maple (?) wood. Shoe for the right foot decorated with an animal (fox?), that for the left foot with a fantastic bird. The animal and the bird are red. The animal's hind feet and tail are yellow. The foliage is painted green, and the ground madder. Flowers are yellow. The design is pierced through and backed with leather.

Collections: Ernest Chaplet, Paris; Louise Lenoble, Paris; Ernest Legros, Paris.

References: Beaux-Arts, May 10, 1942, No. 55 (ill.).

Photograph by the author.

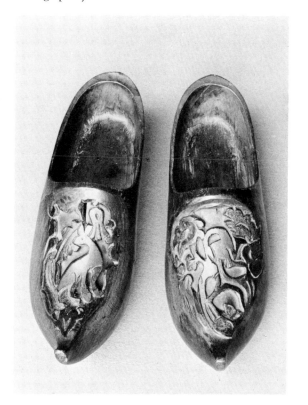

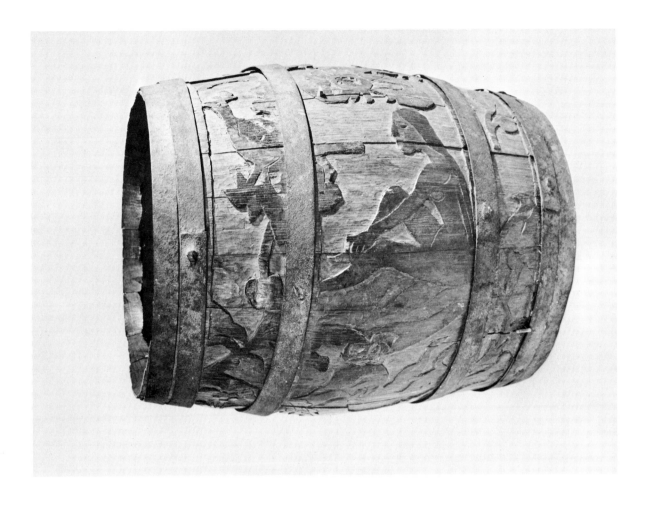

84 BARREL

L. 37 cms. Dia. 31 cms. Carved and painted. Hoops show traces of gilt paint. (See Plate V, p. 90)

Collections: Marie Henry, Le Pouldu; Marlborough Galleries, London.

References: Sale Catalogue, Hotel Drouot, March 16, 1959, #143; Rewald, *Post-impressionism,* p. 300; Malingue, "Du nouveau sur Gauguin," *L'Oeil,* LV/LVI (July–August 1959), 35(ill.).

Photographs: Courtesy of the Marlborough Galleries, London.

Notes:

"He made use of wood, clay, paper, canvas, wall, anything on which to record his ideas and the results of his observations. I still remember a cask on the staves of which he carved a series of fantastic animals that seemed to dance." ("Gauguin et l'Ecole de Pont Aven," *Essays d'Art Libre,* November, 1893. Quoted from Rewald, p. 300.)

The carving of another barrel in Tahiti is mentioned by Hamon (see text, p. 68).

The style is not typical of that of Gauguin in the period between his return from Martinique and his departure for Tahiti, but the barrel must have been executed during this period to have found its way into the collection of Marie Henry. However, the most striking characteristic of the work, its extreme flatness, may have been enforced by the thinness of the wood in which Gauguin was working.

Though the subjects are Breton, there is a touch of the barbaric, particularly in the nude figure, whose head suggests that of the figure on the extreme upper left in the panel *Soyez amoureuses* of 1889 (Cat. No. 76). The clothed figure is very close to the left hand figure on a ceramic executed about this time (Cat. No. 70).

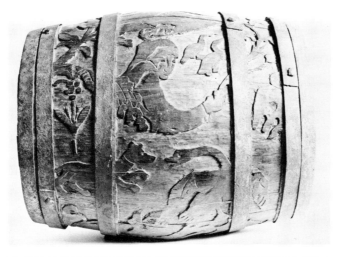

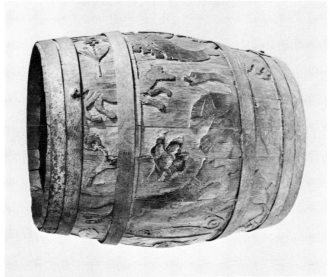

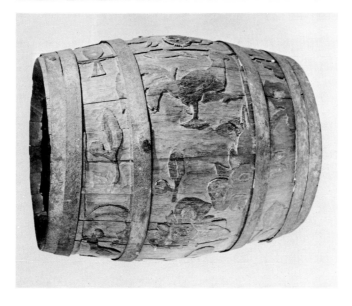

85 SETTEE WITH ARM ENDS DECORATED WITH HEADS

Collections: René Baer, Strassbourg.

Photographs: Courtesy of Réne Baer.

Notes:

A partly effaced label on the back of the settee states:

> Les deux têtes à l'avant des bras de ce banc ont et(ées) sculptées par Gaugu(in) à l'hotel Gloan(ec) . . . Pont-Avan.

(Signature illegible)

A certification accompanying the settee reads:

> Je certifie que les deux têtes sculptées sur les bras au banc breton sont bien de Gauguin. Mon Mari qui était un camarade du peintre était présent lorsqu'il les a sculptées.

E. MOLINARD
Paris le 27 Decembre 1954

The style of the settee is typically Breton, and the carving of the heads suggests the decorative heads on the ends of roof beams in Breton churches.

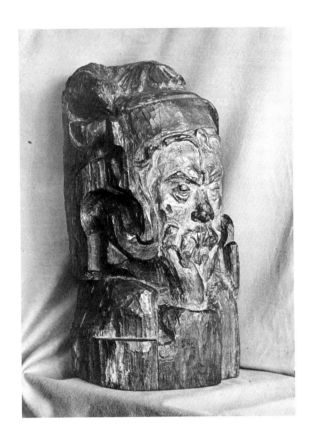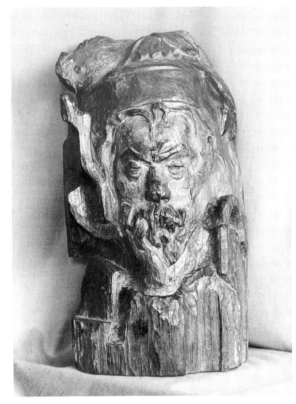

86 BUST OF MEYER DE HAAN

H. 57 cms. Oak, carved and painted. Eyes green, ear red, traces of gilding in the hair, and foliage green.

Collections: Marie Henry, Le Pouldu; Mme Millet, Paris.

Exhibitions: 27–Galerie Barbazanges, Paris, 1919; 8–Luxembourg, Paris, 1928; 75–Galerie Charpentier, Paris, 1960.

References: Rotonchamp, *Gauguin,* p. 70; Morice, *Gauguin,* p. 79; *L'Art aujourd'hui,* Winter, 1927, (ill.); Rey, "Les Bois sculptés de Paul Gauguin," *Art et Décoration,* LIII (February, 1928), 57–64(ill.); Chassé, *Le Mouvement symboliste,* p. 80 (ill.); Chassé, *Gauguin et son temps,* p. 74; Malingue, "Du nouveau sur Gauguin," *L'Oeil,* LV/LVI (July–Aug., 1959), 35, 37.

Photographs by the author.

Notes: (See text, p. 48)

This curious portrait shows the same moody introspective personality that Gauguin expressed in his other representations of Meyer de Haan such as the *Portrait of Meyer de Haan* in the collection of Q. A. Shaw McKean, Boston, and the watercolor entitled *Nirvana* in the collection of the Wadsworth Atheneum in Hartford. Years later, the visage of Meyer de Haan in the same moody contemplative pose appears in the painting *Contes barbares* of 1902 (collection of the Folkwang Museum, Essen).

One of the most curious aspects of the portrait is the chicken roosting on top of Meyer de Haan's head, and the foliage forms that surround it.

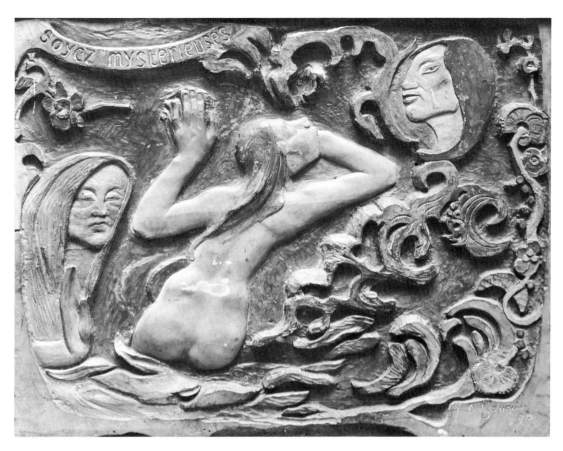

87 "SOYEZ MYSTÉRIEUSES"

H. 73 cms. L. 95 cms. Linden wood, carved and painted. Inscribed: SOYEZ MYSTÉRIEUSES. Signed: Paul Gauguin /90. (See Plate XI, p. 96.)

Collections: Gustave Fayet, Béziers; Mme d'Andoque, Béziers.

Exhibitions: Les XX, Brussels, 1891; 53–Gauguin Retrospective, Paris, 1906.

References: Malingue, *Lettres,* LXXXVI, CXII, p. 273(ill.); Segalen, *Lettres,* LXXIX; Champal, "Le Carnaval d'un ci-devant," reprinted in *L'Art moderne,* February 1, 1891; Aurier, "Le Symbolisme en peinture," *Mercure de France,* March, 1891, p. 165; *Zolotoe Runo,* I:i (1909), 5–14(ill.); Morice, *Gauguin,* p. 167(ill.); P. Girieud, *Albums d'Art Druet,* (ill.); Rewald, *Post-impressionism,* pp. 448, 449, 462, 463; Goldwater, *Gauguin,* p. 15.

Photographs: Musées Nationaux and the author.

Notes: (See text, pp. 48 ff)

In September, 1890, Gauguin wrote Émile Bernard: "J'ai accouché d'un bois sculpté, le pendant du premier—"Soyez Mysterieuses"—dont je suis content, je crois même que je n'ai encore *rien* fait d'approchant" (Malingue, *Lettres,* CXII). In March, 1902, Gauguin wrote De Monfreid about the pieces of sculpture that Fayet had bought and mentions ". . . *Soyez mysterieuses . . . chez Chaudet . . . qui l'avait en dépot . . ."* (Segalen, *Lettres,* LXXIX). Earlier, in March, 1893, when Joyant left Goupil's, he had sent De Monfreid a list (Loize, *Amities,* p. 94) of Gauguin's works that he was returning. Among the items are mentioned: "1 bois sculpté à double face—1 bois sculpté: *Soyez amoureuses."* The reference to a double-faced carving is interesting because, so far as the author knows, none has turned up among the works of Gauguin. However, on the back of *Soyez mystérieuses* there appear signs of what must have been another carving which has been subsequently sawed off, leaving only those parts in which the cutting was deepest. That the part that was sawed off was not part of an abandoned work is indicated by the careful polychromy that remains. It seems most probable that Gauguin had left *Soyez mystérieuses* together with *Soyez amoureuses,* yet Joyant mentions only the latter and the double-faced work. That *Soyez mystérieuses* had not been sold is indicated by the fact that it was left with Chaudet later.

88 "LUXURE"

H. 70 cms. Oak (cut from an old beam 7 x 15 cms.).
Fox is a separate piece of pine, nailed to base (nail
used for fox's nose). Painted, with touches of gilding.
Signed: P Go.

Collections: J. F. Willumsen Museet, Frederikssund,
Denmark.

Exhibitions: 84–Ny Carlsberg Glyptothek, Copen-
hagen, 1948.

References: Rewald, *Post-impressionism,* pp. 445,
447(ill.); Dorra, "The First Eves in Gauguin's Eden,"
Gazette des Beaux-Arts, XLI (March, 1953), 190, 193.

Photograph by the author.

Notes:
 This piece was given to Willumsen by Gauguin in
exchange for one of the Dane's paintings, in the
spring of 1891 (Rewald, p. 445). This version in
wood reproduces an earlier version in clay which has
been destroyed. The earlier version is reproduced in
Malingue, *Gauguin* (Monaco edition, 1943), p. 144.
This earlier version was mentioned in Gauguin's letter
to Émile Bernard in the fall of 1890: "Je vous envoie
une photo de ma statue que j'ai malheureusement
cassé. . . . Elle ne donne pas en cet état ce que
j'avais cherché dans le mouvement des deux jambes"
(Malingue, *Lettres,* CXI). Bernard reproduced the
photograph in his *Souvenirs inédits,* but the original
was destroyed in a fire. Madame Huc de Monfreid
has, however, preserved a copy (Cat. No. 88*a*).
 The statue appears in a painting *Caribbean Woman
with Sunflowers* (collection of Dr. and Mrs. Harry
Bakwin, New York) (Cat. No. 88*b*).

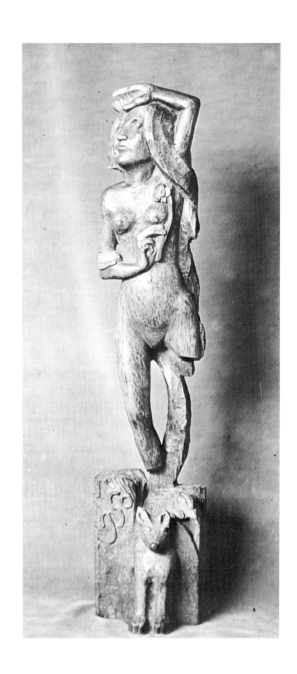

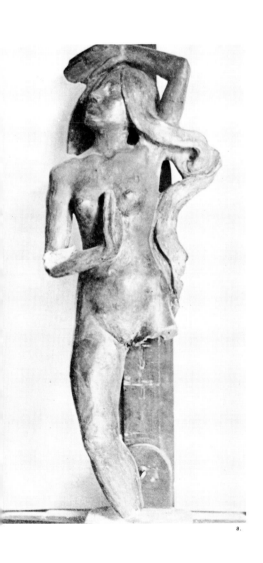

89 PORTRAIT OF
 MME SCHUFFENECKER

H. 60 cms. Plaster. Signed on the base on the left:
P Go.

Collections: Ambroise Vollard; Marcel Guérin, Paris;
Mme Collinet, Paris; Maurice Malingue, Paris; Musée
du Louvre.

Exhibitions: 27 bis–Galerie Charpentier, Paris, 1960.

Photograph: Courtesy of M. Malingue.

Notes:
 This handsome bust is dated by M. Malingue in
1890. The style is strongly reminiscent of the busts
of his family which Gauguin executed in 1877 (Cat.
Nos. 1, 2). In contrast to the earlier works, in which
the contribution of the sculptor Bouillot in the execu-
tion of the marble is hard to assess, we have here an
excellent example of the proficiency of the artist in a
conventional mode of portraiture.
 The bust was cast in an edition of ten by Valsuani
in 1960.

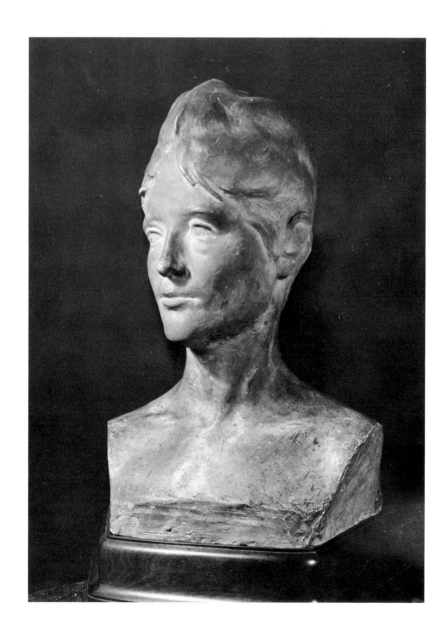

90 DAGGER

L. 36 cms. Blade is from a bayonet. Handle is wood, carved and painted. Signed: P G O.

Collections: Émile Schuffenecker, Paris; Amédée Schuffenecker, Paris; Mme Jeanne Schuffenecker, Paris; Musée du Louvre, Paris (gift of Jean Schmit).

Exhibitions: 28–Nunes et Fiquet, Paris, 1917; 29–Luxembourg, Paris, 1928; 227–Thannhauser Gallery, Berlin, 1928; 251–Kunsthalle, Basel, 1928; 67–*Gazette des Beaux-Arts,* Paris, 1936.

Reference: Varenne, "Les Bois gravés et sculptés de Paul Gauguin," *La Renaissance de l'art français,* December, 1927, p. 524(ill.).

Photograph by the author.

Notes:

There are two daggers which were both originally in the Schuffenecker Collection. One of them has a sheath, this one does not. This one has frequently been referred to as from Tahiti, while the other has been said to come from Martinique. However, in every way, both in the wood, which is European, the nature of the polychromy, and the style of carving with its deeply cut and profuse ornament, this piece belongs with the other productions of the period of 1890. Possibly Gauguin took it with him to Tahiti.

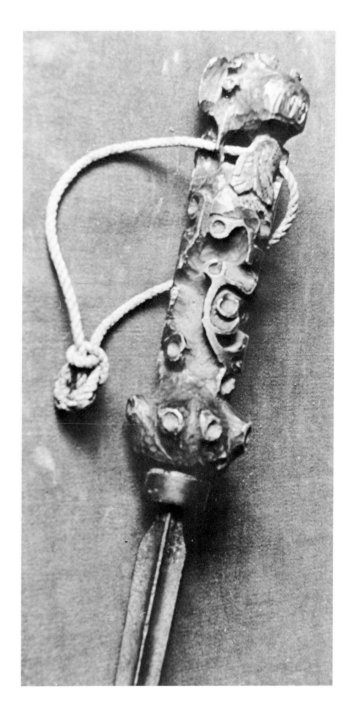

91 "BLACK VENUS"

H. 50 cms. Stoneware. Glazed a mottled dark brown. Bandana painted white in underglaze color. Flowers on base painted white in underglaze color, foliage green. The frieze of animals on the base is blackish brown. Signed: P. Gauguin (behind the right hand on the base). (See Plate VIII, p. 93)

Collections: Maurice Marx, Paris; Denguin Collection, Paris; Harry Guggenheim, New York.

Exhibitions: 45–Gallery Durand-Ruel, Paris, 1893; 227–Gauguin Retrospective, 1906; 16–Gauguin Retrospective, Venice Bienniale, 1928; 18–*Gazette des Beaux-Arts,* Paris, 1936; 89–Orangerie, Paris, 1949; 119–Art Institute Chicago and the Metropolitan Museum, New York, 1959.

References: Rewald, *Post-impressionism,* p. 442(ill.);

Goldwater, *Gauguin,* p. 34; Read, "Gauguin and the Return to Symbolism," *Art News Annual,* 1956, pp. 152–53.

Photographs: Edward Meneely.

Notes: (See text, pp. 31–32)

There was a *Femme noire* exhibited at the Durand-Ruel Exhibition in November–December, 1893. This is probably one of the two pieces of sculpture that Gauguin mentions having sold at that show.

92 STANDING NUDE WOMAN

H. 60 cms. Stoneware, glazed. The body is covered with a blackish-brown glaze. The hair is covered with an ivory glaze turning grey and blue in places. Signed on the base in raised letters: P. Gauguin. (See Plate IX, p. 94)

Collections: Manzi, Paris; Walther Halvorsen, Norway; H. d'Oelsnitz, Paris; Galerie le Portique, Paris; Private Collection, Paris.

Exhibitions: Probably *Les XX, Brussels,* 1891; 32–Luxembourg, Paris, 1928; 131–Galerie Charpentier, Paris, 1960.

References: Barth, "Eine unbekannte Plastik von Gauguin," *Das Kunstblatt,* June, 1929, pp. 182–83; Berryer, "À propos d'un vase de Chaplet," p. 24; Rewald, *Post-impressionism,* p. 442(ill.); Read, "Gauguin and the Return to Symbolism," *Art News Annual,* 1956, p. 154(ill.).

Photographs: Galerie Charpentier and the author.

Notes: (See text, p. 29)

Though this work is generally dated in the period of Gauguin's return to Paris after his first trip to Tahiti, the author has found no clear evidence for such a date. Both the body forms and the features appear more European than Polynesian, in spite of the brownish-black coloration of the flesh. In addition, the style of the conception and execution of the statuette is close to *Black Venus* (Cat. No. 91), which was probably executed about 1889. On the other hand, the execution is far different from that of such pieces as *Oviri* and the *Square Vase and Tahitian Gods* (Cat. Nos. 113, 115), which can surely be dated after the artist's return from Tahiti. Rotonchamp (*Gauguin,* p. 77) mentions Gauguin working on an *Ève debout* in Schuffenecker's studio on the Rue Durand-Claye in the winter of 1890–1891. In 1891 Gauguin sent to the exhibition of *Les XX* in Brussels, among other things, a statuette in *"grés emaillé"* (Rewald, *Post-impressionism,* p. 462). In a list of works that he intended to send to the exhibition of the *Société Nationale* in 1891 Gauguin mentions under the heading of ceramics: *"Statue 400 fr"* (Loize, *Amities,* #123).

Finally, the fact that the statue originally belonged to Joyant's partner, Manzi, suggests that it dates from the period before Joyant stopped handling Gauguin's works, in the spring of 1893. In Gauguin's notebook (Huyghe, *Carnet de Gauguin,* p. 222) in the listing

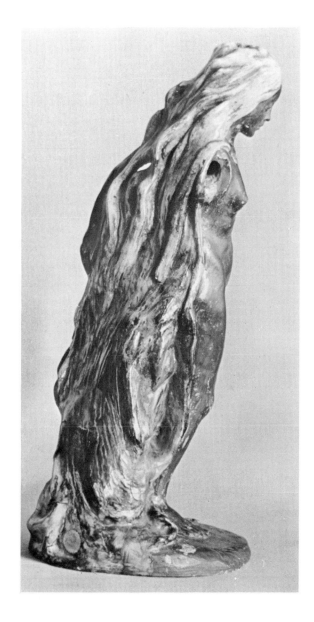 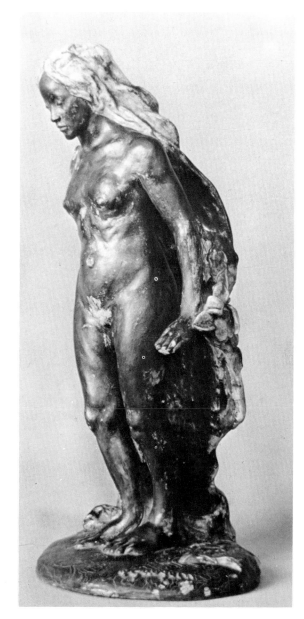

of his financial position after the sale at the Hotel Drouot in 1891, there is the notation: *"Manzy avance (sur statue) 300."*

This statue is made of a red-firing clay that appears to have been fired at a somewhat lower temperature than is usual in Gauguin's stoneware. The base is made of a spiral coil of clay, while there are indications that the rest of the figure was made in the solid and hollowed out later to prevent its overcracking in the firing. The left arm was apparently made separately, for there are marks in the clay indicating where it was joined to the rest of the body. The right arm is missing, and was not joined to the torso before firing, for the point of jointure shows no break in the clay. In making complex figures in terra cotta it is a common practice to fire delicate and unsupported parts separately and attach them after firing with plaster of Paris. (Cf. Edward Lanteri, *Modelling, a Guide for Teachers and Students* [London, 1904], p. 152.) Perhaps Gauguin intended to attach the right arm after firing, but for some reason did not do so.

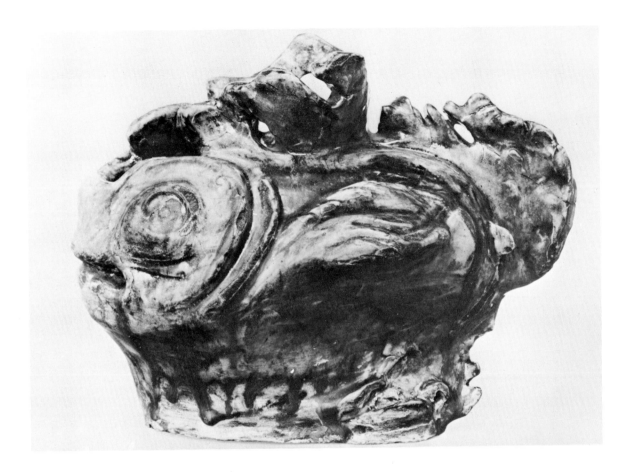

93 VASE IN THE SHAPE OF A FISH

H. 23 cms. L. 32 cms. Stoneware, glazed. Signed over the left eye: P G O. The basic glaze is transparent, with a greenish cast, possibly from reduced iron absorbed from the body. Under the glaze the body is light colored, but reddish where exposed. In places the fish is decorated with a copper transition glaze, that is green with touches of red, and a blue glaze. (See Plate X, p. 95)

Collections: Mette Gauguin, Copenhagen; Jean Gauguin, Copenhagen; Kunstindustrimuseet, Copenhagen (B 3/1931).

Exhibitions: Probably Champ de Mars, 1891; 83– Ny Carlsberg Glyptothek, Copenhagen, 1948.

References: Pola Gauguin, *Paul Gauguin*, p. 97(ill.); Berryer, "À propos d'un vase de Chaplet," p. 18; Loize, *Amities*, #123, p. 92; Bodelsen, *Gauguin Ceramics in Danish Collections*, p. 16(ill.), p. 30.

Photographs: Kunstindustrimuseet, Copenhagen, and the author.

Notes:

In the spring of 1891, when Gauguin left for Tahiti, he gave De Monfreid a list of objects to be sent to the exhibition of the *Société Nationale des Beaux-Arts* at the Champ de Mars. In this list *"le poisson"* is noted among other ceramics, with the further notation: *"Poisson 200 fr"* (Loize, *Amities*, #123).

Though the vase has been referred to as having the form of a lumpfish, it seems more in the nature of a stylization of an ornamental goldfish, particularly in view of its large eyes and feathery fins and tail. The carp, of which one variety is the goldfish, was a favorite fish of the Chinese, who often made vases in that form. These vases were frequently colored blue and red.

The red areas have all the characteristics of a copper reduction glaze, but the blue areas appear to be colored with cobalt. Though blue can be produced with copper, it does not have the quality of the blue in this ceramic. The technique is not strictly that of the *flammé* ware of Chaplet, but rather a development of Gauguin's experiments with free painting with glaze.

Pieces of the tail and top fin have been broken and restored.

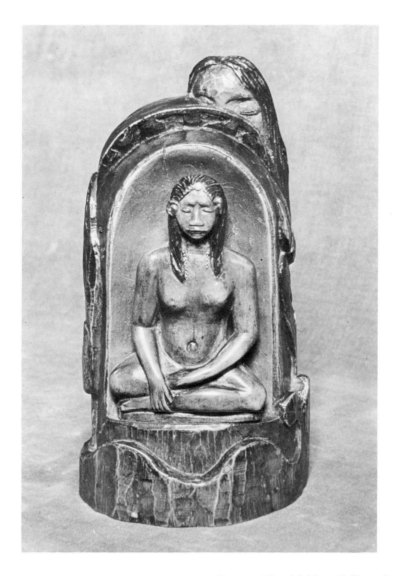

94 "IDOLE À LA PERLE"

H. 25 cms. Tamanu wood. Hair of figures stained black. Niche behind seated figure gilded. Figure with inlaid pearl, gold necklace with gold star. Signed on top: P Go. (See Plate XII, p. 97)

Collections: Daniel de Monfreid; Agnés Huc de Monfreid.

Exhibitions: Probably shown in the Durand Ruel Exhibition, 1893; Gauguin Retrospective, Paris, 1906; 50–Galerie Dru, Paris, 1923; 15–Luxembourg, Paris, 1928; 90–*Gazette des Beaux-Arts,* Paris, 1936; 169–De Monfreid Exhibition, Paris, 1938; Musée de l'Art Moderne, Paris, 1951; 33–Galerie Ándre Weil, Paris, 1951; 76–Tate Gallery, London, 1955; 111–Charpentier, Paris, 1960 (ill.).

References: Jamot, "Salon d'automne," *Gazette des Beaux-Arts,* December, 1906, p. 469; *Zolotoe Runo,* I:i (1909), pp. 5–14 (ill. plaster copy); Morice, *Gauguin,* p. 182(ill.); Alexandre, *Gauguin,* p. 270(ill.); Malingue, *Gauguin,* 1944, p. 150(ill.); Puig, *Paul Gauguin,* p. 45(ill.).

Photographs by the author.

Notes: (See text, p. 56)
 The wood used by Gauguin was apparently tamanu *(Inophyllum calophyllum),* a material used by the Tahitians for their wooden vessels. It has a grain similar to Honduran mahogany, but the color is more orange. The seated figure is made of a separate piece

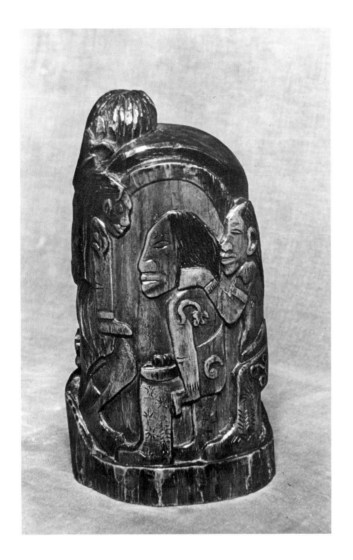

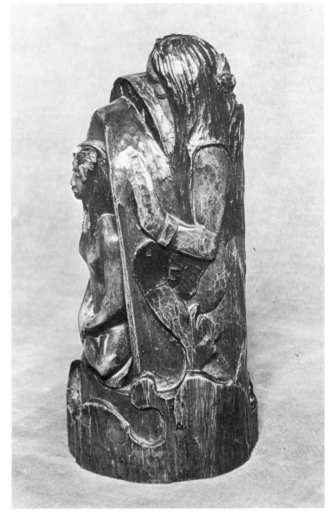

of wood, which was pinned to the main piece after carving.

There are at least two sets of reproductions of the wood sculptures in the De Monfreid Collection. The first set, made about 1900, is referred to in a letter in December 1900 from Gustave Fayet to De Monfreid:

> . . . Quant au moulage des bois qui vous appartiennent, je vous offre mon atelier de céramiste pour les mouler. Cela ne couterait rien. . . . Vous tireriez les épreuves que vous voudriez et nous briserions les moules. . . . (Loize, *Amities*, #128, p. 144)

Examples of these casts have remained in the pos-

session of the heirs of Gustave Fayet. That of the *Idole à la Perle* is in the collection of Mme Léon Fayet.

Another set of reproductions in bronze was authorized by Mme Huc de Monfreid in 1959, and were cast in editions of six by Valsuani.

The seated figure appears in Gauguin's woodcut *Te Atua* (Cat. No. 94*b*) (Guérin No. 31). Sketches of figures in similar poses appear in Gauguin's notebooks as early as about 1888 (see *Le Carnet de Paul Gauguin*, edited by René Huyghe [Paris, 1952], p. 12).

a.

b.

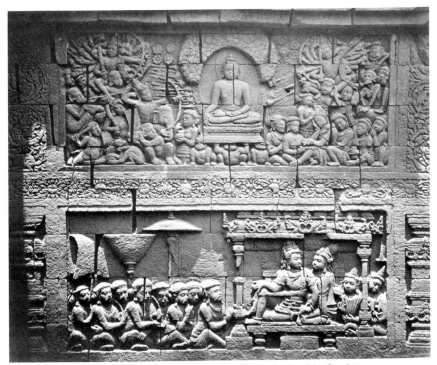

c. Reliefs from the Temple of Borobudur, Java. Above: The Assault of Mara. Below: Scene from the Bhallatiya-jataka. From J. van Kinsbergen, Oudheden van Java. Courtesy Rijksmuseum voor Volkenkunde, Leiden.

95 CYLINDER DECORATED WITH THE FIGURE OF HINA

H. 36 cms. Dia. 13 cms. Tamanu (?) wood. Polychromed with dark stain in the hair. Hina's girdle is gilded. Signed: P G O on top.

Collections: Daniel de Monfreid; Mme Huc de Monfreid.

Exhibitions: Probably in the exhibition at Durand-Ruel, Paris, 1893; Gauguin Retrospective, Paris, 1906; 12–Luxembourg, Paris, 1928; 93–*Gazette des Beaux-Arts,* Paris, 1936; 168–De Monfreid Exhibition, Galerie Charpentier, Paris, 1938; 112–Galerie Charpentier, Paris, 1960.

References: Rey, "Les Bois sculptés de Paul Gauguin," *Art et Décoration,* LIII (February, 1928), 63(ill.); Alexandre, *Gauguin,* (ill.); Puig, *Paul Gauguin,* p. 42(ill.).

Photographs by the author.

Notes:

Hina was the deity of the Tahitian pantheon that made the greatest impression on Gauguin. Her form appears many times in all media. Perhaps the earliest version is a pencil drawing formerly in the collection of Francisco Durrio (illustrated in Guérin, p. xv). Her form also appears in Gauguin's great painting *Que sommes-nous?* (Boston Museum of Fine Arts) and many others (cf. Wildenstein, "L'Idéologie et l'esthétique dans deux tableaux-clés," *Gauguin, sa vie, son oeuvre,* p. 127 ff). She also appears as a dominant figure in Catalogue numbers 97, 105, 115, and her head appears in number 117.

One suspects that the figure was derived by Gauguin from the type of female representation in Indonesian art, with a certain modification of pose to achieve the more static frontality appropriate to an idol.

The figure of the votary of Hina (at right) also appears on the back of Catalogue number 96, and, at a much later period, in the *Tahitian Women with Mango Blossoms* (Metropolitan Museum of Art, New York). The original source of the figure is probably to be found in the second standing figure from the left in the scene below *The Meeting with the Ajivaka,* represented in Gauguin's photographs of the reliefs of the temple of Borobudur in Java (see below).

A plaster cast of this piece is in the collection of P. Bacou, Puissalicon, and six bronze casts were made by Valsuani in 1959 (see notes under Cat. No. 94).

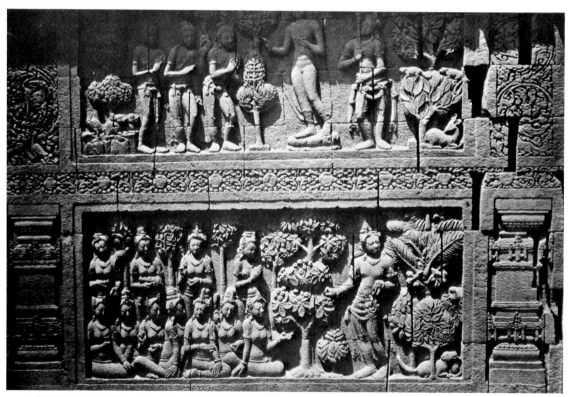

a. Reliefs from the Temple of Borobudur, Java. Above: The Tathagata meets an Ajiwaka monk on the Benares Road. Below: Maitrakanyaka-jataka. Arrival at Nandana. From J. van Kinsbergen, Oudheden van Java. Courtesy Rijksmuseum voor Volkenkunde, Leiden.

220

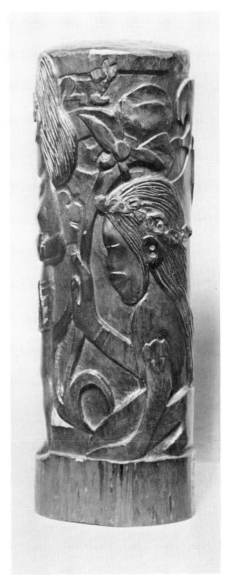

96 "HINA AND TE FATOU"

H. 32 cms. Large diameter 14 cms. Tamanu wood. Signed: P G O on the top. (See Plate XV, p. 99)

Collections: Daniel de Monfreid; Mme Huc de Monfreid.

Exhibitions: Probably in the exhibition at Durand-Ruel's, Paris, 1893; Gauguin Retrospective, Paris, 1906; 54–Galerie Dru, Paris, 1923; 13–Luxembourg, Paris, 1928; 91–*Gazette des Beaux-Arts,* Paris, 1936; 165–De Monfreid Exhibition, Paris, 1938; 120–Galerie Charpentier, Paris, 1960.

References: Zolotoe Runo, I:i (1909), 5–14(ill.); Rey, "Les Bois sculptés de Gauguin," *Art et Décoration,* LIII (February, 1928), 57–63(ill.); Morice, *Gauguin,* p. 156(ill.); Alexandre, *Gauguin,* 211(ill.); Puig, *Gauguin,* p. 38(ill.).

Photographs by the author.

Notes: (See text, pp. 60–61)

This was another favorite motif of the artist. It represents a myth that he recounts in *Noa-Noa* (see text, p. 60). This particular composition appears in a drawing *Parau Hina Tefatou* (Rewald, *Gauguin Drawings,* No. 85), in a wood cut (Guérin, *L'Oeuvre gravé de Gauguin,* No. 31), and on a vase (Cat. No. 115). Perhaps the earliest version of this motif is found in a pencil drawing formerly in the Collection of Francisco Durrio (illustrated in Guérin, p. 3).

A plaster cast of this piece is in the collection of Mme Léon Fayet, Arles; and it was cast in bronze in an edition of six by Valsuani in 1959 (see notes under Cat. No. 94).

The curious animal on the base appears to be based on figures carved by the Marquesan artist in which a front view is formed by two profile views.

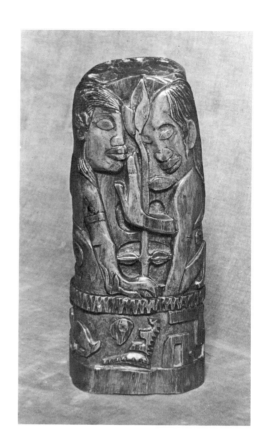

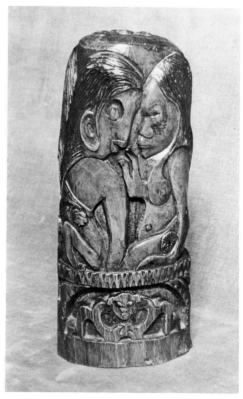

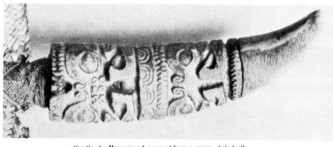

a. Handle of a Marquesan fan carved from a sperm whale tooth. From Von den Steinen, <u>Die Marquesaner und ihre Kunst</u>.

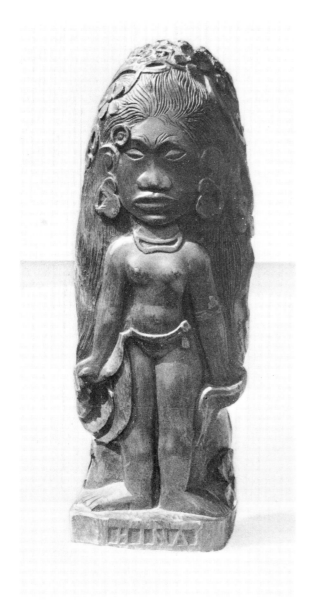 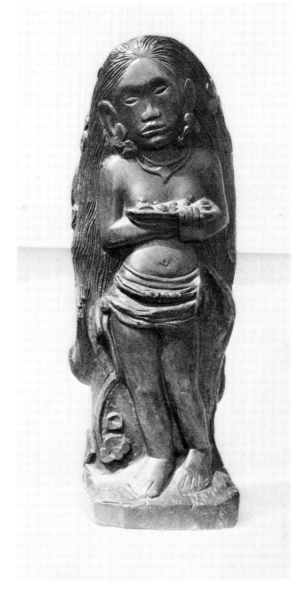

97 "HINA"

H. 40 cms. Tamanu wood. Signed on the side: P G O. Inscribed under one figure: HINA.

Collections: Alden Brooks.

Exhibitions: Probably in the Durand-Ruel Exhibition, Paris, 1893; 16–Luxembourg, Paris, 1928 (ill. p. 13).

References: Castets, "Gauguin," *Revue Universelle,* III: xcvi (1903), 536(ill.); *L'Art aujourd'hui,* Winter, 1927; Rey, "Les Bois sculptés de Gauguin," *Art et Décoration,* LIII (February, 1928), 57–64; Art Institute Chicago, *Gauguin Catalogue,* 1959, p. 58.

Photographs: Alden Brooks.

Notes:

This piece was probably one of the two sculptures sold at the Durand-Ruel Exhibition in 1893. It consists of two figures back to back, one the moon-goddess Hina and the other a woman bringing an offering of flowers. The figure of Hina is similar to the *Hina* in the De Monfreid Collection. In addition to the other representation of Hina noted under the latter work (Cat. No. 95), this figure appears prominently in Gauguin's woodcut *Te Atua* (Cat. No. 94*b*).

The figure of the votary is the same as that on the De Monfreid *Hina* (Cat. No. 95), and is derived from the same source.

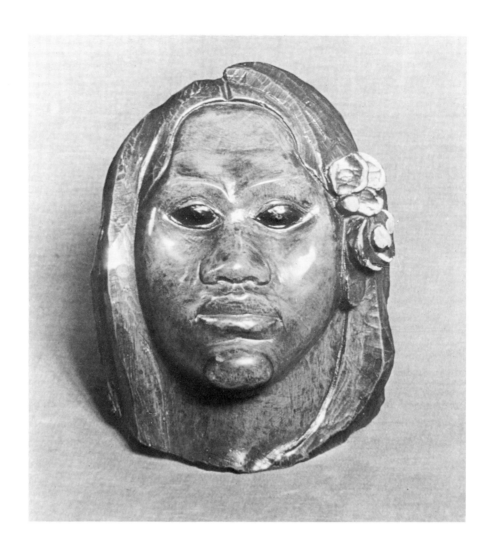

98 MASK OF A TAHITIAN WOMAN

H. 25 cms. W. 20 cms. Pua wood? Eyes painted dark green, hair black, lips red, flower gilded. On the reverse is a standing nude woman.

Collections: Mme G.-D. de Monfreid; Mme Huc de Monfreid.

Exhibitions: Possibly in the exhibition at Durand-Ruel's gallery, Paris, 1893; Gauguin Retrospective, Paris, 1906; 56–Galerie Dru, Paris, 1923; 17–Luxembourg, Paris, 1928; 60–*Gazette des Beaux-Arts,* Paris, 1936; 170–De Monfreid Exhibition, Paris, 1938;

35–Galerie André Weil, Paris, 1951; 109–Galerie Charpentier, Paris, 1960, (ill.).

References: Jamot, "Salon d'automne," *Gazette Beaux-Arts,* December, 1906, p. 469; Rey, "Les Bois sculptés de Gauguin," *Art et Décoration,* February, 1928; Alexandre, *Gauguin,* p. 196; *L'Art aujourd'hui,* Winter, 1927, (ill.); Puig, *Gauguin,* p. 46.

Photographs by the author.

Notes:

This piece, in a more thoroughly European tradi-

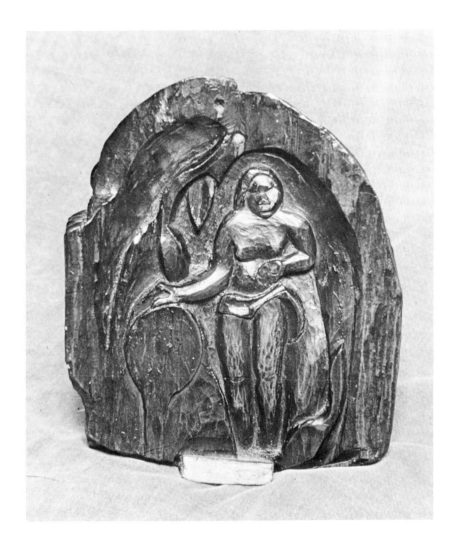

tion than Gauguin's other sculpture in Tahiti, has always been associated with the figure of Tehura from his book *Noa-Noa*. Though there may be doubt as to whether Tehura was actually the name of Gauguin's *vahine,* or only a romantic fiction, this representation does not fit her description:

> . . . Sur son visage charmant je ne reconnus pas le type qui jusqu'à ce jour, j'avais vu partout reigner dans l'ile et sa chevelure aussi était très exceptionelle: poussée comme la brousse et légèrement crépue. . . . Je sus dans la suite qu'elle était originaire des Tongas. (*Noa-Noa,* pp. 100–1)

Though this mask certainly does not have frizzy hair and represents a pure Polynesian type, it will perhaps always be associated with the appealing figure of Gauguin's account of Tehura in his book.

The mask has been cast in bronze by Valsuani in an edition of six.

The scene carved on the back recalls the painting *Eve* (see Rewald, *Post-impressionism,* p. 468), signed and dated 1890.

According to Mme Huc de Monfreid, this sculpture was offered by Gauguin to her mother *"pour payer le modèle"* after she had posed for him.

99 "IDOLE À LA COCQUILLE"

H. 27 cms. Dia. 14 cms. Toa (ironwood). Mother-of-pearl aureole and pectoral. Teeth inlaid bone. Parts of the carving darkened with black. Signed: P G O. (See Plate XIV, p. 99)

Collections: Daniel de Monfreid; Mme Huc de Monfreid.

Exhibitions: Probably in Durand-Ruel Exhibition, Paris, 1893; Gauguin Retrospective, Paris, 1906; 14–Luxembourg, Paris, 1928; 92–*Gazette des Beaux-Arts,* Paris, 1936; 167–Monfreid Exhibition, Paris, 1938; 76–Tate Gallery, London, 1955; 110–Galerie Charpentier, Paris, 1960.

References: Rey, "Les Bois sculptés de Gauguin," *Art et Décoration,* LIII (February, 1928), 57–64; Alexandre, *Gauguin,* p. 210(ill.); Puig, *Paul Gauguin,* p. 41; Bodelsen, "Gauguin and the Marquesan God," *Gazette des Beaux-Arts,* March, 1961, pp. 167 ff.

Photographs: Musées Nationaux and the author.

Notes:

The pose of the main figure recalls that of the *Idole à la perle* (Cat. No. 94), but here the Indonesian features have disappeared in an attempt to create a more purely Polynesian characterization. Gauguin has simulated the filed teeth of a Marquesan cannibal with a bit of bone, and the lower parts of the figures are ornamented with designs representing tattooing. As Bodelsen has pointed out, the figures on the side are similar to those in one of the illustrations in *Ancien Culte mahorie* (facsimile edition, Paris, 1951, p. 7), and the common source is to be found in Marquesan ornamental carving (Cat. No. 99*a*, 99*b*).

The ultimate source of the idea of the idol is the same as that of the *Idol à la perle.*

Gauguin very seldom used ironwood for his sculpture, probably because of its excessive hardness, and the fact that it was not easily available. In one letter to De Monfreid in March 1893 he said:

> En ce moment je sculpte sur troncs d'arbres genre bibelots sauvages. J'ai a rapporter un morceau de bois de fer qui m'a usé les doigts, mais j'en suis content. (Segalen, *Lettres,* XII)

As this is the only known piece of carving in ironwood from this period; the letter dates its execution exactly.

This sculpture has been reproduced both in plaster and in bronze (see notes under Cat. No. 94).

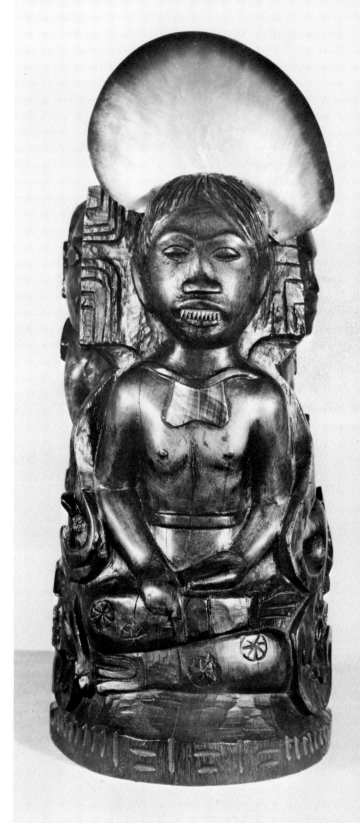

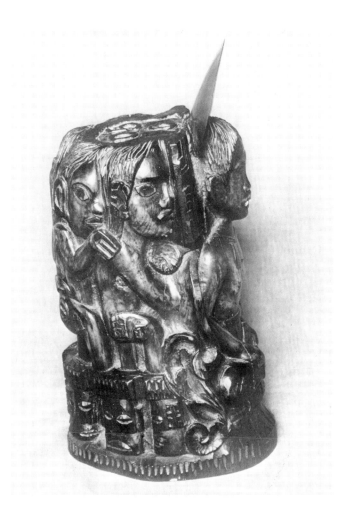

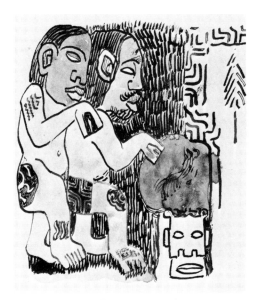

a. Watercolor from the manuscript of Ancien Culte mahorie.
Cabinet des Dessins, Louvre.

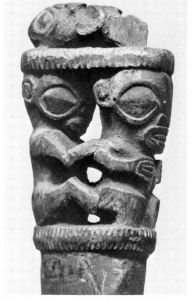

b. Handle of a Marquesan oar. Courtesy of the British Museum.

c. Marquesan stylization of the hand. After Karl
Von den Steinen, Die Marquesaner und ihre Kunst,
Vol. II, Fig. 96.

100 "L'APRÈS-MIDI D'UN FAUNE"

H. 34 cms. W. 12 cms. Depth 9 cms. Tamanu wood. Signed on the top: P G O. (See Plate XIII, p. 98)

Collections: Stéphane Mallarmé, Paris; Henri Mondor, Paris; Private Collection, Paris.

References: C. Mauclaire, *Mallarmé chez lui*, p. 19.

Photographs by the author.

Notes:

This work, inspired by *L'Après-midi d'un faune* of Mallarmé, was the gift of the artist to the author in return for a copy of the author's idyll dedicated "au sauvage et bibliophile, son ami Stéphane Mallarmé." The composition consists of three main figures, one with goat legs, and two small figures which appear in the interstices of the composition. The face of the goat-legged faun is that of Te Fatou, the Polynesian earth god, represented in *Parau Hina Tefatou* (Cat. No. 96).

Camille Mauclair describes the piece: ". . . Une bûche de bois orangé où Paul Gauguin avait sculpté un profil de Maori. . . ." The background of the sculpture is lightly stained a dull red.

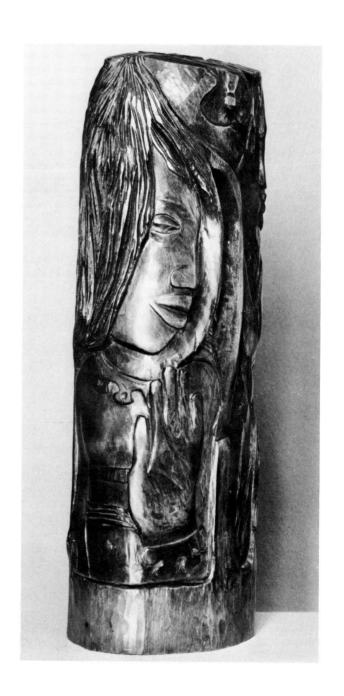

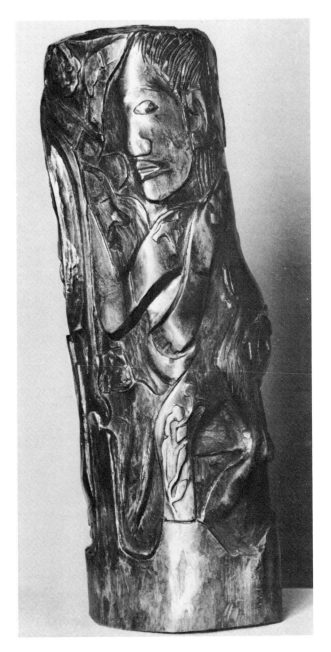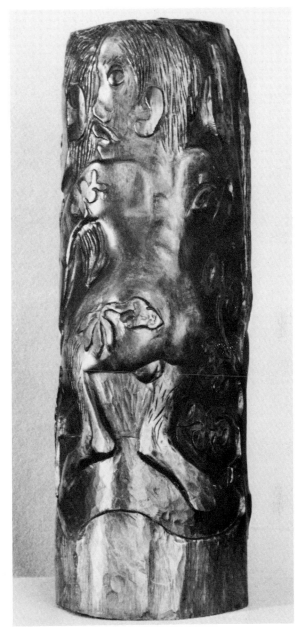

229

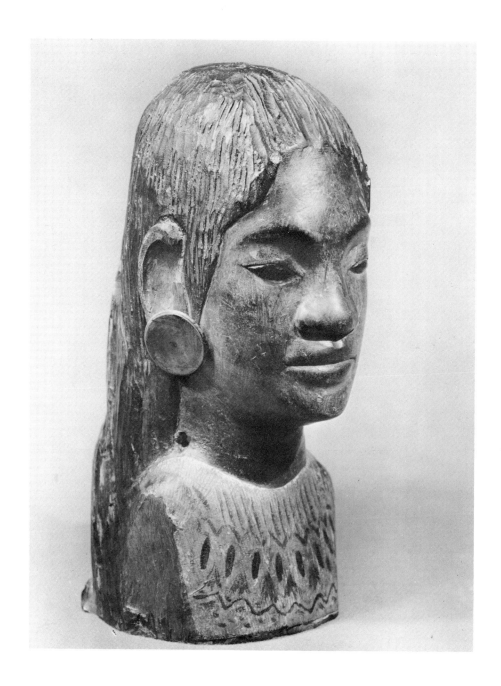

101 BUST OF A TAHITIAN GIRL

H. 25.4 cms. Tamanu wood. Polychromed and decorated with a shell necklace and another of coral. Not signed.

Collections: Private Collection, France; Frank Partridge, London.

Exhibitions: 46–Sale Exhibition, Sotheby and Co., London, June 28, 1961.

Photograph: Courtesy of Sotheby and Co.

Notes:

Formerly the property of the daughter of a friend of Gauguin's. In either 1894 or 1895, when she was a small child, Gauguin gave her this sculpture instead of the doll that he had promised. The necklaces of coral and the shells of small sea snails accompanied it. The wood used is Solomon Islands Cedar *(Calophyllum Inophyllum),* common through-

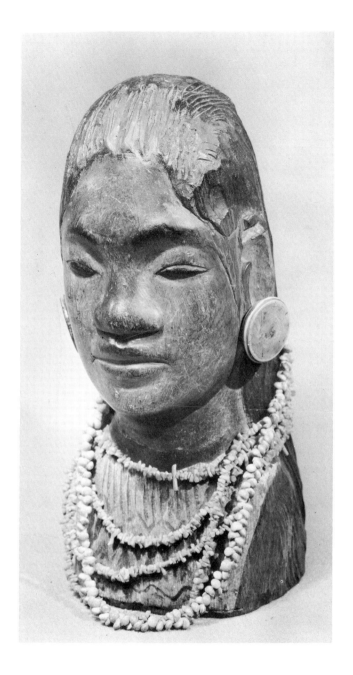
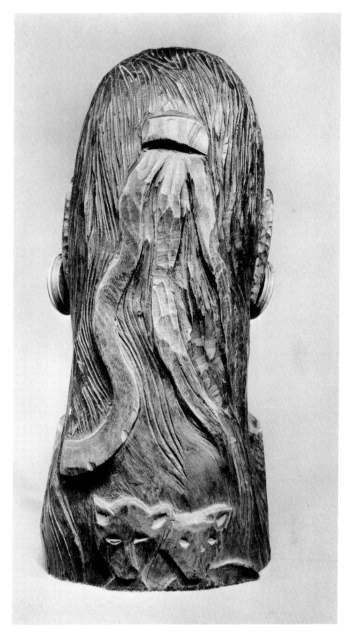

out the Pacific. (Sale catalogue, Sotheby and Co., p. 20)

In addition to the necklace, which is supported on small wooden pegs on either side of the neck, the earrings are added ornaments, made apparently from large buttons of boxwood. There was a hole through the top of the left ear, now broken, apparently to hold a flower.

The hair is stained black, as are the eyebrows and eyes. The dress is white with pattern worked out in black and brown. Mouth is stained red.

102 CYLINDER WITH TWO FIGURES

H. 35.5 cms. Pua wood(?). Signed: P G at either side of the crouching figure.

Collections: Ker X. Roussel (given to him by Gauguin); Private Collection, Paris.

Exhibitions: 133–Galerie Charpentier, Paris, 1960.

References: Zolotoe Runo, I:i (1909), 5–14(ill.); Morice, *Gauguin,* p. 158(ill.).

Photographs by the author.

Notes:

The wood from which this work is carved is not the usual tamanu. It is a darker brown, uniform in color and without any obvious grain. Of the Tahitian woods, it seems to fit the description of pua the best (see Appendix B).

The figures themselves are free of any clear Polynesian influence, but on the sides between the figures Gauguin has used Marquesan motifs as decoration. On the right side of the standing figure there are two Marquesan *atua* figures (Cat. No. 102*a*). On the left side there is a variant of the Marquesan *atua* figure at the top (Cat. No. 102*d*). At the bottom Gauguin has used the Marquesan *matahoata* motif common in tattooing (Cat. No. 102*c*).

The fact that this piece was given to Roussel indicates that it must have been done during Gauguin's first trip to Tahiti.

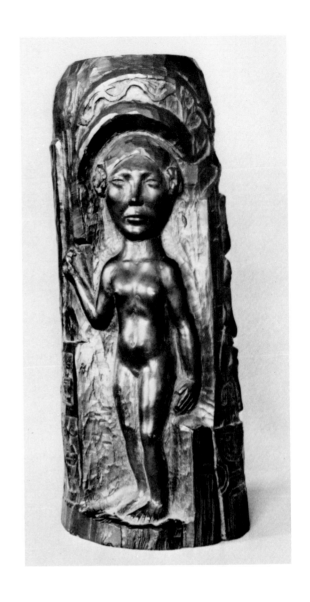

c. Representation of Marquesan tattooing patterns.
From Von den Steinen, Die Marquesaner und ihre Kunst

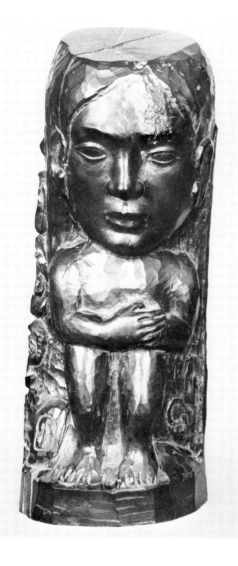

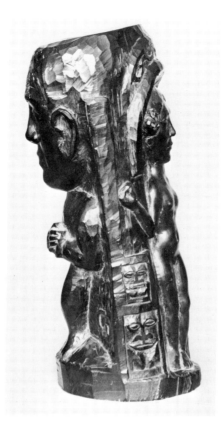

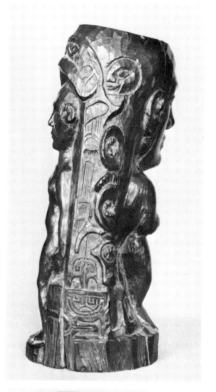

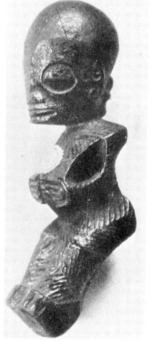

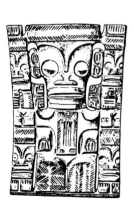

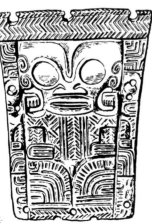

d. Seated Tiki.
From Van den Steinen,
Die Marquesaner und ihre Kunst.

a. Marquesan Atua figures.
From Von den Steinen, Die Marquesaner und ihre Kunst.

b. Rubbing made by Gauguin of a Marquesan Atua figure.
Manuscript of Noa-Noa, Cabinet des Dessins, Louvre.

233

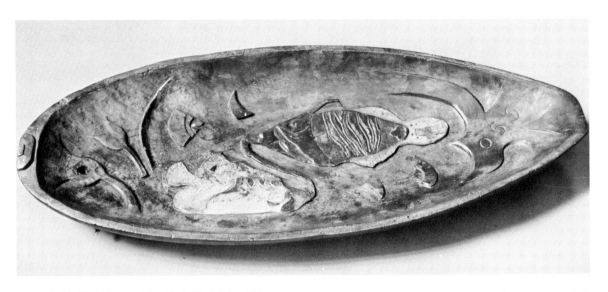

103 BOWL FOR POI ("LA PIROGUE")

L. 90 cms. W. 36 cms. Tamanu wood. Carved and decorated with paint. Signed: P G O.

Collections: Daniel de Monfreid; Mme Huc de Monfreid.

Exhibitions: 107–*Gazette des Beaux-Arts,* Paris, 1936; 171–De Monfreid Exhibition, Paris, 1938; Galerie Jean Loize, Paris, 1951 (supplement); 119–Galerie Charpentier, Paris, 1960.

Photograph by the author.

Notes:

Poi is a thick paste made from breadfruit and is a Polynesian staple. Characteristic of the native poi bowl is the hole (extreme left) for the draining of excess liquid. As it was hardly probable that Gau-

guin was a great consumer of poi, the presence of the hole indicates that this is a native bowl that has been decorated by Gauguin, as in the case of Jénot's poi bowl (cf. text, p. 56). The fish decoration is unique in Gauguin's decorative carving, and as far as the author knows, the only other designs based on fish are the very similar motifs used on the cover of Gauguin's *Cahier pour Aline* (Collection of the Bibliothèque Doucet), a watercolor illustration for *Ancien Culte mahorie* (facsimile edition, Paris, 1951, p. 18), and the woodcut (below) *L'Universe est crée* (courtesy Museum of Fine Arts, Boston). On both the poi bowl and the cover, Gauguin made use of the brilliant coloring of tropical fish. Here one fish is red, brown, white, and yellow. The other is red, green, brown, and yellow. Contrary to his usual practice when using fine woods, Gauguin has used the paint quite thickly, indicating that the bowl was not intended for its original purpose.

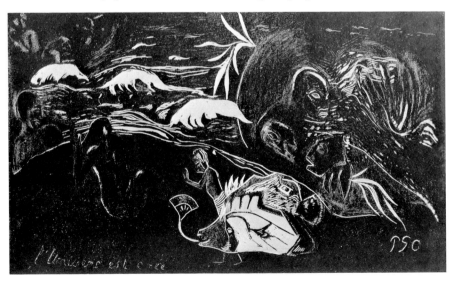

104 CANE

L. 86 cms. Head carved with Polynesian figures heightened with gold. Signed in red: P Go.

Collections: Émile Schuffenecker, Paris; Amédée Schuffenecker, Paris; Mme Jeanne Schuffenecker, Paris; Musée du Louvre (gift of Jean Schmit).

Exhibitions: Though the descriptions do not permit positive identification of this cane, it may have appeared in the following exhibitions: 27–Galerie Nunes et Fiquet, Paris, 1917; 63–Galerie Dru, Paris, 1923; 28–Luxembourg, Paris, 1928; 230–Thannhauser Gallery, Berlin, 1928; 72–*Gazette des Beaux-Arts,* Paris, 1936; 85–Orangerie, Paris, 1949 (see also Cat. No. 116).

Reference: Varenne, "Les Bois gravés et sculptés de Paul Gauguin," *La Renaissance de l'art français,* December, 1927, p. 524(ill.).

Photographs: Musées Nationaux and the author.

Notes:

This cane was given to Émile Schuffenecker by the artist in the period between his two trips to Tahiti. It was probably executed 1893–1894.

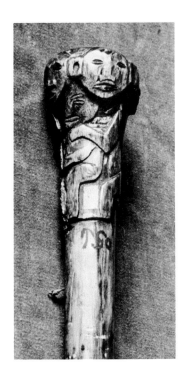

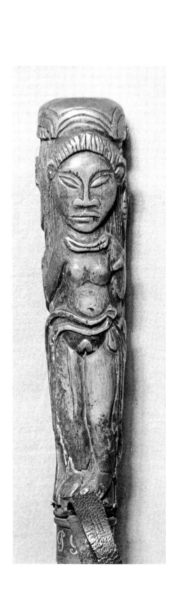

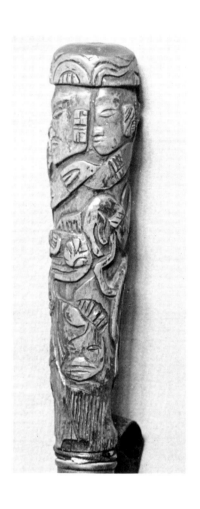

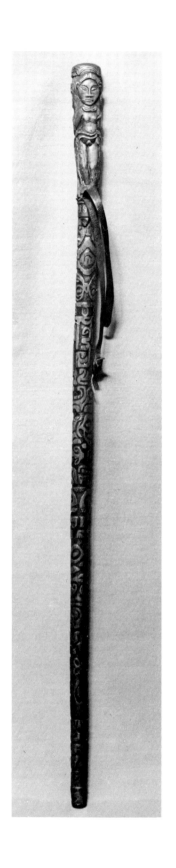

105 CANE

L. 91 cms. Probably nono wood (*Morinda citrifolia*). Iron band with the initials PGO inlaid in gold.

Collections: Musée de la France d'Outre-mer (gift of Lucien Vollard).

Photographs by the author.

Notes:

This may have been one of the four canes listed under item numbers 56, 57, and 58 in the sale of Gauguin's effects at Papeete. A fifth, number 59, was sold to M. Levy, and is recorded as having a pearl inlaid in the pommel. A sixth had been destroyed in Atuona by the gendarme Claverie because he found the ornament of the pommel, an erect phallus, obscene (see Wildenstein, *Gauguin, sa vie, son oeuvre*, pp. 200 ff).

The pommel of this cane, which is a separate piece of wood, is ornamented with the figure of the goddess Hina, similar to the representation of Hina in the cylinder in the De Monfreid Collection (Cat. No. 95). The shaft of the cane is ornamented with designs drawn from Marquesan tattooing.

The dating of this cane is difficult, but it should be compared with the cane listed under Catalogue number 117, which was done about 1893–1895.

106 CANE WITH A PEARL IMBEDDED IN THE POMMEL

References: Segalen, *Lettres*, p. 42; Rotonchamp, *Gauguin*, pp. 145, 232; Wildenstein, *Gauguin*, pp. 203, 207.

Notes:

This is one of the canes which appeared in the inventory of Gauguin's effects and on the sale list in 1903 (Wildenstein, *Gauguin, sa vie, son oeuvre*). Segalen mentions its being sold, and Rotonchamp (*Gauguin*, p. 232) specifies that it was sold to a jeweler, M. Levy. According to the sale list, M. Levy bought a cane in lot number 59. Its present whereabouts is unknown.

Rotonchamp (p. 145), describing Gauguin's costume in Paris during the period from 1893–1895, says: "Il portrait, en guise de canne un baton decoré par lui-même de sculptures barbares et dans le bois duquel une perle fine était incrustée."

Morice (*Gauguin*, p. 27) mentions another cane that Gauguin gave the painter Degas when the latter visited his show at Durand-Ruel's in 1893.

(No photograph)

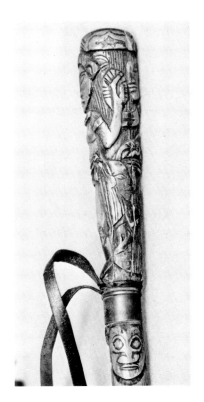

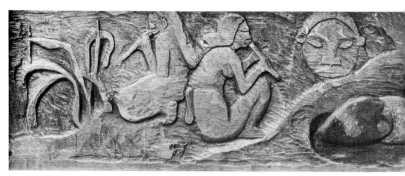

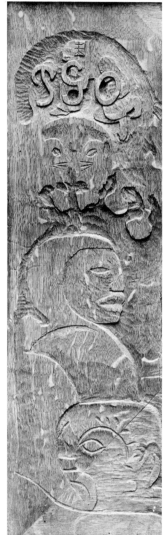

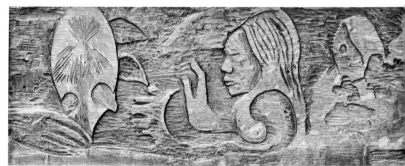

107 "PAPE MOE"
(MYSTERIOUS WATERS)

H. 81.5 cms. W. 62 cms. Oak. Carved and painted.

Collections: Gustave Fayet, Béziers; Antoine Fayet, Védilhan; Burhle Collection, Zurich.

References: Zolotoe Runo, I:i (1909), 5–14(ill.); Morice, *Gauguin,* p. 172(ill.); Rotonchamp, *Gauguin,* p. 95(ill.); Goulinat, "Les Collections Gustave Fayet," *L'Amour de l'Art,* 1925, pp. 131–42(ill.); Malingue, *Gauguin,* 1944, p. 147(ill.); Kunstler, *Gauguin,* plate 59.

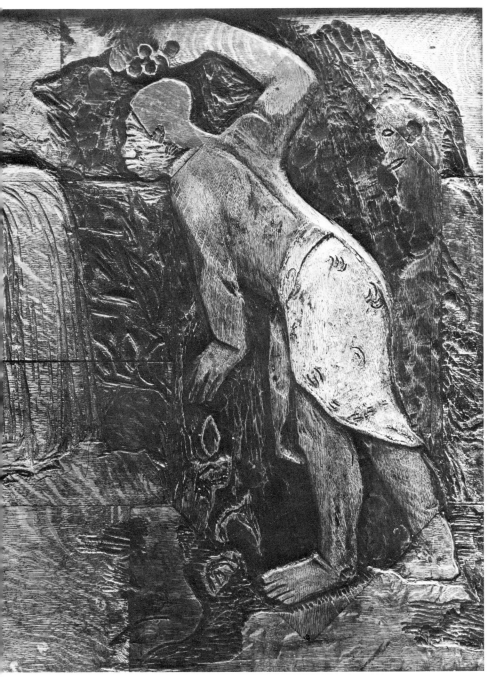

Photographs: Musées Nationaux.

Notes: (See text, pp. 63 ff)

This relief was once part of a complex panel which has been cut into individual pieces. The subject is apparently a scene in *Noa-Noa*:

> Tout a coup, à un détour brusque, j'aperçus dressée contre la paroi du rocher qu'elle caressait plutôt qu'elle ne s'y retenait de ses deux mains, une jeune fille, nue: elle buvait à une source jaillisante, très haute dans les pierres. . . . (*Noa-Noa*, facsimile edition, p. 87)

The title, literally "sleeping water," was given to a poem by Charles Morice for *Noa-Noa* which draws its inspiration from the scene described by Gauguin (*ibid.*, p. 89).

The scene was another favorite of the artist, and appears in a watercolor, a monotype, and a painting (cf. Rewald, *Gauguin's Drawings,* p. 30, Figs. 52, 53).
Three Panels from Pape Moe
I: H. 66 cms. W. 19.5 cms. Oak. Unpainted. Signed: P G O.

Collections: Gustave Fayet, Béziers; Mme d'Andoque, Béziers.

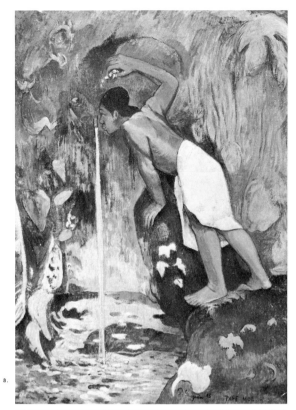

a.

b. Collection Viollet.

II: L. 48 cms. W. 20 cms. Oak. Unpainted.

Collections: Gustave Fayet, Béziers; Mme P. Bacou, Puissalicon.

III: L. 48 cms. W. 20 cms. Oak. Partly polychromed.

Collections: Gustave Fayet, Béziers; Mme P. Bacou, Puissalicon.

References: Morice, *Gauguin,* p. 1(ill.); Goulinat, "Les Collections Gustave Fayet," *L'Amour de l'Art,* 1925, pp. 131–42; Alexandre, *Gauguin,* p. 263(ill.); Kunstler, *Gauguin,* plate 60.

Notes: (See notes under *Pape Moe*)

These three panels form a continuous scene with the panel of *Pape Moe* proper. They are full of motifs drawn from Gauguin's work executed in the South seas. In the upper panel appears Gauguin's traditional interpretation of the head of Hina, with a group of *vivo* players, a theme that Gauguin used many times in the paintings executed during his first stay in Tahiti. In the upright panel, the figure of the idol is based on a conception similar to the background figure in Gauguin's painting *The Spirit of the Dead Watching (Manau Tupapau)* in the collection of A. Conger Goodyear, New York. In the bottom panel the central figure is based on the figure of Hina in the wood carving *Hina and Tefatou* (Cat. No. 96).

108 WOODCUT TRANSFORMED INTO A LOW RELIEF ("MANAO TUPAPAU")

H. 22.3 cms. L. 52.7 cms. Not signed. (Guérin No. 39.)

Collections: Francisco Durrio; Walter Geiser; present location unknown.

Exhibitions: 31–Luxembourg, Paris, 1928; 69–Kunstmuseum, Basel, 1950.

References: Guérin, *Oeuvre gravé,* No. 39.

Notes:

Guérin says: "Ce bois été modifié par Gauguin. . . . L'artiste a manifestement transformé son bois gravé, en un bas-relief. . . . Le paysage qui forme le fond de ce bois est emprunté à un tableau de Gauguin intitulé *Matamua* et daté de 1892."

The idea of the relationship between woodcut and wood carving may have influenced the very flat carvings which begin to appear among Gauguin's works at this time.

(No photograph)

240

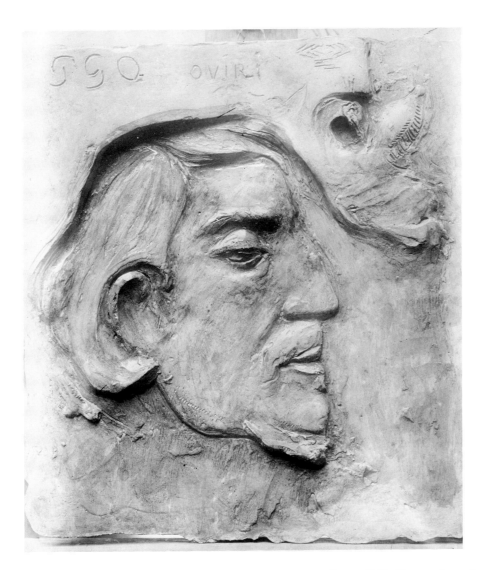

109 SELF-PORTRAIT OF GAUGUIN

H. 35.5 cms. L. 34 cms. Plaster, painted. Replicas in bronze. Signed: P G O. Inscribed: OVIRI (the savage).

Collections: Amédée Schuffenecker (plaster); present whereabouts unknown. Bronze replicas are to be found in the following collections: A. Zwemmer, London; Folkwang Museum, Essen; N. Siegel, Copenhagen.

Exhibitions: May have been in Salon de Automne, 1906, as 172 *"un portrait sculpté peint (plâtre)*—Collection Schuffenecker"; 67–Galerie Dru, Paris, 1923: *"Plâtre peint et sculpté, profile de Gauguin"*; 223–Thannhauser Gallery, Berlin, 1928 (bronze); 247–Kunsthalle, Basle, 1928 (bronze); 85–Ny Carlsberg Glyptothek, Copenhagen, 1948 (bronze); 74–Tate Gallery, London, 1955 (bronze); 91–Winkel and Magnussen, Copenhagen, 1956 (bronze); 122–Galerie Charpentier, Paris, 1960 (bronze from London).

References: Morice, *Gauguin,* p. 78 (ill.—plaster?); Guérin, *Oeuvre gravé,* frontispiece (ill.); Malingue, *Gauguin,* 1944, p. 152; Kunstler, *Gauguin,* plate 58; Raymond Cogniat, *Gauguin,* p. 119.

Photograph: Musées Nationaux.

Notes:

 The Tate Gallery Catalogue of the 1955 *Gauguin* Exhibition remarks that nothing definite is known about the bronzes, neither the caster, nor the size of the edition. The history of the plaster is even more mysterious. A photograph of it was in the collection of Vizzavona, and it is reproduced in Morice (*Gauguin,* p. 78). Number 67 in the Dru Exhibition, if it refers to this piece, suggests that the plaster was painted, though the Vizzavona photograph shows no signs of polychromy. Guérin (*Oeuvre gravé*) refers to it as *"plâtre patiné."*

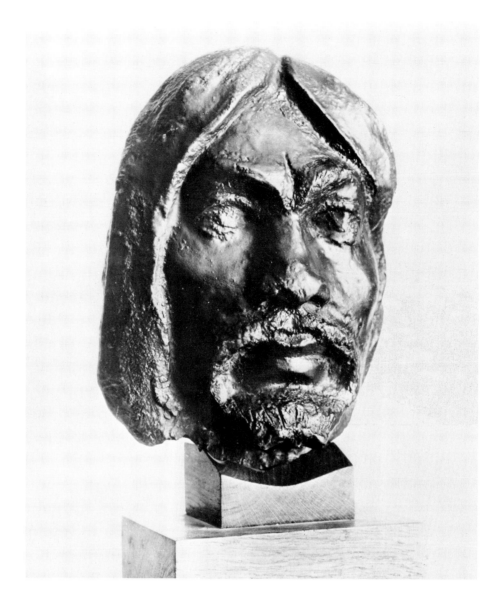

110 MASK

H. 25 cms. Bronze with a black patine. Not signed.

Collections: Ambroise Vollard, Paris. Three copies of this mask are known: Musée de la France d'Outre-mer (gift of Lucien Vollard); Lazarus Phillips, Montreal; Walter P. Chrysler, Jr., New York.

References: Rewald, "The Genius and the Dealer," *Art News,* May, 1959, pp. 30 ff.

Photograph: Courtesy of Lazarus Phillips.

Notes:

The mask was apparently ordered cast by Vollard, but the size of the edition and the founder are not known.

In his article Rewald dates the head in 1891–1893 on the basis of its similarity with the head of Te Fatou in the painting *Hina and Te Fatou* (Museum of Modern Art, New York, Lillie P. Bliss Collection). However, because of the difficulty of transporting the wax model from the South seas without damage, it seems more probable that it was executed in France after Gauguin's return. The head is very similar to the head in the panel *La Guerre et la Paix* (Cat. No. 127) and, as with many of Gauguin's male portraits, there is a suggestion of self-portrayal under the guise of a "savage."

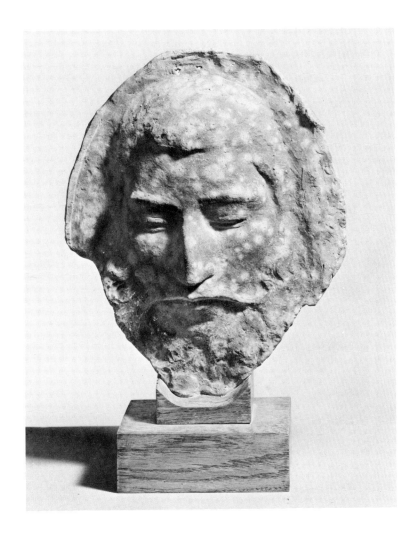

111 MASK

H. 29 cms. Terra cotta. Lightly glazed with greyish black.

Collections: Ambroise Vollard, Paris.

References: Sale Catalogue, April 15, 1958, Parke-Bernet Galleries, New York.

Photograph: Taylor and Dull.

Notes:

The Parke-Bernet Catalogue (p. 20) states that the mask is a cast of an original by Paul Gauguin. The nature of the surface suggests that the original was in wax. Contrary to their statement, the head is not that of a tattooed male Tahitian, but is probably a self-portrait of the artist. On May 6, 1959, the Parke-Bernet Galleries offered at auction a plaster replica of this mask.

Gauguin made many masks during his career as an artist, but it has not been possible to trace all of them. In a letter to De Monfreid in December, 1896 (Segalen, *Lettres*, XXVII) the artist said: "Je serais *trés heureux* si vous pouviez m'envoyer ici la tête de sauvage *emaillée* (Masque)." Other masks have appeared in exhibitions beginning with the Gauguin Retrospective of 1906 where number 178 is described *"masque au diadem,"* and number 179 as *"masque aux épines,"* both from the Schuffenecker Collection. In 1917 the Nunes et Fiquet catalogue mentions *"34-Masque, portrait de Gauguin."* Number 68 in the Galeries Dru catalogue of 1923 is described as a *"masque, portrait de Gauguin."* In the list of the sale of Gauguin's effects at Papeete in 1903, number 35 is identified as *"un masque"* sold to M. Bouzer. However, no mask is mentioned in the inventory of Gauguin's belongings made at Atuona (Wildenstein, *Gauguin*, pp. 202–4, pp. 206). Possibly the mask appears in the inventory under number 66 as *"3 modèles en cire."* If that is the case, this mask may have come from that source (see also Cat. No. 129).

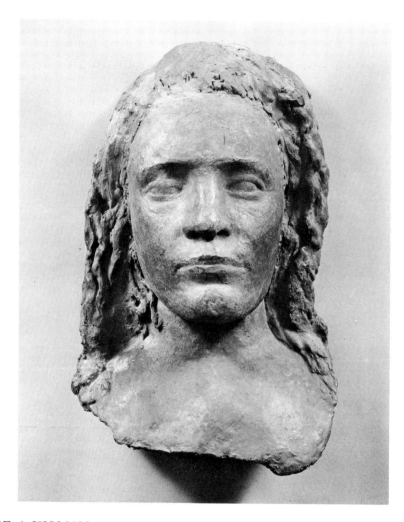

112 MASK OF A WOMAN

H. 37 cms. Wax. Not signed.

Collections: Ambroise Vollard, Paris; Edward Jonas, Paris; Wildenstein and Co., New York.

Photograph courtesy of Wildenstein and Co. (wax).

Notes:

A plaster model of this mask is in a private collection in Paris. According to its owner, it was acquired from Vollard.

The mask has also been cast in bronze. According to Mr. Walter P. Chrysler, Jr., who owns the bronze which he bought from the estate of Ambroise Vollard, he was told by Edward Jonas that it was a unique cast that Vollard had had made shortly before his death. The bronze still bears the sale ticket number 98. It was exhibited in: 1850–1950. The Controversial Century. Paintings from the Collection of Walter P. Chrysler, Jr. The Chrysler Museum of Art, Provincetown, Massachusetts, 1962 (not in catalogue). Another bronze cast is in the collection of Joseph H. Hirschhorn.

The subject of this portrait and the time of its execution are difficult to determine. The fact that the original was made in modeling wax suggests that it was made in France. Even though the *"modèles en cire"* are mentioned in the inventory of Gauguin's effects made at Atuona after his death (Wildenstein, *Gauguin, sa vie, son oeuvre,* p. 203, item 66) none are mentioned in the record of the sale at Papeete (*ibid.,* pp. 206–8). The probability of a work in such an easily damaged medium as wax having survived to reach Paris intact seems unlikely.

Gauguin's style in portrait sculpture does not evolve in the same manner as that in his other works, so it is difficult to determine the date of the mask on the basis of style, but the slightly non-European cast to the features suggests that it may have been done during the period between 1893 and 1895 in France. The features themselves have a certain similarity to Annah the "Javanese" (see Cogniat, *La Vie ardente de Paul Gauguin,* No. 71).

113 "OVIRI"

H. 74 cms. Stoneware. Glazed in parts, red and black. Signed on the side, near the figure's left foot: P G O. Inscribed: OVIRI on the front of the base. (See Plate XVI, p. 100)

Collections: Gustave Fayet, Béziers; Ambroise Vollard, Paris; Private Collection, Paris.

Exhibitions: Société Nationale, Paris, 1895; 162– Béziers, 1901; 57–Gauguin Retrospective, Paris, 1906; 75–Tate Gallery, London, 1955.

References: Segalen, *Lettres de Gauguin à Daniel de Monfreid,* 2nd ed., Paris, 1950, LXVIII, LXXI, LXXV, p. 234; Castets, "Gauguin," *Revue universelle,* October 15, 1903, p. 536; *Zolotoe Runo,* I:i (1909), 5–14(ill.); Morice, *Gauguin,* pp. 158, 159(ill.); Rotonchamp, *Gauguin,* pp. 194, 197; Vollard, *Souvenirs d'un marchand de tableaux,* p. 201; Malingue, *Gauguin* (1944), p. 151; Kunstler, *Gauguin,* plate 57; Loize, *Amities,* pp. 144–46.

Photograph: Musées Nationaux and the author.

Notes: (See text, pp. 64 ff)

The early history of *Oviri* is a sad one. Though accounts vary as to what actually happened in the exhibition of the *Société Nationale* in 1895, they all agree that Gauguin's ceramic statue raised a storm of protest. Whether it was summarily thrown out as Castets and Morice suggest, or retained only through the threat of Chaplet to remove all his works, as Vollard states, the reaction was a bitter disappointment to the artist. Even the collector Fayet seems to have had a curiously ambiguous attitude toward the piece (see the correspondence between Fayet and De Monfreid in Loize, *Amities*).

The artist always considered *Oviri* among his finest works, and desired it to be placed over his grave, a wish that ought to be carried out if the piece is ever reproduced in a durable material. There already exists three casts in plaster which have been given the surface finish of wood. The author believes that the conception of the piece is based upon a clay material, and that the graining of the casts is superficial, though other competent opinion disagrees. Mme Gustave Fayet has no knowledge of a wood original, though she recollects the circumstances of the making of the three plaster copies (private conversation, September 8, 1959). One copy was given to Daniel de Monfreid, and is now in the collection of his daughter, Agnès Huc de Monfreid. The second was kept by Fayet, and passed into the collection of his son, Léon. The third was kept by the artist who made the casts.

Gauguin used the theme of *Oviri* many times. Per-

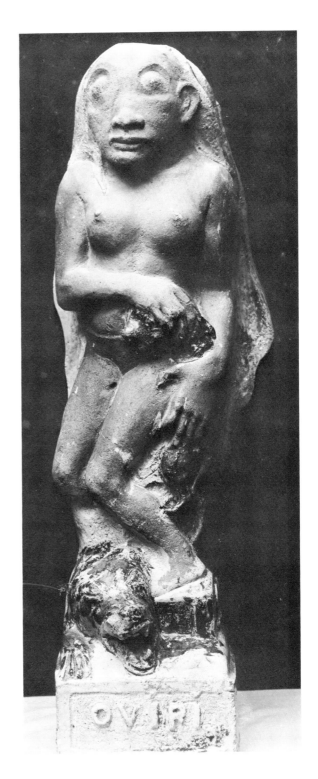

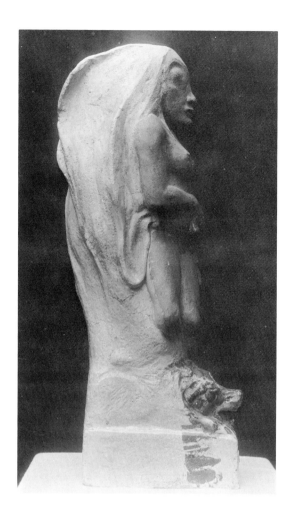 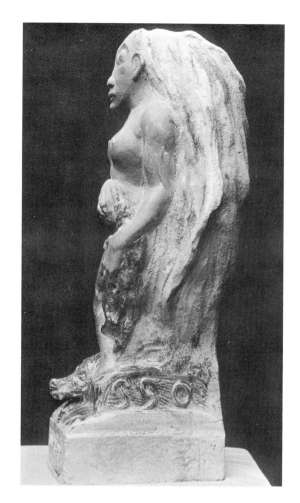

haps the earliest example was a pencil drawing formerly in the Schuffenecker Collection (Guérin, *Oeuvre gravé de Gauguin*, p. xxvii). Other examples of the use of this figure are: *Oviri*, watercolor (Rewald, Drawings, No. 77) (see Cat. No. 113*a*); *Oviri*, woodcuts (Guérin Nos. 48, 49); *E. Haere Oe I Hea* ("Where Are You Going?"), painting (1892), present whereabouts unknown; *Rave Te Hiti Ramu* ("The Presence of an Evil Monster"), painting (Matsukata Collection).

Oviri is modeled in a coarse stoneware clay. The base of the figure was formed around a rectangular form (wood?) which was later removed. The rest of

the figure was relatively freely formed of wads of clay built up and worked together, the interior being open from both the base and through the aperture in the top and back. The natural color of the fired clay gives a light, slightly purplish brown where it has been exposed to the air in the firing. The mass of hair has been covered with a transparent glaze, preserving the clay from the action of the air during firing, and as a result the clay has retained its original light buff color. The color of the wolf's head and the whelp are dark red verging on black, with greenish overtones in places, suggesting that it may be a form of copper reduction glaze.

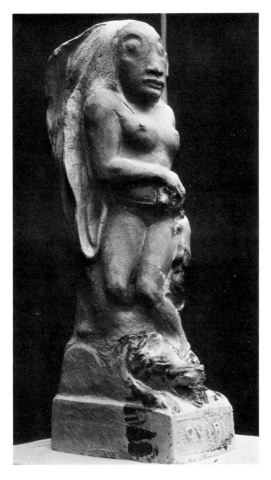 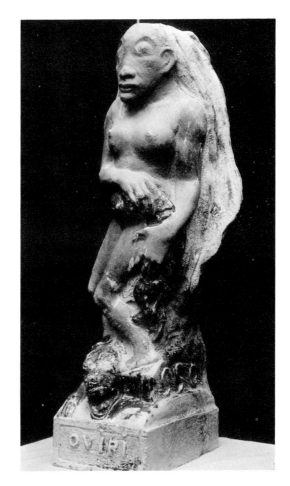

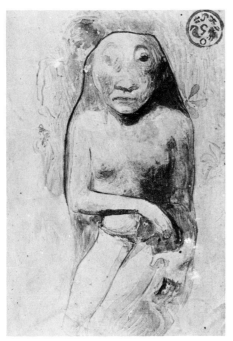 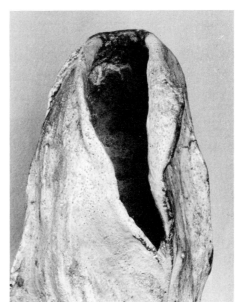

a.

114 POT IN THE FORM OF A GROTESQUE HEAD

Collections: Maurice Malingue, Paris.

Photographs: Courtesy M. Maurice Malingue.

Notes: (See text, p. 64)

Apparently this pot exists in two (or more) almost identical examples, this, and another in a private collection in Paris. Unfortunately the author has not been able to see either. According to M. Malingue, his example bears an inscription on the bottom that he has been able to decipher in part:

Oviri 1895/ . . ./ . . ./ . . ./ . . ./
offert/ Chaplet céramiste

Over the top of the incised inscription appears, written in brush: *"30 mai."* This cannot be the date of the making of the pot, if it is the work of Gauguin, for he left for Tahiti on May 10 of that year.

The existence of more than one example of the pot is a rare occurrence in the work of Gauguin. That and the nature of the forms themselves in the pot suggest that it was made from a mold, and not modeled, as were his earlier works in ceramics, by hand directly in the clay. That Gauguin did use a process of molding in his pottery after his return from his first trip to Tahiti is strongly suggested by the existence of no less than three versions of the *Square Vase with Tahitian Gods* (Cat. No. 115).

The theme, Oviri (savage), is one that Gauguin used a number of times during and after his first trip to Tahiti (see notes under Cat. No. 113). The particular interpretation here differs from the others in a number of ways. In the first place, the general treatment of the piece suggests the fetish skull of the South seas, as used by Gauguin in a number of his works (see, for example, the woodcut *Te Atua*) (Fig. No. 22). As shown (text, pp. 64 ff) the term "Oviri" was associated with the idea of death. Here there is another curious element associated with Gauguin's work before his trip to Tahiti, the thumb(s) in the mouth, which appears on the *Jar in the Form of a Grotesque Head* in the Louvre (see Cat. No. 66).

This pot is reminiscent of the pots of the sculptor Jean Carriès, and bears a resemblance to one of the top figures on the right post of the stoneware portal that Carriès was making for the Princess Scey-Montbéliard. There was an important retrospective exhibition of Carriès's works in Paris in 1895, and Arsène Alexandre's book, *Jean Carriès, imagier et potier* (Paris, 1895) appeared the same year. The portal is reproduced in Alexandre's book on page 164.

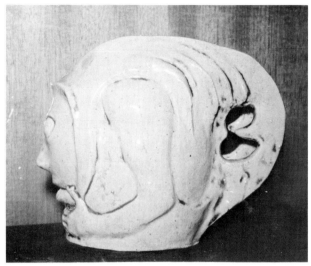

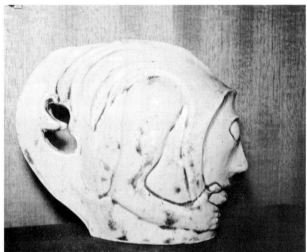

115 SQUARE VASE WITH TAHITIAN GODS

H. 33 cms. Terra cotta. The vase is based on the wood cylinders *Hina and Tefatou* and *Hina* in the De Monfreid Collection. It exists in three versions, one in the Kunstindustrimuseet, Copenhagen, another belongs to the Louvre, and the third is in a private collection in New York.

Exhibitions: 86–Ny Carlsberg Glyptothek, Copenhagen, 1948; 87–Orangerie, Paris, 1949 (Louvre version); 73–Kunstmuseum, Basel, 1949–1950; 123–Chicago Art Institute and the Metropolitan Museum, New York, 1959, (New York version).

References: Berryer, "À propos d'un vase de Chaplet," 1944, Fig. 30, p. 24; Bodelsen, *Gauguin Ceramics in Danish Collections,* No. 11, p. 30.

Photographs: Musées Nationaux, Kunstindustrimuseet, Stephen Hahn.

Notes: (See text, p. 64)

This vase is unique among Gauguin's works in that it exists in three nearly identical versions. Its history can be traced back to 1915 when Helge Jacobsen bought

the Copenhagen version in Paris (below right). That vase is made of a fairly fine-grained terra cotta, burnt a typical light red, and showing evidence of a considerable amount of hand work on the interior. It has a certain amount of darkening on the prominent parts of the figures which Bodelsen has shown to be caused by absorbed lead glazes.

The version in the Louvre (pp. 250–51) is made of a coarse greyish material that has the appearance of cement, and also shows signs of paint. It has no bot-

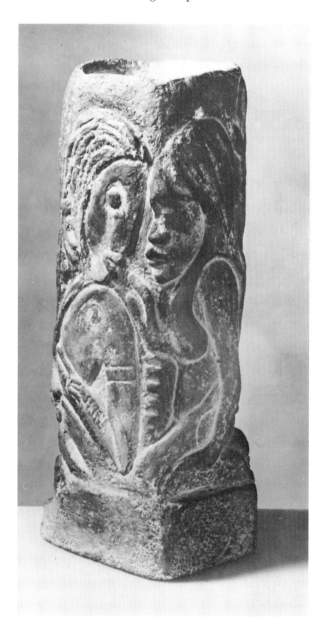

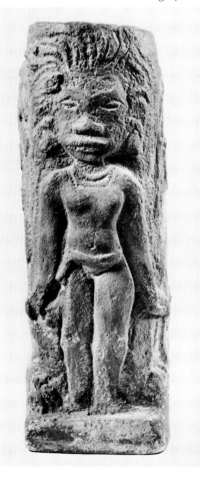

a.

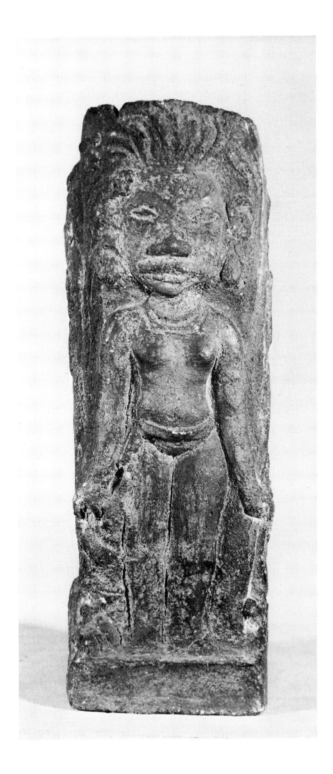 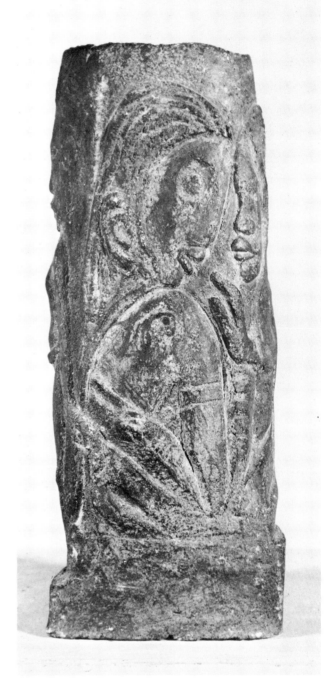

tom, and the interior shows a sharply rectangular sec-
tion as if it had been molded around a block of wood
which was later withdrawn.

The general appearance of the version in New York
is similar to that of the Louvre, with the exception that

it has a bottom and shows hand work on the
interior (See *a*, p. 249).

In all three versions the outlines of the figures have
been reinforced by a line worked in the material
before hardening.

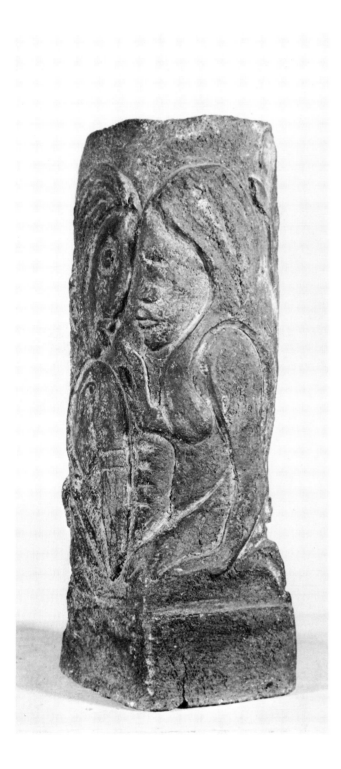 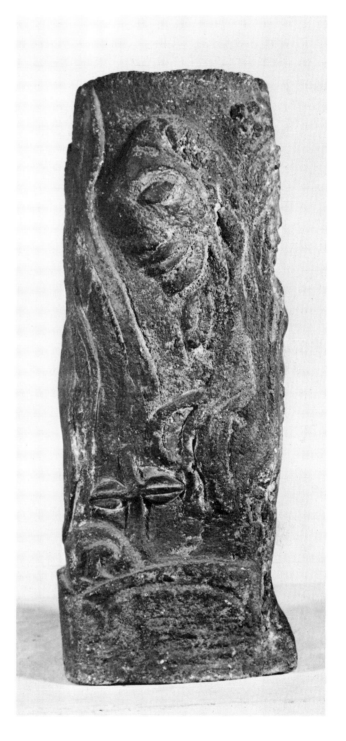

251

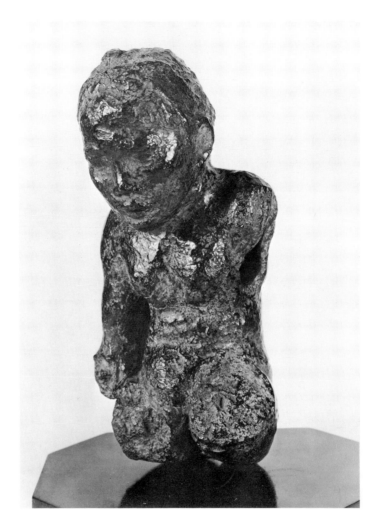

116 TORSO OF A WOMAN

H. 30.5 cms. Unfired clay.

Collections: Ambroise Vollard, Paris; Marcel Gué-rin, Paris; Benay and Fred Clark, Beverly Hills, California.

Exhibitions: 121–Chicago Art Institute and the Metropolitan Museum of Art, New York, 1959.

References: Malingue, *Lettres,* Figs. 24, 25; Goldwater, *Gauguin,* p. 37(ill.).

Photograph: Bucholz Gallery.

Notes:

Curt Valentin (Bucholz Gallery) had ten copies of this piece cast in bronze by Valsuani. Copies are in the collections of: Mr. and Mrs. William B. Jaffe,

New York; The Stephen Hahn Gallery, New York; Knoedler Gallery, New York; Joseph H. Hirschhorn, New York.

The sculpture is generally referred to as a Tahitian woman, but its provenience has not been documented. The material, raw clay, which has now been waxed, would almost certainly preclude the statue's having been made in Tahiti. Even those pieces to which Gauguin referred as clay covered with wax, which he placed around his house in Tahiti during his second stay (Segalen, *Lettres,* XXVI), had disintegrated in the tropical climate. The very coarse clay is similar to that used in the *Square Vase* in the Collection of the Louvre (Cat. No. 115), which dates from about 1894. Possibly this piece also dates from the same period in France.

In its present state the sculpture is badly eroded. According to M. Malingue, the piece was gradually powdering away while in the collection of Marcel Guérin (private conversation, summer 1961).

117 CANE DECORATED WITH POLYNESIAN MOTIFS

L. 88 cms. Hawthorn wood with iron ferrule. Signed: P G (?).

Collections: Raymond Duport, Paris.

Photographs: Courtesy M. Raymond Duport.

Notes:

M. Duport has had the wood identified as hawthorn. The combination of a European wood with Polynesian motifs indicates a date for this cane after Gauguin's first trip to Tahiti and before his second departure. The technique is an interesting one. After carving the cane, the whole piece was fire-blackened. The relief surfaces were then sanded to restore the original color of the wood, leaving the background dark (information courtesy of M. Duport).

The figure ornamenting the pommel is apparently another version of the goddess Hina in her avatar as the first woman born in this world—*Hina-te-'u'uti-maha'i-tua-mea*—who had a front face and a back face (Henry, *Ancient Tahiti,* p. 402).

Beneath the pommel is a frieze of seated Polynesian figures, then a series of forms of a Marquesan tiki head. In the next zone down is a head whose right ear suggests a "P" and whose left ear suggests a "G." Below that are several designs from tiki heads, and in the bottom zone two heads suggesting the heads of *Hina and Te Fatou* (Cat. No. 96).

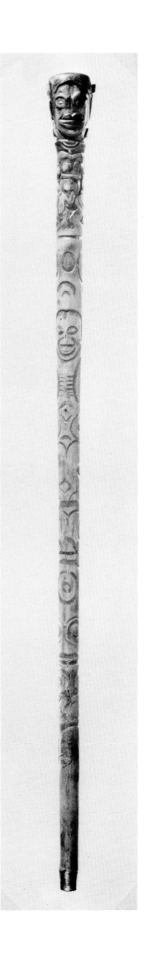

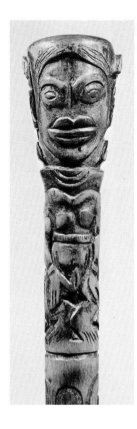
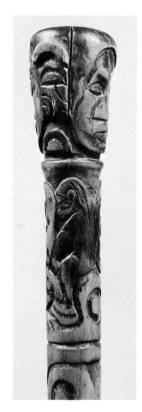
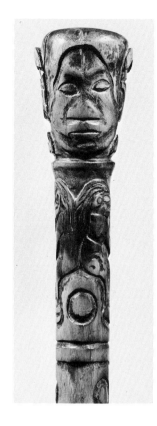
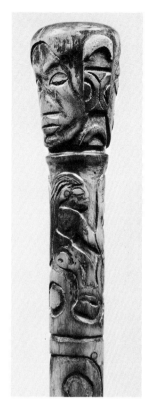

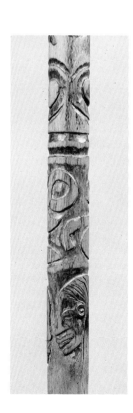
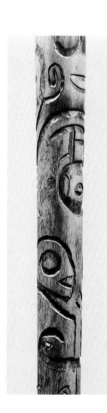
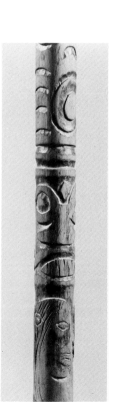

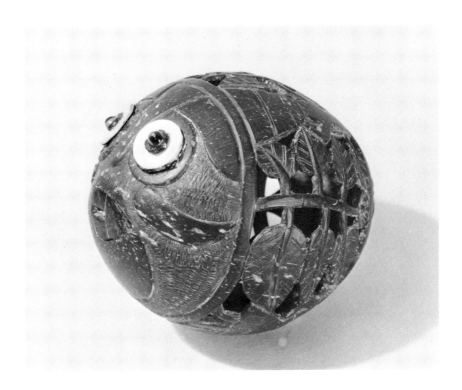

118 COCONUT CARVED AS A COIN BANK

L. 7.6 cms. Circumference: 23. cms. Signed: P G O. Ornamented with three figures of girls, foliage, and a grotesque face. The eyes of the face are formed of small mother-of-pearl buttons with *kilali* seeds fixed with black pitch in the centers. The mouth is an inserted piece of coconut shell to fill the third of the natural apertures in the coconut. The mouth has sharp teeth carved of a piece of bone. Originally there was a small piece of sheet brass or gold behind the teeth. Coin slot: 1.7 cms. long.

Collections: Philip W. Ward, Chicago.

Photographs by the author.

Notes:

Mr. Ward acquired the coconut from the Michael Reese Service League Thrift Shop in about 1956. It was at that time broken in half through the middle zone, and wrapped in a page of the *Chicago Daily Tribune* comic section for Sunday, December 15, 1901. On the newspaper was written in what appears to be a woman's hand:

Papas P[F?]olly
South Sea Curio acquired 1895 Paris sojourn

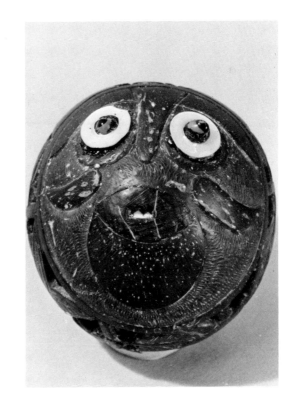

255

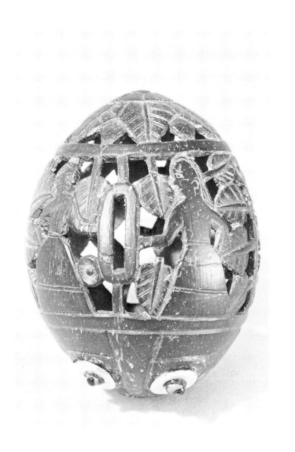 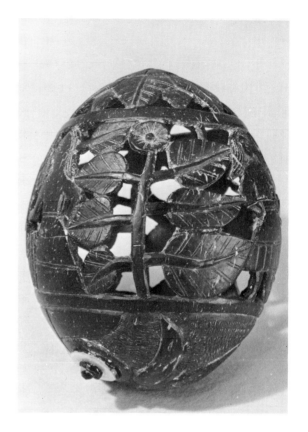

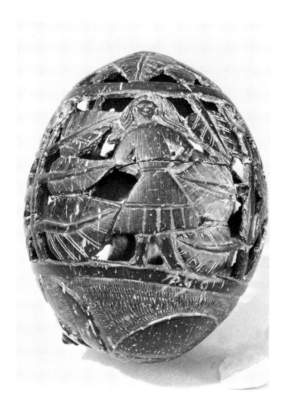 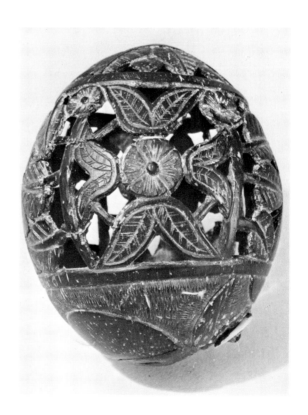

256

Reported to have been old native handiwork
However discovered to be the recent work of
a [...]
Frenchman who for a time lived in the islands.

Mr. Ward did not discover the signature P G O on the coconut until 1961, at which time he tried to trace the provenience of the piece more exactly. He was told at the Thrift Shop that it was believed to have been given them by the family of Leander (?) McCormick.

Though the history of this piece is scanty, it has an authentic ring. The signature is fairly typical in its form. The early purchase of the piece also favors its authenticity, as carved coconuts by Gauguin had no real commercial value that would warrant the effort of forging them in 1895.

If the piece was bought in 1895, it must have been made before Gauguin's second trip to Tahiti, and indeed, except for the statement that it was made by a Frenchman in the South seas, and the fact that it is a coconut, there is little to connect the work with Polynesia. There are no specifically Polynesian motifs on the shell. Even the grotesque animal's head on the end seems closer to Chinese motifs.

The one problem that arises is that it is hard to see how a piece of Gauguin's work that, according to the history of the piece, must have been executed between 1891 and 1893 could have become disassociated with his name, and appeared on the market as a South-seas curio while he was still in Paris and his name was connected with a certain notoriety.

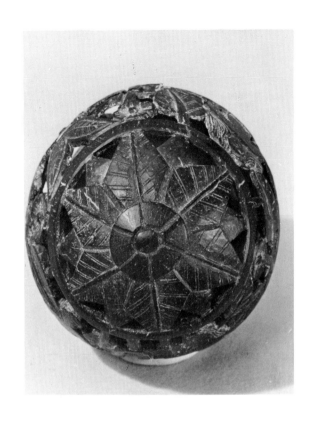

119 PHOTOGRAPH OF GAUGUIN'S HOUSE IN TAHITI

Collections: Daniel de Monfreid; Mme Huc de Monfreid.

Notes: (See text, p. 68)
On the left side of the picture can be seen the figure of a nude woman, done in earth covered with wax, which Gauguin mentioned in a letter to Daniel de Monfreid in a letter in November 1896 (Segalen, *Lettres,* XXVI). At the bottom right, just behind the trunk of the slanting tree, can be seen one of the carved coconut tree trunks mentioned by Gauguin in a letter to De Monfreid in April 1896 (Segalen, *Lettres,* XXI).

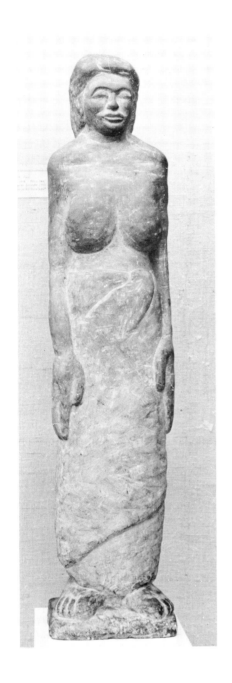

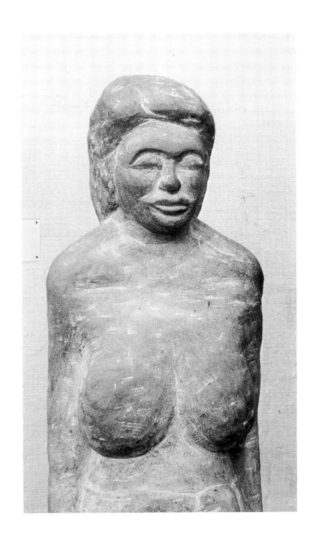

120 FIGURE OF A STANDING WOMAN

H. 115 cms. Grey limestone (?). Signed on the left side of the back of the base with a cartouche of a small dog.

Collections: Ambroise Vollard, Paris; Private Collection, Paris; Walter P. Chrysler, Jr., New York.

Exhibitions: 1850-1950. The Controversial Century. Paintings from the Collection of Walter P. Chrysler, Jr., The Chrysler Art Museum of Provincetown, Massachusetts (not in catalogue).

Photographs by the author.

Notes:

This statue was bought by Mr. Chrysler in 1953 from a private collector in Paris. According to Mr. Chrysler, he was told by Edward Jonas that it had been

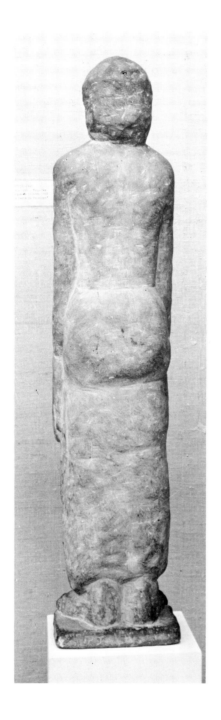 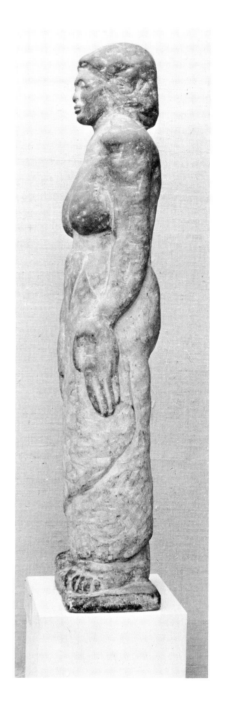

originally in the collection of Ambroise Vollard, and that Vollard had got it from Gauguin during the artist's second stay in Tahiti.

Though there has been strong evidence that the little dog may have been regarded as more or less a signature by Gauguin, this is the only case in which it is clearly intended to replace the more usual P G O.

Gauguin executed very little sculpture in stone, and as far as is known, this is the only piece of its type dating from his second stay in Tahiti. It should be compared in conception with the statue of a woman made of clay covered with wax, which Gauguin placed outside his house in Tahiti (see Cat. No. 119).

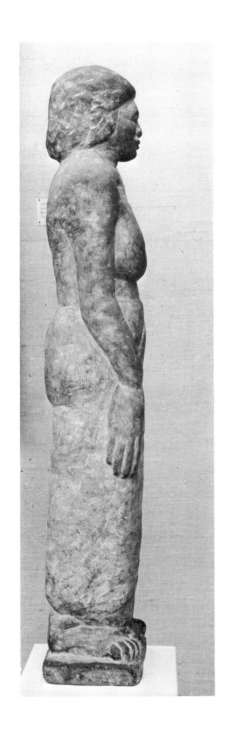

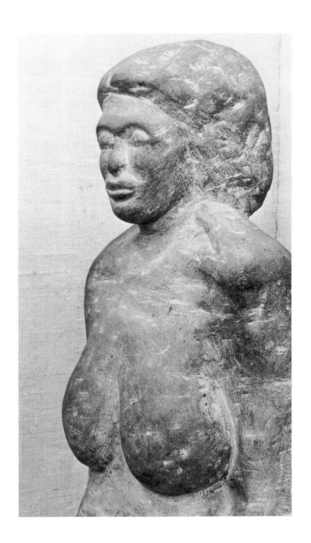

261

121 PANEL FROM THE DINING ROOM OF GAUGUIN'S HOUSE

L. 196 cms. (total). W. 25 cms. Pine. Carved.

Collections: M. Monnon, Tahiti; François Hervé, Tahiti; M. Hamon, Tahiti; Robert Rey, Paris; National Museum, Stockholm.

Exhibitions: 65–*Gazette des Beaux-Arts,* Paris, 1936; 82–Orangerie, Paris, 1949; 72–Kunstmuseum, Basel, 1949–50; 49–Musée Cantonal, Lausanne, 1950; 137– Third Biennial of Sculpture, Antwerp; 77–Tate Gallery, London, 1955; 151–Galeries Charpentier, Paris, 1960.

References: Rey, *Le Renaissance du sentiment classique,* p. 60(ill.); Hamon, *Gauguin, le solitaire du Pacifique,* p. 20; Rey, "Le Dernier décor de Gauguin," *La Revue des Arts,* June, 1953, p. 121.

Photograph: Giraudon.

Notes:

This panel from Gauguin's house at Punaauia was probably a decorated baseboard on the wall. It was originally one piece and undoubtedly polychromed. It was at one time painted over and sawed in two when removed. It has been cleaned of its overpaint, but unfortunately it was impossible to save the coloring.

Sources for two of the figures on the left can be found in the artist's sketchbook now in the Cabinet des Dessins of the Louvre (RF 30 564 fol. 52 R, 47V, 46V). The right-hand figure of the group of three appears in the sketchbook with the notation "*d'après Delacroix*" on the same page (Cat. Nos. 121*a*, 121*b*, 121*c*).

a.

b.

c.

L. 148 cms. W. 25 cms. Redwood? Painted. Signed: P G O. Inscribed: *TE FARE AMU*. (See Plate XVIII, p. 102)

Collections: Émile Schuffenecker, Paris; Amédée Schuffenecker, Paris; Mme Jeanne Schuffenecker, Paris; Katia Granoff, Paris; Henry Pearlman, New York.

Exhibitions: 21–Galerie Nunes et Fiquet, Paris, 1917; 20–Luxembourg, Paris, 1928; 101–*Gazette des Beaux-Arts,* Paris, 1936; 81–Orangerie, Paris, 1949; Baltimore Museum, Baltimore, 1958; 125–Chicago Art Institute and the Metropolitan Museum of Art, New York, 1959.

Photographs: Jack Stevens and the author.

Notes:

Te Fare Amu means "the dining room"—literally, the shelter for eating. Whether this plank came from Gauguin's house in Tahiti or that in the Marquesas is not certain. Six carved planks were sold at the auction of Gauguin's effects at Papeete on the third of September, 1903 (Wildenstein, *Gauguin, sa vie, son oeuvre,* pp. 201 ff). Of these six, four can be identified as the planks of the doorway of Gauguin's house in the Marquesas which were bought by Victor Segalen. Another plank was probably *Soyez mysté-rieuses* (Cat. No. 87). One remains to be accounted for. However, there was a great deal more material sold at the auction than was recorded in the inventory of Gauguin's belongings in the Marquesas (Wildenstein, pp. 202 ff, 206 ff), indicating that perhaps some of his effects that had been left behind in Tahiti were included in the sale. Evidence in favor of the piece having come from Gauguin's house in Tahiti is to be found in the fact that the width of the plank is the same as the panel from his dining room, now in the Stockholm Museum (Cat. No. 121). The planks that can be surely identified with the Marquesas are all 40 cms. wide, except the one known as *Te Atua* (Cat. No. 133), which is only 20 cms. wide. We also have a fairly accurate description of Gauguin's house in the Marquesas, and no mention is made of *Te Fare Amu* (G. LeBronnec, "Les Dernières années," in *Gauguin, sa vie, son oeuvre,* p. 189 ff). On inspecting the reconstruction of Gau-

guin's house, it is difficult to see where the panel might have been placed. A final point that ought to be considered is that none of the pieces from the house in the Marquesas was signed, and it hardly seems consistent to sign this piece while leaving the others unsigned.

The figure on the left appears a number of times in the work of Gauguin, notably in one of the headings for the journal *Sourire* (Guérin No. 72) and the woodcut *Te Atua*. The original source was probably a native spear rest of carved wood (see below, photo courtesy of the British Museum).

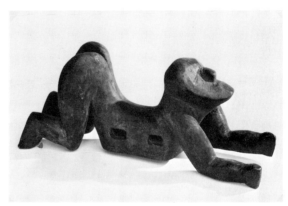

a. Spear rest in carved wood from the Society Islands. Courtesy of the British Museum.

123 PANEL WITH TWO FIGURES

L. 182 cms. W. 40 cms. Redwood? Carved and painted. Signed: P G O in block letters.

Collections: Amédée Schuffenecker, Paris; Mme Jeanne Schuffenecker, Paris; present whereabouts unknown.

Exhibitions: 19–Luxembourg, Paris, 1928; 99–*Gazette des Beaux-Arts,* Paris, 1936.

References: Varenne, "Les Bois gravés et sculptés de Paul Gauguin," *La Renaissance de l'art français,* December, 1927, p. 518(ill.); Rey, "Les Bois sculptés de Paul Gauguin," *Art et Décoration,* LIII (February, 1928), p. 60(ill.).

Photograph: Art et Décoration.

Notes:

Though the author has not seen this piece, its general style indicates that it may have been executed during Gauguin's second stay in Tahiti. It is one of the rare cases in which Gauguin signed his initials in block letters. All the pieces with this type of signature seem, curiously, to have been in the collection of Amédée Schuffenecker. Other pieces with this type of signature are *Les Cigales et les Fourmis* (Cat. No. 72) and *Te Fare Amu* (Cat. No. 122).

The kneeling figure on the left was taken from a Theban tomb mural of the Eighteenth Dynasty (top right, courtesy of the British Museum). A photograph of this mural was found among Gauguin's effects at his death, and is now in the collection of Mme Joly-Segalen. The figure on the right appears in the baseboard decoration in the painting *Te Reri Oa* of 1897 (bottom right, courtesy of the Courtauld Institute of Art).

a.

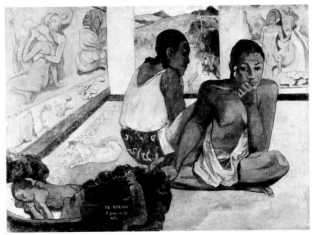

b.

124 "SIRÈNE ET DIEU MARIN"

H. 20 cms. L. 42 cms. Redwood? Signed: P. Gauguin.

Collections: Émile Schuffenecker (?); present location unknown.

Exhibitions: 25–Nunes et Fiquet, Paris, 1917; "Bois sculptés: *Le Gorille et la Chimère*" (?); 61–Galerie Dru, Paris, 1923; "Bois sculptés: *Singe et Chimère*" (?).

Print: Courtesy of the Boston Museum of Fine Arts.

Notes:

Though the present location and nature of the relief entitled *Le Gorille et la Chimère* is not known, it may well be that this print was taken from it. Carl Schniewind has noted on the mat of the print that it was made from a carving, and was presumably made posthumously. The format, style, and the rough wood suggest that the lost piece was similar to the redwood boards that Gauguin carved to decorate his house in Tahiti during his second stay. The Mermaid appears on such a board in the painting *Te Reri Oa* (Cat. No. 123*b*) and on the carved panel catalogued under number 121 and on the carved settee (Cat. No. 130).

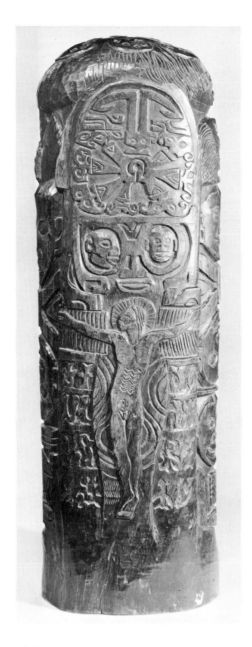

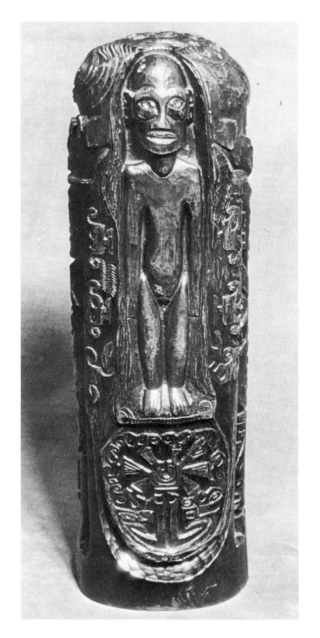

125 WOOD CYLINDER WITH CHRIST ON THE CROSS

H. 50 cms. Toa wood. Signed on top: P G O.

Collections: Daniel de Monfreid; Mme Huc de Monfreid.

Exhibitions: Possibly in the Gauguin Retrospective, Paris, 1906; 11–Luxembourg, Paris, 1928; 108–*Gazette des Beaux-Arts,* Paris, 1936; 166–De Monfreid Exhibition, Paris, 1938; 15–*Exposition d'Art sacré,* Paris, 1950; 113–Galerie Charpentier, Paris, 1960.

References: Zolotoe Runo, I:i (1909), 5–14; Morice, *Gauguin,* p. 45(ill.); Rey, "Les Bois sculptés de Gauguin," *Art et Décoration* LIII (February, 1928), 57–64; Daragnès, "Les Bois gravés de P. Gauguin," *Arts graphiques,* XLIX (1935), 35–42(ill.).

Photographs: Archives Photographiques and the author.

Notes: (See text, p. 68 ff)

As is pointed out in the text, the subject matter of this piece indicates that it was done after 1894 when Gauguin suffered a broken ankle. The wood (*Casuarina equisetifolia*) places its execution in the

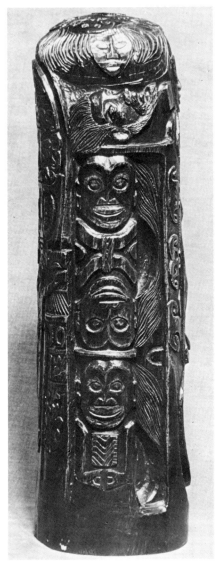

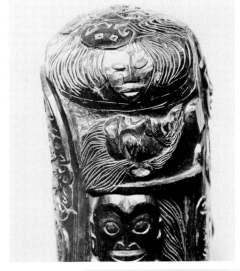

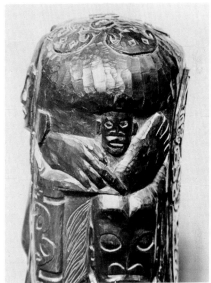

tropics. The bearded head on the side is related to a wood engraving which Gauguin sent Daniel de Monfreid during the winter of 1896–1897 (Guérin No. 52) (Cat. No. 125c).

A replica of the side of the crucified Christ was in the Fayet Collection (see Cat. No. 125a), according to Mme P. Bacou (private conversation, September 8, 1959). A print of the same side was made from the original by Daniel de Monfreid, with the addition of Gauguin's initials (information from Mme Huc de Monfreid). Another print from the side was also made (Guérin No. 84).

Aside from the major figures, the most striking element of the cylinder is its ornamentation based on Polynesian motifs. The main motif which appears above the head of the Christ is based on that of a Marquesan ceremonial or war club of a somewhat

unusual type (Cat. No. 125e) of which Gauguin possessed a rubbing heightened in watercolor of part of the ornamentation (see Cat. No. 125d). The detail that Gauguin copied consists of an inverted half-*atua* face above a rosette of radiating chiroid forms surrounded by a series of *mataio* faces of a variant form. These latter faces are repeated as a decorative element around the signature on the top and on either side of the figure on the side opposite the Christ. The whole motif is repeated in reverse below this figure.

On the side of the Christ, just below the rosette appears another motif drawn from a Marquesan club, a *matahoata* face with tiki eyes. In bands on either side of the figure of the Christ are forms based on Easter Island script.

On the sides appear tiki heads.

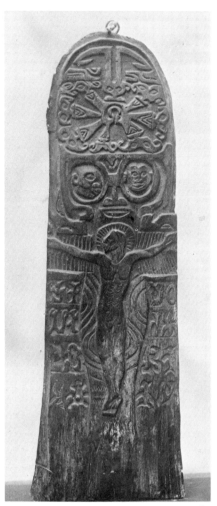

a.

b. Marquesan carved ornament.
From Von den Steinen,
Die Marquesaner und ihre Kunst.

c.

d. Rubbing from a Marquesan war club.
From the manuscript of Noa-Noa, Cabinet des Dessins, Louvre.

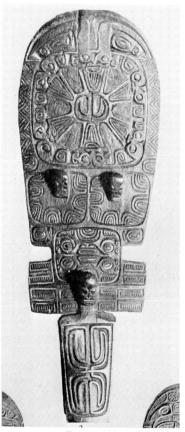

e. Marquesan club head.
From von den Steinen, Die Marquesaner und ihre Kunst.

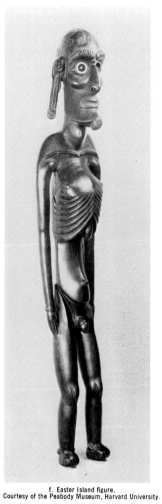

f. Easter Island figure.
Courtesy of the Peabody Museum, Harvard University.

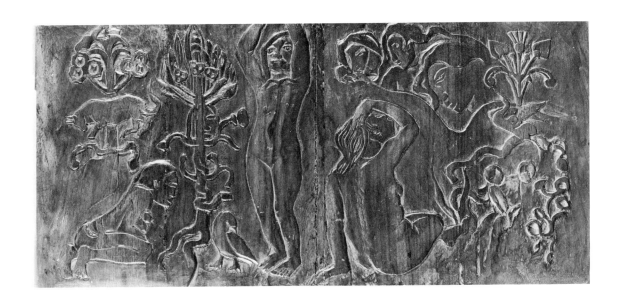

126 "QUE SOMMES-NOUS?"

H. 29 cms. L. 60 cms. Wood.

Collections: Ambroise Vollard, Paris; Jean Ribault-Menetière, Paris; Henry Dauberville, Paris.

Exhibitions: 84–Orangerie, Paris, 1949; 70–Kunstmuseum, Basel, 1949–50; 38–Galerie André Weil, Paris, 1951; 143–Galerie Charpentier, Paris, 1960.

References: R. Palluchini, "Que sommes-nous?—Un panneau sculpté par Gauguin," *Arts,* September 12, 1947.

Photograph: Courtesy of Berneheim-Jeune.

Notes: (See text, pp. 68, 70 ff)

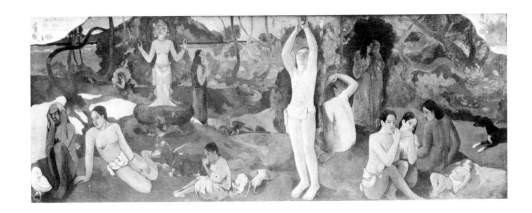

127 "LA GUERRE ET LA PAIX"

Top panel: L. 99.5 cms. H. 48.5 cms. Thickness 3.4 cms. Tamanu wood, polychromed. Not signed. Bottom panel: L. 99.5 cms. H. 44.5 cms. Thickness 3.3 cms. Tamanu, polychromed. Inscribed: LA GUERRE ET LA PAIX. Signed on lower right: P G O.

Collections: Gustave Fayet, Béziers; Léon Fayet, Arles; Lawrence K. Marshall, Cambridge.

Exhibitions: 52–Gauguin Retrospective, Paris, 1906; 37–Galerie André Weil, Paris, 1931; 78–Tate Gallery, London, 1955.

References: Segalen, *Lettres,* LXX, LXXII, LXXV, LXXVIII, LXXIX; *Zolotoe Runo,* I:i (1909), 5–14; Rotonchamp, *Gauguin,* p. 194; Goulinat, "Les Collections Gustave Fayet," *L'Amour de l'Art* (1925), pp. 135–42; Malingue, *Gauguin* (1943), p. 148; Loize, *Amities,* p. 144; Dorival, "Sources of the Art of Gauguin," *Burlington Magazine,* XCIII (April, 1951), 118–22.

Photographs: Courtesy of Mr. L. K. Marshall.

Notes: (See text, pp. 68, 73 ff)

Unlike his other works in the South seas in which he used precious hardwoods, Gauguin has used relatively heavy polychromy on these two pieces. The foliage of the plants is a heavy green, the fruit red. The hair of the figures is brown, except for the second figure from the left in each panel, in which case the hair is clearly red. In the upper panel, the horse is brown, the bird and the fox are red. In the lower panel, the dog, on the right is red, and the adjacent bird blue. Gilding has been used on the signature, the earring of the head just above, and on the stamens of the flowers surrounding the head of Christ. The head of the axe in the hand of the figure just to the right of the head of Christ is green. In both the upper and lower panels Gauguin has left the bodies of the figures the natural coppery color of the wood, as is the background. The snake under the head of Christ is black.

On the bottom edge of the upper panel is a rabbeted step in which Gustave Fayet placed a bar for the mounting of the two pieces on the wall.

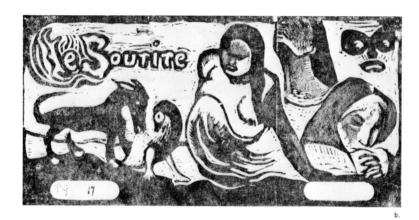

b.

a. Photograph of a detail of the Column of Trajan which was in the possession of Paul Gauguin.
Collection of Mme Joly-Segalen. Photograph courtesy of Richard Field.

272

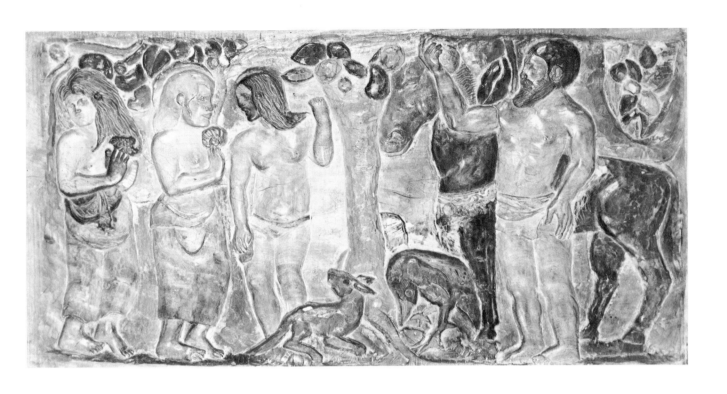

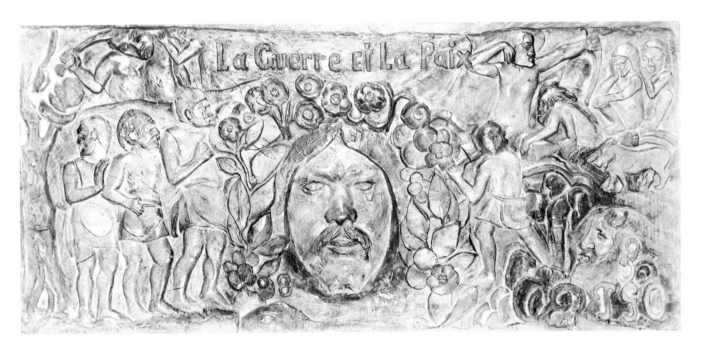

128 "LA PAIX ET LA GUERRE"

L. 66 cms. H. 29.5 cms. Thickness 4 cms. Miro wood. Signed: P G O. Inscribed: LA PAIX ET LA GUERRE.

Collections: Ambroise Vollard, Paris; Alex Maguy, Paris.

Exhibitions: Possibly 93–bis Gauguin Retrospective, Paris, 1906; 165–Galerie Charpentier, Paris, 1960.

References: Malingue, *Lettres*, plate 34.

Photograph: Courtesy Alex Maguy.

Notes:

The theme of this relief is the same as that of the Fayet *War and Peace*. The wood seems to be rosewood *(Thespia populnea)*, called miro by the Polynesian. The use of miro is associated with the Mar-

quesas, while Gauguin used either tamanu wood or toa wood for his major sculptures in Tahiti. The piece that the artist used here is the outside of a rather large log, the carved surface corresponding with the outer surface of the log, while the back is sawed flat.

Like so many of Gauguin's wood carvings from the tropics, where well-cured wood was difficult to obtain, this piece has cracked, and a small patch is barely visible on the center-left edge. Unfortunately, rosewood soon loses its color, and the original color that the artist saw is long gone.

The group of two figures on the left is based on a watercolor, *Two Tahitian Women* (collection of Knoedler and Co., illustrated in Rewald, *Drawings*, No. 86). In the watercolor the two figures have halos which suggest a Christian religious significance. The central figure is the same as that in the painting *Arearea no Varua Ino* ("Pleasure of the Evil Spirit") of 1894, now in the Ny Carlsberg Glyptothek in Copenhagen.

129 MASK OF A POLYNESIAN WOMAN

Wood.

References: Loize, *Amities,* p. 133, #360; Joly-Segalen, "Paul Gauguin and Victor Segalen," *Magazine of Art,* December, 1952, pp. 373–74.

Photograph: Courtesy of Mme Huc de Monfreid.

Notes: (See text, p. 75)

This piece was destroyed during World War II, while in a French collection. It was probably the mask that was sold to M. Goupil in Tahiti (cf. Loize, *Amities*). It is known through a photograph in the possession of Mme Huc de Monfreid, and through a drawing by Victor Segalen in the possession of his grandson, M. Joly. The facial characteristics correspond with those of Pahura, Gauguin's *vahine* during his second stay in Tahiti.

130 SETTEE

L. 208. cms. Wood, with carved frieze in the back rest, consisting of a head in the center with animal and foliage patterns on either side. Apparently not signed.

Collections: Cora Timkin Burnett; present location unknown.

Exhibitions: American Art Association—Anderson Galleries Inc., New York, sale of November 15, 16, 1929.

References: "Gauguin Settee Sells at Auction for $375," *The Art Digest,* December 1, 1929, p. 13(ill.); "$15 Gauguin Art Put Up at $50,000," *New York Times,* March 17, 1960.

Photograph: Courtesy of John Rewald.

Notes:
 The settee and a table were bought in Tahiti by Mrs. Cora Timkin Burnett, according to the references. In a letter (see notes under Cat. No. 131) Dr. J. C. Burnett said that his wife bought the settee in 1923.
 There is a reference in a letter from Gustave Fayet to Daniel de Monfreid to a table and a settee by Gauguin (see notes under Cat. No. 131). However, according to this letter, the settee mentioned was signed by Gauguin, while apparently this one is not.
 The decorative motifs carved on the back rest of the settee recall the figures on the baseboard of the

wall in Gauguin's painting *Te Reri Oa* of 1897 in the collection of the Courtauld Institute of Art, London (Cat. No. 123*b*). The rabbit on the extreme right may be a souvenir of Brittany, for it is very similar to the rabbit (?) carved on one of the beams in the chapel of Trémalo near Pont Aven (see Cat. No. 130*a*), which Gauguin copied in a sketch of Christ that served as a basis of his painting *The Yellow Christ* of 1889 (Rewald, *Gauguin Drawings,* plate 19).
 The deer to the right of the central head was apparently based on the deer represented in the scene of the *Meeting of Buddha and the Monks on the Road to Benares* from the temple of Borobudur (reversed) (Cat. No. 95*a*).

a.

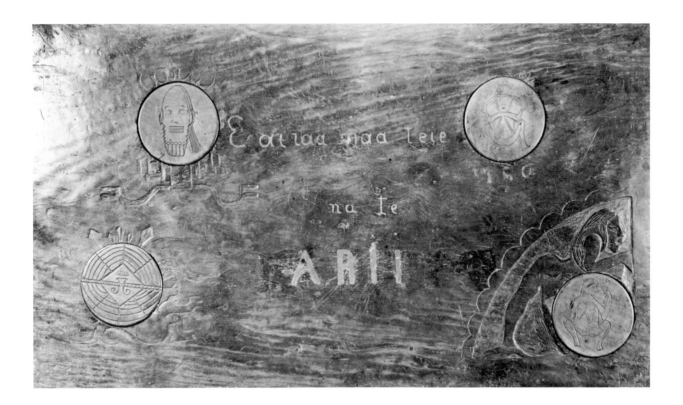

131 TABLE

L. 160 cms. W. 92 cms. Apitong wood, carved and polychromed. Signed: P G O. Inscribed: TE AIRAA MAA TEIE NA TE ARII ("This is the Table of the Chief"). The legs of the table are not as old as the top, and are of different wood. The table is ornamented with four medallions of a wood differing from that of the table top and ornamented with designs cut with a "V" gouge. The inscription is incised, as are the other ornamentations on the table top proper, and filled with color.

Collections: Cora Timken Burnett; Jon Streep, New York; Dr. Armand Hammer.

Exhibitions: 379–American Art Association—Anderson Galleries, Inc., New York, sale of November 15, 16, 1929; 33–Second Annual Exhibition of Modern and Old Masters, Finch College Art Gallery, New York, March 15–April 16, 1961.

References: "Gauguin Settee Sells at Auction for $375," *The Art Digest,* December 1, 1929, p. 13; "$15 Gauguin Art Put Up at $50,000," *New York Times,* March 17, 1960.

Photographs: Courtesy of the Hammer Galleries.

Notes:

In a letter to Jon Streep, written on January 10, 1958, Dr. J. C. Burnett stated that his wife, Cora Timken Burnett, bought the table in Tahiti in March, 1923, from Gauguin's son.

The wood is said to be apatong (*sic*) "which resembles redwood and is indigenous to Tahiti" (*New York Times,* March 17, 1960). According to S. J. Record ("Some Trade Names of Woods," *Tropical Woods,* III [Sept., 1925] p. 7), apitong (*Dipterocarpus grandiflora* or *D. vernicifluus*) is a wood found in the Philippines, and sometimes called Philippine mahogany. This tree has not been reported in Tahiti, nor is the name Polynesian. However, it should be remembered that Gauguin could not have obtained such a large plank of a native wood, for he specifically stated that the native woods were not exploited commercially (letter to Daniel de Monfreid, February 25, 1901, Segalen, *Lettres,* LXXII). Probably this plank constituted part of a table that had been imported into Tahiti.

The medallions on the table are made of separate pieces of a different wood than the table top. As they lack both the patine and wear of the rest of the table top, they appear to be later additions, though the recesses in the table into which they fit seem old. The style of the medallions, executed in more or less linear cuts with a "V" gouge, are almost without paral-

lel in the work of Gauguin. The only other example of a similar technique is to be found in a paint box that is said to have belonged to Gauguin (see Cat. No. A–16). Considering the style, the state of the wood, and the technique, I find it difficult to accept the medallions as the work of Gauguin.

In a letter to Daniel de Monfreid on February 4 (1928?) Gustave Fayet wrote:

> Mon ami Edouard Desdomaine a quitté la France pour aller finir ses jours à Tahiti. Il vient de m'envoyer ces 3 photographies. Le canapé et la table sont bien de Gauguin, et signés. Elles appartiennent à un commerçant de Tahiti qui en demande la modeste somme de 75.000. Un rien, quoi? (Loize, *Amities*, p. 146, #444)

Though Loize believes that this letter was written in 1928, it is strange that another settee and table should turn up in Tahiti after the first set had been bought by Mrs. Burnett. Perhaps they are the same, and the letter dates earlier than 1928. I was unable to find the photographs among the papers of Mme Huc de Monfreid in 1959.

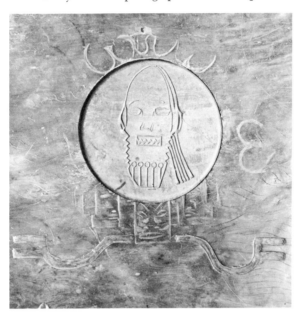

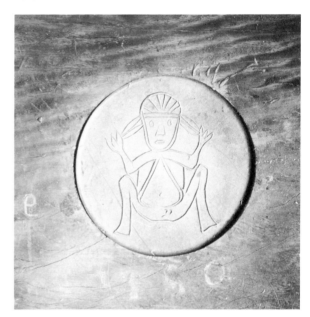

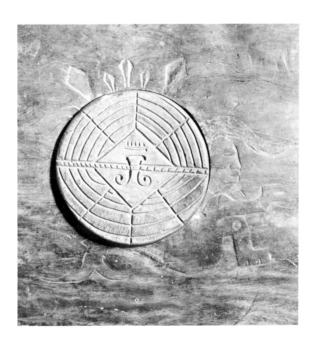

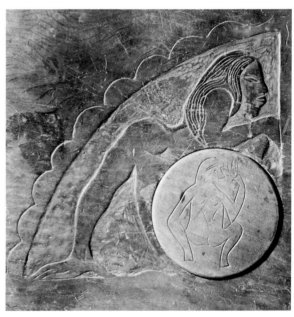

132 CARVED DOOR FRAME FROM GAUGIN'S HOUSE IN THE MARQUESAS

Lintel: L. 242.5 cms. W. 39 cms. Inscribed: MAISON DU JOUIR.
Right upright: H. 159 cms. W. 40 cms.
Left upright: H. 200 cms. W. 39.5 cms.
Right base panel: L. 205 cms. W. 40 cms. Inscribed: SOYEZ AMOUREUSES ET VOUS SEREZ HEUREUSES.
Panels are redwood, carved and painted. None are signed. (See Plate XIX, p. 102)

Collections: Victor Segalen, Paris; Dr. and Mme P. Fouquiau, Paris; Musée du Louvre, Paris.

Exhibitions: 24–Luxembourg, Paris, 1928; 172–De Monfreid Exhibition, Paris, 1938; 55–Galerie Kléber, Paris, 1949.

References: Varenne, "Les Bois graves et sculptés de Paul Gauguin, *"La Renaissance de l'art français,* December, 1927, p. 517(ill.); Segalen, *Lettres,* Introduction, p. 38; Rey, "Le Dernier décor de Gauguin," *La Revue des Arts,* June, 1952, pp. 115–21(ill.); Joly-Segalen, "Paul Gauguin and Victor Segalen," *Magazine of Art,* December, 1952, pp. 370–74(ill.); Loize, *Amities,* #359, Letter of E. Vermeersch to Daniel de Monfreid, February 26, 1904; LeBronnec, "Les Dernières années," in *Gauguin, sa vie son oeuvre,* pp. 189–200; Wildenstein, "Documents inédits ou peu connus," in *Gauguin, sa vie, son oeuvre,* p. 207.

Photographs: Giraudon and the author.

Left base panel: L. 153 cms. W. 40 cms. Redwood. Carved and painted. Inscribed: SOYEZ MYSTERIEUSES.

Collections: Émile Schuffenecker, Paris; Amédée Schuffenecker, Paris; Mme Jeanne Schuffenecker, Paris; Private Collection, Solothurn, Switzerland.

Exhibitions: 173–Gauguin Retrospective, Paris, 1906; 19–Nunes et Fiquet, Paris, 1917; 58–Galerie Dru, Paris, 1923; 10–Luxembourg, Paris, 1928; 46–*Gazette des Beaux-Arts,* Paris, 1936; 71–Kunstmuseum, Basel, 1949–50.

References: Segalen, "Gauguin dans son dernier décor," *Mercure de France,* June, 1904, p. 681; *Zolotoe Runo,* I:i (1909), 5–14(ill.); Vauxcelles, "À propos des bois sculptés de Paul Gauguin," *L'Art décoratif,* January, 1911, pp. 37–38(ill.); Segalen, *Lettres,* Introduction,

p. 38; Morice, *Gauguin,* p. 21(ill.); Rey, "Les Bois sculptés de Paul Gauguin," *Art et Décoration,* February, 1928, 60(ill.).

Photograph: Musées Nationaux.

Notes: (See text, pp. 76–77)

The first group of four panels were bought by Victor Segalen at the auction of Gauguin's effects at Papeete on September 3, 1903, for a total of sixteen francs (Wildenstein, *Gauguin,* p. 207). Very probably one of the other planks sold at that time was the *Soyez mystérieuses,* formerly in the collection of Amédée Schuffenecker. There has been a great deal of confusion of the two versions of *Soyez mystérieuses,* but where the dimensions have been given, it is this version that has appeared in exhibitions. The other version (Cat. No. 87), originally in the collection of Gustave Fayet, has not been exhibited since the Gauguin Retrospective of 1906, according to the Fayet family. This version certainly belongs in both style and material to the period of Gauguin's second stay in the South seas. The complementary nature of the form and subject, as well as its dimensions, suggest that this piece belongs with the foregoing panels as part of the door frame of Gauguin's house at Atuona. Actually, Segalen, in his article, "Gauguin dans son dernier décor," mentions five panels in the door frame, one of which was entitled *Soyez mystérieuses,* but there was no such panel among those that he purchased at Papeete.

The theme of these five panels goes back to the two great panels of 1889 and 1890—*Soyez amoureuses* and *Soyez mystérieuses* (Cat. Nos. 76, 87). Like the themes, the figures themselves find their origins in Gauguin's earlier works:

Left base panel:

Figure on the left: Appears first in a sketchbook in the Cabinet des Dessins, Louvre (R. F. 30564 fol. 52 R) (Cat. No. 121a). Used in the panel from the dining room of Gauguin's house in Tahiti (Cat. No. 117).

Middle figure: Sketchbook, Cabinet des Dessins, 47 R (Cat. No. 132a).

Right figure: Possibly *ibid.,* p. 46 (Cat. No. 121c).

Left upright:

The figure is a modification of that of the nude woman appearing on the left in Catalogue number 119 (*Photograph of Gauguin's House in Tahiti*).

Lintel:

The heads at either extremity are similar to the head

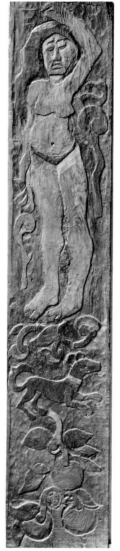

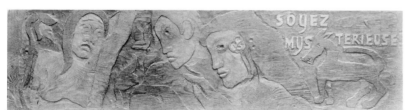

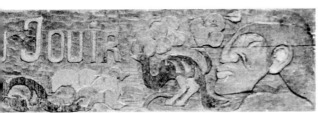

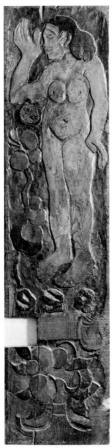

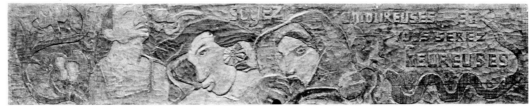

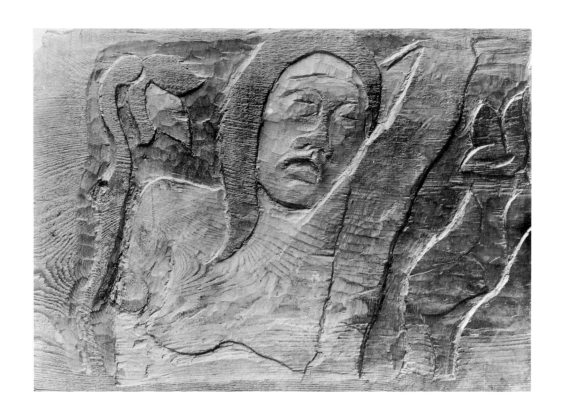

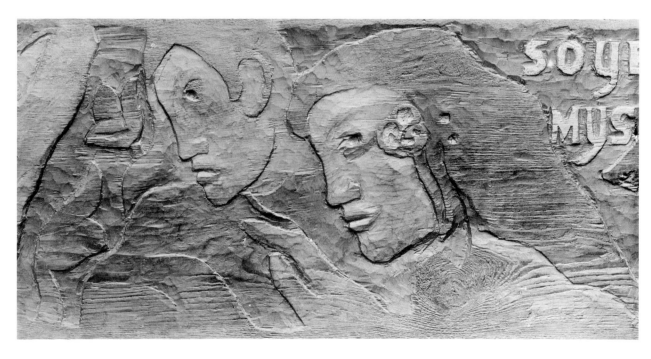

that appears at the top of the woodcut *Te Atua* (Guérin No. 61) (Fig. 22).

Right upright: (Not identified)

Right base panel:

Figure on the left: This figure appears in one of the title blocks of *Le Sourire* (Guérin No. 75), and in the woodcut *Soyez amoureuses* (Guérin No. 58) (Cat. No. 132*b*). (Courtesy, Museum of Fine Arts, Boston.)

Figure in the middle: Sketchbook, *op. cit.,* fol. 46 V (the notation *"d'apres Delacroix"* appears on the same page in Gauguin's writing) (Cat. No. 132*a*).

Figure on the right: Appears in the panel from Gauguin's dining room in Tahiti (Cat. No. 121) and in the title to *Le Sourire* (Guérin No. 75), as well as in the woodcut *Soyez amoureuses* (Guérin No. 58) (Cat. No. 132*b*).

a.

b.

133 "TE ATUA" (THE GODS)

Photograph by the author.

L. 58 cms. W. 20 cms. Redwood. Carved and painted.

Collections: Victor Segalen; Mme P. Fouquiau, Paris.

Exhibitions: 21–Luxembourg, Paris, 1928; 173–De Monfreid Exhibition, Paris, 1938; 56–Galerie Kléber, Paris, 1949; 364–Galerie Jean Loize, Paris, 1951; 152–Galerie Charpentier, Paris, 1960.

References: Segalen, "Gauguin dans son dernier décor," *Mercure de France,* June, 1904, pp. 679–85; Morice, *Gauguin,* pp. 118, 119; Segalen, *Lettres,* Introduction; Joly-Segalen, "Paul Gauguin and Victor Segalen," *Magazine of Art,* December, 1952, pp. 371–72.

Notes: (See text, pp. 77–78)

This panel was placed above a clay statue in front of Gauguin's house at Atuona. On the left appears the figure of a rat (?) painted red, and on the right an exotic bird painted green and white and red. In the center is pasted a poem by Charles Morice, copied in Gauguin's hand:

Les Dieux sont morts et Atuana meurt de leur mort.
Le Soleil autrefois qui l'enflammait l'endort
D'un sommeil triste, avec de brefs reveils de rêve:
L'arbre alors du regret point dans les yeux de l'Ève
Qui, pensive, sourit en regardant son sein,
Or sterile scellé par les divins desseins.

Victor Segalen found the panel *in situ* and brought it back to France. The clay god was too fragile to save.

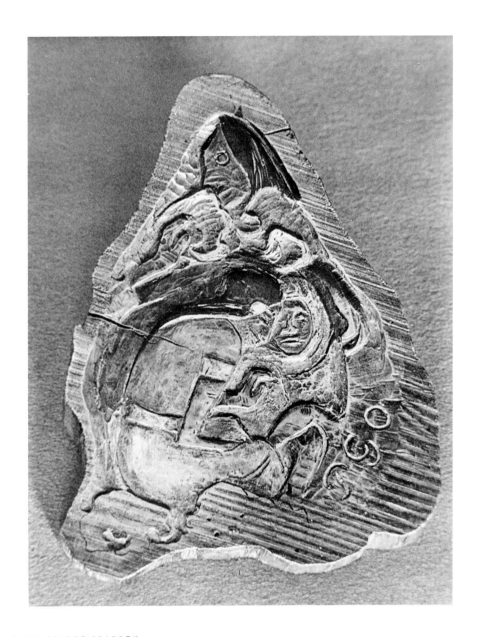

134 "PARAU HANO-HANO"
(TERRIFYING WORDS)

Largest dimension 21 cms. Tamanu wood? Carved
and painted. Signed: P G O. (Plate XVII, p. 101)

Collections: Gustave Fayet, Béziers; Mme d'Andoque,
Béziers.

Photograph by the author.

Notes:

This piece is carved on a wedge-shaped section cut
from a small log. It is probably a scrap of tamanu
wood that Gauguin cut off to square up an end. Con-
trary to his usual practice, the polychrome is quite
heavy here. The theme for the piece follows the paint-
ing of the same title reproduced in Malingue, *Gau-
guin,* 1948, plate 238. Malingue dates the painting
in 1902.

135 "THÉRÈSE"

H. 66 cms. Miro wood (*Thespia populnea*). Signed:
P G O. Inscribed: THÉRÈSE below left hand.

Collections: M. Pietri, Papeete; G.-D. de Monfreid;
Amédée Schuffenecker, Paris; Private Collection, Paris.

Exhibitions: 22–Nunes et Fiquet, Paris, 1917; 60–
Galerie Dru, Paris, 1923; 23–Luxembourg, Paris,
1928; 248–Kunsthalle, Basel, 1928; 224–Thannhauser
Gallery, Berlin, 1928; Galerie Jean Loize, Paris, 1951
(supplement); 168–Galerie Charpentier, Paris, 1960.

References: Gauguin, *Avant et Après*, p. 46; Segalen,
"Gauguin dans son dernier décor," *Mercure de France*,
June, 1904, pp. 679–85; *Zolotoe Runo*, I:i (1909),
5–14 (ill.); Vauxcelles, "À propos des bois sculptés
de Paul Gauguin," *L'Art décoratif*, January, 1911,
p. 38(ill.); Segalen, *Lettres*, Introduction; Morice,
Gauguin, p. 205(ill.); Varenne, "Les Bois gravés
et sculptés de Paul Gauguin," *La Renaissance de
l'art français*, December, 1927, Cover (ill.); Alexandre,
Gauguin, p. 225(ill.); Pola Gauguin, *My Father*,
p. 262; Loize, *Amities*, p. 133, #360; Chassé, *Gau-
guin et son temps*, pp. 97–109; LeBronnec, "Les
Dernières années," in *Gauguin, sa vie, son oeuvre*,
p. 196(ill.), p. 199.

Notes: (See text, pp. 75, 78–79)
This piece was bought by M. Pietri at the Gauguin
sale in Papeete in 1903 (Loize, *Amities*, p. 133).

Originally the eyes, the earrings, the bracelets, the
girdle, and the P G O were gilded. All the parts
except the earrings appear to have been regilded. The
tips of the breasts are formed of copper nails.

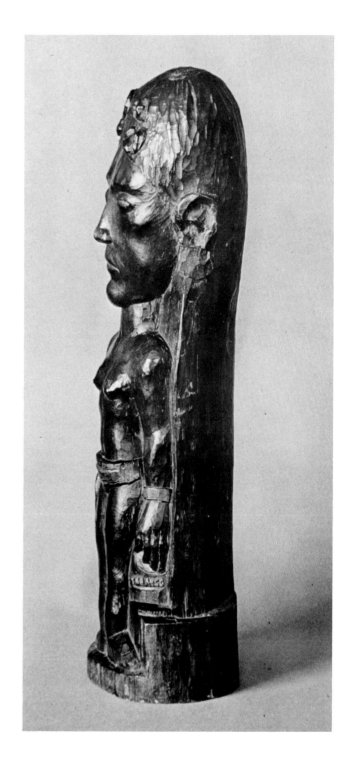

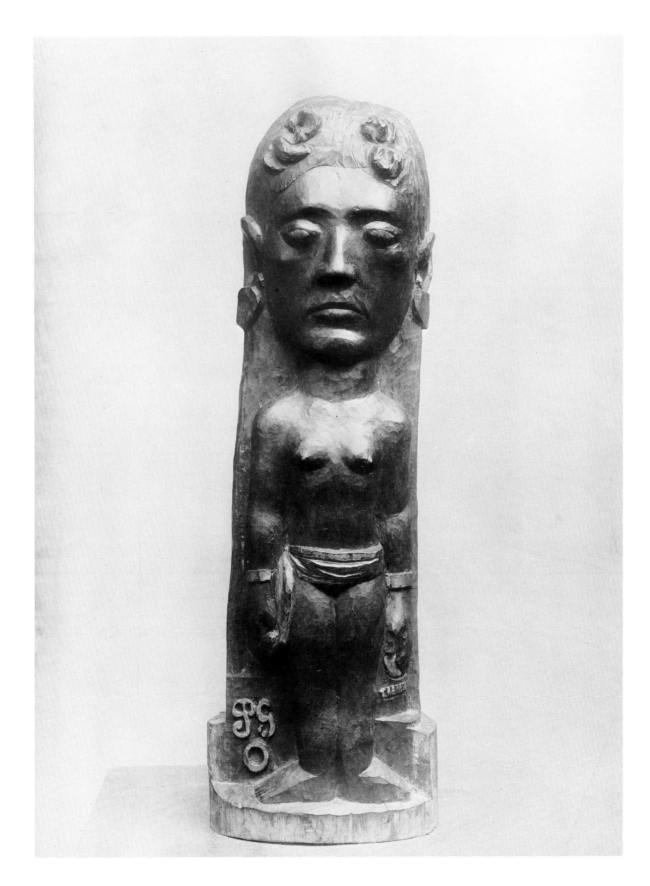

287

136 "PÈRE PAILLARD"

H. 65 cms. Miro wood (*Thespia populnea*). Inscribed:
PERE PAILLARD ("Father Lechery"). Signed:
P G O.

Collections: M. Pietri, Papeete; Émile Schuffenecker,
Paris (?); Ambroise Vollard, Paris; Etienne Bignou,
Paris; Chester Dale, New York.

Exhibitions: Galerie Blot, Paris, 1910; 23–Nunes et
Fiquet, Paris, 1917; 59–Galerie Dru, Paris, 1923;
22–Luxembourg, Paris, 1928; Society of the Four Arts,
Palm Beach, February, 1956; 102–Wildenstein, New
York, 1956; 124–Chicago Art Institute and the
Metropolitan Museum, New York, 1959.

References: Gauguin, *Avant et Après,* p. 46; Segalen,
"Gauguin dans son dernier décor," *Mercure de France,*
June, 1904, pp. 679–85; Vauxcelles, "Ā propos des
bois sculptés de Paul Gauguin," *L'Art Décoratif,"*
January, 1911, pp. 37-38; Segalen, *Lettres,* Intro-
duction; Morice, *Gauguin,* p. 205; Pola Gauguin, *My
Father,* pp. 262, 266; Loize, *Amities,* #360, p. 133;
Chassé, *Gauguin et son temps,* pp. 97–109, 115(ill.);
Read, "Gauguin—Return to Symbolism," *Art News
Annual,* 1956, p. 154; Goldwater, *Gauguin,* p.
40(ill.); LeBronnec, "Les Dernières années," in *Gau-
guin, sa vie, son oeuvre,* p. 196(ill.), p. 199.

Notes: (See text, pp. 75, 78–79)

Père Paillard, the companion piece to *Thérèse,* was
also bought by M. Pietri at the Gauguin sale at
Papeete in 1903. This horned figure invites compari-
son with a number of other representations of horned
figures in Gauguin's work. The original piece from
which the other representations seem to be drawn is
a horned head on a pedestal that is shown in two
photographs pasted on page 56 of Gauguin's manu-
script version of *Noa-Noa* (see Cat. No. A–14). It
is this piece that seems to have served as the basis for
two monotypes (Rewald, *Drawings,* Nos. 120, 121).
The nature of the piece in the photographs is such
that it would be possible to derive *Père Paillard* from
it, but it would seem much more difficult to derive
it from *Père Paillard.* While *Père Paillard* is based
on a fairly normal Western representation of a horned
devil, the head in the photograph is very much differ-
ent, and its derivation obscure. Even the material
from which it is fashioned is impossible to determine
from the photograph.

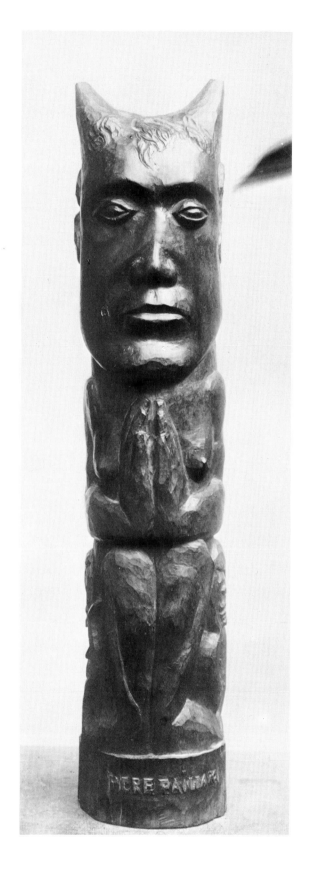

137 "SAINT ORANG"

H. 94 cms. Miro wood? Signed with a P G on the buttocks. Inscribed on the chest: SAINT ORANG.

Collections: Ambroise Vollard, Paris; Musée de la France d'Outre-mer (gift of Lucien Vollard).

Exhibitions: 93–Gauguin Retrospective, Paris, 1906.

Photographs by the author.

Notes: (See text, pp. 75, 79)

This piece probably represents the gendarme Claverie, Gauguin's *bête-noire* in the Marquesas, to whom he referred in *Avant et Après:*

> Prends-garde à toi chère petite; le gendarme poilu gardien de la morale mais faune en cachette, est là qui te guette. Sa vue satisfaite il te donnera une contravention pour se venger d'avoir troublé ses sens et par suite outragé la morale publique. (Facsimile edition, p. 5)

In December, 1902, Claverie had replaced the gendarme Charpillet, who had been more or less sympathetic to Gauguin. Soon after his arrival, Claverie, who had known Gauguin in Tahiti, swore to drive him off the island.

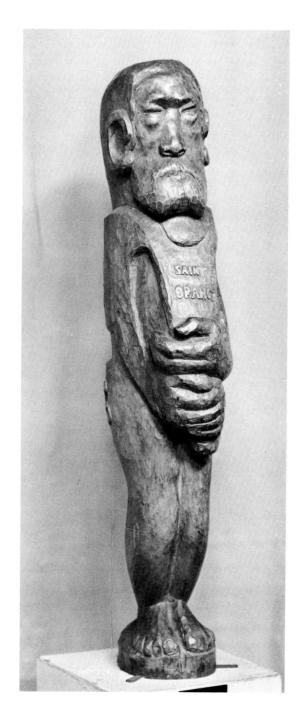

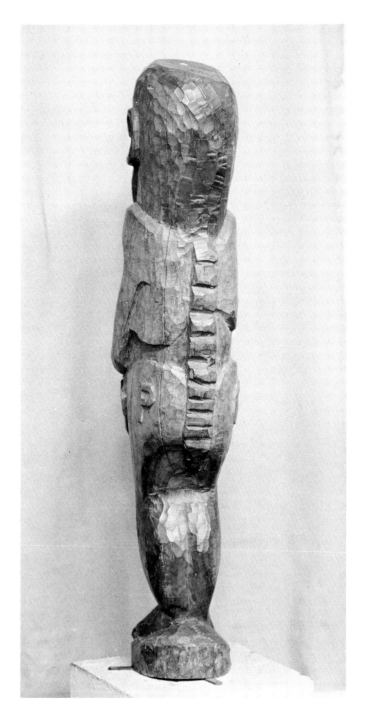

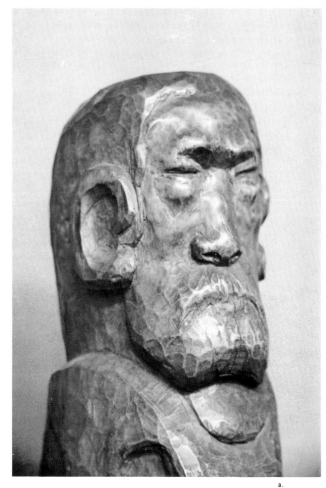

a.

138 THE LEPER

H. 155 cms. Tou wood (*Cordia subcordata*).

Collections: M. Nordmann, Tahiti; Dr. Rollin; André Urban, Paris; Private Collection, Nantes.

Exhibitions: Galeries Kléber, Paris, 1949 (not in catalogue).

Reference: Rollin, "Un Lépreux de Gauguin," *Gazette des Beaux-Arts,* November 13, 1936.

Photograph: André Urban.

Notes:

Dr. Rollin in his article points out that this figure has the characteristics of a leper (ithyphallic, among other things) and bears a Marquesan tattoo (*koniho*) on its upper lip.

Curiously, the *koniho* tattoo was part of the tattooing of women rather than men in the Marquesas (see Karl von den Steinen, *Die Marquesaner und ihre Kunst,* I, 128).

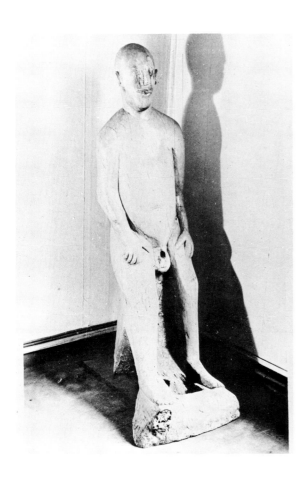 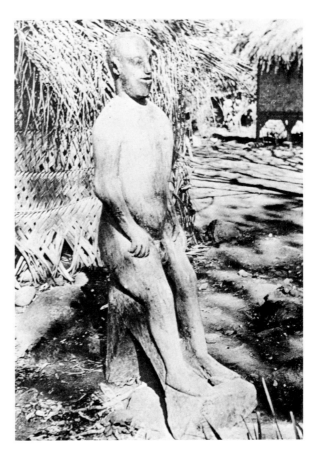

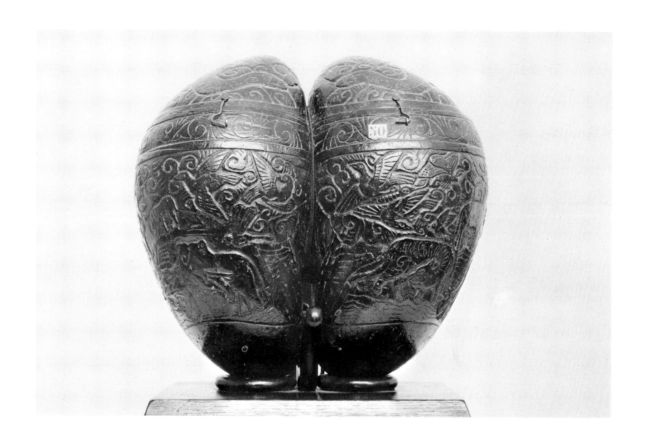

139 CARVED "COCO DE MER"

H. 30 cms. Carved from a nut of the *coco de mer* (*Lodicea seychellarum*). Inscribed: A MR PAILLARD. Signed: P. GAUGUIN.

Collections: Mme Cecilie Sorel; Georges Richaud; Stephen Hahn Galleries (bought at auction, Versailles, 1960).

Exhibitions: Possibly B–Leicester Gallery, London, 1924, "Coconut carved and painted by Gauguin at Tahiti"; Galerie Kléber, Paris, 1949 (not in catalogue); 36–Galeries André Weil, Paris, 1951; 169–Galerie Charpentier, Paris, 1960.

Photographs: Courtesy of Stephen Hahn.

Notes:

The fruit of the *coco de mer,* which grows only in the Sechelle Islands, is like a large double coconut. The name *coco de mer* was given the nuts because they were found washed ashore on the coast of India long before their origin was discovered. Their rarity caused magical powers to be attributed to the *coco de mer,* and their flesh was used as a love potion.

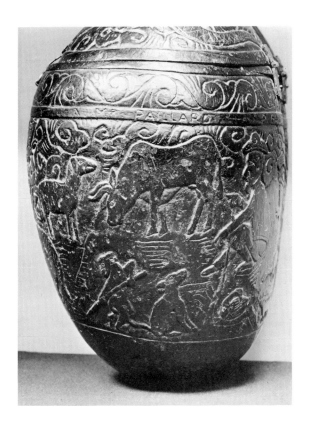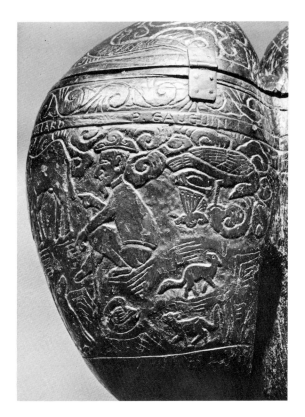

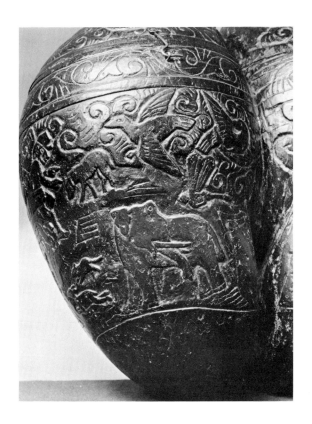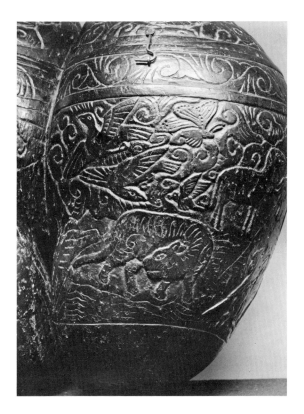

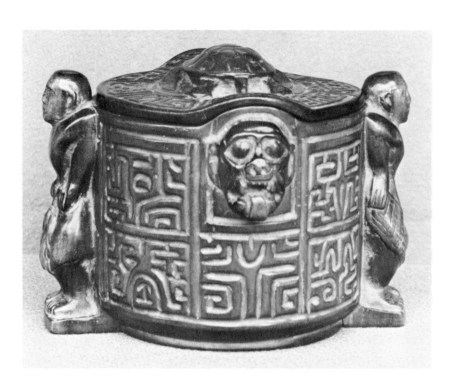

140 WOODEN JAR WITH COVER

H. 16.5 cms. Tamanu wood. Signed on the bottom shoulder: P Go. Ornamented with two standing figures on the sides and two grotesque heads. Top ornamented with a tortoise. The background on the side and top is filed with Marquesan designs.

Collection: Mrs. Christian Rub, Santa Barbara.

Photographs by the author.

Notes:

The jar was bought in Atuona, Hiva-Oa, in the Marquesas by Mr. Rub during a stay in 1947–1948. It was bought from a native who had it as a gift from Gauguin, according to Mrs. Rub. The jar and cover are carved of tamanu wood. The bottom has been made as a separate piece, fitted inside the outer cylindrical part and fastened with wooden pegs.

The two standing figures hold the fish and the banana, the two most important foods of the Polynesian. The two grotesque heads with the protruding tongues are reminiscent of similar motifs which appear on the figures used to decorate Maori houses. The patterns filling the interstices between the figures are derived from the Marquesan *kea* design (see Karl von den Steinen, *Die Marquesaner und ihre Kunst,* I, 162 ff). Into the design under one of the grotesque heads Gauguin has worked his initials P. G. The tortoise on the cover, though executed in a European manner, is a favorite Marquesan motif.

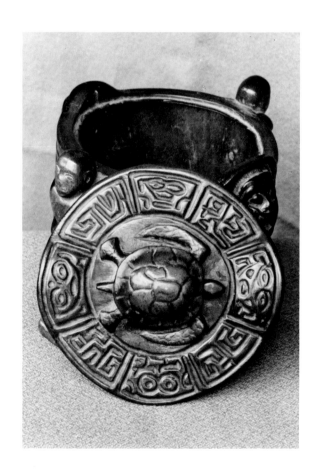

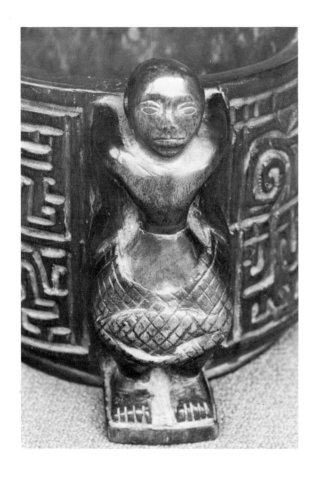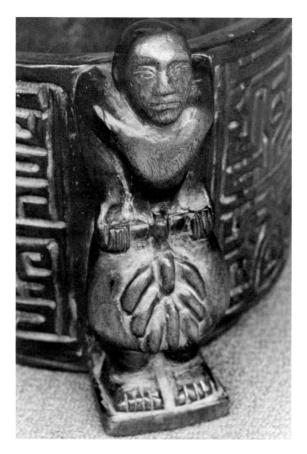

295

141 GUN STOCK

L. 35 cms. Wood, carved on one side. Not polychromed. Not signed.

Collections: M. Grelet, Fatu Hiva, Marquesas; Thomas Olsen, Sandviken, Norway.

Exhibitions: 60–Kunstnerforbundnet, Oslo, 1955.

References: Renée Hamon, *Gauguin,* p. 46(ill.); Wildenstein, *Gauguin, sa vie, son oeuvre,* pp. 170, 184, note 10.

Photograph by the author.

Notes:
Grelet was an acquaintance of Gauguin, who lived on the island of Fatu Hiva, to the south of Hiva-Oa where the artist resided. He apparently acquired the gun stock from Gauguin before the latter's death. Pottier recorded: "Un Norvegien peu connu en France est venu en Polynesie vers 1932, accompagné de sa femme. . . . Ils achetèrent à Fatu Hiva un fusil dont la crosse était sculptée sur l'une de ses faces" (Wildenstein, p. 184, note 10). Loize (*Amities,* p. 184) comments: "Un dessin joint semble avoir été fait d'après le photographie que Pottier dit avoir vue. Il est au-dessous, que l'achat en fut fait en 1939, à Grelet, colon de Fatu Hiva pour 400 francs. Une photographie de cette sculpture avait été reproduite déjà par Renée Hamon."

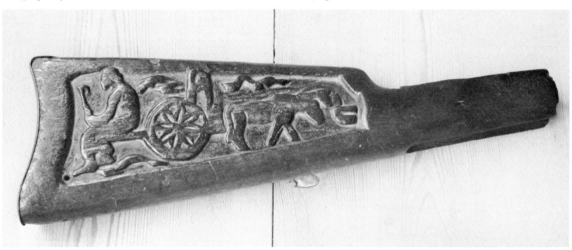

142 PICTURE FRAME

H. 50 cms. W. 43 cms. Redwood? Stained dark brown, with touches of red paint on the ornaments.

Collection: Musée de la France d'Outre-mer (gift of Lucien Vollard).

Photograph by the author.

Notes: (See text, p. 56)
This frame was probably one of those sold in 1903 at Papeete after Gauguin's death. The sale record lists eight frames under the following item numbers: 24, 31, 94(2), 115(4) (Wildenstein, *Gauguin,* pp. 206–7). However, the pattern motifs seem to belong to a period before his removal to the Marquesas. The photograph in the frame is of a tattooed Marquesan warrior holding a Marquesan war club. The same photograph, in a larger size, is in the Musée de la Marine in Marseilles, with the mark of the photographer, *L. G., Papeete.*

143 THREE WOODEN SPOONS

Nono wood? (*Morinda citrifolia*) One signed: P G O.

Collections: Daniel de Monfreid; Mme Huc de Monfreid.

Exhibitions: 371–Galeries Jean Loize, Paris, 1951.

References: Loize, *Amities*, plate 5, p. 135; Loize, "Gauguin sauvé du feu," *Gauguin, sa vie, son oeuvre*, p. 178(ill.).

Photographs by the author.

Notes:
In the inventory of Gauguin's effects made at Atuona at the time of his death, nine carved wooden spoons are listed (Wildenstein, *Gauguin*, p. 203, #54). In the sale that took place later in Tahiti two items, 46 and 47, are identified by the rubric *"un lot de cuillers en bois"* (*ibid.*, p. 207). These three spoons come from a lot of five bought by the Commissaire de Marine of the *Durrance*. They were bought by De Monfreid in 1926 from the commissaire's son, while another was bought by Albert Sarraut, and the fifth is in the museum at Nantes. The fate of the other lot is not known.

These spoons, reminiscent in many ways of the wooden spoons executed in boxwood by the Bretons, are probably done in the wood known as nono. This wood is described by Teiura Henry (*Ancient Tahiti*, p. 59) as a dense yellow wood without apparent grain, used by the Tahitians. Her description fits the material of these spoons exactly.

144 POI BOWL

L. 46 cms. W. 20.5 cms. Pua wood? Signed:
P G O.

Collection: Musée de la France d'Outre-mer (gift of
Lucien Vollard).

Photograph by the author.

Notes:
 Possibly number 28, *"un plat marquisien,"* listed
in the sale of Gauguin's effects (Wildenstein, *Gau-
guin,* p. 206). Though the general form and the orna-
ment are based on Marquesan prototypes, the signature
and the particularities of execution leave no doubt
that it is Gauguin's work.

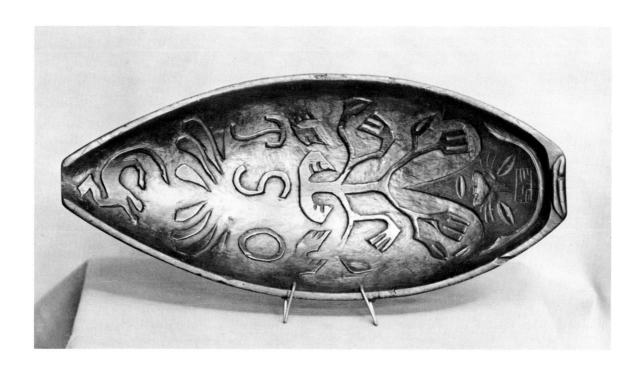

145 DEEP BOWL

L. 44 cms. (over-all). W. 26 cms. Tamanu wood.
Signed: P G O.

Collection: Musée de la France d'Outre-mer (gift of
Lucien Vollard).

Photograph by the author.

Notes:

Jénot describes Gauguin having decorated his poi
bowl with Marquesan patterns in 1891, and having
seen an identical bowl in the Gauguin Retrospective
of 1906 (Wildenstein, *Gauguin,* p. 122). Gauguin
probably made several during his stays in the South
seas. The fact that in the very first he used Mar-
quesan patterns, makes it difficult to state at what
period this particular bowl was made. The Tahitians
did not decorate their wooden utensils with carv-
ing. A bowl of the same type appears in Gauguin's
painting *Tahitian Repast* (1891) in the Louvre,
Paris.

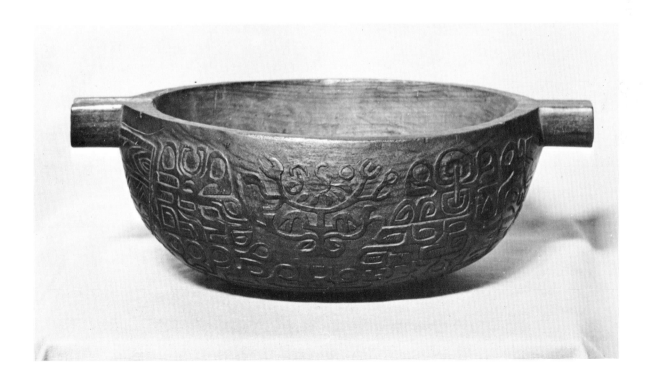

A–1 "BIRTH OF VENUS"

H. 44 cms. Oak wood, with traces of original poly-chrome. Signed: P Go on the flat side of the base.

Collections: Private Collection, Paris.

Photographs: Courtesy M. Jean Cailac.

Notes: (See text, pp. 1–2)

The title *Naissance de Venus* is based on the nature of the figure, and the presence of the dolphin, an animal sacred to Venus, on the base. The statue was bought about 1922 by its present owner in a store on the Rue Boulard which was liquidating the studio of a sculptor. The purchaser did not note the name of the artist, and the store has since disappeared. From the style of the work, and the meticulous execution, the work can hardly be dated after 1880, when Gauguin was still under the influence of Bouillot, but the signature, P Go, seems not to have been adopted by Gauguin before 1886 at the earliest. The fact that the piece was found in the studio of a sculptor who died about 1922 might indicate that Gauguin gave it to a friend. In such case the piece might not have been signed before the time of the gift.

As the piece probably dates from a period in which Gauguin's style was still unformed, and the signature at best does not date from the period of the execution of the piece, any attribution to Gauguin must be uncertain. The fact that the work was found among the effects of an artist, who according to the date of his death, was probably a contemporary of Gauguin, speaks in its favor.

Some time ago the owner of the *Birth of Venus* clipped an entry from a catalogue listing a *Naissance de Venus* by Paul Gauguin. Unfortunately no one has been able to identify the catalogue from which the entry was taken.

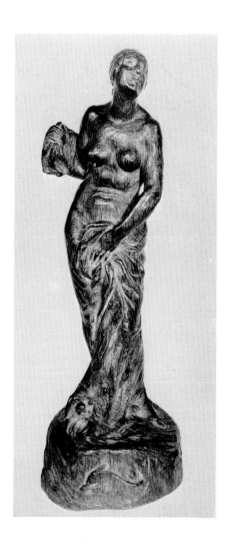

A–2 PORTRAIT OF ALINE

Notes:

According to the catalogue of the Gauguin exhibition at the Tate Gallery in 1955, Gauguin made a wax bust of his daughter Aline in 1880 (*Tate Gallery Catalogue,* London, 1955, p. 39). M. Maurice Malingue has informed the author that there is a bronze bust of Aline in a private collection in Denmark. It is probably a cast of this wax.

I have been unable to trace this work in Denmark.

A–3 SEATED WOMAN

H. 36.5 cms. Walnut. Touched with traces of red paint. Not signed.

Collections: Ambroise Vollard, Paris; Private Collection, Paris.

Photograph by the author.

Notes:

The author is by no means sure of the attribution of this piece to Gauguin. Favorable evidence is found in the fact that the composition, that of a relief wrapped around a cylindrical piece of wood, was one commonly used by Gauguin, and that the figure has been carved in a scrap of wood that had been used for some other purpose (there are signs of an old mortise on the right). Against the attribution to Gauguin is a certain softness in form, particularly evident in the head, and the rather conventional treatment of the folds of the drapery.

The tentative nature of the carving, as well as the conventional stylization of the drapery and hair, would suggest a very early date.

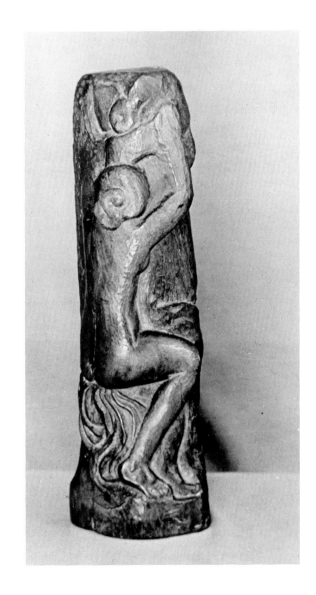

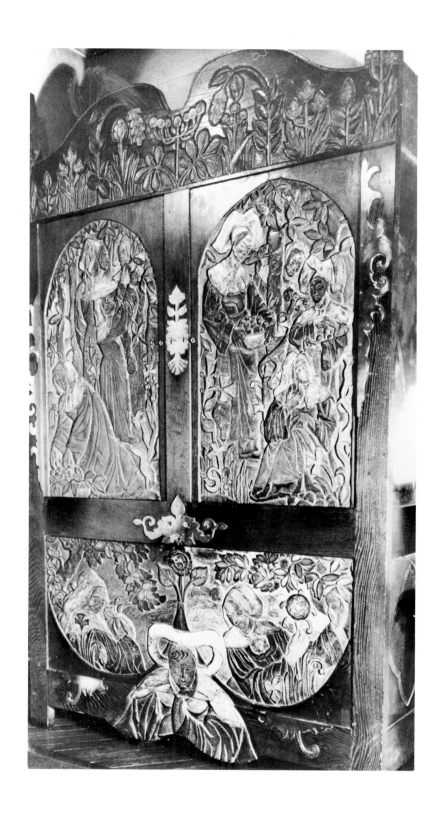

A–4 ARMOIRE

H. 241 cms. W. 150 cms. D. 50 cms. Oak.

Collections: Émile Bernard, Paris; M.-A. Bernard-Fort, Paris.

References: Paul Gauguin, *Lettres de Paul Gauguin à Émile Bernard, 1881–1891,* p. 96(ill.); Rewald, *Post-impressionism,* p. 197(ill.).

Photographs: Courtesy M. Bernard-Fort. Details by the author.

Notes: (See text, p. 36)

In the *Lettres de Paul Gauguin à Émile Bernard, 1881–1891,* this armoire appears with the title:

> *Bretonnes cueillant des Pommes.* Armoire sculptée par Émile Bernard et Paul Gauguin à Pont Aven en 1888. (Seul le panneau du bas est de Paul Gauguin.)

Louis Vauxcelles, "Tradition italianate et tradition française," *Histoire générale de l'art français de la Revolution à nos jours* (Paris, 1922), tome II, Chap. VII, p. 276, states: "[Gauguin] sculpte, aidé de Bernard, un buffet de cuisine."

In spite of these statements, I must have recourse to the Scotch verdict "not proven." It is possible to distinguish a stylistic difference between the upper panels and the lower. This difference consists of the use of rounder and more sensuously rhythmical forms in the lower panel together with a composition that makes use of the structural panel form, but is not bounded by it. However, when one looks at the forms and composition of the bottom panel in the *Corner Cabinet* executed by Bernard alone (Cat. No. A–4a), one is struck by the fact that just these differences are apparent in the work of Bernard. In short, it is not possible to discover any element in the carving of the bottom panel of the *Armoire* which would distinguish the hand of Gauguin from that of Bernard.

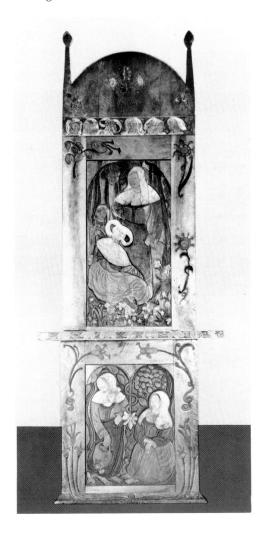

a.

303

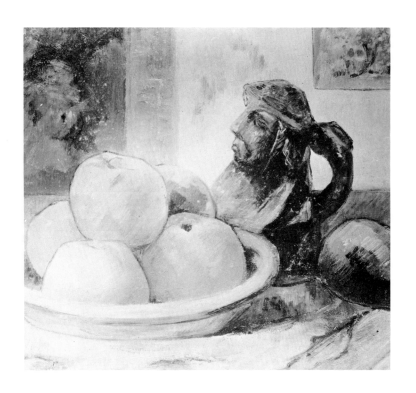

A–5 STILL LIFE WITH TOBY JUG

Signed and dated 1889.

Collections: Gustave Fayet, Béziers; Mr. & Mrs. Walter E. Sachs, New York.

References: Bodelsen, *Gauguin Ceramics in Danish Collections,* p. 14.

Photograph: Courtesy of Mr. Sachs.

Notes:

Bodelsen has already pointed out that the jug in this painting was probably one made by Gauguin.

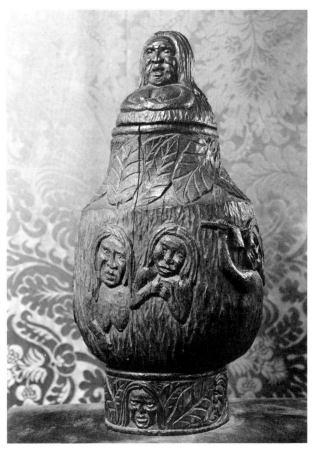

A–6 WOODEN JAR WITH COVER

H. 45 cms. Wood.
Collections: Amédée Schuffenecker; present whereabouts unknown.

Photograph: Galerie Schmit, Paris.

Notes:

On the basis of the figure on the right holding a pipe, one may surmise that this piece was intended for use as a tobacco jar. In style, it belongs to a curious group of "ugly Gauguins" that were probably executed in 1889 and passed into the Schuffenecker Collection. In this group are this jar, the base and lid of the *Fontaine* in the Louvre, and the *Standing Figure of an Old Woman* (Galerie St. Etienne, New York). The Negroid cast of the features seems to have been influenced by Gauguin's trip to Martinique, and bear a close resemblance to some of the figures in *Soyez amoureuses* and on the base of the *Fontaine* made by Gauguin (Cat. Nos. 76, 78).

A-7 RELIEF REPRESENTING TWO INDIAN BONDSWOMEN

H. 31 cms. W. 21 cms. Slate. Signed: P G O in a monogram on the lower left.

Collections: Private Collection; Mrs. Christian Rub, Santa Barbara; Dr. and Mrs. Maurice M. Rosenbaum, Long Beach, California.

Photograph: Courtesy of Dr. and Mrs. Rosenbaum.

Notes:

This is a most unusual piece, as both in subject matter and style it follows the Indian art of the Gupta period very closely. The raised seal-like signature recalls the oriental collector's stamp which was adapted to a signature by such Western artists as Whistler and Toulouse-Lautrec. The strong Indian influence might suggest a period about the time of the opening of the Musée Guimet in Paris. Any decision concerning the authenticity of the work will have to wait upon more information about the piece and its history.

A–8 STANDING FIGURE OF ŚIVA

Wood. Signed: P. Go.

Collections: Present whereabouts unknown.

Photograph: Musées Nationaux.

Notes:

This carving has little to suggest that it was done by Gauguin except the signature. However, the photograph is among a number that Vizzavona bought from Druet before 1910, and in a sense, its very atypicality argues in its favor. The work was probably executed under the influence of the oriental collections of the Musée Guimet, which was opened at the time of the *Exposition Universelle* of 1889, and must have made a profound impression on the artist.

A–9 VASE IN THE "STILL LIFE WITH FLOWERS"

Notes:

This picture in the collection of Stavros Niarchos is generally dated in 1891 (Goldwater, *Gauguin,* p. 104). Goldwater also states that the vase is one of Gauguin's own making. These two factors raise a number of difficulties. In the first place, the motif on the side of the vase appears to be a variation of the motif that appears in the manuscript of *L'Ancien Culte mahorie* (facsimile edition, Paris, 1951), p. 35. As Huyghe has pointed out (*ibid.,* p. 17 ff), Gauguin's book is based on J.-A. Moerenhout's *Voyages aux Iles du Grand Ocean.* Huyghe also dates the execution of *Ancien Culte mahorie* from the period of Gauguin's illness in the winter of 1892 (*ibid.,* p. 14). It is hard to see how this figure, which belongs to the Moerenhout-Gauguin interpretation of the Polynesian religion, could have been used before 1893.

A further and much more serious difficulty is found in the fact that Bodelsen has shown that Gauguin could not have found the means to make ceramics in Tahiti (Bodelsen, *Gauguin Ceramics in Danish Collections,* p. 18).

We are forced to the conclusion that if the pot was actually made, that it is most probable that it was made during Gauguin's return to France, and not in Tahiti. This being the case, we must date the still life also after his return. Actually, there seems to be no reason for not doing so. The flowers are not particularly tropical, the pot certainly not, and the gourd is certainly not tropical, for it was at one time in the Schuffenecker collection where it was photographed showing the words "Pont Aven" on it. Identical gourds were sold as souvenirs at the *Exposition Universelle* of 1889.

As I stated earlier, if the pot actually existed, it was most probably made in France, but there are certain reasons to question whether it actually existed. By 1893–1895 Gauguin's style in ceramics had progressed very far away from the simple conception of a pot with an appendage added as decoration. He had by that time developed an almost completely sculptural conception of pottery in which color, incised line, superficial modeling, and the form itself were so closely integrated that one can no more speak of pot and ornament as separate entities. Instead of a pot by Gauguin, it is possible that the pot represented in the painting is an ordinary pot, which, in the painting, Gauguin has enriched by a touch of the exotic.

A–10 VASE IN THE FORM OF A HEAD

Collections: Private Collection, Paris.

Notes:

I have not been able to see this vase. It is said by the owner to have belonged to Ernest Chaplet, and to have been done by Gauguin. The glaze suggests some of Chaplet's work with a rough glaze similar to the oriental orange peel glazes. On this basis, as well as certain similarities to Catalogue number 114, it may have been executed between 1893 and 1895.

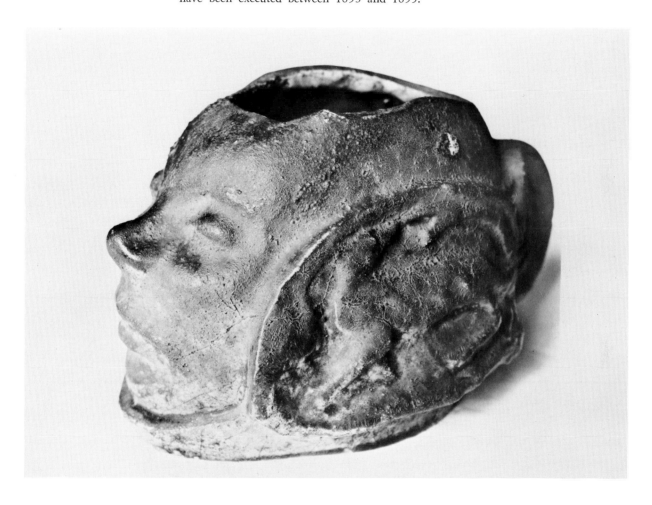

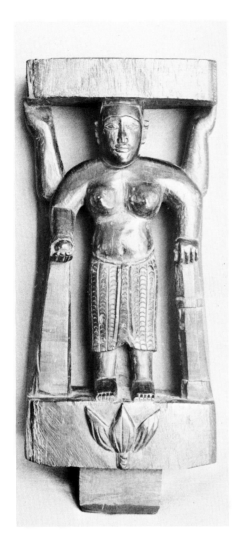

A–11 ATLANTID FIGURE

H. 38 cms. W. 17 cms. D. 8.5 cms. Pua wood ? Not polychromed. Not signed.

Collection: Marcel Brion, Paris.

Photographs by the author.

Notes:

This sculpture was bought in 1912 or 1913 in Marseilles. M. Brion believes that it was bought from a curio dealer by the name of Ansaldi. The dealer stated that he got it from a man from Tahiti who said that it came from Gauguin's house.

Though the style is ambiguous, and the documentation unspecific, this piece should be compared with Catalogue number A–8, to which it has striking similarities.

A-12 SCREEN

Three panels, each: H. 130 cms. W. 30 cms. Wood incised with a hot iron.

Collections: Private Collection, Paris.

Exhibitions: 109–*Gazette des Beaux-Arts,* Paris, 1936: "Paravent. À Mme Oliver Sainsère"; 83–Orangerie, Paris, 1949; 166–Galerie Charpentier, Paris, 1960.

Photograph: Courtesy Galerie Charpentier.

Notes:

The exhibition catalogue of the Galerie Charpentier, *Cent oeuvres de Gauguin,* edited by Maurice Malingue (Paris, 1960) states: "166–Un paravent: Comprenant trois feuilles gravées au fer; monté par Francis Jourdain." I have not been able to study the piece itself, but from the photograph it would hardly seem possible that the two side panels were executed by Gauguin. It is more difficult to be sure of the central panel, which is executed in a very different manner. It is a slight work, executed in a technique which Gauguin seldom used, the two other examples of this technique were executed in 1887 on bamboo (Cat. Nos. 47, 48) and hardly serve as an adequate basis for comparison.

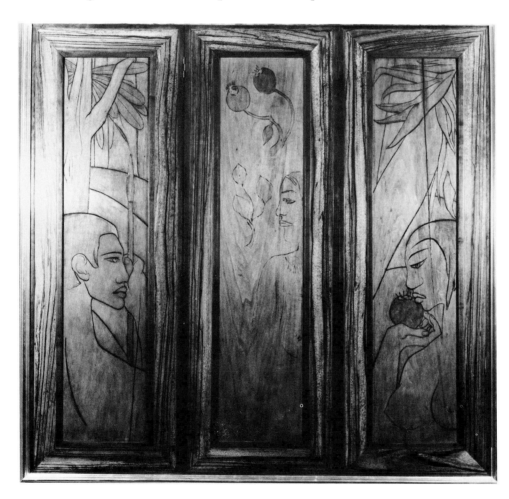

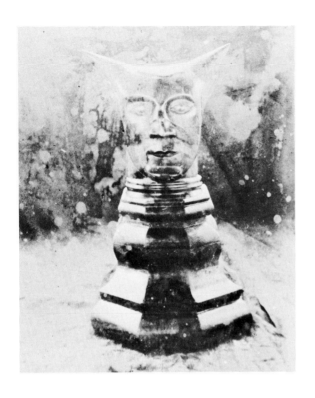

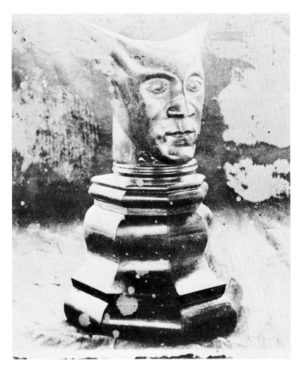

A–13 HEAD WITH HORNS

Notes:

This piece is only known from two photographs inserted in Gauguin's manuscript edition of *Noa-Noa* (p. 56). Neither the material of the sculpture, nor that it was actually executed by Gauguin can be determined with any degree of certainty. That Gauguin attached considerable importance to this head is shown by the fact, not only of the insertion of the photograph in *Noa-Noa*, but also by the fact that it appears in at least three of his works, two monotypes (Rewald, *Drawings,* pp. 120, 121) and in a woodcut (Guérin, No. 67) (A–13a). The interpretation that it is a representation of the devil cannot adequately explain the problem for a number of reasons. One is that in the wood cut this head is associated with a number of other representations of Polynesian deities. Another reason for questioning that the figure represents the traditional devil is that the horns of the devil, and to some extent the devil himself, are derived from the goat-horned god, Pan. In this example, the head and

the horns are clearly tauroid. Finally, the cast of the features is distinctly Polynesian. However, as the bull was unknown in Polynesia before the advent of the European, it is impossible that the head be a traditional symbol of a native god.

Though no exact determination of the significance of this figure appears to be possible, there are a number of suggestive clues. In the first place, the Polynesian language uses a common word for tooth, tusk, and horn—*niho*. Thus the native term for a ram is *pua'a-niho*, literally horned-pig. According to Henry, the god Nihoniho-tetei was a fierce ghoul (*Ancient Tahiti,* p. 417). Literally, this name can be translated "adorned with jutting out horns or teeth." Another clue is found in Linton's statement that the young men of the Marquesas used to put their hair up in two knots on either side of the head, and that "when the hair was dressed with two knots the center and back of the head was shaved, the tapa wrapped knots protruding like horns from the bare skull" (Linton, *The Material Culture of the Marquesas Islands* (Memoirs VIII

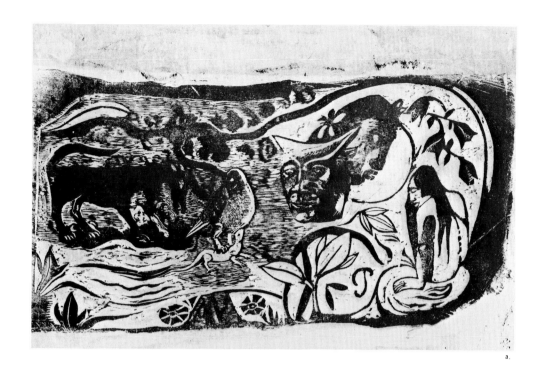

a.

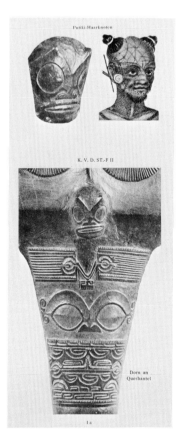

K. V. D. ST.-F II

Dorn an
Querhantel

1 a

b. Detail of a Marquesan war club. Upper right: Detail of the Putiki headdress.
From Von den Steinen, Die Marquesaner und ihre Kunst.

of the Bernice Pauhai Bishop Museum, 1923, p. 419). Finally, it should be remembered that anthropophagy was a very real memory in the minds of the natives of the Marquesas at the time that Gauguin was there. If we put all these elements together the result is that the figure seems to represent a "young man-eating warrior-god." This description perhaps best fits the god 'Oro, one of the chief patrons of the Tahitians, whose sacred animal was the pig. In the Marquesas, the name of 'Oro was Koro, while that of the bull in the Polynesian language was *pua'a-toro*. As the consonants "k" and "t" are not strongly distinguished in the Polynesian language, it may be possible that the Marquesan *puaka-toro*, their term for bull suggested to Gauguin *puaka-Koro*, that is the god 'Oro in his animal avatar.

A variant form of head on a war club is illustrated by Karl von den Steinen (Cat. No. A–13*b*) in which the presence of horns is suggested. Von den Steinen suggests that it is derived from the *putiki* style of hairdressing.

311

A–14 WOOD RELIEF ENTITLED "TA IHEA I TEINEI AO"

H. 49 cms. L. 122 cms. Oak, not polychromed. Signed: P GO.

Collection: Arthur Tooth & Son, London.

Reference: Sales catalogue, Sotheby & Co., June 26, 1955, lot 115*a*.

Photograph: Courtesy of Arthur Tooth and Son.

Notes:

According to the information I have been able to gather, this panel was part of a lot put up at auction at Sotheby's by a dealer who had acquired it from the chateau of Haut-Buc (Seine et Oise). I have been told by a French collector that the owner of the chateau was named Willoughby, an Englishman, and that he disappeared during the German invasion in 1940.

Authorities on the Polynesian language say that *ta ihea* is meaningless, while *i teinei ao* means "the present day."

The panel consists of a *collage* of Gauguin motifs:

Figure on the left: Horseman on the upper left of *The White Horse* (1901). In the Louvre.

Seated figure, lower left center: Based on the figure in the lithograph *Aux Roches noires* of the spring of 1889. This is a figure that Gauguin used many times.

Head, left center, upper margin: This head and its pose is based on the head above and to the left of that of the seated mulatto in the panel *Soyez amoureuses* of 1889 (Cat. No. 76).

Central figure: This figure appears reversed in the panel *Que sommes-nous* (Cat. No. 126).

Figure on the upper right: The pose is the same as that of the figure in the upper right medallion of Gauguin's table (see Cat. No. 131).

On the basis of the motifs it would be difficult to assume a date much earlier than 1901. However, if we try to place the style of the piece in relationship to Gauguin's other works, it becomes clearly evident that the sinuous vinelike forms and the Negroid cast of the features belong to the period of 1888–1889, a period before Gauguin's first trip to Tahiti, and in which the presence of a Polynesian inscription is completely incomprehensible (cf. Cat. Nos. 73, 76).

The weight of the evidence, motifs, style, general quality as well as the unpleasant interpretation of the Polynesian life make it difficult to accept this piece as a work by Gauguin.

312

A–15 CANE

L. 94 cms.

Collections: Amédée Schuffenecker, Paris; present whereabouts unknown.

Photograph: Musée Nationaux.

Notes:

Though this cane probably belonged to Gauguin, the nature of the carving, as it appears in the photograph, is much closer to the type of work that was being done by contemporary Polynesians than to the other works of Gauguin.

A–16 GAUGUIN'S PAINTBOX

Top 36 cms. by 46 cms. Wood.
Collections: Paul Nordmann; Ny Carlsberg Glyptothek.
Photograph by the author.
Notes:

This piece is accompanied by a letter of authentication:

Je sousigné Paul Nordmann declare que la boite de peinture en bois des Iles provient des objets ayant appartenu au peintre Paul Gauguin. Paris le 20 juin, 1948.

(signed) PAUL NORDMANN, *19 rue Mechen.*

In spite of the reference to the *"bois des Iles"* the box is almost certainly of French manufacture, and was probably brought by Gauguin from France. The designs, which resemble those found in Marquesan tattooing and tapa work, are created almost entirely with a remarkable uniform incised line. This lack of freedom in execution is unique in Gauguin's work, but is typical of the native workman. Possibly the piece may have been decorated by a native craftsman in the Marquesas. In the sale of Gauguin's effects at Papeete, item number 86, *"Une Boite à peinture,"* was sold to M. Courtet for 15 francs (Wildenstein, *Gauguin,* p. 207). The relatively high price for which this piece was sold indicates that it must have other value than that of a simple paintbox, and was probably ornamented. Possibly it was the painter's box which ultimately found its way to Copenhagen.

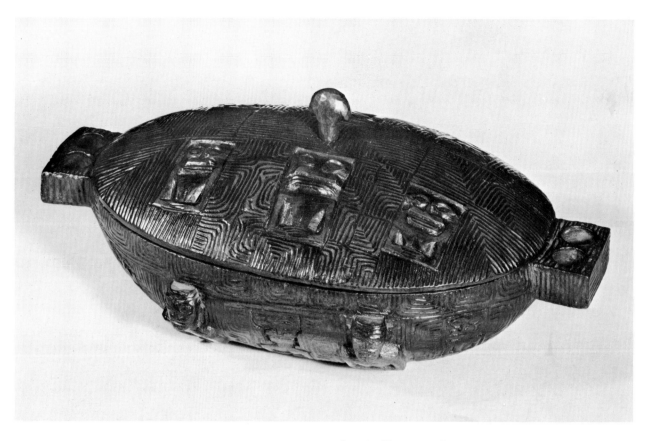

A–17 WOODEN CUP WITH COVER

L. 31 cms. W. 15.5 cms. H. (with cover) 13.8 cms.
Miro wood?

Collections: Edward Petit; Private Collection, Paris.

Photographs: Brame and Co. and the author.

Notes:

According to M. Brame, the owner says that Petit
bought the bowl from Gauguin in Tahiti as one of
his works. Petit was governor of Tahiti from 1901
to 1904.

In the inventory of Gauguin's effects made after his
death is listed:

> No. 54 1 Lot curiosités indegènes comprenant:
> une soupière sculptée, un coco, deux
> couvercules de calebasse, un tiki doré,
> deux tikis en pierre, neuf cuillères
> sculptées.

In the sale of Gauguin's effects in Papeete, no
soupière is mentioned, but item 38 was *"un plat
marquisien,"* which was bought by Petit for 15 francs

(see Wildenstein, *Gauguin, sa vie, son oeuvre,* pp.
203, 207).

The covered bowl was probably in Gauguin's posses-
sion when he painted *The Still Life with Puvis de
Chavanne's 'Hope'* (private collection, Chicago) which
is dated 1901, for the bowl shown in the picture has
the characteristics of this one.

Now the first problem is whether Petit actually
bought this piece from Gauguin before his departure
in 1901 for the Marquesas, or is it the *"plat marqui-
sien"* which Petit bought in 1903 at the sale of Gau-
guin's effects. A second question, which depends in
part on the first, is whether it is actually a work by
Gauguin, or is it a native Marquesan work. Bodelsen
has already pointed out the similarity of the bowl in
the painting to a Marquesan bowl (Bodelsen, "Gau-
guin and the Marquesan God," *Gazette des Beaux-
Arts,* March, 1961, pp. 172–73). Now that the bowl
itself is known, its similarity is far more striking.
Close inspection shows that this cup is not of the
finest workmanship by native standards, and that it
was made with modern tools. Gauguin certainly had
the competence and knowledge of native work neces-
sary to make such a cup, but it is difficult to believe
that he would have adhered so slavishly to traditional
prototypes.

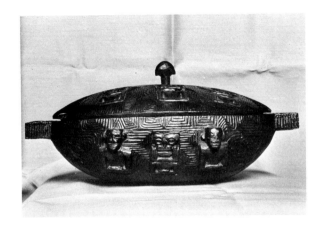

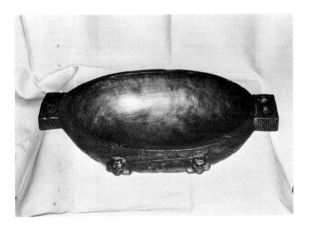

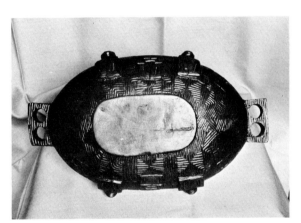

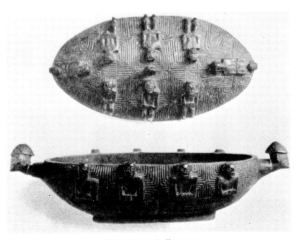

a. Native bowl from the Marquesas.
From Von den Steinen, Die Marquesaner und ihre Kunst.

315

A–18 TWO IDOLS

Collections: Present location unknown.

Reference: Zolotoe Runo, I:i (1909), pp. 5–14(ill.).

Photograph: Musées Nationaux.

Notes:

In *Zolotoe Runo* these two works are attributed to Gauguin. They are illustrated in the Vizzavona photograph together with other material by Gauguin which was in the Schuffenecker Collection. The general type of the figures is more suggestive of Africa than Oceania, but it has not been possible to identify an exact origin. The forms and carving of both are weak in some respects. If they belonged to Gauguin, it is more probable that he acquired them rather than made them himself, but in either case they indicate that Gauguin may have been one of the first to appreciate Negro sculpture.

A–19 STANDING FIGURE WITH EGYPTIAN HEAD

H. 109 cms. Tamanu wood? Not signed.

Collections: André V. Simeon, Altadena.

Exhibitions: Exhibition of Primitive Art, Long Beach Museum of Art, October 4, 1959–January 31, 1960, illustrated in catalogue: "Sculpture by Gauguin"; *Contrasts in Sculpture,* Origins of Art Research Foundation, Altadena, California, January 14, 1962: "Sculpture by Paul Gauguin."

Photographs: Courtesy of the Origins of Art Research Foundation.

Notes:

According to André Simeon, he bought the sculpture in Atuona from the descendent of one of Gauguin's native mistresses shortly after 1918. Mr. Simeon also states that he has seen in Tahiti a photograph of the sculpture with both Paul Gauguin and the Pastor Vernier. He also states that the piece is vouched for by Dr. Louis Rollin.

Except for the carved panels in Gauguin's house in Atuona, which are described by Victor Segalen, and *Père Paillard* and *Thérèse,* which are described by Gauguin in *Avant et Après,* the sculpture executed by Gauguin in the Marquesas is exceedingly difficult to document. Not only is the documentation difficult, but the existence of a number of unusual pieces (see Cat. Nos. 131, 140) dating from Gauguin's second stay in the South seas, makes any stylistic analysis hazardous without better information. At best, one can say that the present sculpture is atypical in terms of Gauguin's total work, even though his use of Egyptian models in his work is well known. Any final decision on this figure must wait upon the recovery of an adequate documentation.

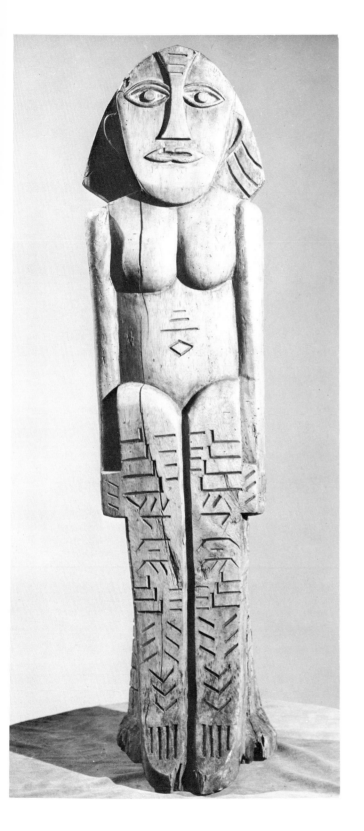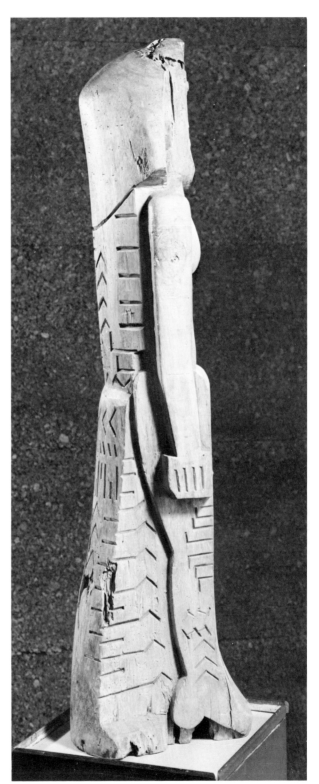

A-20 THE SWANS

L. 33 cms. H. 20 cms. Oak wood polychromed. Apparently not signed. Decorated with three swans on a body of water with foliage at the top of the panel. The swans are red. The water is blue-green. The foliage is green.

Collections: Ernest de Chamaillard; Marcel Heskia, Paris.

Exhibitions: Gauguin et ses amis, Vienna, November, 1949.

Photograph: Courtesy of Marcel Heskia.

Notes:
 On the back of the photograph appears the notation:

Je sousigné declare . . . petit panneaus 33 cms de large sur 20 cm de haut, qui représent trois cygnes se debattant dans des vagues (cygnes rouges, fond bleu vert, foliage vert. Les cygnes sont les mêmes que ceux de Pont Aven, où des garconnets jouent dans l'eau de la rivière.
 Cette oeuvre fut executée par P. Gauguin, au Pouldu en 1890. Donnée par Gauguin au peintre Chamaillard.
 (Les Amis de Gauguin).
Exposition—Gauguin et ses Amis—Novembre 1949, Wienne Autriche, organisée sous le haut patronnage du Général Bethouard.
Au dos, un essai de peinture par P. Gauguin.
 (signed) MARCEL HESKIA
I have not seen the piece, but its style conforms to that of *Les Ondines* (Cat. No. 75) and that of *Christ and the Woman of Samaria* (Cat. No. 59), both of which date from about the period in which M. Heskia believes the work to have been done.

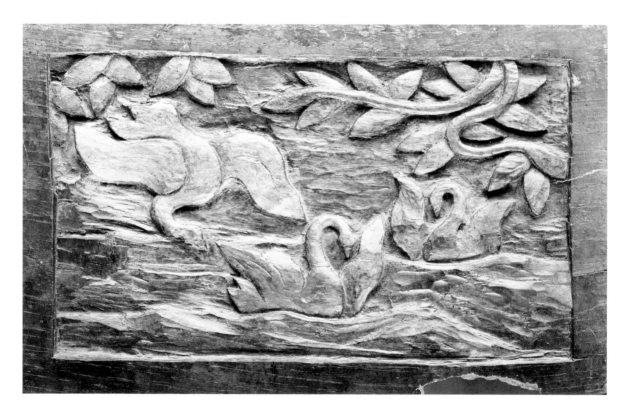

BIBLIOGRAPHY

EXHIBITION CATALOGUES

Société anonyme des artistes peintres, sculpteurs, graveurs, etc. (Impressionists). *5ᵉ exposition de peinture.* Rue des Pyramides, Paris, 1880.

—. *6ᵉ exposition de peinture.* 35, Boulevard des Capucines, Paris, 1881.

7ᵉ exposition des artistes indépendants. Salon du Panorama de Reichshoffen, Paris, 1882.

8ᵉ exposition des artistes indépendants. 1, Rue Laffitte, Paris, 1886.

Exposition. Les XX. Brussels, 1891.

Salon de la Société Nationale. Paris, 1891.

Exposition d'oeuvres recentes de Paul Gauguin. Galeries Durand-Ruel. Paris, 1893. Introduction by Charles Morice.

La Libre esthétique, Brussels, 1896.

Exposition internationale de 1900 à Paris. Catalogue général officiel: Oeuvres d'art français. Paris, Lille, 1900.

Exposition de la Société des Beaux-Arts. Salle Berlioz. Béziers, 1901. Preface by M. Fabre.

Salon d'Automne, 4ᵐᵉ Exposition. Paris, 1906. Introduction by Charles Morice. (Gauguin Retrospective.)

Spring Exhibition: Works of Gauguin, Cézanne, etc. National Gallery. Budapest, May, 1907.

Exposition Paul Gauguin. Galerie Nunes et Fiquet. Paris, 1917. Introduction by Louis Vauxcelles.

Paul Gauguin; exposition d'oeuvres inconnues. Galerie Barbazanges. Paris, 1919. Introduction by Francis Norgelet.

Exposition retrospective de P. Gauguin. Galerie L. Dru. Paris, 1923. Introduction by Georges Daniel de Monfreid.

Gauguin Exhibition. Leicester Gallery. London, 1924.

Gauguin Ausstellung. Kunsthalle. Basel, 1928. Introduction by W. Barth.

P. Gauguin, sculpteur et graveur. Musée du Luxembourg. Paris, 1927. Catalogue by Charles Masson and Marcel Guérin.

Paul Gauguin. Galerien Thannhauser. Berlin, 1928. Preface by W. Barth.

La Vie ardente de Paul Gauguin. Galerie Wildenstein —Gazette des Beaux-Arts. Paris, 1936. Biographical text and catalogue by Raymond Cogniat. Introduction by Henri Focillon.

Georges-Daniel de Monfreid et son ami Paul Gauguin. Galerie Charpentier. Paris, 1938. Introduction by Maurice Denis.

Gauguin. Wildenstein Galleries. New York, 1946. Introduction by Raymond Cogniat.

Paul Gauguin. Ny Carlsberg Glyptothek. Copenhagen, 1948. Catalogue by Haavard Rostrup.

Gauguin, exposition du centenaire. Orangerie des Tuileries. Paris, 1949. Introduction by René Huyghe. Catalogue by Jean Leymarie.

Gauguin et ses amis. Galerie Kléber. Paris, 1949. Introduction and catalogue by Maurice Malingue.

Ausstellung Paul Gauguin. Kunstmuseum. Basel, 1949–1950. Catalogue by Georg Schmidt.

Gauguin et le groupe de Pont Aven. Musée des Beaux-Arts. Quimper, 1950. Introduction by René Huyghe. Catalogue by Gilberte Martin-Mery.

Gauguin et ses amis. Galerie André Weil. Paris, 1951.

Les Amities de peintre Georges-Daniel de Monfreid, de Maillol et Codet à Segalen, et ses reliques de Gauguin. Galerie Jean Loize. Paris, 1951. Text by Jean Loize.

Cinquantenaire de Paul Gauguin. Pont Aven, 1953.

Paul Gauguin. Tate Gallery. London, 1955. Introduction and notes by Douglas Cooper.

Paul Gauguin. Kunstnerforbundet. Oslo, 1955. Introduction by Sigurd Willoch.

Gauguin. Wildenstein Galleries. New York, 1956. Forewords by Robert Goldwater and C. O. Schniewind.

Gauguin og Hans Venner. Winkel & Magnussen. Copenhagen, June–July, 1956.

Gauguin. The Art Institute of Chicago and the Metropolitan Museum of Art. New York, 1959. Foreword by James J. Rorimer and Allan McNab. Introduction by Theodore Rousseau, Jr.

Cent oeuvres de Gauguin. Galerie Charpentier. Paris, 1960. Introduction by Raymond Nacenta. Preface by Jean Leymarie. Catalogue by Maurice Malingue.

Second Annual Exhibition of Modern and Old Masters. Finch College Art Gallery. New York, March–April, 1961.

Gauguin et ses amis. Pont Aven, August–September, 1961.

GAUGUIN MANUSCRIPTS AND NOTEBOOKS

Gauguin, Paul. *Album Gauguin (Briant).* (MS) Cabinet des Dessins, Louvre.

———. *Diverses choses.* (MS) Cabinet des Dessins, Louvre.

———. *Carnet de Paul Gauguin.* Edited by René Huyghe, Paris, 1952.

———. *Carnet de Paul Gauguin: Tahiti.* Edited by Bernard Dorival. Paris, 1954.

———. *Ancien Culte mahorie.* Edited by Pierre Berès. Paris, 1951.

———. *Noa-Noa.* Facsimile edition. Stockholm, 1947.

———. *Cahier pour Aline.* (MS) Bibliothèque d'Art et Archéologie, Paris.

———. *Sketchbook.* Cabinet des Dessins, Louvre, RF 30 564 fol.

———. *Avant et Après.* [1903] facsimile edition. Copenhagen, [ca.] 1948.

———. *Notebook.* National Gallery. Stockholm. Inv. No. 22/1936.

Schuffenecker Album. Cabinet des Dessins, Louvre, RF 28 8—.

GAUGUIN: LETTERS

Gauguin, Paul. *Lettres de Gauguin, à sa femme et à ses amis.* Edited by M. Malingue. Paris, 1946.

———. *Lettres de Gauguin à Daniel de Monfreid.* Precédées par Victor Segalen. Edition établie et annotée par Mme Joly-Segalen. Paris, 1950.

———. *Gauguin Letters to Ambroise Vollard and André Fontainas.* Edited by John Rewald. Translated by G. Mack. San Francisco, 1943.

———. *Lettres de Paul Gauguin à Émile Bernard, 1881–1891.* Edited by M.A. Bernard-Fort. Geneva, 1954.

ARTICLES AND PAMPHLETS BY GAUGUIN

Gauguin, Paul. "Les Guêpes," *Papeete,* 1899–1900.

———. "Notes sur l'art à la Exposition Universelle," *Le Moderniste.* June 4 and 13, 1889, pp. 84, 86, 90, 91.

———. "Qui trompe-t-on ici," *Le Moderniste,* September 21, 1889, pp. 170, 171.

———. *Racontars de rapin.* Paris, 1951.

———. *Le Sourire.* Facsimile edition of nine issues. Introduction and notes by L. J. Bouge. Paris, 1952.

BOOKS

Alexandre, Arsène. *Paul Gauguin: sa vie et le sens de son oeuvre.* Paris, 1930.

———. *Jean Carriès, imagier et potier.* Paris, 1895.

Andrews, Edmund M. D., and Andrews, Irene D. *A Comparative Dictionary of the Tahitian Language.* Chicago, 1944.

Bacou, Roseline. *Odilon Redon.* 2 vols. Geneva, 1956.

Baudelaire, Charles. *Oeuvres complètes.* Edited by J. Crépet. Paris, 1925.

Bernard, Émile. *Souvenirs inédits sur l'artiste-peintre Paul Gauguin.* Introduction by René Maurice. Lorient, n.d. [1939].

———. *Lettres à Émile Bernard.* Brussels, 1942.

Blacker, J. F. *The A.B.C. of English Salt-Glaze Stoneware.* London, 1922.

Bodelsen, Merete. *Willumsene, i Halvfemsernes Paris.* Copenhagen, 1957.

———. *Gauguin Ceramics in Danish Collections.* Copenhagen, 1960.

Bouge, L. J. "Traduction et interpretation des titres en langue tahitienne inscrits sur les oeuvres océanienne de Paul Gauguin," *Paul Gauguin, sa vie, son oeuvre.* Edited by Georges Wildenstein. Paris, 1958.

Bracquemond, Félix. *Du Dessin et de la couleur.* Paris, 1885.

Brassey, Lady. *Tahiti.* London, 1882.

Brongniart, Alexandre. *Traité des arts céramiques ou des poteries.* 3rd edition. Paris, 1877.

Burnett, Robert. *The Life of Paul Gauguin.* New York, 1937.

Carlyle, Thomas. *Sartor Resartus.* Everyman edition. London and New York, 1908.

Chassé, Charles. *Le Mouvement symboliste dans l'art du XIXᵉ siècle.* Paris, 1947.

———. *Gauguin et son temps.* Paris, 1955.

———. *Gauguin et le groupe de Pont-Aven.* Paris, 1921.

Cogniat, Raymond. *Gauguin.* Paris, 1947.

Cook, Captain James. *A Voyage to the Pacific Ocean.* 3rd edition. 3 vols. London, 1785.

Cox, Warren E. *The Book of Pottery and Porcelain.* New York, 1944.

Danielson, Bengt. *Love in the South Seas.* New York, 1956.

Debidour, Victor Henry. *La Sculpture bretonne.* Rennes, 1953.

Deck, Théodore. *La Faïence.* Paris, 1887.

Demmin, Auguste. *Guide de l'amateur de faïence & porcelaines, poteries, terres cuites, peinture sur lave et emaux.* Paris, 1863.

————. *Histoire de la céramique.* Paris, 1875.

Denis, Maurice. *Théories.* Paris, 1920.

————. *Nouvelles théories.* Paris, 1921.

Dordillon, Monsignor René Ildefonse. *Grammaire et dictionnaire de la langue des Iles Marquises.* Paris, 1931.

Dovski, Lee van. *Paul Gauguin oder die Flucht von der Zivilisation.* Bern, 1948.

Dupuis, Charles. *L'Origin de tous les cultes, ou la religion universelle.* Paris, 1794.

Exposition universelle de 1889 à Paris. Catalogue général, officiel: Histoire retrospectif du travail et des sciences anthropologique. Lille, 1889.

Fauconnet, André. *L'Esthétique de Schopenhauer.* Paris, 1913.

Fénéon, Felix. *Oeuvres.* Paris, 1948.

Field, Richard. "Gauguin plagiaire ou créateur," in René Huyghe *et al., Gauguin.* Paris, 1960.

Flaubert, Gustave. *Salammbô.* Paris, 1863.

Frazer, Sir James. *The Golden Bough.* New York, 1958.

Gasset, José Ortega y. *The Dehumanization of Art.* New York, 1956.

Gauguin, Pola. *My Father, Paul Gauguin.* New York, 1937.

————. *Mette og Paul Gauguin.* Copenhagen, 1956.

Gauss, C. E. *The Aesthetic Theories of French Artists, 1855 to the Present.* Baltimore, 1949.

Girieud, P. *Paul Gauguin: Album d'Art Druet.* Paris, 1928.

Goldwater, Robert J. *Primitivism in Modern Painting.* New York and London, 1938.

————. *Paul Gauguin.* New York, 1958.

Graber, Hans. *Paul Gauguin.* Basel, 1946.

Guérin, Marcel. *L'Oeuvre gravé de Gauguin.* Paris, 1927.

Guillot, François. *Souvenirs d'un colonial en Océanie.* Annency, 1935.

Hamon, Renée. *Gauguin, le solitaire du Pacifique.* Paris, 1939.

Hamy, D. E. T. *Les Origines du Musée d'Ethnographie, histoire et documents.* Paris, 1890.

Handy, E. S. C. *Polynesian Religion.* Bulletin XXXIV, Bernice Pauahi Bishop Museum, Honolulu, 1927.

————. *Marquesan Legends.* Bulletin LXIX, Bernice Pauahi Bishop Museum. Honolulu, 1930.

Hawksworth, John. *An Account of the Voyages Undertaken by the Order of His Present Majesty for Making Discoveries in the Southern Hemisphere.* 3 vols. London, 1773.

Hearn, Lafcadio. *Two Years in French West Indies.* New York, 1923.

Hegel, G. W. F. *The Introduction to Hegel's Philosophy of Fine Art.* Translated by Bernard Bosenquet. London, 1905.

Henry, Teuira. *Ancient Tahiti.* Bulletin XLVIII, Bernice Pauahi Bishop Museum. Honolulu, 1928.

Hetherington, A. L. *Chinese Ceramic Glazes.* South Pasadena, 1948.

Humbert, Agnes. *Les Nabis et leur époque.* Geneva, 1954.

Huyghe, R. (ed.). *Le Carnet de Paul Gauguin.* Paris, 1952.

Huysmans, J. K. *L'Art moderne.* New edition. Paris, 1908. [1st ed., 1903.]

Jaussen, Monsignor Tépano. *L'Ile de Paques.* Posthumous work edited by R. P. Ildefonse Alzard. Paris, 1893.

Jénot. "Le Premier sejour de Gauguin à Tahiti," *Gauguin, sa vie, son oeuvre.* Edited by Georges Wildenstein. Paris, 1958.

Kinsbergen, J. van. *Oudhen van Java op last der Ned-Indische Regering, onder toezigt van het Bataviaasch Genootschap van Kunsten en Wetenschappen gephotographeered door J. van Kinsbergen.* 's Gravenhage, 1852–1856.

Knight, Richard Payne. *The Symbolical Nature of Ancient Art and Mythology.* London, 1818.

Kunstler, Charles. *Gauguin, peintre maudit.* Paris, 1937.

Langer, S. K. *Philosophy in a New Key.* New York: Mentor Books, 1948.

Lanson, Gustave. *Histoire illustreé de la littérature française.* Paris, 1923.

Lanteri, Edward. *Modelling: A Guide for Teachers and Students.* London, 1904.

LeBronnec, G. "Les Dernières années," *Gauguin, sa vie, son oeuvre.* Edited by Georges Wildenstein. Paris, 1958.

LeChartier, Henri. *Tahiti et les colonies française de la Polynesie.* Paris, 1887.

Leenhardt, M. *Folk Art of Oceania.* Paris, 1950.

Lehmann, A. G. *The Symbolist Aesthetic in France, 1885–1895.* Oxford, 1950.

Leymarie, Jean. *Paul Gauguin.* Basel, 1960.

Linton, Ralph. *The Material Culture of the Marquesas Islands.* Memoirs, Bernice Pauahi Museum, VIII. Honolulu, 1923.

————. *Archaeology of the Marquesas Islands.* Bulletin XXIII, Bernice Pauahi Bishop Museum. Honolulu, 1925.

Linton, Ralph, and Wingert, P. S. *Art of the South Seas.* In collaboration with René d'Harnoncourt. New York, 1946.

Loize, Jean. *Gauguin écrivain, ou les sept visages de "Noa Noa."* Paris, 1949.

——. "Gauguin sauve du feu," *Gauguin, sa vie, son oeuvre.* Edited by Georges Wildenstein. Paris, 1958.

Madsen, S. T. *Sources of Art Nouveau.* New York, 1955.

Malingue, Maurice. *Gauguin.* Monaco, 1943.

——. *Gauguin, le peintre et son oeuvre.* Paris, 1948.

Mallarmé, Stéphane. *Oeuvres complètes.* Paris, 1945.

——. *Propos sur la poesie.* Edited by Henri Mondor. Monaco, 1946.

Marks-Vandenbroucke, U. F. "Gauguin, ses origines et sa formation artistique," *Gauguin, sa vie, son oeuvre.* Edited by Georges Wildenstein. Paris, 1958.

Mativet, M. (Monchoisy). *La Nouvelle cythère.* Paris, 1888.

Mauclair, Camille. *Mallarmé chez lui.* Paris, 1935.

Meier-Graefe, J. *Entwicklungsgeschichte der Modernen Kunst.* Stuttgart, 1904.

Mellville, Herman. *Omoo, a Narrative of Adventure in the South Seas.* London, 1922.

Moerenhout, J. A. *Voyages aux iles du Grand Océan.* Paris, 1837.

Morice, Charles. *Paul Gauguin.* Paris, 1919.

Nocq, Henry. *Tendences nouvelles.* Paris, 1896.

O'Brien, Frederick. *Mystic Isles of the South Seas.* New York, 1921.

Olcott, H. S. *Le Bouddhisme.* Paris, 1883.

Oldman Collection of Polynesian Artifacts, The. Memoir XV, The Polynesian Society, New Zealand, 1943.

Parsons, E. C. *Folklore of the Antilles.* Memoirs of the American Folklore Society, XXVI. 1933.

Picquenot, F. V. *Géographie physique et politique des établissements française de l'Océanie.* Paris, 1900.

Pissarro, Camille. *Lettres à son fils Lucien.* Edited by John Rewald. Paris, 1950.

Pleyte, C. M. *Die Buddhalegende in den Skulpturen des Tempels von Boro-Budur.* Amsterdam, 1901.

Portal, Frederick. *Des Couleurs symboliques.* New edition. Paris, 1957.

Posse, Hans. *Lucas Cranach d. Ä.* Vienna, 1942.

Puech, Jules L. *La Vie et l'oeuvre de Flora Tristan.* Paris, 1925.

Puig, René. *Paul Gauguin, G. D. de Monfreid, et leurs amis.* Perpignan, 1958.

Radiquet, Max. *Les Derniers sauvages.* Paris, 1929.

Rewald, John. *History of Impressionism.* New York, 1946.

——. *Paul Gauguin.* New York, 1954.

——. *Post-impressionism: From Van Gogh to Gauguin.* New York, 1956.

——. *Degas Sculpture.* New York, 1956.

——. *Gauguin Drawings.* New York, 1958.

Rey, Robert. *Gauguin.* Paris, 1923.

——. *La Renaissance du sentiment classique.* Paris, 1931.

Ribot, Th. *La Philosophie de Schopenhauer.* 4th edition. Paris, 1890.

Roberts, W. A. *The French in the West Indies.* New York, 1942.

Rookmaaker, H. R. *Synthetist Art Theories: Genesis and Nature of the Ideas on Art of Gauguin and His Circle.* Amsterdam, 1959.

Rostrup, Haavard. *Franske Billedhuggere frå det 19 og 20 Aarhundrede.* Copenhagen, 1938.

——. "Gauguin et le Danemark," *Gauguin, sa vie, son oeuvre.* Edited by Georges Wildenstein. Paris, 1958.

Rotonchamp, Jean de. *Paul Gauguin: 1848–1903.* Paris, 1925.

Scott, Temple (J. H. Isaacs). *A Bibliography of the Works of W. Morris.* London, 1897.

Sebillot, P. *Traditions de la Haute Bretagne. Les Littératures populaires.* Tome IX, Part 1. Paris, 1882.

Segalen, Victor. *Les Immemoriaux.* Paris, 1956.

Seger, Herman August. *Collected Writings.* Edited by Albert V. Bleininger, B.Sc. Easton, Pennsylvania, 1902.

Seroff, V. I. *Debussy, Musician of France.* New York, 1956.

Serusier, Paul. *A B C de la peinture.* Paris, 1950.

Steinen, Karl von den. *Die Marquesaner und ihre Kunst.* 3 vols. Berlin, 1925.

Thiron, Yvonne. "L'Influence de l'estampe japonaise dans l'oeuvre de Gauguin," *Gauguin, sa vie, son oeuvre.* Edited by Georges Wildenstein. Paris, 1958.

Tollner, M. R. *Netsuke.* San Francisco, 1954.

Van Gogh, Vincent. *Lettres de Vincent van Gogh à son frère Théo.* Paris, 1930.

——. *Verzamelde Brieven van Vincent van Gogh.* Amsterdam, Antwerp, 1955.

Vauxcelles, Louis. "Tradition italianisante et tradition française," *Histoire générale de l'art française de la Revolution à nos jours.* 3 vols. Paris, 1922. Tome II, chap. VII.

Vidlenc, Georges. *William Morris, son oeuvre et son influence.* Caen, 1914.

Vinson, Julien. *Les Religions actuelles.* Paris, 1888.

Vollard, A. *Souvenirs d'un marchand de tableaux.* Paris, 1948.

Walton, William. *Chefs d'oeuvre de l'Exposition universelle de Paris, 1889.* Paris and Philadelphia, 1889.

Wildenstein, Georges. "Gauguin en Bretagne," *Gauguin, sa vie, son oeuvre.* Edited by Georges Wildenstein. Paris, 1958.

————. "Documents inédits ou peu connus," *Gauguin, sa vie, son oeuvre.* Edited by Georges Wildenstein. Paris, 1958.

————. "L'Idéologie et l'esthétique dans deux tableaux-clés de Gauguin," *Gauguin, sa vie, son oeuvre.* Edited by Georges Wildenstein. Paris, 1958.

Wilson, William. *The Missionary Voyage to the South Pacific Ocean by Captain James Wilson.* London, 1799.

Wyatt, M. Digby. *Industrial Arts of the Nineteenth Century at the Great Exhibitions of MDCCCLI.* London, 1853.

Wyzewska, Isabelle. *La Revue wagnerienne, essai sur l'interpretation esthétique de Wagner en France.* Paris, 1934.

PERIODICALS

Anonymous. Review of *Perigrinations of a Pariah* by Flora Tristan. Foreign Quarterly Review, XXI April–July, 1838), 150–88.

Artistic Japan. Edited by S. Bing. Vols. III (1888); XXIV (1890).

Aurier, Albert. "Le Symbolisme en peinture," *Mercure de France,* March, 1891, pp. 155–65.

————. "Les Symbolistes," *Revue encyclopédique,* April, 1892. Reprinted in Aurier, *Oeuvres posthumes,* Paris, 1893.

Barth, Wilhelm. "Eine unbekannte Plastik von Gauguin," *Das Kunstblatt,* June, 1929, pp. 182–83.

Berryer, Anne Marie. "À propos d'un vase de Chaplet," *Bulletin des Musées Royaux d'Art et d'Histoire,* January–April, 1944, pp. 13–27.

Bodelsen, Merete. "Gauguin and the Marquesan God," *Gazette des Beaux-Arts,* March 1961, pp. 167–80.

————. "An Unpublished Letter by Théo Van Gogh," *Burlington Magazine,* XCIX (June, 1957), 199–202.

————. "The Missing Link in Gauguin's Cloisonism," *Gazette des Beaux-Arts,* LIII (May–June, 1959), 329–44.

————. "Gauguin's Bathing Girl," *Burlington Magazine,* CI:dclxxiv (May, 1959), 186–90.

————. "Gauguin's Cézannes," *Burlington Magazine,* CIV (May, 1962), 204–11.

Boudot-iamotte, M. "Le Peintre et collectionneur Claude-Émile Schuffenecker," *L'Amour de l'Art,* October, 1936, p. 284.

Castets, H. "Gauguin," *Revue universelle,* III:xcvi (October 15, 1903), 536(ill.).

Chassé, Charles. "De Quand date le synthétisme de Gauguin?" *L'Amour de l'Art,* April, 1938, p. 127.

Chastel, André. "Gauguin: erotisme et féerie," *Médicine de France,* VII:mcmil, pp. 41–8.

Daragnès, Jean Gabriel. "Les Bois gravés de Paul Gauguin," *Arts graphiques,* XLIX (1935), 35–42.

Dorival, Bernard. "The Sources of the Art of Gauguin from Java, Egypt and Ancient Greece," *Burlington Magazine,* XCIII (April, 1951), 118–22.

Dorra, Henri. "The First Eves in Gauguin's Eden," *Gazette des Beaux-Arts,* XLI (March, 1953), 189–202.

————. "Émile Bernard et Paul Gauguin," *Gazette des Beaux-Arts,* XLV (December, 1955), 227–46.

Fénéon, Félix. "Calendrier décembre," *La Revue indépendente,* VI:15 (January, 1888), 170.

Florisoone, Michel. "Gauguin et Victor Segalen," *L'Amour de l'Art,* December, 1938, pp. 385 ff.

Garnier, Eduard. "La Céramique et la verrierie modernes," *Gazette des Beaux-Arts,* XXXI (January, 1885), 26–38.

"Gauguin Settee Sells at Auction for $375," *The Art Digest,* December 1, 1929, p. 13.

Goulinat, J. G. "Les Collections Gustave Fayet," *L'Amour de l'Art,* 1925, pp. 131–42.

Jacquier, H. "Le Dossier de la succession, Paul Gauguin," *Bulletin de la Société des Études océaniennes,* X (September, 1957), 685–706.

Jamot, Paul. "Le Salon d'Automne de 1906," *Gazette des Beaux-Arts,* December, 1906, pp. 465–71.

Joly-Segalen, Annie. "Paul Gauguin and Victor Segalen," *Magazine of Art,* December, 1952, pp. 370–74.

Lassen, Erik. "Nyere Dansk Keramisk Kunst," *Keramik* (Copenhagen, 1956), p. 356. (Courtesy of Merete Bodelsen.)

Leblond, Marius-Ary. "Gauguin en Océanie," *Revue universelle,* III:xcvi (July, 1903), 536, 537.

Leonard, H. S. "An Unpublished Manuscript by Paul Gauguin," *Bulletin of the City Art Museum of St. Louis,* XXXIV:iii (Summer, 1949), 41–8.

Lethève, Jacques. "La Connaissance des peintres préraphaelites anglais en France," *Gazette des Beaux-Arts,* May–June, 1959.

Lindberg-Hanson, Jacob. "Discovering Paul Gauguin, the Woodcarver," *College Art Journal,* XII:ii (Winter, 1953), 117–20.

Loize, Jean. "Un inédit de Gauguin," *Les Nouvelles littéraires,* May 7, 1953, p. 1.

Lostalot, Alfred de. "Les Artistes contemporains— M. Félix Bracquemond," *Gazette des Beaux-Arts,* August, 1884, pp. 155–61.

Malingue, Maurice. "Du nouveau sur Gauguin," *L'Oeil,* IV/IVI (July–August, 1959), 32–39.

Marx, Roger. "Souvenirs sur Ernest Chaplet," *Art et Décoration,* March, 1910, pp. 89–98.

———. "Les Arts décoratifs et industriels aux salons du Palais de L'Industrie et du Champ-de-Mars," *Revue encyclopédique,* September 15, 1891, pp. 584–89.

Mellor, J. W. "The Chemistry of Chinese Copper-Red Glazes," *Transactions of the Ceramic Society,* XXXV (1935–1936), 364–78.

Monkhouse, Cosmo. "Some Original Ceramists," *Magazine of Art,* V (1882), 443–50.

———. "Elton Ware," *Magazine of Art,* VI (1882), 228–33.

Morice, Charles. "Paul Gauguin," *Mercure de France,* December, 1893, pp. 289–300.

———. "Quelques opinions sur Paul Gauguin," *Mercure de France,* November, 1903, pp. 413–33. (Includes statements by Carrière, Dolent, Durrio, Geffroy, La Rochefoucauld, Luce, R. Marx, Redon, Regnier, Roy, Seguin, and Signac.)

New York Times. March 17, 1960. (Article entitled "$15 Gauguin Art Put Up at $50,000.")

Piotrowski, A. "Deux tablettes avec les marques gravées de l'île de Pâques," *Revue d'ethnographie et des traditions populaires,* VI (1925), 425.

Read, Sir Herbert E. "Gauguin: Return to Symbolism," *Art News Annual,* 1956, pp. 122–58.

Record, S. J. "Some Trade Names of Woods," *Tropical Woods,* Vol. III, September, 1925.

Rewald, John. "The Genius and the Dealer," *Art News,* May, 1959, pp. 30 ff.

Rey, Robert. "Les Bois sculptés de Paul Gauguin," *Art et Décoration,* LIII (February, 1928), 57–63.

———. "Dernier décor de la demeure de Gauguin aux iles Marquises," *La Revue des Arts,* II (June, 1953), 115–21.

———. "L'Exposition Gauguin au Musée Luxembourg," *Gazette des Beaux-Arts,* Vol. CXII, February 15, 1928.

Ribault-Menetière, Jean. "Sur deux lettres de Gauguin," *L'Arts,* January 11, 1946.

———. "Une Lettre inédite de Paul Gauguin," *L'Arts,* March 28, 1947.

———. "Une Lettre inédite de Paul Gauguin à Charles Morice," *L'Arts,* September 27, 1946.

Rollin, Louis. "Un Lépreux de Gauguin," *Arts,* November 13, 1936.

Salmon, André. "Chamaillard et le group de Pont Aven," *L'Art Vivant,* July 1, 1925, pp. 15, 16.

Schniewind, C. O. "Paul Gauguin," *Bulletin, Art Institute of Chicago,* XLIII (September 15, 1949), 44–50.

Segalen, Victor. "Gauguin dans son dernier décor," *Mercure de France,* June, 1904, pp. 679–85.

Seguin, Armand. "Paul Gauguin," *L'Occident,* January–June, 1903, pp. 158–67, 230–39, 298–305.

Sizeranne, Robert de la. "Chaplet et la renaissance de la céramique," *Revue de Deux Mondes,* LVII (May, 1910), 157–71.

Terrasse, Charles. "Paul Gauguin," *L'Art aujourd'hui,* Winter, 1927, pp. 29–33, Plate Nos. 61–80. (Editions Morancé, Paris.)

Tralbaut, M. E. "Rond een pot van Gauguin," *Mededelingenblad vriended van de nederlandske ceramiek,* No. 18, April, 1960.

Tristan, Flora. "De l'art et de l'artiste," *L'Artiste,* I (1838), 117–21.

———. "De l'art depuis la Renaissance," *L'Artiste,* I (1838), 345–50.

———. "Episode de la vie de Ribera," *L'Artiste,* I (1838), 192–96.

———. "Frangment de Mephis," *L'Artiste,* I (1838), 413–16.

Tschann, Gaspard. "Paul Gauguin et l'exotisme," *L'Amour de l'Art,* December, 1928, pp. 460–64.

Varenne, Gaston. "Les Bois gravés et sculptés de Paul Gauguin," *La Renaissance de l'Art français,* December, 1927, pp. 517–24.

Vasseur, P. "Paul Gauguin à Copenhague," *Revue de l'Art,* March, 1935, pp. 117–26.

Vauxcelles, L. "À propos des bois sculptés de Paul Gauguin," *L'Art Décoratif,* January, 1911, pp. 37–38.

Wilson, Thomas. "Anthropology at the Paris Exposition in 1889," *Report of the United States National Museum for the Year Ending June 30, 1890.* Washington, 1891.

Zolotoe Runo (Toison d'Or), I:i (1909), 5–14. Includes reproduction of works of Gauguin. Captions in French. Text in Russian. (Reprinted from *La Plume,* May 1, 1901.)

INDEX

INDEX OF THE
WORKS OF GAUGUIN

[Italic page numbers refer to the principal entry in the Catalogue.]

SCULPTURE AND CERAMICS OF PAUL GAUGUIN
Christopher Gray

designer: Edward D. King

typesetters: Monotype Composition Company, Baltimore and
 Progressive Composition Company, Philadelphia

typefaces: Text: Linotype Fairfield. Display: De Roos Roman

color separations: Lanman Engraving Company, Washington, D.C.

printer: Universal Lithographers, Baltimore

paper: Warren's Offset Enamel Dull

binder: Moore & Company, Baltimore

cover material: Holliston Mills Record Buckram